THE SCULPTURE OF
LEONARD BASKIN

THE SCULPTURE OF
LEONARD BASKIN

IRMA B. JAFFE

A STUDIO BOOK · *THE VIKING PRESS* · NEW YORK

To my mother, Yvonne, and Karin

Copyright © Irma B. Jaffe, 1980
All rights reserved
First published in 1980 by The Viking Press
625 Madison Avenue, New York, N.Y. 10022
Published simultaneously in Canada by
Penguin Books Canada Limited

Library of Congress Cataloging in Publication Data
Jaffe, Irma B
The sculpture of Leonard Baskin.
(A Studio book)
Bibliography: p.
Includes index.
1. Baskin, Leonard, 1922– 2. Sculptors—United
States—Biography. I. Title.
NB237.B38J33 730'.92'4 [B] 79-20202
ISBN 0-670-62526-4

Printed in the United States of America
by the Murray Printing Company, Westford, Massachusetts
Set in Janson
Index prepared by David Beams

CONTENTS

ACKNOWLEDGMENTS

❧

It is a pleasure to acknowledge the debts one accumulates in the course of writing a book, and it is my greatest pleasure now to acknowledge my largest debt in connection with the present work. This I owe to Leonard Baskin. The artist was patient, carefully thoughtful, and quite open in answering my questions and engaging in discussion with me about his life, his art, and his opinions on the art of others. Baskin's art-historical sophistication and broad humanist learning made our interviews in his studio and home on Little Deer Isle, Maine, a delight to which I returned day after day for more than two weeks during the summer of 1977.* Lisa Baskin sat in often while we talked, and frequently added to or clarified her husband's statements, always with tact and intelligence.

I talked with Jay and Estelle Unger, Lisa Baskin's parents, and with a number of the artist's long-time friends including Harold Hugo, Sidney and Emma Kaplan, Kenneth Nesheim, Dale Roylance, and Paul and Cynthia Propper Seton. I also interviewed Grace Borgenicht, Thomas Cornell (by phone), Lloyd Goodrich, Chaim Gross, William Lieberman, Beth Neville, Selden Rodman, and Herman Schickman, all of whom generously shared with me their thoughts about Baskin and his art.

Knowing of the late Professor Rudolf Wittkower's interest in Baskin, I asked Margot Wittkower, who was editing her husband's writings for posthumous publication, whether he had written anything on Baskin. It turned out that he had, although because of space and illustration limitations the passage had been deleted from the draft of his last lecture of the series "Sculpture: Processes and Principles," published posthumously under the same title. Wittkower wrote, "I would like to add a word about three American carvers . . . Isamu Noguchi, Sidney Geist, and Leonard Baskin. . . . The third name, Leonard Baskin, who is not yet fifty, I am introducing here because he is probably the most gifted all-round artist of his generation in America. He produces powerful hallucinatory and often haunting designs and sculptures and is certainly a carver of unusual talent." I thank Margot Wittkower for permission to publish this comment, and all of the above-named for giving me their valuable time and important insights.

A special note of thanks goes to Peter Maurer and Istvan Makky of Bedi-Makky, the art foundry where Baskin's bronzes are cast. Maurer and Makky took me through the foundry and explained the French sand-casting technology that the foundry uses for Baskin's sculptures. It became clearer to me how much art there is in this technology; it was Peter Maurer who developed the unusual and very rich an-

* All statements attributed to Baskin by direct quotation in this book were made to me during our conversations, unless otherwise indicated.

thracite-black patina of many of Baskin's sculptures of the seventies.

Lawrence Fleischman and his staff at the Kennedy Galleries, and Grace Borgenicht and her gallery staff, were helpful at all times and must be thanked especially for making it possible for me to locate Baskin's works. Deborah Brown, daughter of the late Boris Mirski, whose Boston gallery represented Baskin in that city for many years, generously provided me with many photographs.

Good criticism from colleagues, including Patrick A. Heelan, Charles Kelbley, Yvonne Korshak, and William J. Richardson, helped to sharpen many points; the incisive criticism of my husband, Sam Jaffe, has made this book shorter and more readable than it was in the first draft.

Lillian Rosati is not only my right arm, but both hands with ten fingers; she has tirelessly and patiently typed a manuscript densely interlaced with additions, deletions, and revisions. Barbara Burn at Viking has brought this book into being.

My thanks go, finally, to the administration and to the Research Council of Fordham University for their continuing support of my research and writing; for the present work I was the recipient of a Fordham Faculty Research Grant and a semester's leave of absence.

—Irma B. Jaffe
Fordham University

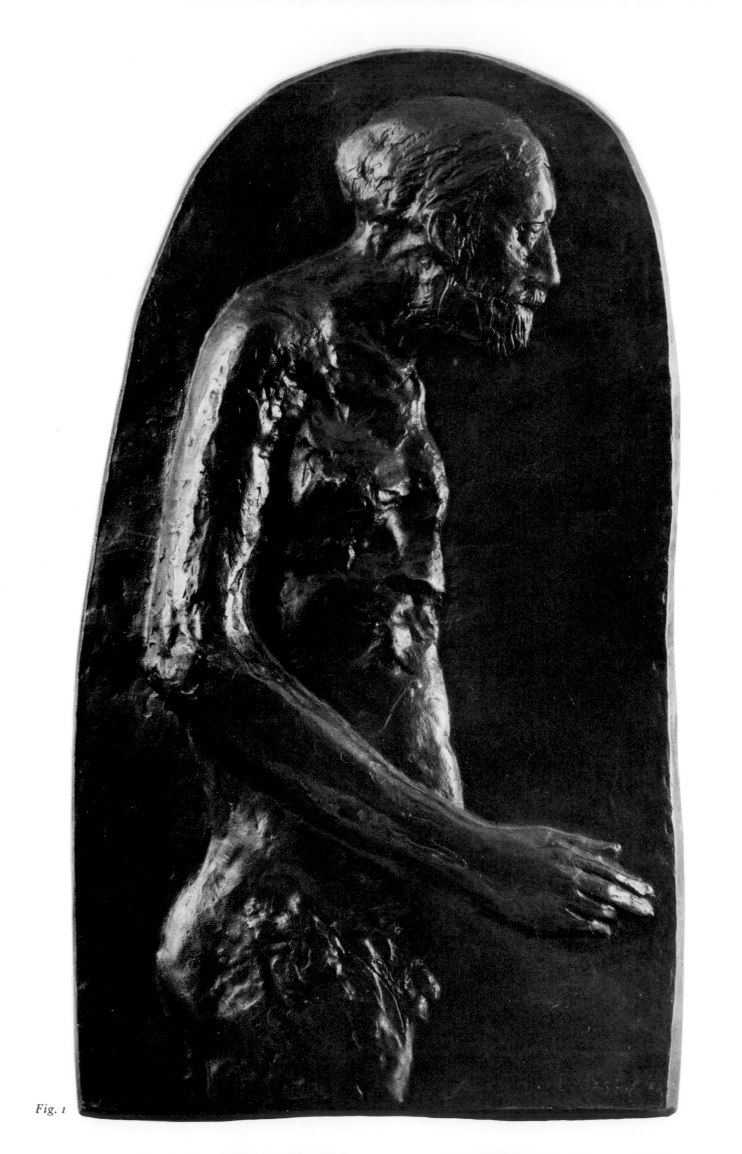

Fig. 1

Et hominem esse memento.

The epigraph that heads this introduction, "Remember thou art a man," appears as the third motto in Leonard Baskin's *Flosculi Sententiarum*, a small book of moralizing verses and maxims that he selected because they fit especially well with his own thought. For this artist, the human being is still at the center of the only universe we can know and so, since 1952, when his professional career began, he has explored what he thinks of as the landscape of man—the human figure. Committed to traditional techniques of carving and modeling, and to the human figure as the primary motif of sculpture, Baskin has maintained an aesthetic position uncompromisingly counter to the prevailing current of modernist art.

Baskin has been equally opposed to all modernist styles: to abstraction because he has a settled conviction that painting and sculpture must mediate between artist and viewer some moral insight about human experience and is convinced that abstractions cannot do this; to Pop, Neo-Realism, and Photo-Realism because he rejects what he sees as the banal and formally indifferent, the vulgar, and the noncommittal as inappropriate emotional settings for serious art. Whether one shares his views or not one must consider them seriously as those of a sophisticated artist who thinks hard and constantly about art—his own and others—and one must be aware of them in order to understand the aesthetic choices Baskin has made as a consequence of his own rather different artistic purposes. He has suffered in various ways as a result of his adversary position, and we will see how not only the subject of his art but even its emotional content reflects at times his view of himself as an opponent of contemporary styles, "defying malice while enduring it."[1]

All art is in some sense autobiographical. In the eighteenth century Buffon observed that "the style is the man," and in our own time Jean Cocteau has said that with every line "we compose our self-portrait." Invented around 1800 with the emergence of individualism as a significant social phenomenon, the term "autobiography" was meant to describe a written account of one's life;[2] in the course of the last 175 years the ideology of individualism has glorified autobiography to the point where writer Tom Wolfe has characterized our pres-

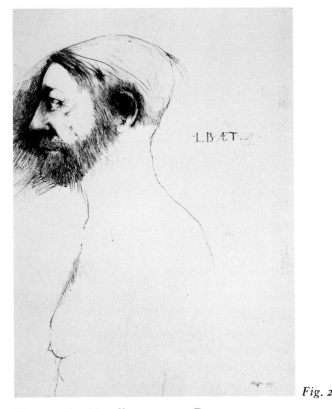

Fig. 2

Fig. 1: The Mendicant. 1967. Bronze relief, 24½ x 13 inches.

Fig. 2: Self-Portrait, age 42. 1964. Pen and ink.

ent as "the Me Decade." It is not to be wondered at that the term "autobiographical" has at last appeared in the literature on the plastic arts, usually in the context of art criticism. Personality is a magnetic field that attracts experiences sensitized to it, and the autobiographical work of art is a map of the field on which these experiences are spread and clustered. Exactly how the autobiographical presence is manifested, or is to be discerned, in a single work or in the *oeuvre* of a painter or sculptor is not always immediately evident, and it is one of the aims of this study of Leonard Baskin's sculpture to arrive at an understanding of the deep structure of his art through insights afforded by the more than ordinarily persistent physical presence of the artist in his works, and by the plain facts of his life.

Talking with Baskin, I commented that there was a physical and expressive resemblance between him and many of the faces and figures he has made. Even he seemed surprised when he heard himself reply, "I fully believe that all my figures are me." Thinking about this later, and looking at his works, I realized that there are basically two Baskin face types, although in some works neither type is evident. One face type is represented by a stone carving, *The Guardian* (Fig. 27), the other by *Hephaestus*, a bronze (Fig. 114). A photograph of the artist's parents reveals that the two face types correspond to the faces of his mother and father, and that, in the peculiar way of family resemblances, Baskin looks like both of them (Figs. 2, 3, 4, 5, 7). A frequently repeated figure style contains an indefinable constant, despite wide variations, that is recognizably based on Baskin's own figure; the sculptured figures, both freestanding and relief, are characterized by sloping shoulders, barrel chest, small buttocks, and legs that tend to be slim, sometimes spindly. *The Mendicant* (Fig. 1), modeled two years after his pen-and-ink self-portrait (Fig. 2), is one version of this figure, in which he represents himself as an old beggar; *Daedalus* (Fig. 117) is another, in which he appears as a young, idealized artist.

In his essay "On the Nature of Originality" Baskin proposes that it is the artist's presence in his work that gives it its uniqueness. "The only meaningful originality is the originality of content. Fortunately, for all our universal similarity of structure, each of us is a unique human being. . . . Each artist must give expression to this uniqueness. The work of art must be irrevocably tied with lines of tradition and sequence to all other works of art created by man, and it must yet be unique in the sense of the artist's own critical and central uniqueness."[3] In insisting on a necessary link between originality and tradition, Baskin touches on an issue central to his philosophy of art and places himself in the twentieth-century tradition of aesthetic criticism represented by W. H. Auden and T. S. Eliot. By tradition today, Auden wrote, "we

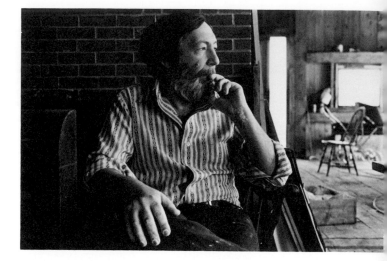

Fig. 3: Leonard Baskin. *Photograph by B. A. King.*

no longer mean what the eighteenth century meant, a way of working handed down from one generation to the next; we mean a consciousness of the whole of the past in the present. Originality no longer means a slight personal modification of one's immediate predecessors; it means the capacity to find in any other work of any date or locality clues for the treatment of one's own subject matter."[4]

The vexing relationship between innovation and tradition is Eliot's theme in his famous essay "Tradition and the Individual Talent." He regrets the modern "tendency to insist . . . upon those works [of an artist] in which he least resembles anyone else" since without this prejudice one would find that "not only the best but the most individual parts of his work may be those in which the dead [artists], his ancestors, assert their immortality most vigorously. . . . Tradition . . . cannot be inherited, and if you want it you must obtain it by great labour. It involves, in the first place, the historical sense . . . and the historical sense involves a perception, not only of the pastness of the past, but of its presence."[5]

Baskin's total person is embedded in just such a historical sense. The importance to him of tradition is born of an extraordinarily rich culture compounded of a profound knowledge of the Old Testament and of the literary and visual monuments of Western civilization. His education was based largely on parabolical literature and its interpretation; the habits of his thinking are symbolic. I believe his strength as an artist derives primarily from his consequent identification, sometimes conscious, more often unconscious, with the essentially symbolic prophetic tradition, reinforced by the mythic imagery that is central to his cultural heritage.

This book deals mainly with Baskin's sculpture. His production as an artist has been prodigious and a single volume could not begin to treat justly his countless drawings, woodcuts, etchings, and lithographs, and the extraordinarily creative contribution he has made to book design. I have elected, therefore, for the present, to write about what the artist considers his major life work, touching incidentally on a few graphic works as they relate to the sculptures under discussion. The first time I saw a work of sculpture by Leonard Baskin was in 1958, in the home of Professor Julius Held. At that time Baskin was only six years into his career. The work I saw that day, *Seated Fat Man* (Fig. 31), full of vitality and that indefinable quality recognized as presence, remained vivid in my memory. A few years later I noticed an announcement of a Baskin show at the Grace Borgenicht Gallery in New York. I went to see it, and again found myself entirely absorbed by the mysterious aura that emanated from the silent, hieratic forms. Over the years, almost from exhibition to exhibition, I have watched Baskin's art develop and deepen;

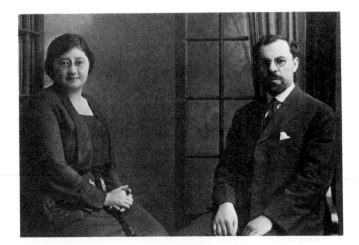

Fig. 4: Rabbi Samuel Baskin and May Guss Baskin, the artist's parents. *Photograph courtesy of Pearl Baskin Rabinowitz.*

changes came slowly, and one could always see Baskin's past in his present, but steadily his work increased in expressive range, dramatic suggestiveness, and formal assurance.

Baskin's art has followed an internal formal development that is almost uninfluenced by contemporary styles. One may notice, perhaps, in the uniformly crusty surfaces of relatively early works such as *Seated Birdman* (Fig. 90) or *Wilfred Owen* (Fig. 112) traces of dripping plaster that suggest something of the unitary field and Expressionist aesthetics of Jackson Pollock, and it is not without interest that Baskin's radical shift in style around 1967 to smooth surfaces occurred contemporaneously with the rise of reductivist aesthetics in abstract sculpture. Baskin insists there are no connections and I am inclined to agree, although with a lurking reservation to make room for the familiar but mysterious spook of zeitgeist. In the fifties and early sixties there are more carvings, in stone and wood, than one finds after 1967, and these carved figures are usually composed of a few rounded, immobile forms that swell commandingly into the space around them. Although stone carving disappears from his work entirely after 1958, Baskin has continued to carve wood, and in 1977 created his greatest work to date in that medium (Fig. 113). For a number of years his bronzes were cast from forms built up in plaster, but since 1967 he has worked mostly in clay.

Baskin's command of sculptural form is authoritative, but a sculptor's forms cannot be separated from their content and I have been engaged as deeply with the latter as with the former. For this reason it has seemed useful to structure this book in two parts. The first part is biographical and art historical; here are introduced those facts and experiences in Baskin's life that appear to me to have had a discernible effect on his art, as well as those historical sources that have influenced his forms. The second part is thematic; the formal and art historical discussion is continued and developed in the context of exploring the meanings of the major themes that have occupied his sculptural imagination. Meanings are elusive and many-faceted. Sculptural form, unlike poetry, is composed of parts that do not have even relatively fixed meanings, as words do. All art, of course, including the art of poetry, is by its nature allusive and resonating, but without a dictionary of formal parts, the plastic arts are particularly so. The viewer and critic participate in the work of art by lending themselves—their imagination, intelligence, aesthetic sensibility—to the work of art by entering into its allusive and resonating frame. This means that the work of art changes from viewer to viewer, from time to time, from epoch to epoch; thus the meaning of a work of art is only partly what the artist intended it to be. Once the work is in the world,

living among people, the meaning with which the artist endowed it merges with the meanings that people find in it.

The critic's highest purpose, I believe, is elucidative rather than evaluative: with sufficient and appropriate light, quality becomes evident. But no single explanation or method or plane of meaning can possibly account for the complex thing a work of art is, let alone an entire *oeuvre*. I have tried, therefore, in the following pages, to provide an art historical perspective in which Baskin's work may be located in the Western and modern archaizing tradition, and to probe, where suggestion led me, into the conglomerate, sedimented psyche of a culturally rich and intellectually and artistically gifted personality. As Donald Kuspit has observed with such simple truth, "Life leads art, or art life, in whatever devious ways; and clues to the way any given art comes into being and acquires its 'bearing' can be found in the artist's personal and social history. This seems obvious enough, but it is not easy to demonstrate concretely."[6] Trying to cope with the devious ways of life and art, I have felt my way through poetic analogy, psychological guesses, and the givens of the artist's life, and the resulting interpretation can hardly lay claim to the kind of truth that we usually believe science offers. But I admit to no untruth. The nature of art is spiritual, no matter how necessary an embodiment perceptible to the senses may be, and thus requires the spirit of understanding to reach its inner meaning. And so I invite the reader to enter with me into a hermeneutic circle of inquiry surrounding the meaning of Baskin's sculptural form and content, the circle in which belief, affinity, and sympathy lead to understanding. The circle comes round when understanding leads to sympathy, affinity, and belief.[7]

Fig. 5: Leonard Baskin in his studio. The Boston Red Sox were winning. Little Deer Isle, Me. 1977.

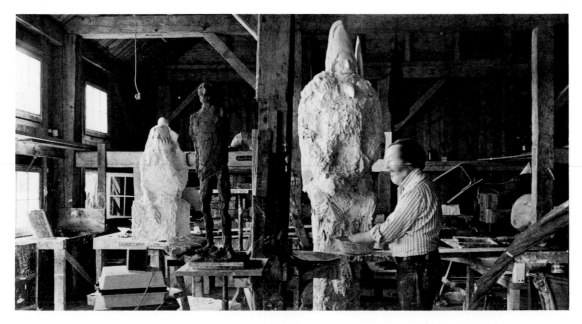

PART · ONE

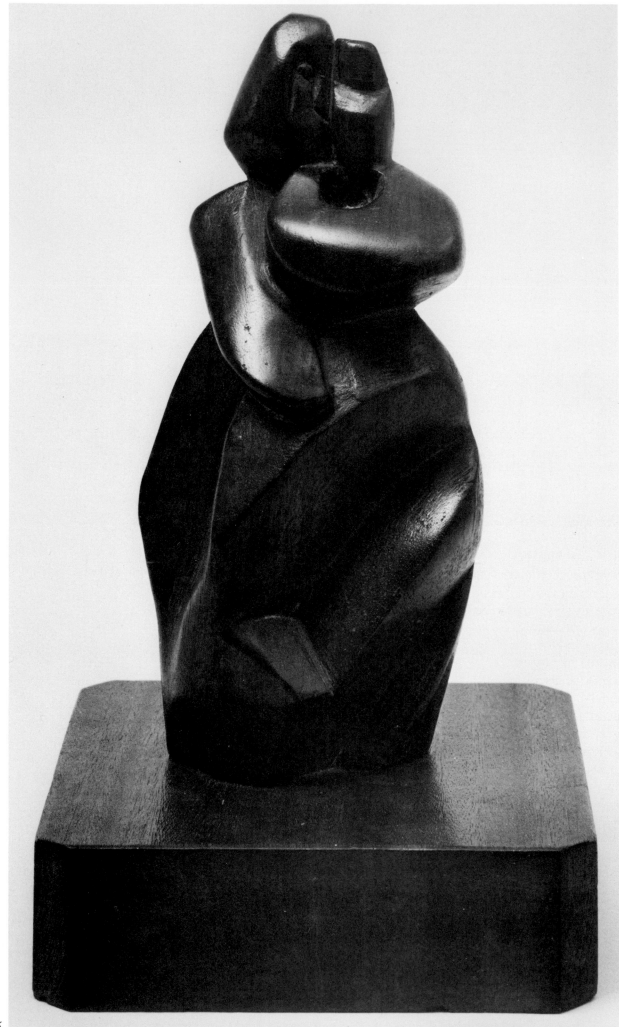

Fig. 6

BEGINNINGS

I am on the same ancient thoroughfare
That I was on that summer, on the day and hour.
—Boris Pasternak, "Explanation"[1]

In the spring of 1977 Leonard Baskin finished *The Altar* (Fig. 113, a-f). This extraordinary carving in linden wood had occupied him for over a year and effectively summarizes the first quarter-century of his sculptural thought. It is a masterpiece in the traditional sense of the word, for it glows with the aesthetic and technical mastery that had become his in this period, and climaxes a major thematic concern—the story of Abraham and Isaac. *The Altar* is an immense work, not only in its physical dimensions but also in the complexity and depth of its meaning, and its full content can only be grasped by rediscovering the steps that brought it into existence. The work is the final chapter of the first volume of Baskin's "autobiography." We must go back to the beginning to understand it. Absurdly, it began at Macy's in 1936.

It began there only in the specific sense that it was there, one day in his fourteenth year, that Baskin first glimpsed himself as he watched a young woman modeling plasticene in a crafts exhibition at Macy's Department Store on Thirty-fourth Street in New York City. Perhaps it is more accurate to say that he saw himself then in the blinding light of revelation, and has never ceased from that moment to search for the inner self of that first vision. For before that, he had no self to speak of. He was a young *yeshiva bocher* who liked chemistry, insects, and natural history. Of art—drawing, painting, carving, or modeling—he knew nothing; art was not a subject discussed in the Old Testament, the Talmud, or the biblical commentaries.

"From nine a.m. to seven p.m. I was in school, at the yeshiva," Baskin remembers. This was in Brooklyn, where the family had moved from New Brunswick, New Jersey, in

Fig. 6: Woman Playing Cello. c. 1938. Wood, 10¼ inches.

1929. In the morning, when minds were fresh, the pupils studied the Old Testament. They read in Hebrew—they didn't *study* Hebrew, they *read* it—and recited in Yiddish, answering questions on the texts put by the teacher. "The seminary ill prepared me for a beady-eyed world I never made," Baskin wrote in a brief autobiographical sketch. "Hidden away in dark rooms, our bodies shrivelled and our minds expanded as we dealt in metaphors we could not grasp, in abstrusities beyond our ability, and in an Aristotelean logic that made little sense. The teaching technique was recitation, recitation only, with its awful anxiety and sense of Damoclean doom. . . . There was no pandering in our childishness, no condescension by the teachers who were often vicious and who, at the slightest faltering during a recitation, would beat us."[2]

From three to four in the afternoon was the hour of play. "We played ball, or collected and traded stamps," he recalls. (To this day Baskin is a fervent Boston Red Sox fan and an at least equally fervent collector; to stamps he has added art and rare books.) Then from four until six forty-five the boys mastered the requirements of the public school system. Leonard's father, Rabbi Samuel Baskin, assumed charge of his education until he was sixteen. After that, the rabbi said, his second son could choose where he wanted to go to school and what he wanted to study. So in 1938 Leonard went to Seward Park High School, in Manhattan, where he was fortunate to have a sympathetic home-room teacher who did not report his constant absences or send the truant officer after him. High school, the artist says, at least those two years remaining after he left the yeshiva, was a complete blank. He had found a more significant school.

While still at the yeshiva young Baskin had started to attend night school at the Educational Alliance. Several evenings a week, after leaving the Hebrew school a little before seven o'clock, he would stop at home to bolt down a sandwich and then take the trolley over the Williamsburgh Bridge to Manhattan, arriving at the Educational Alliance on the Lower East Side for the life drawing class that began at eight and lasted until ten. This school played an important part in Baskin's life, as it had for countless young men and women, immigrants and children of immigrants from Eastern Europe.

The Educational Alliance was for several decades the intellectual and social center of Jewish life on the Lower East Side. Formed in 1889 from a merger of the Hebrew Free School, the Young Men's Hebrew Association, and the Aguilar Free Library Society, it was housed in the building on East Broadway and Jefferson Street where it still offers many of the educational services for which it was formed, although its principal aim, originally, was to help "Americanize" the

thousands of immigrant Jews who were pouring in from Eastern Europe in those years. In the thirties a rich variety of classes, and the library, were open to all who came, and the lecture program attracted an intelligent and sophisticated audience who came to hear well-known intellectuals speak on a wide range of subjects. The emphasis, however, was mainly on politics and aesthetics.

Art and music had been, from the first, important activities at the Educational Alliance. Even in the 1890s it offered art classes twice a week and over the years a distinguished roster of artists who have gained worldwide recognition taught or studied at the Alliance; these include Peter Blume, Jo Davidson, Sir Jacob Epstein, Philip Evergood, Adolph Gottlieb, Chaim Gross, Joseph Margulies, Louise Nevelson, Barnett Newman, Mark Rothko, Ben Shahn, and Moses Soyer. For Baskin, the most important of the artists teaching at the Alliance in 1938 was the admirable sculptor Maurice Glickman.[3] It was at this school and with Glickman that Baskin's professional education began. He had found his way there himself, led by the passion for art that had been stirred in him at Macy's.

What exactly did happen that day at Macy's? Baskin had noticed an advertisement in a newspaper of a crafts exhibition to be held at the store and persuaded his brother, Bernard, to go with him to see it. In the Depression years free entertainment was a prime desideratum, and according to Baskin there was no better entertainment, at any price, than walking through the immense world of Macy's. For a boy whose appetite for collecting was already insatiable, Macy's was more than ordinarily fascinating. There is an incongruous yet real connection, I believe, between his pleasure in the welter of things that surrounded him in the huge department store and his abiding taste for living amid a welter of things. His home today is a kind of aesthetic Macy's crammed with paintings, sculpture, fine prints, fine furniture, porcelain, and other *objets d'art*, and an extraordinary library.

One of the regular stops for Baskin on visits to Macy's was the book store, but on this particular day the brothers did not get there. They stopped at the crafts exhibition to watch the young woman who was demonstrating the technique of modeling—she was modeling a head—and Leonard stood transfixed as she skillfully worked the meaningless lump of plasticene into a form. It was his first experience of the "exaltation of building in the reality of space," as he describes it. "I could never [again] fix my attention elsewhere for long. This childish perception of the displacing presence of sculpture made sure and final the commitment then entered into. Nothing since has had a real depth of meaning, no event, not even years of execrable work, has threatened the glassy rigidity of that aspiration."[4]

Impatient after watching a while, as most youths would have been, Bernard Baskin left. Leonard remained fixed to the spot for several hours, until the store closed. He bought five pounds of plasticene and at home modeled the *Venus de Milo,* which he followed with Michelangelo's *Moses.* He found them illustrated in the *Book of Knowledge.*

Baskin, his brother, and his sister, Pearl, devoured the *Book of Knowledge*—all twenty volumes. In the scholarly atmosphere created by Rabbi Baskin the children took for granted that learning and living were identical. The rabbi's large library was a significant fact with which they lived, and its effect on all of them was permanent; as adults, not only Leonard but Bernard, too, became a book collector, and Pearl is a librarian. The rabbi was a demanding father and teacher whose chief means of communication with his children was tests: What had they learned in school that day? Even for Pearl, who attended public school, the catechismic imperative was a daily ordeal. Not that Rabbi Baskin was harsh; friends remember him as a particularly sweet-natured man, often with the gleam of good humor in his eyes; he laughed heartily at good jokes. But he had high standards and expected his children to live up to them.

The meaning and spelling of words—"one must never use a word one can't spell," Leonard Baskin would still insist —was a favorite game in the Baskin home, and "What does such-and-such mean," words like *cunctator* or *crapulous,* not in the vocabulary of everyday conversation, might start a passionate, angry, but enjoyable argument settled finally by the dictionary. Baskin's speech today is studded with uncommon words that give it an archaic stylishness.

As a boy he contributed his share—more than his share, he thinks now—to the fueling of heated discussions in the family circle. "All old Jewish men wear derbies," he observed provocatively one evening when the family was gathered at the dinner table. It must have seemed as if a bomb had exploded in their midst. Leonard fought singlehandedly the united forces marshaled instantly against him, and, listening to his recollection of this unforgotten scene, one senses that he felt a certain zest in fighting alone, especially in the one-to-one verbal combat with his father. "The Talmud says, 'One is jealous of everyone except one's son and one's students'—an interesting phrase," Baskin noted and paused for a moment to reconstruct the scenes from his childhood. One could easily follow his thoughts back to those moments of filial anxiety when he added, "Funny . . . my son, Tobias, says I did the same thing to him."

Samuel Baskin had been ordained a rabbi in Wilno, Poland, at the age of eighteen and left soon after for America, joining the tens of thousands of other young men who emigrated from Europe at the turn of the century. He made his

way west, settled for a time in Salt Lake City and then Denver, but finally came east. A marriage during his western sojourn ended in divorce. He married his second wife, May Guss, in Philadelphia in 1918 and brought her to New Brunswick, where he had obtained a post as rabbi. Here the Baskins' three children were born, Bernard in 1920, Leonard in 1922, and Pearl in 1925. In 1929 the family moved to Brooklyn, where Samuel Baskin became rabbi of Congregation B'nai Israel on Hughes Steet and Bedford Avenue. The call to Brooklyn was welcomed not only for the professional advancement but also because the rabbi was now able to send his sons to a yeshiva. In New Brunswick they had had to attend public school.

"I adored my father," Leonard Baskin says, but he felt totally out of sympathy with his mother, whose materialistic values were alien to his own. His father was a scholar, aloof from everyday family concerns, almost always closeted in his study when at home. Mrs. Baskin had the responsibility of forming the family unit through the daily chores of housekeeping. "She was a remarkable woman," Lisa Baskin, Leonard's wife, recalls. "She was intelligent, beautiful—but of course she was frustrated because the conditions of her life gave her no constructive opportunity to exert her strong will." So she nagged or shrieked in chronic anger. Leonard remembers his father as quiet and self-controlled and his mother as highly emotional, hardly ever happy. "She knew the cost of everything and the value of nothing," her son quotes from Oscar Wilde.

Every culture has its ways of demeaning women. May Baskin was a typical victim of a culture whose men included in a morning prayer repeated every day of their lives, "Thank you, God, for not having made me a woman." One of Baskin's sharpest memories is of a teacher at the yeshiva reciting the words of Hosea: "Plead with your mother, plead; / For she is not My wife, neither am I her husband; / And let her put away her harlotries from her face, / And her adulteries from between her breasts / Lest I strip her naked, / And set her as in the day that she was born, / And make her as a wilderness, / And set her like a dry land, / And slay her with thirst. / And I will not have compassion upon her children; For they are the children of harlotry (Hosea 2:4–6)." Baskin remembers how the teacher's bearded face glowed as tears ran down his cheeks, and how his eyes shone with rapture. He also remembers how the poetry enthralled him.

Leonard often felt himself an outsider in the family, an object of ridicule, "ganged up on" by his brother and sister. Bernard was his mother's favorite, Pearl his father's. So did the middle child perceive the distribution of family affection. "I was the middle child. The middle child either survives or is destroyed . . . I survived "[5] He did not think much about

being different from the others, but dimly perceived that he was. He brought home tramps and strangers with whom he struck up sudden friendships in the street and gave them food to eat. He was seized by tremendous enthusiasms and made to feel foolish for them. From an early age he felt "embattled," as he still does. According to family friends who remember him as a youth, he was moody, often impatient, and quick-tempered.

After completing his *Venus de Milo* and *Moses* Baskin found in his father's study and copied a bronze portrait bust of Friedrich Schiller, "a miserable cast, a hundred times removed from the original," Baskin the connoisseur now remembers it. Chosen by accident, the subjects of these first three pieces nevertheless adumbrate three sustained iconographical interests developed in Baskin's mature sculpture: classical mythology, the Old Testament, and portraiture of admired artists and poets. Following the excitement awakened in him by his first encounter with sculpture, he discovered the Brooklyn Museum, which he explored over and over again from top floor to basement. At that time there were casts from the antique on the top floor, which he studied attentively, but he was most moved by the primitive collections, especially the Northwest Coast Indian masks and totem poles and the Easter Island carvings. He carved a totem pole himself and then a stone figure that he lugged up from Brooklyn to the beach at Madison, Connecticut, a few years later.*

In the summer of 1936 Leonard joined a WPA class, where he carved a panther that he copied from the gate of the Brooklyn Zoo. The teacher shamed him for copying. She encouraged the students to invent, to let the material suggest forms, and under her tutelage he began to carve in a quasi-Cubist style, "fraught with the influence of Zadkine, Laurent, and Archipenko" (Fig. 6).[6] Then that fall he enrolled at the Educational Alliance, where his natural gift was quickly recognized. In the summer of 1937, in a juvenile hobby competition held there, he won first prize—a microscope set—for a group of his sculptures including *A Negress* and *A Lioness with Cubs*. When interviewed by a reporter from the *New York Journal and American* the fifteen-year-old artist was working on *A Polar Bear*, chiseling the forms out of a large block of marble that he had found on the East River Drive (Fig. 7). "I like marble," he told the reporter. "I did another piece, a nude called *Awakening*. That's in the Federal Art Show on 57th Street." Baskin also participated that summer in the young people's drama group production of *H.M.S. Pinafore*, for which he painted the sets. His next venture into the theater did not occur until thirty years later when, in 1967,

* Some of Baskin's friends were working as trainee architects under Edward Durrell Stone, who was building a house on the shore for W. T. Grant.

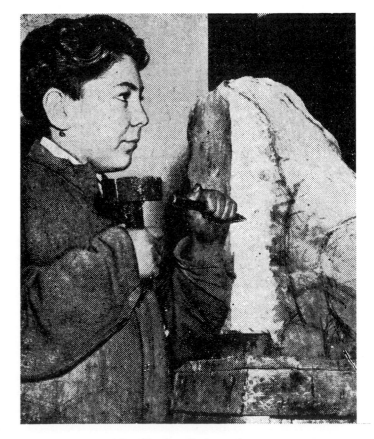

Fig. 7: Leonard Baskin carving a polar bear. 1937.

Eliot Feld commissioned him to paint the backdrop for his ballet company's production of *At Midnight*, set to music by Gustav Mahler.

No one lives untouched by the political forces that move modern society, but some—and Leonard Baskin is one of these —are more directly affected and feel a personal responsibility to respond. The world in which Baskin was growing into maturity was trembling on the verge of collapse. For millions— in Manchuria, in Ethiopia, in Spain—it was already rubble. In the thirties, faced with the evidence of economic conflict and military aggression abroad, and with catastrophic disintegration of the economy at home, many American intellectuals and artists found in the left-wing movement a coherent ideology for achieving a rational, moral, and socialist society in which humanism, the love of knowledge and art for their own sakes, could once again flower, unpolluted by materialism.

It was not difficult in those days to persuade a fifteen-year-old youth of the justice and beauty of the socialist vision. Marxist ideas were common currency and one heard them repeated wherever one went, especially in artistic and intellectual circles. At first Baskin argued with the considerable skill of a well-schooled and intelligent young Talmudic scholar against this ideology and the specific political positions taken by its fervent proponents as the events of the late thirties unfolded. But eventually he came around. "Slowly my mind found its way elsewhere," he recalled of this period. "The lustrous other world with its ranks of possibility became apparent. I stretched into it and was incapable of ever returning." Nevertheless, the world of his father would never be forgotten, and while he has "no official links to Jewry," Baskin readily acknowledges his ever-present sense of himself as a Jew. "My brain is serried with an infinity of memory-traces that recall the sound and smell of *shul*, of home, of yeshiva, of the nearly all-Jewish street."[7]

Helping his mind to find its way elsewhere was his principal mentor, Maurice Glickman, his teacher at the Educational Alliance for whom Baskin still feels a great appreciation. Baskin never repudiated the social philosophy he learned from Glickman, although, like most men and women of his generation who embraced that dream, he is now disillusioned about the Soviet Union and questions the possibility of man's ever realizing the socialist utopia. In those days, however, arguing with Glickman about "everything on earth" without admitting at first that his views were affected, he gradually began to see society in a far more comprehensive way than he had been able to within the boundaries of a rabbinical home and a yeshiva schooling.

But it was not only politics that Baskin learned from Glickman. He begged his teacher to let him help around the studio, and for two years he "made a pest of himself," watch-

ing the older artist's every move, absorbing all he could as a novice until he had learned the fundamentals of his art. "The best way to learn about art," Baskin still advises young artists, "is to attach yourself to an artist. You've got to be in his studio, in his guts, in his hair, bothering him all the time. I was the protégé of [Maurice Glickman] and at the end of a year his wife couldn't stand me. But it was enormously fruitful."[8] Consumed with an ardent love for sculpture, Baskin gave himself utterly to learning what Glickman had to teach and through this relationship he was transformed from a talented boy into a promising sculptor, from a youth with an inherited and all but unconscious value system to a young man with an awakening self-awareness and a new, deliberately chosen ideology.

Always a voracious reader, Baskin turned now to Marxist and proletarian literature, and began also to read the publications of the American Communist Party. "But I never could read the *Daily Worker*," he recalls. "I was always too bright for that. I read the *New Masses*, and later on, *Masses and Mainstream*. I also used to look at *Science and Society*, which I think really was a good magazine. Of course I was gobbling up books—Jakob Wassermann's *The World's Illusion*, and all of Rolland's *Jean Christophe*—you can only read that when you're sixteen or seventeen, it's unreadable at any other age. I had two favorite pieces of Marxist writing. One was Lenin's *State and Revolution*, which I think is a great classic; the other is a collection of writings by Plekhanov. I never attempted to read the economic basis of Marxism. I couldn't, of course. But I understood the concepts. Then there was another book, a collection of writings with Engels' speech at Marx's grave, and things by Eleanor Marx. But I must admit at the same time I was reading the *Partisan Review*, much to the scandal of some of my friends."

He read the poems and plays of García Lorca, already a cult figure in left-wing circles, and a few years later he carved a *Death Head of Lorca* (Fig. 8), his homage to Spain's great anti-fascist poet. The novel that moved him most deeply at this time was Martin Andersen Nexø's *Pelle the Conqueror*, which tells the story of a proletarian hero whose life symbolizes the awakening and development of the working-class movement in Denmark. The protagonist is followed in four volumes from countryside (volume 1, childhood, feudalism) to town (volume 2, youth, the guild system) to the city (volume 3, manhood, the working-class struggle to organize unions) and back to the country (volume 4, full maturity, workers' cooperatives). As Harry Slochower points out in his *Three Ways of Modern Man*, the hero's powerful individuality is essentially anti-proletarian.[9] Though gripped by proletarian sympathies during the thirties, Baskin was, I believe, attracted to Pelle the hero and conqueror more than to Pelle

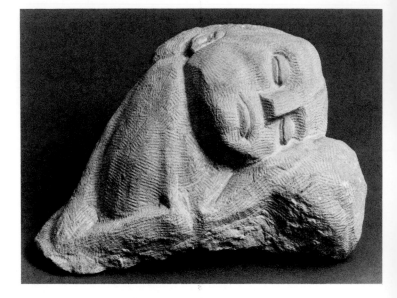

Fig. 8: Death Head of Lorca. Before 1949. Stone, 10 inches.

the proletarian. In any case, the novel's impact on him was great and is reflected in his carving, some years after reading it, the figure of *Pelle the Conqueror* (Fig. 9). During the war, doing service on a freighter that crossed back and forth over the North Atlantic, Baskin wrote an autobiographical novel obviously based on Nexø: in three volumes the hero moves through three love affairs with women who represent capitalism, socialism, and communism. "It was a good idea," Baskin says, "but the writing was rubbish."

While Maurice Glickman was, for several years, his closest friend, Baskin speaks of Ludwig Ehrensreich, among friends of his own age, as "the most gifted person I have ever known." He and Ludwig talked endlessly about art and about their plans for being artists. "His sketchbooks are incredibly beautiful—he drew like a seventeenth-century master." The two boys sometimes went together to gallery exhibitions and to the Brooklyn Museum, but usually Baskin went alone. He began regularly to visit the uptown galleries, which were mostly on Fifty-seventh Street at that time. The Brummer and Neidendorf galleries were favorites. The Museum of Modern Art aroused his curiosity, but the Metropolitan absorbed him utterly, and gradually he furnished his mind with its contents. He began to collect exhibition catalogues and found his way to the Italian Line in Rockefeller Center, where one could get, free, *L'Italia*, a government-published magazine that always contained two large color reproductions of Old Masters. Baskin cut them out, mounted them, made an index, and had the sheets bound into a book at the bindery that his father operated for a time. He had already begun to collect books on art and he remembers that the first one he bought was the Phaidon book on the Impressionists. He also remembers, painfully, that he bought on the installment plan Thomas Craven's book on American art.

At this time American art was overwhelmingly representational. The first wave of widespread interest in abstract and non-figurative styles influenced by contacts with Cubism, Futurism, and German Expressionism had lasted only a few years after the Armory Show in 1913, and although some artists—Stuart Davis, Arthur Dove, and John Marin, for example —continued to work in variations of these modernist modes, many more, such as Charles Sheeler and Charles Demuth, sought a solution to modernism by assimilating it into representational images. The only important sculptor to persist in abstraction was John Storrs. Until the mid-thirties the most significant artists working in three-dimensional form in America were Gaston Lachaise and Elie Nadelman, both of whom remained figurative. Reaction against conceptualizing styles had centered during the twenties in the painting of the realist "Fourteenth Street School" of Kenneth Hayes Miller and the Soyers, which set the stage for Social Realism and So-

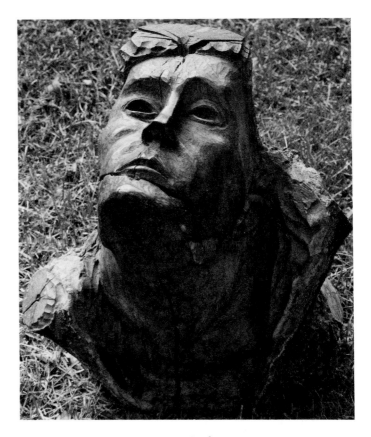

Fig. 9: Pelle the Conqueror. Before 1949. Wood, 18 inches.

cial Protest art during most of the thirties, styles that owed much to the socialist convictions of many of the leading artists of the period. At the opposite end of the political spectrum conservatives were beginning to cohere around the slogan "America First," and this important segment of opinion found its imagists in American Regionalism, with such painters as Thomas Hart Benton and Grant Wood representing small-town or rural life in middle America. Social Protest, on the other hand, principally emerged from the East Coast urban and working-class milieu at the hands of Ben Shahn, Jack Levine, and Philip Evergood. Other painters, such as Edward Hopper and Charles Burchfield, who did not have so conscious or systematic an ideology, painted the American scene without polemical overtones. Sculptors also responded to the social-political appeal of the thirties. Isamu Noguchi, who had already made successful abstractions in Paris inspired by both Brancusi and Constructivism, turned to a figurative style as more consonant with his political sympathies. His *Death* (1934), a contorted figure hanging from a rope, represents a lynched Black man, according to the artist, an idea that he says "no doubt stemmed from my sudden emergence into the field of social protest."[10] David Smith had made abstractions since the beginning of the decade, but in 1937, the year of the bombing of Guernica and of Picasso's famous painting memorializing the event, he began his series of *Medals for Dishonor*, number nine of which is entitled *Bombing Civilian Populations*.

The artists the young Baskin would have seen while making the rounds of the galleries tended to fit artistically into one or another of these groups. The new development of American abstract art was almost unknown outside the small circle of artists and their friends who were beginning to work toward non-representational styles, although the abstract movement was gradually gaining adherents.

In 1936 the American Abstract Artists was formed, and at least twenty-eight members participated in the first group exhibition at the Squibb Gallery in April 1937; Ibram Lassaw was the sole exhibiting sculptor.[11] Also in 1936 the Museum of Modern Art held its important exhibition "Cubism and Abstract Art." In 1938 the American Abstract Artists held their second show, accompanied by a catalogue in which the rationale for the group was stated by Lassaw: the discoveries of "modern physics, electricity, and machinery" were adduced, together with psychology and psychoanalysis, as the conditions that demanded new attitudes toward the meaning of art. "The artist no longer feels that he is 'representing reality,' he is actually making reality," Lassaw wrote. Wayne Andersen has succinctly summarized the situation at the end of the decade: "An unprecedented union of art, technology, and psychology was now in the hands of a nascent American avant-

garde."[12] Leonard Baskin witnessed this new "union" and the rebirth of abstraction in America, and he turned away from it, permanently.

Of American sculptors of his artistic generation who have won substantial recognition, those born between World War I and the Depression, Baskin stands almost alone in his rejection of abstract or non-objective imagery, technological innovation, the use of synthetic plastic media, open form, and imagery drawn from everyday life. These are the features that, taken together, separately, or in various combinations, characterize art that is systematically, methodologically, or ideologically committed to modernism. Baskin is a modern artist whose images are formed out of a profound identification with a world that he sees as a continuum of unchanging human experience. "Man has not changed," Baskin declares, his voice a mixture of quiet despair and pride. "The critical thing for me in relation to the fact of the twentieth century is that essential human qualities of life have remained the same, physically and psychologically. People eat and shit, drink and piss; they love and hate. I'm talking about human beings in a real world. Everything that surrounds them admittedly has changed. How they make their bread, how in fact they earn their money to make their bread. Obviously things have changed from the time of Aristotle to the time of Einstein. But not basic human life. No matter how fast we go, we still function as physical beings. That becomes of overwhelming importance for my art. The continuum of human life—that is what makes art sublime. That's why a break in the continuum is so destructive for art."

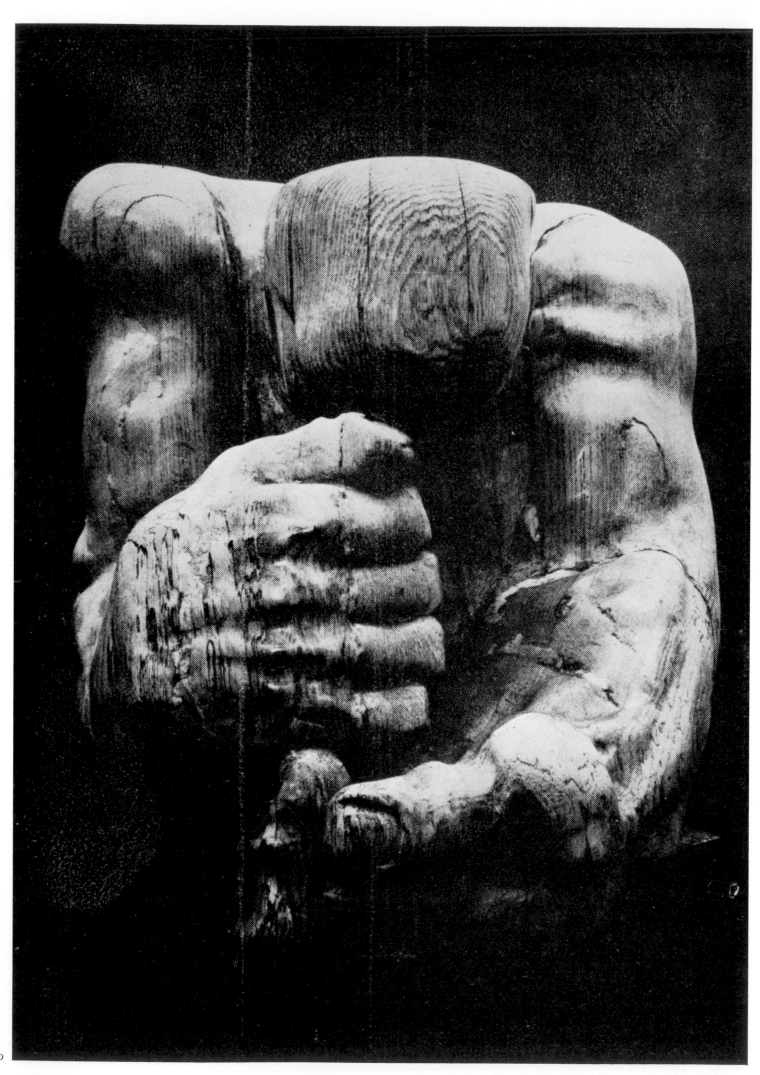

Fig. 10

MISSTEPS IN·THE·RIGHT DIRECTION

ᴋ

*R*ather unwillingly, Baskin allowed his parents and Maurice Glickman to persuade him to go to college; after graduating from high school he had decided that further formal education would be of no use to him. But he entered the New York University School of Architecture and Allied Arts, located on two floors of a factory building on Sixth Avenue opposite the back of the New York Public Library, and here he soon found himself in a congenial circle of student architects and industrial designers. Some of them, Frank Labianca, Jay Sam Unger, Ray Johnson, and Frederick Ginsbern, now successful architects, became his first patrons. He had his first exhibition at Glickman's studio in 1939 and in 1940 won an Honorable Mention for Sculpture in the Prix de Rome competition. At the school he took a course with René Chambellan, in whose huge workshop on East Thirty-ninth Street so many of New York's worst public monuments were modeled and cast, and he learned there to despise the pointing technique by which small, sometimes admirable models were used for gigantically enlarged works emptied of any aesthetic content. Baskin remembers Chambellan as "a lovely little man. He made the dolphins on the approaches to the Prometheus at Rockefeller Center, and in fact most of the decorations at Rockefeller Center were executed in his studio. He did a lot of Paul Manships, from scale models. His shop was interesting because he knew everything about how to make things."

On financially shaky ground, the school was unable to survive when it began to lose students to the military draft. Baskin won a scholarship that enabled him to go to Yale, where for the next two years his life was both "horrendous" and "wonderful." He was writing poetry, bad poetry, he says firmly, refusing to let anyone see it; he almost never went to classes, but read his way through the Linonia and Brothers

Fig. 10: Prometheus. Before 1949. Red oak.

Reading Room in Sterling Memorial Library. Here he discovered William Blake, "not an insignificant moment in my life," and as a direct consequence of his discovery that Blake had printed his own books, Baskin taught himself to print on a press in Jonathan Edwards College. He began immediately ambitious plans for a publishing enterprise that, with the characteristic Baskin taste for erudite humor, he called The Gehenna Press: the name involves a pun on the word "type" since it comes from a line in the first book of Milton's *Paradise Lost.* The monster King Moloch "made his Grove / The pleasantest Valley of Hinnon, Tophet thence / and Black Gehenna called, the type of Hell." He produced as his first book *On a Pyre of Withered Roses*, a collection of his own poems. "The desire to print magnificently has been a secondary passion of mine," Baskin has said. "People like me who care about printing—the architecture of the page—constitute the tiniest lunatic fringe group in the nation."[1] It is interesting to note Baskin's pride in his identification with rare and precious, though eccentric, people. One thinks of his collection of rare and precious objects of art, objects that, when he acquired them, were on the outer fringes of the collector's market, although they subsequently became much in demand and are now avidly sought after and extremely costly.

It was in these years at Yale that Baskin discovered Gustav Mahler, whose music ever since has touched him with special power. From the age of fourteen to sixteen he had studied the cello with his customary zeal and learned to play fairly well. He joined a school orchestra, but finally gave up serious thoughts about a musical career; he had one fatal defect for a musician, he admits with a regretful laugh: "I could not hear when I was off key." At Yale there was a music room to which he contrived to get a key so that he could slip in late at night and play records. His taste then as now ran to the classics, but he liked occasionally to listen to early Romantic music.

Once in a while Baskin showed up for the drawing course in which he had enrolled. The instructor would sketch over Baskin's drawings to correct them and Baskin would regularly walk out of the classroom when this happened. He and the instructor had fierce disagreements, and on one occasion Baskin voiced an unflattering opinion of his instructor's work as both artist and teacher. "I was brash and arrogant and quite horrendous, I think. But with total conviction of my own future greatness. I have always thought it an absolute necessity for anyone who aspires to be an artist to have a conviction of his own greatness—otherwise how can you carry on, in the face of all the grandeur that's preceded you?" There were bouts with depression, nevertheless. It was probably his determined belief in himself that gave him the courage to acknowledge the sorry ineptness of the work he was doing,

and this kept him alive, though far from healthy. He began to drink heavily and gained an enormous amount of weight. At twenty he must have been the kind of bloated figure that he was later to depict in drawings and sculpture: *Poet Laureate* (Fig. 32) is a bitter homage to Dylan Thomas, who drowned his gift in alcohol.

Warnings came from the dean's office until one day he was called in and told to leave. He pleaded for another chance. "There's an innate trait in human beings to stay where they are, however strong the impulse to move on," Baskin comments in retrospect. He was reinstated but he did not reform and in a short time he was called in again and expelled. He had anticipated the falling of this ax, however, and had already enlisted in the navy as a Naval Air Corps cadet.

During the Battle of Britain Baskin had smothered his anti-Nazi feelings and his tendency to sympathize with England. He allowed left-wing propaganda to persuade him that the war was between two imperialist powers that should be permitted to destroy each other and thus weaken the capitalist system. His conflict was resolved on June 21, 1941, by the Nazi attack on the Soviet Union, and from then on he wholeheartedly supported the Allied war effort.

The first hurdle in the Naval Air Corps cadet program was coping with the strenuous physical training. Not quite five feet eight inches tall, Baskin weighed about 180 pounds and was unable to run a city block. At the end of the training program, he weighed 140 pounds, could run endlessly, and went up ropes "like a monkey," he remembers. Eventually, however, he was "washed out" of the program for failing at precision maneuvers, which meant landing on carriers. He did succeed in accumulating one hundred solo hours of flying, however. "In the beginning it's full of exaltation, flying into the clouds, you know. But I'm an anti-exuberance man. I wasn't one of the hot-rod kids."

He tried to get into a language program to learn Chinese but lacked the prerequisites, so he landed instead in boot camp, where he distinguished himself by insolent and insubordinate behavior that led to a court-martial. Found guilty, he was given a suspended sentence and allowed to get into the Armed Guards, where he was assigned anti-aircraft gunner duty on a freight ship that carried war materiel to England. After several Atlantic crossings he was transferred to a freighter in the Pacific. The ship's carpenter, "Chips," as all ship's carpenters are called, let Baskin set up a small "studio" in his carpenter's shop, where he carved a number of figures including *Torso* (Fig. 11). Whatever leisure time he had was given to carving and to writing poems, short stories, and the long three-part novel inspired by Nexø.

The war over, Baskin returned to New York, where under the G.I. Bill he resumed his interrupted education at the

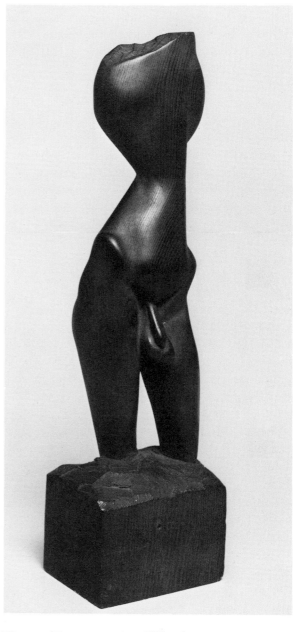

Fig. 11: Torso. c. 1943. Wood, 13¼ inches.

New School for Social Research. He married a friend of his sister's, Esther Tane, a psychology student at Brooklyn College, took a studio apartment on the edge of the East River in Brooklyn, and renewed his ties to the left-wing movement. He had left New York at the age of nineteen; he was now twenty-four. In the five years of his absence a new American art had come into being.

During the thirties, when the abstract movement was beginning to form in New York, large numbers of artists were anti-fascist and socially conscious.[2] Their leftist sympathies were strained by pressure from the Communist Party to paint proletarian subjects and to acknowledge art as a political weapon, but most were of two minds about this. They recognized the validity of Lenin's often quoted epigram that "to be above the struggle is to be beside the point," but they resented and resisted constraints on their artistic freedom. Their leftist-universalist tendencies responded to the supranationalist, spiritual appeal of Kandinsky and Mondrian, whose writings and paintings were well known to them, and they welcomed particularly the latter's reductionist imagery. His primary colors and straight lines at right angles were seen as basic to all human experience and thus easily understood by everyone, educated or not. Many artists believed that Neo-Plasticism provided the final solution to the problem of creating a people's art. The abstract movement that prevailed in the thirties was therefore structuralist and geometrizing, with biomorphic Surrealist elements beginning to appear. Among the sculptors, abstraction incorporated also the lessons of Russian Constructivism with its emphasis on materials and techniques. Because casting in bronze was costly, it is likely that economic considerations also contributed initially to the search for new methods. Less expensive sculpture made of direct-welded metals had the added appeal of association with factory production methods and seemed to be less elitist, which accorded with the social consciousness of the Depression era.

The Moscow trials of 1936–1938 raised painful questions about the humanity of the leaders of the Soviet Union, and the Nazi-Soviet pact in 1939 gave the coup de grâce to utopian and socialist hopes centered in the new Russia. The best the left could say was that socialism had been betrayed by Stalinism, and the opportunity to say so was not often missed. The exodus from left-wing organizations was not through the Red Sea but out of it. The problem that artists faced on the opposite, "unknown shore," as Dore Ashton has characterized the aesthetic geography of Abstract Expressionism, was how to make art without giving up the modernist ground they had won. Reductionist aesthetics had lost their appeal along with interest in a people's art.

Human spiritual freedom had been a well-articulated goal among Communist fellow travelers and in popular-front

groups. For some artists this goal was interpreted in terms of freedom from traditional aesthetic principles of color, composition, and materials; above all it meant freedom from the communication of specific, generally "readable" subject matter. In the early forties these artists found they could salvage from the wreck of their political disillusionment the one bright shining ideal of freedom. Now, however, spiritual freedom was not to be won for Everyman but by each artist for himself. This solution retained the goal of "freedom"; it was simply weighed on the opposite side of the objective-subjective scale. Thus the abstract art of the forties brought painting and sculpture to an unprecedented intensity of self-reference.

The key to this solution was offered by Surrealism, which stressed the role of the subjective unconscious, seemingly expressed by naturalistic forms that suggest bones and human anatomical parts often vaguely sexual in shape. Seymour Lipton, who in the thirities had made wood sculpture based on social themes, turned to abstract skeletal forms or, as he has said, to the "construction of horns, pelvis, etc., so as to convey a fierce struggle on a broad biological level."[3] Noguchi also returned to abstract sculpture, which used suggestive forms to elicit personal, unconscious associations. Lassaw, who had been highly influenced by Mondrian in the thirties, began to incorporate free-form biomorphic shapes into his Constructivist space-boxes. Even Calder's organic shapes took on a new, strangely animated look. David Smith found the Surrealist vocabulary useful for continuing his anti-war themes in abstract terms, but it also gave him a private symbolism in which he referred to his domestic life. The urge to universalize art did not disappear; it turned inward to be channeled through the artist's psyche.

This abstract and personal art was unacceptable to artists who remained convinced that art must be a weapon in the struggle for freedom. The goal sounded the same, but to leftists artistic freedom acknowledged the necessity of representing the recognizable world of objects. As a social instrument that could liberate working people from exploitation, black people from oppression, minority groups from the social evils that burdened them, and all humanity from war, art had a responsibility to communicate in a public language, not to a few, but to many—the subway masses.

On January 28, 1948, Harriet Van Horne interviewed a gallery owner on her radio program, "Manhattan Close-ups." The owner's uncle, Friedrich Alexan, had founded the Tribune Subway Gallery in 1945.

"Why did your uncle select this site?" Van Horne asked.

"Well, Mr. Alexan believes that art is part of everyday living. He doesn't regard pictures as something to look at in museums and study with hushed reverence. Art is for the

people. And where in New York can most people be found at one time or another?"

"The subway, of course. . . . You should be proud of your gallery, Mr. Giniger."

"We are. Sometimes I think we should have followed Mr. Alexan's original advice and named it the Lower Level Louvre."[4]

It was in the Tribune Gallery's small publication, *Tribune of Art*, that Leonard Baskin's first notice as a professional artist appeared.[5] In the February–March 1948 issue of the pamphlet, critic Sidney Finkelstein's review of the Tribune Subway Gallery exhibition "Twelve Young American Artists in a Changing World" mentions Baskin's "powerful sculpture, *No More War* [unlocated]." In the next issue Baskin himself wrote a short review essay on "Nineteen Unknown Soldier Artists in Postwar America." He was too much of an artist to praise the sincere but inept attempts of the young artists he wrote about, but he found "a healthy dissatisfaction with tried and proven ways . . . the most directly positive note in the show." Like Finkelstein, whose book *Art and Society* he had read, Baskin is concerned in this essay with the definition of Realism.

Greatness in art is the free, significant and profound expression of reality. And by reality is meant the penetration beneath surfaces to the true meanings of things in their relation to life. Realism means the uncovering of societal factors that make for change in history. . . . Young artists must seek in the masters, in Rembrandt, in Goya, in Daumier, and in the masters of the present, in Orozco, in the Picasso of *Guernica*, in Kollwitz, for inspiration and guidance. . . . The great technical advances of the modern art movement must be assimilated and used, and this interaction will change their character and meaning. Holding steadfast to reality must be the purpose of these young artists, if they wish to emerge from their present dilemma.

Realism has become possibly the most difficult word in the aesthetic vocabulary to define, or, at least, on which to find agreement as to definition. The problem was sharply in evidence in an exhibition at the Whitney Museum during the summer of 1975, when selections from the museum's permanent collection of art since 1945 were displayed. The curator placed Baskin's *Hephaestus* (Fig. 114) in the gallery labeled Realism, where works by Edward Hopper and Richard Estes were hung. *Hephaestus* looked quite out of place, and would have been in greater visual harmony standing in front of a Jackson Pollock in the gallery devoted to Abstract Expressionism, but this would have raised other problems with which the exhibition was not designed to deal. So the fact that the forms of *Hephaestus* are recognizably like forms seen in

nature had to take precedence over other considerations of style and meaning.

For most people realism implies verisimilitude, the faithful imitation of natural appearance. For others it means plight consciousness, or social consciousness in a more general sense, and deals with the hard facts of life and with people in commonplace situations of work or leisure. Baskin, in an essay he published in *New Foundations*, a Marxist cultural journal of which he became art editor in 1948, quotes Friedrich Engels on realism, which, Engels held, "implies besides truth of detail, the truthful reproduction of typical characters under typical circumstances."[6] This sounds very much like the classical Renaissance aesthetics of Alberti in its emphasis on imitation and typicality. Alberti's realism, however, was ontological; the artist must select from nature what in his artistic judgment was most beautiful and typical. The Renaissance notion of what constitutes nature and the typical is thus utterly different. Engels was interested in these terms not in their metaphysical implications but in their social sense. At the same time, his definition of realism is quite opposite to the casual, random, transient realism of his contemporaries, the Impressionists. In sculpture such a definition is somewhat exemplified by the late-nineteenth and early-twentieth-century proletarian images of Aimé-Jules Dalou and Constantin Meunier, two sculptors whose work Baskin highly esteems.[7] These artists, however, preferred heroic associations for the working-class hero, and tended to couch their sculptural statements in poses and gestures that recall pietàs, entombments, and the like belonging to the great, classically rooted tradition. The homely genre figures of John Rogers, probably the most popular artist in America in the third quarter of the nineteenth century, secure in their Victorian middle-class and rural settings, are, ironically, perfect realizations of Engels' definition. This was of course not at all what Baskin (or Engels) had in mind. Baskin appears to ignore the problem of realism's "ambiguous relationship to the highly problematical concept of reality," which as Linda Nochlin points out is at the heart of the difficulty of defining realism, and he uses the terms "realism" and "reality" interchangeably. Nevertheless, his own definition is essentially epistemological, since it depends on the distinction between seeing as a passive, sensual experience of what things seem to be and seeing as an active, mentally organized judgment about what things really are. For him, the distinction lies along the cut between realism and naturalism. "Naturalism tends to exclude the individual, to limit his function to nothing more than a kind of *camera obscura*. Realism in no way means the depiction of things as they seem, but rather as they are." His epistemology was nevertheless wrapped in Marxist ideology, which, as we saw in Engels, conceives of reality primarily in social terms. "It is

not true," he continues, "that the portrayal of reality necessarily involves themes of an immediately political nature . . . it is *all* of men's existence that is the artists' province. Whatever he deals with, the artist must inform as to the inner workings and meanings of society."[8]

The issue of realism in art was forced to the foreground in the forties by the growing success of the American abstract and non-figurative artists and was widely debated not only by a puzzled public but by artists themselves. Baskin, as we know, had never been seriously attracted to abstraction, although he acknowledged "the tremendous technical development of the modern art movement."[9] He insisted, however, that these advances were significant only insofar as they could be put to the service of "reality"; otherwise they were no more than aesthetic dogma. His criticism ignored an important dichotomy in abstract art that many others, too, overlooked. On one hand, the claim is made by proponents of abstraction that art is and must be its own justification and its content is purely aesthetic. This position, crystallized early in the century by Clive Bell, found its most extreme proponent in Ad Reinhardt, who wrote in 1962, "The one thing to say about art and life is that art is not life and life is not art. . . . Art that is a matter of life and death is neither fine nor free." For Reinhardt, art was either true, pure, and free, or false, polluted with meaning, and servile. In the forties many artists agreed with Reinhardt that subject matter was of no consequence, but this position was sharply challenged by painters like Gottlieb, Newman, and Rothko, who wrote, "There is no such thing as good painting about nothing. We assert that the subject is crucial." As for this subject, they went on, "the spectator [must] see the world our way—not his way."[10]

Strangely, there were critical points of contact between Baskin and each side of the abstract position. Like the extreme purists, Baskin was striving for an absolutist art that would transcend the particular. As we shall see, his development toward this early vision has never faltered. On the other hand, like the Abstract Expressionists, he conceived of art as the expression of personal emotion. His radical rejection of these modernist modes arose from his conviction that art must do what human beings do—communicate through a shared language—and his further belief that communication *should* be about life and death. His interest in expression led him to explore the theory of his friend the painter and graphic artist Jacob Landau, who emphasized the notion of necessary distortion, a theory fundamental to German Expressionism. Expressionism has always been a more or less evident factor in Baskin's art, although as he developed his own style, he left behind the strident claims for attention that marked the forms of his sculpture in the late 1940s. Indeed,

his later works often resist such a classification. *Prometheus* (Fig. 10), carved during his years at the New School, summarizes his aesthetic and political position at this time.

Prometheus was the progenitor of the human race, the Titan who challenged Zeus on behalf of the humans he had created. He is the bringer of fire—and thus of technology—who was punished for his revolutionary action in stealing this treasured private property of the gods by being chained to a mountain cliff. Each day he was attacked by an eagle that ate the liver out of his body; each night the liver grew back so that the tortured martyrdom continued, it is said, for thirty thousand years. Baskin's hugely muscled figure with enormous hands is, of course, "the worker." This Prometheus is the progenitor of the *new* race of men, men of the working class, heroic in their spiritual struggle against the ruling gods of capitalist industry. The Titan's challenge to authority has met with defeat, but that great clenched fist promises a new challenge. As a work of art, *Prometheus* strikes us as mostly idea; and it is somewhat confused as sculptural form, yet it has a certain power aside from its "program." Baskin's natural gift is not completely stifled by his didactic conception, and one even senses a non-didactic level of meaning in this figure, for we may surely imagine Prometheus' struggle is the artist's, searching for freedom for his own aesthetic voice.

What is worthy of note is Baskin's choosing a symbolic figure as a metaphor for the working man, instead of depicting an idealized working man as a metaphor for progress and industry, as left-wing artists tended to do at this time. Mythic material had long been out of fashion in American art, but during the forties such symbolism provided new themes for painters and sculptors in the abstract camp. Influenced directly or indirectly by the Jungian concept of the archetype, abstractionists believed it was possible through the language of color and biomorphic form to transmute the emotions of their private experience into universally understood images. Mark Rothko explained that he turned to the myths of antiquity "because they are the eternal symbols upon which we must fall back to express basic psychological ideas. They are the symbols of man's primitive fears and motivations . . . changing only in detail but never in substance, be they Greek, Aztec, Icelandic or Egyptian. And our modern psychology finds them persisting still in our dreams, our vernacular and our art, for all the changes in the outward conditions of life."[11]

The insistence on eternal values common to Baskin and the abstract artists at this time differs in one significant way. The abstractionists gave expression to the anxieties of the age, and found in ancient and primitive art those affects that seemed to echo their own pessimism and uneasiness in the war-torn world. "All primitive expression reveals the constant

awareness of powerful forces, the immediate presence of terror and fear, a recognition of the brutality of the natural world as well as the eternal insecurities of life. That these feelings are being experienced today is an unfortunate fact and to us an art that glosses over or evades these feelings is superficial and meaningless." Baskin, then as now, maintained an unwavering faith in what he calls the redemptive possibilities of human beings. He, too, sees in the mythologies of ancient and primitive peoples the metaphors of grief and violence, but he finds in human survival the rationale for his belief that the consciousness of continuity silently teaches the lesson of struggle, the fundamental lesson of life. "Man's survival is the paradigm," he has written, "our esperance and our fulfillment as life-filled creatures forcing earth to bloom and to yield peace."[12]

His is no easy optimism, but through his voice there rings the life-sustaining courage that one may believe is in the Jewish marrow of his bones, absorbed from the Old Testament on which he was raised, absorbed from the ritualistic telling, over and over again, of persecution, despair, destruction, and yet—survival: We are, in fact, here, are we not, in spite of everything. It may be objected that other artists from perhaps equally devout Jewish families do not exhibit the kind of optimism attributed here to Baskin, but one cannot account for differences among children in a family, or people in any group that undergoes similar experiences. All Jews are surely not optimists, but it is evident that a kind of perverse faith in life in the face of disaster is characteristic of Jewish life and thought as reflected in Jewish literature, and what is suggested here is simply that Baskin shares that faith. In 1948, buoyed as well by the ideological optimism of his Marxist intellectual environment, he invoked Shelley's romantic vision of humanity, "Good, great and joyous, beautiful and free," in concluding "Notes on Style and Reality." Eleven years later, free of his former programmatic optimism, he found within himself the words to celebrate his own image of humankind, words that ring out like a *Sh'ma Ysrael* shouted from a burning auto-da-fé.

Our human frame, our gutted mansion, our enveloping sack of beef and ash is yet a glory. Glorious in defining our universal sodality and glorious in defining our utter uniqueness. The human figure is the image of all men and of one man. It contains all and it can express all. Man has always created the human figure in his own image, and in our time that image is despoiled and debauched. Between eye and eye stretches an interminable landscape. From pelvis to sternum lies the terror of great structures, and from arms to ankle to the center of the brain is a whirling axis. To discover these marvels, to search the maze of man's physicality, to wander the body's magnitudes is to search for the

image of man. And in the act of discovery lies the act of communication. A communal communication of necessity.

The forging of works of art is one of man's remaining semblances to divinity. Man has been incapable of love, wanting in charity and despairing of hope. He has not molded a life of abundance and peace, and he has charted the earth and befouled the heavens more wantonly than ever before. He has made of Arden a landscape of death. In this garden I dwell, and in limning the horror, the degradation and the filth, I hold the cracked mirror up to man. All previous art make this course inevitable.[13]

These are the words of an artist who has found his personal voice. His years at the New School were immensely rich in intellectual growth, but in those same years Baskin was held back artistically in an ideological muddle out of which came dying, mourning, and suffering figures redolent with pathos. Tragic intensity eluded him. He knew he was overburdening his figures with social message, but he had no aesthetic framework in which to structure his ideas and he continued to thrash about, attempting to find sculptural forms for his social convictions. In such works as *Prometheus* and *Pelle the Conqueror* (Figs. 9, 10) , we can see how the idea took command of the work. Nevertheless, Baskin's sculpture revealed his promise of future accomplishment and in 1947 the Tiffany Awards jury honored him with a one-thousand-dollar prize.

It was in the graphic arts that Baskin now found an appropriate vehicle for his didactic tendencies. Prints have traditionally been moralizing message bearers. Easily reproducible into hundreds of copies, a print is cheap and available to people of modest means. In left-wing circles the woodcut was the favored method of printmaking since, as Baskin explained in a review of Antonio Frasconi's prints, they were "cut with unpretentious tools on a simple plank, printed by the hundreds on the cheapest grades of paper. . . . The woodcut—unlike the mezzotint, etching, and steel engraving —is inherently a popular form."[14] Although Baskin says he turned to woodcuts in frustration, unable to achieve in sculpture the kind of image that satisfied him, it seems more likely that he was led to the medium by his commitment to "people's art." He was closely associated with a number of young left-wing graphic artists; Frasconi was one, and his blunt severity and bold juxtaposition of heavy masses and voids seem to have had a considerable influence on Baskin's early graphic style.

It is not clear when Baskin began to make woodcuts, but it appears to have been around 1947. He had already experimented with printmaking almost ten years earlier, using linoleum blocks. Una Johnson, for many years curator of prints at the Brooklyn Museum, acquired for the museum a series of linoleum block prints made in 1939—modestly

entitled *The Creation*—which the young artist brought for her
to see (Fig. 12). In spring 1948 he exhibited a woodcut,
Pogrom in Black, in the Second National Print Annual at the
Brooklyn Museum, where he had exhibited earlier that year
a wood sculpture, *Wounded Soldier. Pogrom in Black* may
allude to the case of the "Trenton Six," which involved six
men accused of murdering a shopkeeper during a holdup in
Trenton, New Jersey, in January 1948. The left-wing press
campaigned to raise money for the defense of the accused
and a fund-raising exhibition on their behalf included works
by Baskin, Frasconi, Jacob Lawrence, and Robert Gwathmey.
At the Philadelphia Art Alliance in 1949 Baskin was repre-
sented by six prints including a series entitled *Prophet*.

Looking back on those years, Baskin sees them as crucial
in expanding his cultural and intellectual understanding. He
found his course work and his professors at the New School
stimulating, and learned much from Julian Levi, with whom
he studied life drawing; he continued to read widely, and
by the time he graduated in 1949 he had come to realize that
sculpture, unlike prints, cannot be made to preach. Like the
older artists who in the thirties had become disenchanted with
the political left, he, too, began to find Communist sloganeer-
ing childish and distasteful, and was less and less able to
tolerate the rigidity of leftist ideology. What he called the
"innate trait in human beings to stay where they are, how-
ever strong the impulse to move on" seems to have held him
to his Communist and fellow-traveling associations for a while
after he had lost most of his confidence in the sincerity of
their stated aims, but when he and his wife left for Europe
in 1950 he knew he was leaving behind a part of his life that
was over. The left-wing movement had taught him a great
deal: it had both opened his eyes and closed them. Now his
eyes were open again, and better than ever prepared to see.

What is of great interest is that when Baskin abandoned
the left-wing movement, he left alone; he went his own way.
The artists who broke with the political left at the end of the
thirties had continued the close associations they had formed
during the decade through working together on WPA
projects and on various artists' committees generated by
their political activities. They met constantly and informally
in one another's studios and in Greenwich Village cafés, and
gradually they clarified their aesthetic ideas and developed
their individual styles. Their cohesiveness created an art com-
munity in New York that drew critics and younger artists
from all over the United States, and their discussions built
up a body of theory that has provided a base for the ongoing
dialogue of modernism in American art.

With whom was Baskin to enter into dialogue? At the
end of the forties there was no general exodus of artists from
the left-wing movement; there was no nucleus around which

*Fig. 12: The Creation: The Moon and
the Sun.* 1939. Linoleum cuts, 6 x 6¼
inches. *Collection of Brooklyn Mu-
seum, Brooklyn, N.Y.*

to built a vital figurative movement. Lachaise and Nadelman, with whom Baskin felt the deepest affinity among American artists, and in whose tradition he set himself, were both dead. Prominent figurative artists such as Doris Caesar, José deCreeft, Chaim Gross, Oronzio Maldarelli, Bernard Reder, and William Zorach, all of whom, except Gross, were born in the nineteenth century, could have felt little community of interest with the younger sculptors, nor, well advanced as they were in their careers, were they stimulated to develop a theoretical and critical context for figurative art. The few artists of Baskin's generation who preferred to work in a figurative style—Milton Hebald, Nathaniel Kaz, James Kearns, Elbert Weinberg, for example—were scattered in various places and in no way constituted a group. Without a community there was nothing to lead, and therefore no leadership, no spokesmen to give criticism of figurative art a sophisticated articulation. The mass media tended to be antagonistic to abstraction, but serious artists like Baskin could not welcome support from such unprofessional quarters, or find any satisfaction or benefit in a dialogue with their critics. By 1950 the strategic positions on the battlefront of art were held, or were under siege, by the avant-garde, and within a few years traditionalists had been completely driven from the field.

The triumph of Abstract Expressionism between 1947 and 1950, together with the Surrealist-Constructivist sculpture associated with it, left Baskin unalterably opposed to the movement's aesthetics on the issue of its non-figurative or hermetic imagery. Equally opposed to naturalism but committed to an art based on natural appearance, in search of form but determined to communicate, Baskin understood his dilemma without knowing how to resolve it. Sailing from America, he could hardly have hoped that the resolution was only a year away, nor did he have any suspicion that it lay in Pisa. There was to be an exhilarating year of intensive study, work, and self-questioning, and then, near the end of it, and by accident (it would have happened anyway, sooner or later, in one place or another), he was to find himself in Pisa, confronting the *Courtiers of Arrigo VII*, four figures carved early in the fourteenth century by Tino di Camaino (c. 1285–1337). In Pisa he was finally and clearly to understand what he had been slowly learning ever since that day at Macy's— that, for him, the critical issue of sculpture was monumentality. This was the clue he needed, the opening word in the dialogue he would take up with the past. He was to find in Tino the partner with whom to begin to explore the essential problem of form in art. And Baskin's dialogue with the past pointed his future direction.

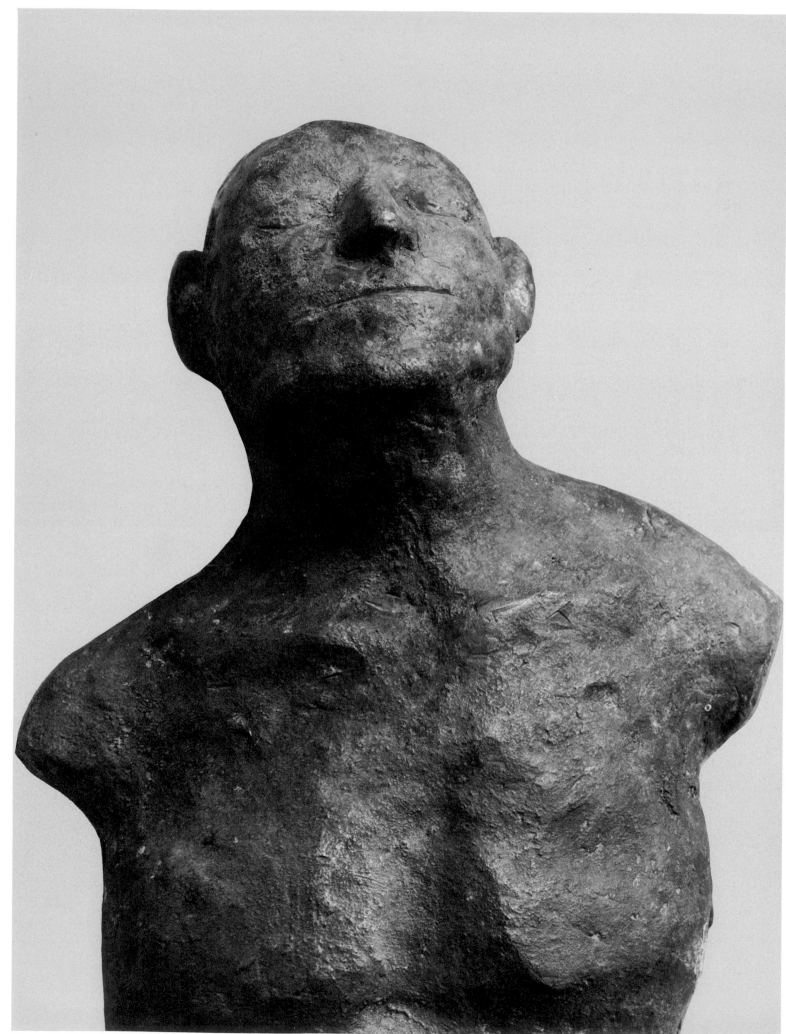

Fig. 15 a

ACHIEVEMENT

*T*he Académie de la Grande Chaumière in Paris was one of the art schools approved by the Veterans Administration for students studying in Europe under the G.I. Bill, and in the postwar years a large number of Americans crowded into Ossip Zadkine's studio there. When Baskin enrolled, his compatriots included Sidney Geist, Israel Levitan, George Spaventa, and Richard Stankiewicz. Gabriel Kohn had studied with Zadkine in 1946–1947, and although he had moved to Rome, he continued to exhibit in Paris and to frequent Zadkine's studio. Baskin remembers that he won Kohn's lively interest in the new imagery he was inventing with the first *Dead Man.*

Baskin had greatly admired Zadkine's aggressive, massively carved figures when they were exhibited in New York at the Brummer Gallery in the late thirties and in the French Pavilion during the World's Fair in 1940–1941. He entered Zadkine's class with hopeful anticipation and brought with him photographs of *Prometheus, Pelle the Conqueror,* and a few other works for the master to see. Calling to the other students to gather around to look at the photographs, Zadkine told Baskin that he had come to the right place. "We'll soon disabuse you of all this Rodin nonsense," Baskin recalls him saying. Zadkine, who never denied his derivation from Rodin nor his admiration for him, must have meant to criticize the sentimentality of these early works, but the young sculptor was deeply offended. He never again saw Zadkine, although he worked from time to time in the studio since, having formally enrolled, he was obligated to do so under the G.I. Bill.

Most of Baskin's time in Paris and its environs was spent in the Louvre and the churches. He returned again and again to the Louvre to study the sixth-century B.C. *Hera of Samos* (Fig. 13) and the great Egyptian and Mesopotamian figures and reliefs. Of the sculpture that he saw in the churches, what most attracted his interest were the life-size medieval *gisants,* supine stone effigies that memorialized monarchs or religious dignitaries buried in the tombs on which the figures rested. Baskin claims that his interest in these figures had nothing to do with a preoccupation with images of death; he happened

Fig. 13

Fig. 13: Hera of Samos. c. 575–550 B.C. Marble, 76 inches. *Collection of the Louvre, Paris.*

Fig. 14: Casts of victims who died in the eruption of Vesuvius, Pompeii, A.D. 79.

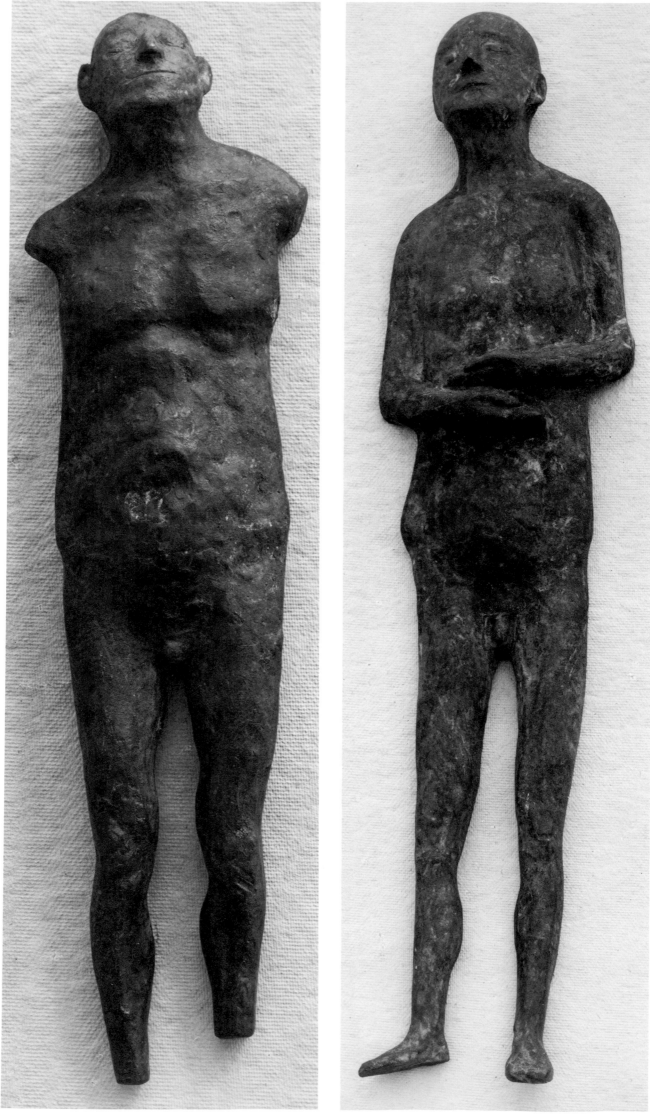

Fig. 15 b

Fig. 16 a

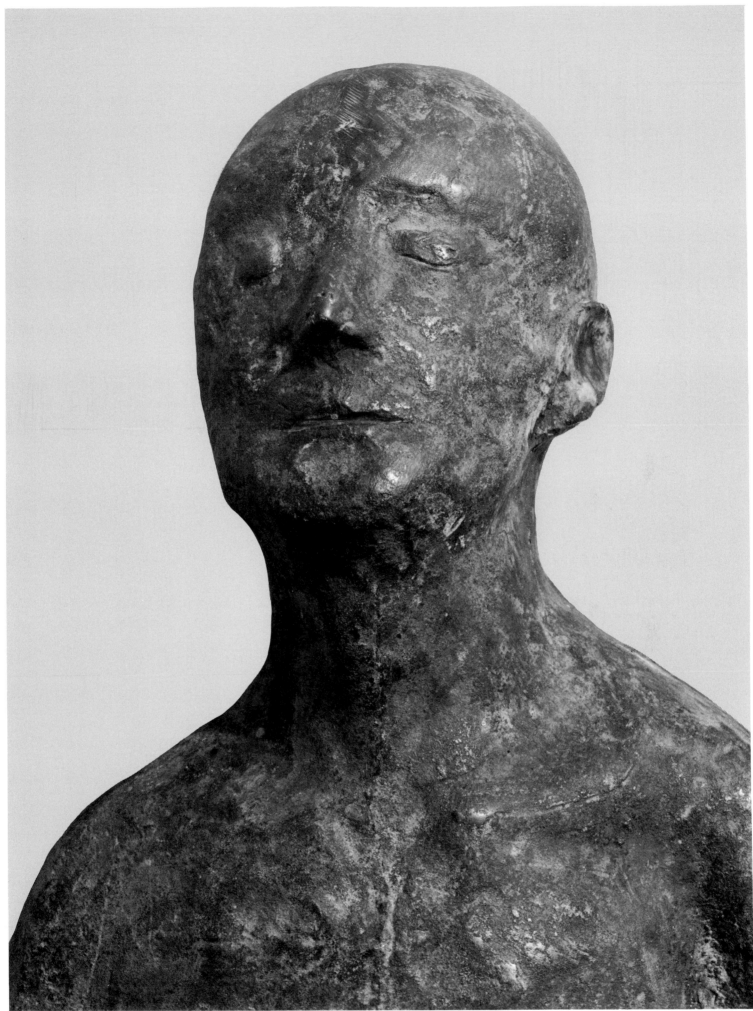

Fig. 16 b

Fig. 15, a & b: Dead Man (1). 1952. Bronze, 18 inches (length). Detail on page 42.

Fig. 16, a & b: Dead Man (2). 1952. Bronze, 21 inches (length). Detail above.

to notice them because there were so many in the churches he visited. Given the persistence of death as a theme in his work, however, one tends to believe a psychological predisposition led him to notice those *gisants* more particularly than the hundreds of other stone carvings at least equally in evidence wherever he went. As psychiatrist Ernst Kris has observed, even when a scientist attributes to chance some discovery, "a close analysis . . . has proved beyond all doubt that what appears to be chance is in fact observation impregnated with previous preconscious experience."[1]

I will return later to this problem of meaning and intention in the course of exploring thematically the content of Baskin's works. For the moment we may concede that on one level the nature of his artistic interests at this time was influenced largely by his class-structured view of society and by social ideals of the kind popularized by Henry Wallace's slogan, "the century of the common man"; we may accept, with reservations, his explanation that he intended to reinterpret these *gisants* in twentieth-century terms, and that the *Dead Men* were meant to memorialize the nobodies of the modern world, "the exhausted factory worker, the forgotten tailor, the inglorious poet."[2]

Working out his ideas for a necropolis of anonymous dead, Baskin was astonished one day, while browsing through books in the stalls along the *quai*, to find in an old journal illustrations of the casts of the dead found at Pompeii, ordinary people like those he intended to represent, literally stopped dead in their tracks when the city was blanketed by the fumes and smoke and ash of the erupting Vesuvius in 79 A.D. (Fig. 14). The eerie naturalness of these eternally present dead may have contributed to the radical simplicity of his new work, for stylistically *Dead Man* (*1*) represents a startling change from Baskin's ideological sculptures of the forties (Fig. 15 a, b). It is as if he had rid himself of preconceived notions of what sculpture should *say*, and had suddenly conceived of sculpture as *being*, liberated from the theatrical role in which he had previously cast his figures. The austerely simple *Dead Man* (*1*) is a composition of two basic forms: a rounded small head contrasted with the much larger bifurcated form comprising the torso and legs. The two forms are unified by the "skin" that seems to be pulled tightly over the protuberances of the shoulders, breasts, stomach, and hip bones, and is stretched over the facial features and dome of the head tilting upward on a short wide neck. Nevertheless, *Dead Man* (*1*) goes beyond the achievement of sculptural form; Baskin has imparted a characterization to his figure without dramatizing death.

The success of this small figure can better be appreciated by comparison with a second composition of about the same time, *Dead Man* (*2*) (Fig. 16 a, b). Here the smaller and larger

masses are not so clearly set off against each other. The attenuated shapes are less convincing as form and tend to give the figure a slightly doughy appearance, as if one could elongate the arms, or pull out the legs indefinitely, until all form were lost. This sense of unachieved form seems also due to a certain slackness that results from arbitrary part-to-part relationships: articulation points at the elbows, hips, and knees seem capricious; they could occur differently, we feel, and so we tend to disbelieve.

In some kinds of modernist sculpture articulation points are deliberately ambiguous and variable, and one could make changes in the image by squeezing it or otherwise pushing the forms around, as in Claes Oldenburg's soft sculptures. Most sculpture, however, whether abstract or figurative, depends a good deal for its effectiveness on its system of articulation; Louise Nevelson's sculptural reliefs, Alexander Calder's mobiles, and Mark Di Suvero's multiform compositions exemplify various kinds of articulation. The introduction of polychromy in modernist sculpture around 1960 —one thinks of John Chamberlain's Abstract Expressionist-related crushed automobile parts, or George Sugarman's horizontal extensions—may have been stimulated by the felt need to mark off part-to-part relationships in a way that would make the abstract image more accessible to perception. Related to this idea is the notion that the presence of color satisfied some unacknowledged desire for nature in abstract art. Ancient marble and medieval stone and wood sculptures were painted, very likely to enhance their naturalistic aspects. Purists among the modernists choose metallic colors or dead white precisely to avoid connotations of nature, while Pop artists used color to heighten the mockery of their naturalism. A sculptor working within the traditions of his métier can depend on the viewer's experience in understanding relationships in a structure of known objects, such as the human figure, and if, as in the case of Baskin, he wishes to avoid naturalism, he will also tend to avoid color, depending on articulation of form alone for the clarity of his design. Such dependence demands immensely knowing judgments when a design is composed of complex interrelationships, as, say, in a figure group by Bernini. In *Dead Man* (*1*) Baskin approached this problem of articulation by reducing the image to its essentials.

The Baskins spent nine months in Paris, with excursions to Chartres and other nearby cathedrals, and they made one trip to Colmar to see Grünewald's Isenheim altarpiece. "For months afterwards I could not regard other work, being haunted by the swollen gaunt green with pustules of disease, lacerated, rutted, bloody body of Christ, hung in the black landscape of despair . . . the weeping and imploring figures of Mary, John, and the Magdalen," Baskin wrote.[3] Grüne-

wald's masterpiece has never lost its hold on him, and its images have flowed into his own language of art. But there was more. He and Esther spent two weeks in London, almost uninterruptedly in the British Museum, where again he was overwhelmed by the Egyptian and Mesopotamian collections. Early in 1951 they moved to Florence to spend the last three months of their *Wanderjahr* in Italy.

During his stay in Paris Baskin had continued to make woodcuts and in Florence he immediately took them to the Galleria F.L.O.G., where he found a warm, responsive welcome. In April 1951 he held his first one-man exhibition of prints there, showing work that ranged from the classicizing expressionist style of Picasso in his "rose period," pervaded with aloof sadness, to the stark expressionism that brings to mind the Mexican Social Realists, especially Orozco. *Son Carrying Father* (Fig. 17) is of particular interest as it takes up the thematic thread that leads to *The Altar*. Twenty years later Baskin would do another son carrying his father, in bronze, with the subject specified in the title, *Aeneas Carrying His Father* (Fig. 125). The most famous source for this motif is Vergil's *Aeneid*, of course, in which Aeneas, no longer able to defend the burning city of Troy, escapes carrying his aged father Anchises on his back. In the woodcut the son's huge fingers and crossed arms are like thick thongs wrapped horizontally around the long vertically hanging arms of the father, binding the two figures together. The image is totally frontal and shows a virtuoso control of overlapping planes: although the head of the father is behind that of the son, and his legs are in front of the son's legs, the figures are compressed into a two-dimensional design that emphasizes the nature of the medium.

In Florence Baskin was officially enrolled at the Accademia di Belle Arti, but he found the teaching sterile and went instead for his instruction to the churches and museums of the city and the dozens of towns in Tuscany, Umbria, and the Latium that were rich with the art that he had come to know from books. He went as far south as Pompeii, to see the casts of the volcano victims. He planned to take the bus, one day, to Siena, but arriving at the bus terminal too late for the Siena bus, he simply took the one that was ready to leave. It happened to be going to Pisa. As it turned out, this was to be a crucial day in Baskin's artistic development, for it was at Pisa that he came unexpectedly upon the work of the Italian late Gothic master Tino di Camaino, of whom he had never heard.

Many of Tino's works had suffered badly, and his name had suffered with them, so that he was virtually forgotten in art history until W. R. Valentiner's monograph in 1935 revived interest in his work. The greatest pupil of Giovanni Pisano, Tino differs essentially from his master in that he

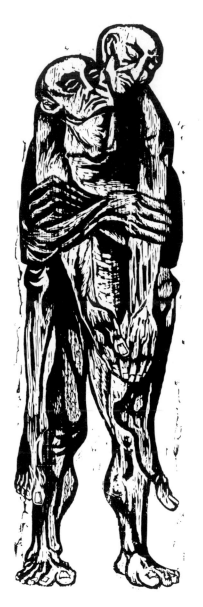

Fig. 17: Son Carrying Father. 1950. Woodcut, 45 x 13½ inches. *Collection of Alfred and Betty Landau, Rockville Centre, N.Y.*

retained certain Byzantinizing features. His figures are marked by hieratic grandeur and ritualistic solemnity, and his style derives its archaic power from a deliberate suppression of grace (Fig. 18). This archaizing quality seems to have been what brought Tino into Baskin's aesthetic horizon. Monumental in their bulk, Tino's figures are nevertheless compressed within strictly confining contours. He tends, however, to broaden and narrow the planes of his forms so that attention oscillates between the tactile appeal of three-dimensional sculpture and the visual pleasure offered by patterns that lie on the surface.

One does not have to be a mystic to see a natural affinity between certain artists that transcends time and place. In the case of Tino, one is intrigued by the fact that art historian Valentiner found in him a stylistic rapport with artists who represent two different currents in modern art, classicism and expressionism, and yet are linked by their common dependence on archaizing; he cites Maillol, Lehmbruck, and Barlach, the very artists whom Baskin, coincidentally, found for himself, and in whose tradition he locates his art. The shock of recognizing in Tino the realization of ideas he had been unable to formulate for himself seems to have set Baskin on the path of self-clarification.

Baskin and his wife returned to New York in the late spring of 1951, Esther won a Rockefeller scholarship for a doctoral program in psychology at the Clark Institute in Worcester, Massachusetts, and the couple moved there later that year; Baskin became an instructor in printmaking at the Worcester Art Museum. Settled at 6 Castle Street, he acquired an antique Vandercook proof press and resumed in earnest the private press he had started at Yale in 1942.

In the more than twenty-five years of its existence The Gehenna Press has produced around one hundred books, all of them extraordinary for the beauty of their design. Baskin has usually chosen obscure texts that would not readily, if at all, find publication elsewhere, such as the rollicking, bawdy sixteenth-century poem *The Tunning of Elynour Rummynge* by John Skelton, poet laureate to King Henry VII, and *The Defense of Gracchus Babeuf Before the High Court of Vendome*. In 1956 The Gehenna Press became the first in the United States to publish a collection of poems by Wilfred Owen. Baskin has illustrated a large number of the books, some of which consist entirely of woodcuts and engravings. The first of these, the first real publication of The Gehenna Press, putting aside the single book that he had printed at Yale in 1942, was the *Little Book of Natural History* (1952), containing twenty-six linoleum engravings of insects and animals by Baskin. Although clearly in the tradition of the medieval bestiary and later books on "natural history"— Hooke's *Micrographia* of 1665 is the actual source for the

Fig. 18: Tino di Camaino. *A Counselor.* Monument to Arrigo VII. c. 1313. Marble. *Museo Nazionale, Pisa.*

book's illustration of a hugely enlarged flea—in Baskin's hands the witches' brew of biting, stinging, crawling insects, spiky porcupine, saber-beaked raven becomes a metaphor for life itself. The structure of Baskin's thought is visible in everything he does, so that the largeness or smallness of things in nature becomes irrelevant. Redefined by the moral-aesthetic context of the artist's *Weltanschauung* and informed by a graphic intelligence of uncommon power, both large and small become monumental; every creature participates equally in the metaphorical universe of Baskin's art, and the beetle in his book of engravings *Horned Beetles and Other Insects* (Fig. 19) is the vulture that tears at the guts of Prometheus.

The pervasiveness of Baskin's artistic personality has given Gehenna Press books a remarkable coherence of style and content. The texts and illustrations have dealt with moral issues embodied in formal elegance and sophistication. Sometimes one senses an indulgence in sheer luxury, both material and technical. Gehenna is thus a "type" of Baskin himself, a self-portrait of an intellectual and aesthete for whom books, as beautiful objects made by human hands, have been a primary preoccupation all of his life.[4]

During 1952 Baskin sent to the Museum of Modern Art a group of woodcuts. William Lieberman, at that time the museum's curator of prints and drawings, was immediately excited by the unusual plastic strength of these prints and got in touch with the artist.

"What can I do for you?" Baskin remembers him asking.

"I need a gallery."

Lieberman introduced him to Grace Borgenicht.

"Lieberman *fought* for me," Baskin says with the characteristic vehemence of a man who divides people into friends and enemies.

Grace Borgenicht recalls that she took the prints, which probably included *Son Carrying Father, Miner's Child, Porcupine, Rhinoceros,* and his magnum opus of 1952, *Man of Peace* (Fig. 20) because they were so powerful. "But I never expected to sell any. They were so stark, so aggressive," she said.

To her surprise she sold all she took. For the next eighteen years Baskin exhibited regularly at the Borgenicht gallery, first graphics, and then, beginning in 1956, sculpture as well. Meanwhile he had been taken on by Boris Mirski in Boston, who continued to represent him there until Mirski's death in 1974.

For several years Baskin hesitated to show his sculpture, and his growing reputation rested on his graphics. He won the O'Hara Museum Prize at the Japanese National Museum in 1954, and two years later *Art in America* included him as a graphic artist in its annual feature "New Talent, USA." Committed as ever to his view of the artist as the conscience of

Fig. 19: Chalcosoma Atlas. 1958.
Etching, 5 x 7 inches; from *Horned Beetles and Other Insects. Collection of the Museum of Modern Art, New York, N.Y.*

his time, Baskin had turned to Goya, Blake, Rouault, and Käthe Kollwitz, and to the Picasso of the *Dream and Lie of General Franco,* from whom he formulated his thoughts on the uses of black and white. Baskin thus placed himself in the tradition of artists who had found in the print medium a vehicle in which to vent their sense of outrage against and pity for the human race, moralists and political partisans who had made human savagery, brutality, and lunacy the targets of their graphic warfare.

In *Man of Peace* we see the full development of Baskin's graphic art at this time, an art in which expressive power and technical virtuosity share equal credit for the effectiveness of the image. The figure stands ambiguously both behind and in front of barbed wire, holding the dead bird both as a sacrificial offering and as accusing evidence of the viewer's own guilt in its death. Yet the inwardness of expression on the face of the *Man of Peace* suggests that he bears a burden of guilt as well. By a strange alchemy of imagination, the twisted wire barbs, sharp-pointed and claw-like, resemble flower blossoms on a trellis. The visual double meanings give a bitter flavor to the title. Baskin's ability to extend the significance of his motifs in this way arises, of course, from his control of the medium. He manipulates the incised lines to produce patterns whose variety feasts the eye and activates the surface of the sheet—wide black sweeping lines, short stabbing lines, lines that suggest anatomy, others that create light, still others that describe texture. Like the abstract modernists with whom he was at odds, Baskin insists aggressively on the two-dimensionality of the sheet, and he respects its flatness with the firmness of a classical Greek vase painter; only strict frontal and profile views are permitted. "I am totally uninterested in decoration," he wrote for the "New Talent" issue of *Art in America.* "Nor do I hold it seemly that works of art should essentially concern their authors' world." He meant, of course, their *private* world; no modern artist has been more concerned with the socio-political world than Baskin. "I could call myself a realist, as I understand that word, one who expresses his ideas, notions, feelings and beliefs about life; every aspect of it. That this necessitates no loss of formal values, the history of art bears witness. I do not objurate the great formal discoveries of the modern movement. Quite the opposite, my desire is to learn these lessons and couple them to my purpose. I seek enrichment for my work in the natural world, in the world of man, in art itself. I should characterize my prints and drawings as didactic and moralistic, and trust they have become so through the device of what was once called 'significant form.' "[5]

So perfectly does *Man of Peace* fit Baskin's description of purpose that one almost believes he made it with that inten-

Fig. 20: Man of Peace. 1952. Woodcut, 62 x 31 inches. *Collection of the Museum of Modern Art, New York, N.Y.*

tion. It demonstrates brilliantly how it is possible to respect modernist two-dimensionality without being decorative, how to use the modernist lesson of interlocking figure and ground without sacrificing the image that can mediate thought. Communication was still a central matter of contention in the fifties, and today, although the issue of abstract versus figurative art is dead, critics writing about abstract art continue to insist on its communicability and to maintain that an abstract work of art makes its statement without recourse to verbal exegesis. Abstract artists and their friends during the fifties, however, were apparently unable to show that this was possible. Robert Goldwater, writing in the Abstract Expressionist journal *It Is* about the Abstract Expressionist "Club," observed that "the proceedings always had a curious air of unreality. One had a terrible time following what was going on. The assumption was that everyone knew what everyone else meant, but it was never put to the test; no one ever pointed to an object and said, see, that's what I'm talking about. . . . Communication was always entirely verbal. For artists, whose first (if not final)concern is with the visible and tangible, this custom assumed the proportions of an enormous hole at the center."[6] It was the "hole at the center" that Baskin rejected both in his woodcuts and in his sculpture. The price he paid for his independence was isolation from his own generation of artists and from modernist critics, who gained control over the professional journals.

He was not completely isolated, of course. His work brought him to the attention of Ben Shahn, whose art Baskin had long admired; strong traces of Shahn's style in Baskin's prints indicate that the older artist's influence was felt even before they met in 1953. That year Shahn went to the Worcester Museum to speak and after the lecture asked to meet Baskin, whose graphic work he had already somehow seen. From their first meeting a close friendship developed that lasted for many years, although it ended in coolness. In 1956 they collaborated on the Gehenna Press book *Thirteen Poems by Wilfred Owen*, which Shahn illustrated with fifteen drawings plus a portrait of Owen that Baskin wood-engraved from Shahn's drawing. Then, in 1957, Baskin met Rico Lebrun, with whom he formed his most important personal and professional friendship.

Lebrun's aesthetic interests and Baskin's were in perfect accord. Like Baskin, Lebrun was committed to the human figure as the ultimate expression of spiritual meaning, and rejected Abstract Expressionism as undisciplined and narcissistic self-expression, lacking the power of revelation. The two artists shared a broad knowledge of the Western tradition and saw in it a deep and constant concern with moral values; both were convinced that it was the responsibility of the artist to reflect his time in its most comprehensive significance. They

talked hopefully of creating together, in painting and sculpture, a new figurative movement whose technique would be, as Lebrun said, "compassion and the resolute heart."[7]

Baskin's profound love for Lebrun and his work is expressed in a letter written to Lebrun on receiving a set of photographs of *Genesis*, the mural Lebrun executed in 1961 for Pomona College in Claremont, California, as a companion to the *Prometheus* fresco by José Clemente Orozco. "Caro Rico, José Clemente can rest in peace. Hallowed ground has not been despoiled. A great new shaft of light and truth has joined with the titan and man continues to twirl at the burning center. Job, Noah, Eve have been torn from the Bible and have been made to stand witness for the unholy coupling of tenderness and horror, which is our age. Only you, Rico, were man and artist enough for this task."[8] But his deepest love is expressed in his grief at Lebrun's untimely death in 1964, a grief that saturates the massive figure of *Achilles* (Fig. 54), in which he portrays himself mourning for his friend. Lebrun's death, Baskin wrote, was "a savage stroke levelled at American art and deprived me of my greatest ally in the struggle for figurative art."[9] Not the least of Baskin's tributes to Lebrun can be seen in Lebrun's influence on his drawing style, especially noticeable in his illustrations for the *Iliad* (1962) and *The Divine Comedy* (1969).

But Shahn and Lebrun were themselves peripheral to the main interests of the dominant groups in the American art community from the fifties on and could not win the kind of critical support necessary to fuel an alternative movement. Like Baskin they founded their public careers on the bases of their individual gifts and the largely unmediated response of the public to their art.

Although Baskin did not show sculpture during the period 1952–1956, he was working in wood, stone, and clay, trying to discover the essence of the sculptural forms that had so moved him in Europe—the iconic Egyptian and Sumerian figures, the strange, awkward power of Tino, the hypnotic silence of the *Hera of Samos*. His major carving of the early fifties is *Man with Dead Bird* (Fig. 21), a three-dimensional statement of the woodcut *Man of Peace*. Comparing the two images, one sees immediately the artist's concept of the essential nature of each medium: sculpture is a space-displacing mass, while the graphic image belongs to the two-dimensional world of its ground. The design of *Man with Dead Bird* is compressed so that the arms and bird are completely enclosed within the contours of the major forms, and both legs now face forward. The figure strongly suggests the original character of its mass, a single log that has been carved from its curved surface. It immediately calls to mind the famous *Sheikh El-Beled* (Fig. 22), which Baskin knew only from illustrations, but which he had studied attentively.

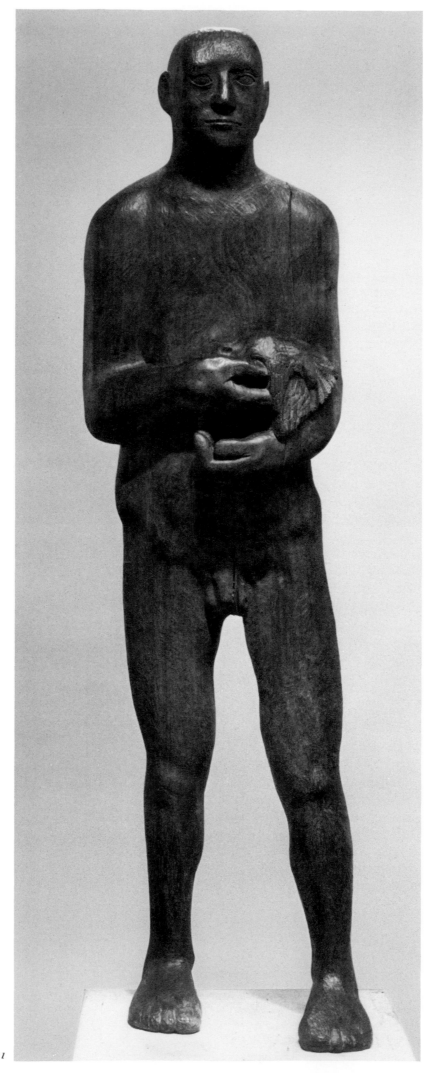

Fig. 21

Subtle adjustments have transformed the confident vitality of the ancient Sheikh into the burdened anxiety of the modern man. The Sheikh's head tilts upward, and is separated from the squarish shoulders by a columnar neck; the solid geometric forms are thus related so as to emphasize the different character of these forms—the spherical head, the cylindrical neck, the sloping rectangular shoulders—with the result that the crisp effect of differentiation is achieved. The stance is upright, the left foot forward but on a parallel with the right foot. The head of *Man with Dead Bird* does not tilt, but is set forward, like the entire upper torso, imparting to the pose a trance-like unease. The columnar neck flows without pause into the deeply sloping shoulders so that the head and shoulders are linked by an unbroken rhythm that moves down through the bent arms and into the complex of curvilinear forms that represent the climax of this movement, the hands supporting the bird. The dead bird is so small that it cannot represent a physical weight of any consequence and thus becomes a spiritual burden, similar in idea but contrasting in meaning to the upright staff of the Sheikh, so slender that it cannot represent a physical support and thus becomes a symbol of the Sheikh's authority and power. The man's left foot, moreover, although placed forward, turns inward; he is not walking, like the Sheikh, or striding into the space ahead, like Rodin's pigeon-toed *St. John*, but seems to stand heavily fixed to the spot, with the awkward expressiveness of Tino's *Courtier*, the supposed Vicar of Pisa. The iconic inwardness of the facial expression of *Man of Peace* and the tense urgency of the pose is thus supported by the total impression of the static inward-turning of the forms. In this, Baskin's figure reminds us of Picasso's *Man with Sheep* (Fig. 23), which he knew from a published illustration.

Between 1952 and 1956 Baskin continued work on the series of *Dead Men* that he had started in Paris (Fig. 15, 16, 24, 25, 36), investigating the formal possibilities of the theme with variations of poses and shapes while holding the figures to a minimal, holistic image. This wholeness is highly suggestive, and in its elemental simplicity imbues the figures with the sense of form emerging from formlessness, like the creation of Adam out of a single lump of shapeless clay. Baskin's Adam is the archetypal ancestor who lives on in the human race, the horizontal man who dies countless deaths and yet persists in living. In the *Dead Men* Baskin found his solution to the modern quest for sublimity—not in size, not in wrenching the image from familiar contexts, not in rejecting the human accumulation of treasure stored in memory, association, nostalgia, legend, and myth, which to some modernists were "impediments,"[10] but in aggressively shaping size, context, and historical memory into the determined contours of his monumental intention. These small bronze figures (most of them

Fig. 22

Fig 23

Fig. 21: Man with Dead Bird. 1954. Walnut, 63 inches.

Fig. 22: Sheikh El-Beled. Egyptian, Old Kingdom, c. 2500 B.C. Wood, 50 inches. *Cairo Museum, Cairo, Egypt.*

Fig. 23: Picasso. *Man with Sheep.* 1944. Bronze, 86½ inches. *Vallauris, France.*

are between fourteen and eighteen inches long) are handled with the austere simplicity that is characteristic of larger works. There is variation in the treatment of surfaces, some exhibiting the irregular pressures and manipulation of the artist's hands as he dragged or pushed the clay, others a coarse, grainy skin, and others a smooth, glossy finish. But in all of them the incidents of the surface are never permitted to compete for attention with the forms.

In 1956 Baskin made his first major statement of the Dead Man theme with a life-size limestone carving. A male figure with bumps and depressions that emphasize the anti-ideal, *The Great Stone Dead Man* (Fig. 25) nevertheless evokes memories of the ideal by conveying a serenity that one associates with classical sculpture. The combining of two such incompatible images in the single figure creates a peculiar reverberation between the ideal and the anti-ideal, and expresses that complex inversion of values that is at the heart of much of this artist's work. In the ideal we see a grotesque distortion; in the anti-ideal we see a transcendent stillness. Each holds in check the full expression of the other and both contribute to heightening the ambiguous effect of the whole.

The *Great Stone Dead Man* was not the first stone carving of Baskin's mature period. A year earlier he had made a *Classic Head* and a small but powerful *Glutted Death* (Fig. 26) with Death represented not as the skeleton of tradition but as a massive, monolithic figure swollen with gorging. Another limestone carving of this period, *The Guardian* (Fig. 27), is of great interest for the revealing light it throws on Baskin's originality in adapting formal and iconographic sources to his aesthetic and interpretive needs, and for the glimpse it gives us of the artist's view of himself at this time.

The Guardian is unmistakably linked to Rodin's *Balzac* (Figs. 28, 29), which Baskin knew not only in its final form but also in many of the preparatory studies Rodin had made for it. In a number of these studies Rodin posed the figure with its arms crossed high over the chest and resting on the bulging stomach. Baskin has quoted Rodin in a different language, as it were. The great thrusts and counterthrusts of the *Balzac* have been compressed into an image of utter immovability. Thoroughly frontal, the central axis cuts through the entire figure from head to base with absolute symmetry. Our first impression is of pugnacious strength. The figure is wrapped in a strange kind of drapery that looks more like a second, thickened skin adhering to the forms, which seems to give the figure a compact impenetrability. Though very different in affect, this treatment is surely derived from Egyptian sculpture in which garments cling revealingly to the figure (Fig. 30).

For all its evidently unyielding immobility, *The Guardian* appears curiously defensive and vulnerable. The large square

Fig. 24

Fig. 24: Dead Man. 1955. Bronze, 17 inches (length).

Fig. 25: The Great Stone Dead Man. 1956. Limestone, 70 inches.

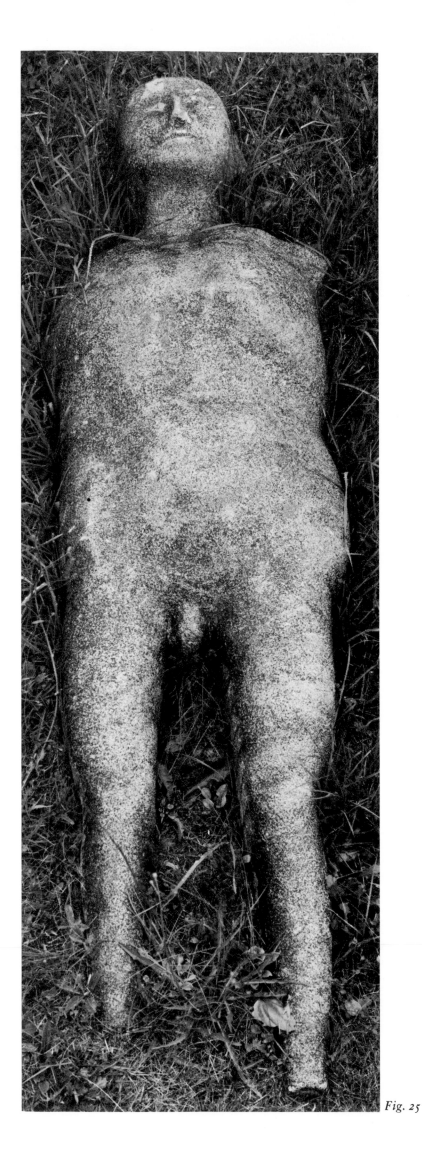

Fig. 25

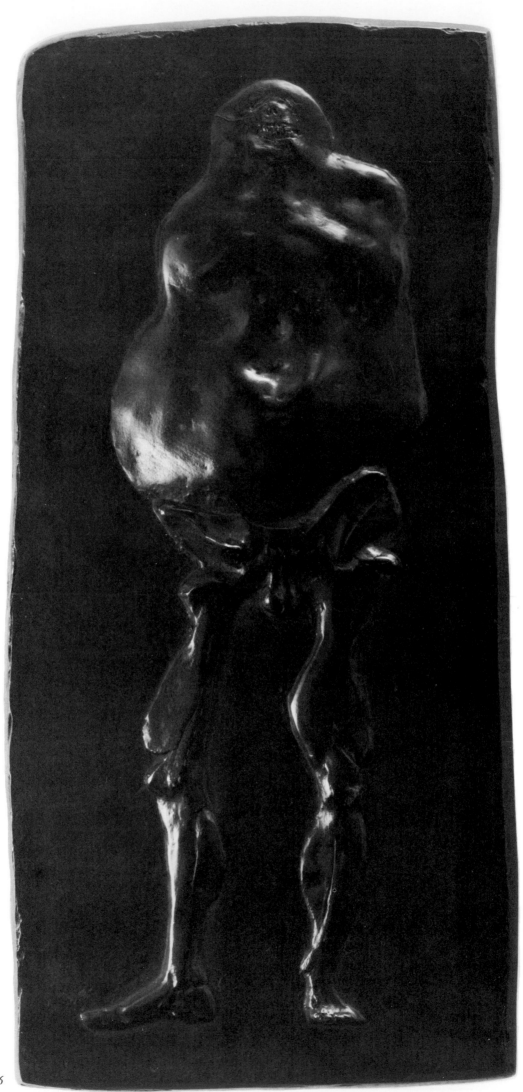

Fig. 26

head is sunk into the chest and shoulders, as if it could be retracted like a tortoise head into the body itself under its protective covering. The second "skin" that covers the body to protect it also constricts the great intertwined arms. The legs, too, are bound together by this tightly stretched membrane. The swelling stomach and thickened waist give weight and bulk to this fortress figure, but the very subtlety of the modeling of these forms produces a fleshy reality that is more poignantly revealing than naked, exposed flesh. *The Guardian* is an ambiguous giant; encased in its strange sheath, the figure conceals nothing. Even the face with its features carved in low relief or shallowly incised is suffused with an emotion that belies the stolid inertness of the image. This is no obdurate, insensitive hired watchman, but one who has chosen his position with a challenging deliberateness.

In Rodin's *Balzac* Baskin saw the guardian of realism, the repudiator of romanticism, the author of the *Human Comedy* who depicted individuals of every class and profession. It is with this Balzac that the sculptor of the *Dead Man* series identifies himself in *The Guardian*. Baskin has always felt himself embattled, almost alone in defending the tradition of the human figure in American sculpture. He saw himself then, as now, quite literally the guardian of values on which there could be no compromise; any opening was a potential entry through which the enemy could pour and ultimately destroy the fortress. "I see myself as standing very much in battle against a whole lot of others who have found a way of working which for me denies the central essence of art, its humanity and its humanness," Baskin said. "Their art doesn't tell us about the deepest and most profound ideas of human beings in contact with other human beings. I see myself very much embattled, and very much isolated."

But if *The Guardian* shows Baskin inflexible, unyielding, beyond any thought of concession, it also reveals his vulnerability. *The Guardian* cannot be decapitated, nor its arms and legs cut off, but its soft belly can be stabbed. Like Prometheus, the archetypal artist-creator who made humankind out of clay and whose belly was torn by the great predatory bird, *The Guardian* will remain fixed to his post, suffering and unrepentant.

Baskin had used Rodin's crossed-arm motif once before in a very different context. The *Seated Fat Man* (Fig. 31), one of the finest of the early bronzes, is a self-hugging, large-headed, thick-necked, heavy-bodied grotesque with slender, shapely legs. The inventive distortion of formal aesthetic relations is a visual metaphor for the moral distortion of complacency. In this, the *Seated Fat Man* is related to the bronze *Poet Laureate* of the same year (Fig. 32), although in the latter the signs of advanced, bloated decay give a tragic cast to the ironically jaunty tilt of the fat-cheeked, heavy-jowled

Fig. 26: Glutted Death. 1955. Stone, 15½ inches.

Overleaf: *Fig. 27, a & b: The Guardian.* (Two views.) 1956. Limestone, 27 inches.

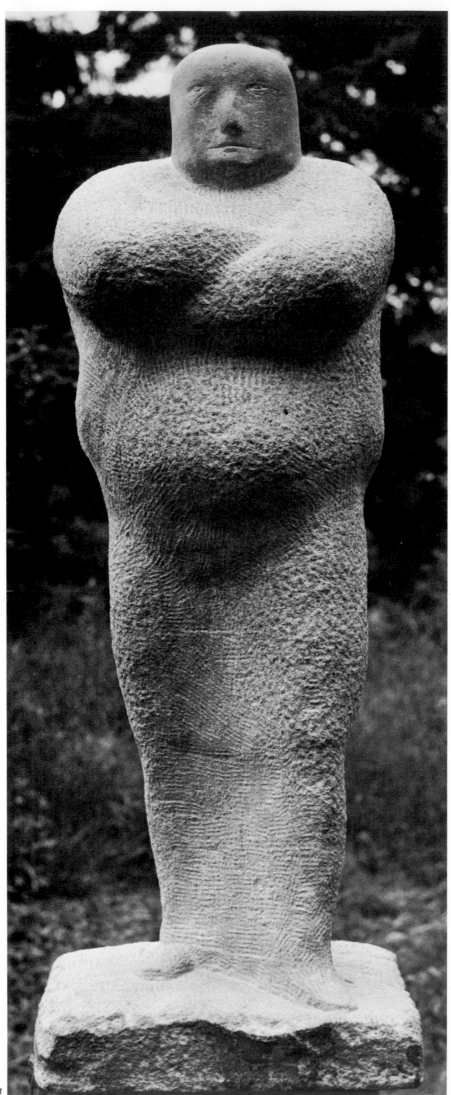

Fig. 27 a

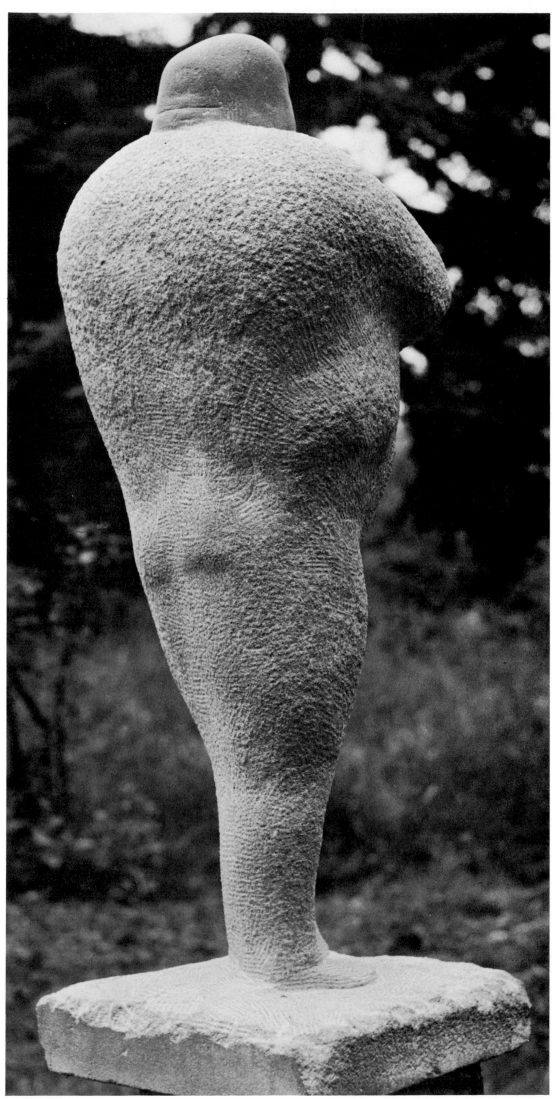

Fig. 27 b

head of an artist who betrays his gift. The source of imagery for *Poet Laureate* (and, probably, for *Seated Fat Man* as well) is suggested in *Isaiah* (28:1–6):

Woe to the crown of pride of the drunkards of Ephraim,
And to the fading flower of his glorious beauty,
Which is on the head of the fat valley of them that are smitten
 down with wine!
Behold, the Lord hath a mighty and strong one,
As a storm of hail, a tempest of destruction,
As a flood of mighty waters overflowing,
That casteth down to the earth with violence.
The crown of pride of the drunkards of Ephraim
Shall be trodden under foot;
And the fading flower of his glorious beauty,
Which is on the head of the fat valley,
Shall be as the first-ripe fig before the summer,
Which when one looketh upon it,
While it is yet in his hand he eateth it up.
In that day shall the Lord of hosts be
For a crown of glory, and for a diadem of beauty,
Unto the residue of His people,
And for a spirit of judgement to him that sitteth in judgement,
And for strength to them that turn back the battle at the gate.

Do we not also see Isaiah's "mighty and strong one" in *The Guardian?*

Baskin had been teaching at Worcester for only one year when he accepted an invitation to join the faculty at Smith College in Northampton. He was to remain there for twenty-one years,* instructing the Smith women as well as male students from nearby Amherst in printmaking and sculpture. His students remember him as an inspiring art teacher whose demand for excellence gave them a heightened respect for art and artists.

Beth Neville, an admirably gifted assemblagist, recalls him at Smith in the late fifties as "an awesome kind of person. You either gave up in despair, or you worked harder than ever to do your best." He imparted to students his professionalism and commitment to uncompromising standards. Quick to praise good work, he was frequently caustic with students who exhibited a lack of seriousness. Neville remembers one day when a student came to class with brilliant red polish on her long fingernails. "How can you expect to hold a hammer with those?" Baskin asked with angry scorn. But he was patient with serious students, which was particularly important to those whose preference for figurative art received little encouragement elsewhere; in his person he demon-

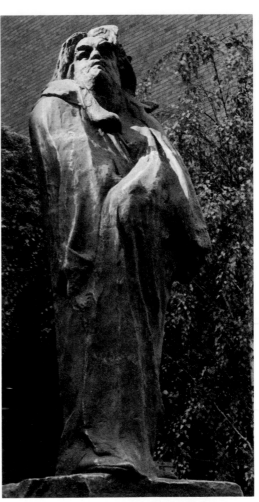

Fig. 28

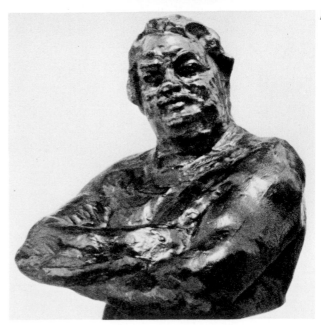

Fig. 29

* Baskin resigned when he moved with his family to England in 1973.

strated that it was possible to become a successful and respected artist following one's own bent, against the current. Thomas Cornell, today a fine and successful graphic artist, warmly acknowledges the value of his training with Baskin and speaks of the artist's intelligence and individuality as significant factors in his impact on students. A number of others of Baskin's students have gone on to careers in art, outstanding among them Michael Mazur, whose drawings of grotesque and grisly subjects are among the superb pleasures of contemporary American art, and Charles Wells, a sculptor who has been living in Italy since winning the Rome Prize Fellowship in 1964. Baskin's awesome personality had some undesirable consequences, however, for it imposed on his students not only his demanding standards, but also his style. Only the strongest could work their way out of his stylistic influence to find a voice of their own.

While he was making gratifying progress in his professional career, Baskin's personal life was deeply touched by tragedy. Esther Baskin became ill in the mid-fifties with multiple sclerosis, a diagnosis that carried an indeterminate but certain death sentence. Despite this, the couple decided to have a child, and a son, Tobias, was born in 1957. Esther fought to live as long as she could, even when living meant confinement to a hospital bed in the Baskin home at Fort Hill, in Northampton, where they had moved in 1955. After Tobias' birth she managed to write two books, *Creatures of Darkness* and *The Poppy and Other Deadly Plants*, but the disease became steadily more debilitating and eventually she was completely bedridden. She wasted away slowly and died in 1970. Friends remember her fierce courage and strength—and extraordinary realism. When her husband fell in love with Lisa Unger she was in complete agreement with the decision that was finally reached: she and Leonard were divorced and Leonard and Lisa were married.

In the fall of 1963 Lisa, daughter of the architect Jay Sam Unger, Leonard's close friend ever since they had been fellow students at the New York University School of Architecture and Allied Arts, had visited Northampton with her father to show Leonard her work; she was about to graduate from Cornell where she was a student in the School of Fine Arts and Architecture, and was considering a career as an artist. Highly impressed with her drawings, the artist suggested that after commencement she come to work with him as an apprentice—as he had done years earlier with Glickman—rather than go on to graduate school. In the following months Lisa and Leonard spoke often by phone, and they met in New York during Christmas week. They met again at the opening of Baskin's exhibition at the Borgenicht Gallery in February, and at the private party following the gallery reception they found the opportunity for a long and mutually absorbing

Fig. 30

Fig. 28: Auguste Rodin. *Monument to Balzac.* 1897. Bronze, 106 inches. *Collection of the Museum of Modern Art, New York, N.Y.*

Fig. 29: Auguste Rodin. *Bust of Balzac.* 1893–1895. Bronze, 18 inches. *Collection of the Hirshhorn Museum and Sculpture Garden, Washington, D.C.*

Fig. 30: Mycerinus and His Queen. Egyptian, Old Kingdom, c. 2500 B.C. Basalt, 54 inches. *Boston Museum of Fine Arts, Boston, Mass.*

Fig. 31

conversation. In the late spring of 1964 Lisa took an apartment in Northampton and began studying with Baskin. She became increasingly involved in the Baskin household and, as time went on, she and the artist became increasingly involved with each other. Eventually she moved into the Baskin home; the artist-apprentice relationship had changed.

There was no subterfuge. The three lived together harmoniously—or as harmoniously as life could ever be for high-strung, sensitive Lisa and temperamental, sensitive Leonard—with Lisa assuming direction of the household, helping to take care of Tobias, filling in when necessary for the nurses who took care of Esther, and operating an antique shop. It was a strange arrangement, and to many it seemed scandalous, but to the principals it seemed the only solution. Finally, however, it proved unsatisfactory and in 1967 Leonard and Esther were divorced. Leonard and Lisa were married immediately afterward and the three continued to live together. Lisa's and Leonard's son, Hosea, was born on December 27, 1969, and a few years later, on March 11, 1974, Lisa gave birth to their daughter, Lucretia, named for Lucretia Mott, founder of the Female Anti-Slavery Society who, with Elizabeth Cady Stanton, organized the first women's rights convention in the United States. In 1972 Lisa's activities in the women's movement in Northampton elicited an invitation to co-edit a special issue of the *Massachusetts Review* (Winter–Spring 1972) dedicated to "Woman: An Issue." She contributed portrait drawings of Susan B. Anthony, Harriet Tubman, and other eminent feminists and wrote an introductory essay for a series of fifteen reproductions of self-portraits by women artists whose names have become far better known since the landmark Los Angeles County Museum exhibition of 1976–1977, "Women Artists: 1550–1950."

When asked about the relationship between the events of his life and his art, Baskin says there has been only one noticeable cause-and-effect. Until the middle sixties he had made very few female figures. He concedes that his love for Lisa, and her prodding, broke down his single-minded interest in the male figure, the vehicle through which he thought he could best express the forms and ideas that attracted him. The prominent place of death and grief in Baskin's sculpture and graphic work has sometimes been thought to reflect the long illness of his first wife. Surely death was a presence in the Baskin home for many years. It is perfectly evident, however, that the artist was attracted to death as a theme long before Esther Baskin was stricken. Generally Baskin insists that the facts of his life have had very little to do with his art, but after we have looked at his *oeuvre* more fully, the relationship between the two will appear, I think, far more significant than he believes it to be.

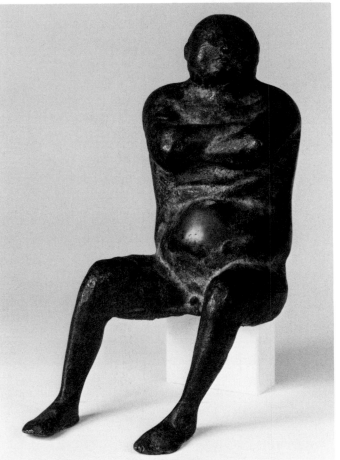

Fig. 31: Seated Fat Man. 1956. Bronze, 12½ inches.

Fig. 32: Poet Laureate. 1956. Bronze, 9 inches.

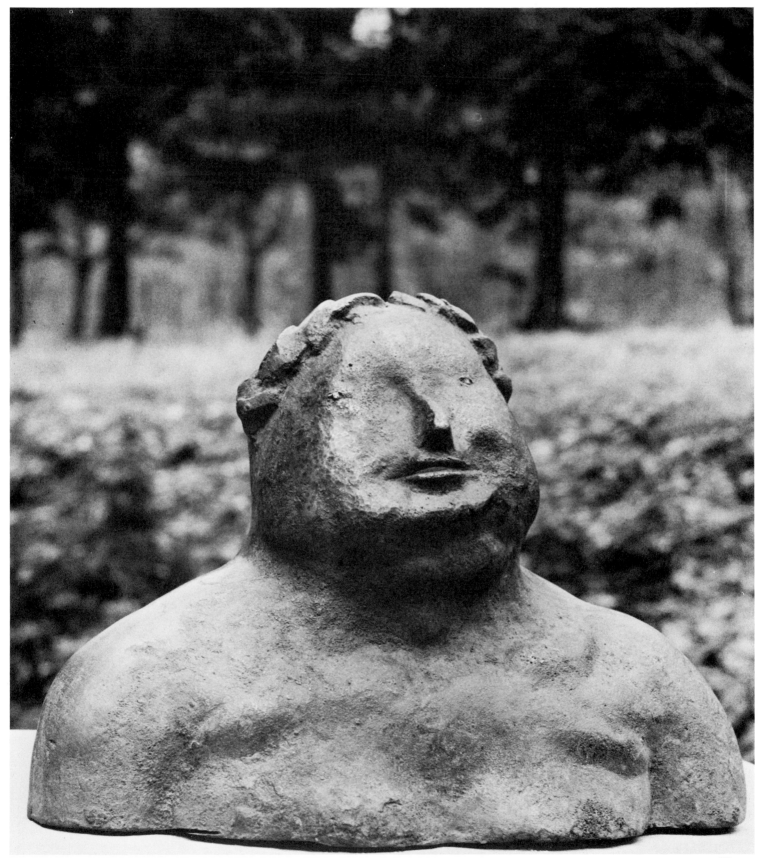

Fig. 32

Baskin's first one-man exhibition, aside from the early student works shown at Maurice Glickman's studio and the New York University School of Architecture and Allied Arts, was held at the Boris Mirski Gallery in Boston in the spring of 1956. In November the Worcester Art Museum gave him his first museum show, and in March of 1957, at the Borgenicht Gallery, he faced the New York art community as a professional sculptor for the first time. He had landed in the middle of the triumph of Abstract Expressionism—between the Museum of Modern Art's "Twelve Americans" show of 1956 and its "The New American Painting" exhibition organized by the International Program for a European tour in 1958–1959. His figurative, harsh, and unsettling art was not welcome in all quarters, but the reviewer for *Arts*, although disturbed by what appeared to him or her as nothing more than morbidity and an obsessive concern with the old and mutilated, nevertheless recognized that Baskin's figures were "easier to analyze for the source of their unattractiveness than they are to dismiss for their intractable ugly but solemn reality."[11] *Life* devoted its entire art section in the issue of March 25 to Baskin's "Images of Mortality," with illustrations of *Man with Dead Bird*, details of *Youth* and a *Dead Man*, *John Donne in His Winding Cloth* (Fig. 33), and *Poet Laureate*. And although the Museum of Modern Art had shifted much of its weight to the American modernist camp, it acquired from his first show its major work, *Man with Dead Bird*. Two years later the museum included Baskin in its "New Images of Man," an exhibition that reflected the reemergence of interest in the figure as a vehicle of tragic emotion.

As the decade of the fifties ended, the situation in American art became quite ambiguous. In the midst of its international success, the style by this time widely called Abstract Expressionism had begun to look academic; there was a sense of uncertainty in the air that came with the recognition that the movement had spent itself after fifteen years of amazing vitality—just a little less time than it had taken for the High Renaissance to emerge, peak, and disappear into Mannerism. In New York galleries and in national exhibitions one began to see painting and sculpture in which the human figure was more or less present. As early as 1957 Allen Weller found in organizing the important University of Illinois biennial "Contemporary Painting and Sculpture" exhibition that "the all-consuming and popular fascination with form, and the style of painting that deals with non-objective ideas or depends in large part upon the manner in which the material is manipulated, seems to have lost its forward impulse." Many believed that abstraction had gone as far as it could, but that the "return to the figure" and "return to humanism" were imminent. They were both right and wrong, and even where they were

right, they were wrong: Figurative art did reappear, but not in the way suggested by the "New Images of Man" exhibition. As Dore Ashton writes, "The return. . . was not to the figure as conceived by the Expressionist, who sought to express states of the soul in its lineaments. The intense desire to be ' objective,' reflected in most painting tendencies in the 1960s . . . dominated the figure painters."[12] And the sculptors as well. The new note, in reaction against the highly charged subjective emotionalism of Abstract Expressionist art, was objectively cool. Objectivity, with irony, became the stance of the sixties for figurative artists in the Pop Art movement; without irony, in the New Realism as well as in the various reductive styles of abstraction.

But this development was not at all evident as the sixties began. Alfred Barr's double-edged introduction to the Museum of Modern Art's "Recent Painting USA: The Figure" in 1962 makes that clear.

Here are paintings of . . . figures . . . figures in deep perspective, in flat silhouette . . . figures shredded, veiled, swathed, fragmented, emerging reluctantly from interpenetrating planes or tentacles of pigment . . . figures . . . figures. . . . There is not much reassurance to the unadventurous in the fact that almost all of the paintings in the exhibition are traditional or at least precedented in their overt subject matter. . . . The latent content is another problem, deeply involving not only personal symbolism but personal form or style. . . . These human figures were painted in a period . . . when the painted surface often functioned in virtual and even dogmatic independence of any represented image. Some of these paintings suggest uncertainty as to whether a painting in the 1960s can or cannot, should or should not, live by paint alone. Others seem more confident. Ambiguous or decisive, more strength to them!

The equivocal character of art tendencies in the years clustered around 1960 is suggested by William Seitz, then the Museum of Modern Art's associate curator of the Department of Painting and Sculpture Exhibitions.

The need of certain artists to defy and obliterate accepted categories, to fabricate aggressive objects . . . these manifestations are signs of vitality. . . . Those who decry such development . . . should surely be heard. On the opposite side—though who can honestly declare himself to be entirely in one camp or the other?—lies an unqualified faith in the purity of the regenerative human activity of art no matter where it may lead. Somewhere between these opposed prejudices lies the realization . . . that Western art is, has always been, and should continue in a state of ferment and constant redefinition.[13]

The moment was propitious for a powerfully gifted young figurative sculptor to be taken seriously. Baskin rapidly acquired a national and international reputation when the International Council of the Museum of Modern Art organized a large exhibition of his sculptures and graphics to send on tour in Europe during 1961. The show opened in Rotterdam and traveled to Germany and France. The large catalogue, which carried a long, informative essay written by Peter Selz, then curator of the Department of Painting and Sculpture Exhibitions at the Museum of Modern Art, and his wife, Thalia Selz, was sold out long before the exhibitions closed. During the summer of his fortieth birthday in 1962 Baskin was the subject of a witty and insightful article by Brian O'Doherty, published in *Art in America*, in which O'Doherty stressed the elusive contradictions in Baskin's personality: a perfect faith in cold reason and a lived allegiance to imagination. That fall Baskin's work was exhibited in a ten-year retrospective at Bowdoin College, with catalogue essays by Rico Lebrun, Julius Held, Winslow Ames, Harold Joachim, and Ray Nash.

By 1963, however, the modernist dialogue found new breath in *Artforum*, a journal that has exerted a major influence on American art as well as art criticism since its inception. A kind of clarification also came out of the mix of artists included in the Museum of Modern Art's "Americans 1963," which brought into public prominence young artists associated with the Pop art movement such as Robert Indiana, Marisol, Claes Oldenburg, and James Rosenquist, together with abstractionists ranging from the high priest of purism, Ad Reinhardt, to the surrealistic Lee Bontecou. These artists shared not much more than a common rejection of both Abstract Expressionism and the kind of humanism implied in the "New Images" exhibition. To Baskin they presented a solid phalanx of the enemies of art with whom there could be no rapprochement.

Whatever hopes he might briefly have held for a new figurative movement with which he could identify evaporated with the triumph of Constructionist-rooted formalism on one hand, and dead-pan or grotesque realism on the other. On the threshold of maturity Baskin embraced his isolation with the zealous certainty of an artist conscious of being "spurred by historical imperative." He had chosen his subject, "Man, harried and brutalized, distended and eviscerated, but noble withal, rich in intention, puissant in creative spur, and enduring in the posture of love,"[14] and his continuing task was to find forms that would express his personal and intense vision. He had developed a vocabulary of motifs through which he was able to effect that mysterious organization of insights, intuitions, and intentions that an artist transforms into structures: works of art, objects in the world whose mode of being is to

absorb us totally in their reality. What remained to be accomplished was the difficult descent into deeper self-knowledge and the even more difficult ascent to higher understanding. Like Vergil beside Dante, artists of the past have walked at Baskin's side—Bruegel and Bosch, Blake and Goya, Barlach and Kollwitz, and Rodin, too—guiding him through the inferno they have already seen. He has made pride, envy, avarice, sloth, gluttony, and lust his central concerns, and he has experienced the seven deadly sins in images of his own face and body.

There is more grief than joy—but some joy—more despair than hope—but some hope—in Baskin's inferno. In the descent there is no bottom; in the ascent no final peak. But Baskin's art has continued to broaden in range, and in *The Altar* he has achieved a richness of content he had never realized before. But *The Altar*, as I have said, was half a lifetime in the making, and we have only begun to trace its history in Baskin's *oeuvre*. Still in his fifties, he is at a new threshold. It is our task to look back; it is his privilege to keep his gaze forward.

PART · TWO

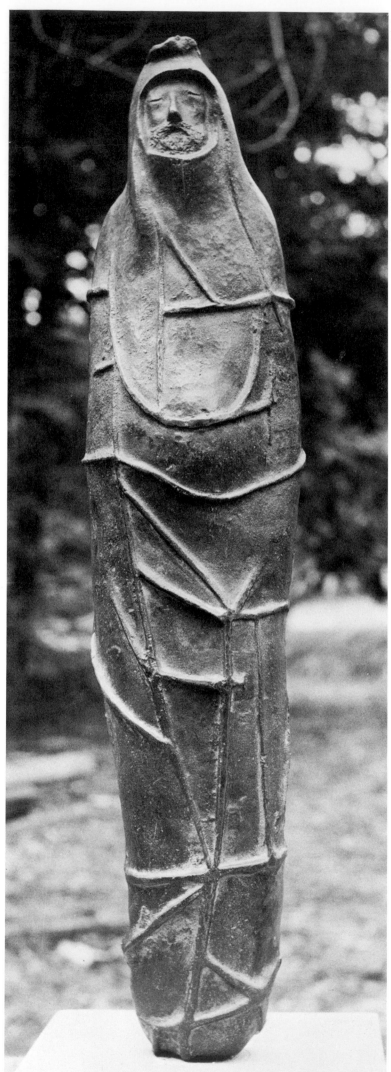

Fig. 33

DEATH
AND
GRIEF

༄

Death, be not proud, though some have called thee
Mighty and Dreadful, for thou art not so;
For those whom thou think'st thou dost overthrow
Die not, poor Death; not yet canst thou kill me.
From rest and sleep, which but thy pictures be,
Much pleasure; then from thee much more must flow;
And soonest our best men with thee do go—
Rest of their bones and soul's delivery.
Thou'rt slave to fate, chance, kings, and desperate men,
And dost with poison, war and sickness dwell;
And poppy or charms can make us sleep as well
And better than thy stroke; Why swellest thou then?
One short sleep past, we wake eternally,
And Death shall be no more: Death, thou shalt die.

—John Donne

ঌৎ

Like John Donne, whose fierce love for the human body was inextricably webbed with his obsession with death (Fig. 33), Leonard Baskin has found in the human figure and death the double theme—the physical-metaphysical reality—through which he has discovered the awe of life's constant renewal. As will become evident, I believe that Baskin's sense of renewal is embedded in the notion of atonement, a theme he has been concerned with in several drawings (Fig. 34). Though without Donne's religious faith in resurrection, Baskin's affirmation of the triumph of life over death is nevertheless a spiritual conviction; the evils of our time—and all time—are human evils, and yet, in poems in words or clay that "hold the cracked mirror up to man," as Baskin wrote, the human spirit ministered by art redeems human life. With Jacques Lipchitz, whose later works often have an affect similar to his own, Baskin would say that "Sculpture is divinity. . . . Art is man's distinctly human way of fighting death. Art is an action

Fig. 33: John Donne in His Winding Cloth. 1955. Bronze, 22 inches.

against death. It is denial of death."[1] It is the artist, now, who stands at the altar in place of priest or rabbi, showing man what he is, and reenacting for the community the symbols of the values by which it lives.

That art has moved into the vacuum left by the disappearance of religion in modern life has frequently been remarked. People now crowd museums as they crowded churches in the Middle Ages, often and as a matter of course. While many modernists—artists and critics—insist on the magico-hermetic nature of the new religion whose meaning is in its rituals, others take the Platonic view that art ultimately serves a human purpose outside itself. For Baskin, perhaps more than for most, the altar of art must rest, as religious altars did, on a moral support system with which it is completely integrated. The aesthetic and the ethical must be unified in the artist's work of art just as the inexplicable mysteries of religion were once absorbed into the everyday work life of a religious man. In his dialogue with the past one must recognize Baskin's search for the wholeness that is at the heart of the Old Testament, with its promise for every threat, its comfort for every grief. It is with the memory of Isaiah's voice that Baskin makes his images of cowardice, shame, and death; but from the spiritual desert that these images symbolize, "shall waters break out, And streams in the desert. / And the parched land shall become a pool, / And the thirsty ground springs of water" (Isaiah, 35:6–7). Like the ancient prophets, with whom there is much evidence to believe he deeply identifies, Baskin accuses humankind of worshiping false gods, of wearing the crown of pride, of erring in vision and stumbling in judgment, of making a covenant with death and hell. But despite the human failings over which he despairs, Baskin does not forsake the human figure: "It contains all and it can express all." It is the "gutted mansion" that houses the consciousness of spiritual oneness expressed in the word "humankind." Baskin is unusual among modern artists in seeing beyond the evident fragmentation of modern life to what he calls man's "universal sodality." It is within the structure of this continuous Old Testament dialectic between fragmentation, associated with God's vengeance, and wholeness, God's compassion, that Baskin's figures of dead men will be viewed as images of atonement and redemption.

The theme of death, grief, and suffering appeared in Baskin's work almost from the beginning, in the early *Male Figure, Arms Upraised* of c. 1938 *(Fig. 35)*, with *Death Head of Lorca* of c. 1940, and in his post-war work, which, in addition to *Prometheus* and *Wounded Soldier*, included *Mourning Mother*, a *Blind Woman*, and a twisted, hanging *Thief—Crucified with Christ*. Death has, of course, often appealed to the romantic imagination of youth, which can well afford to contemplate the end of life because it is in all prob-

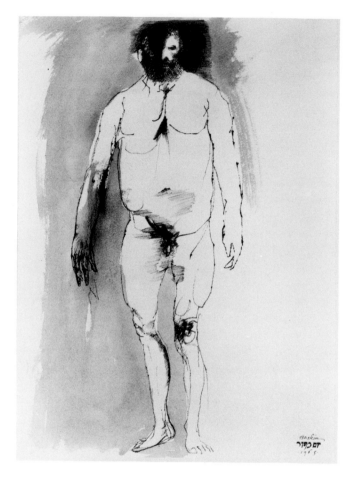

Fig. 34: Day of Atonement II. 1965. Ink, 21½ x 15½ inches. *Collection of Harold Bell, Ardsley, N.Y.*

ability so distant. Traditionally a major theme in art, death had, however, attracted little interest among twentieth-century artists. Baskin's focus on death is thus exceptional for his time, and its ultimate source is his life experience. No Jewish home in the thirties was free from the consciousness of death as reports of the German concentration camps began to gather. At the end of the war photographs of the death camps with their trenches glutted with victims became horribly familiar. Baskin, always the collector, kept mounted in an album photographs of Buchenwald and Dachau that he cut out from newspapers and magazines, just as he had earlier made a book of reproductions of art masterpieces. In 1948 he wrote a poem entitled "Buchenwald."

> The whitest birds outlining grey,
> living flight, churning the lie
> of empty sockets; scented wings flay
> dug-up men, blinded to the sky.
>
> Bones of men, the special wonder
> of clay and blood, side by side
> eyes and brain, a finger's plunder
> Graveless children race to hide.
>
> A lily flowered in half-tooth mouth,
> poem rhymed on ribs one by one
> starlings retch, fly home towards south
> I hear my heart and refuse the sun.[2]

Fig. 35: Male Figure, Arms Upraised.
c. 1938. Wood, 46 inches.

Baskin's experience in the war, moreover, probably helped to stimulate already present tendencies to fantasize about his own death.

In Paris in 1950, at the Académie de la Grande Chaumière, he began the series of figures of Dead Men for which he first became famous (Fig. 36). The series, and the theme, hold a prominent place in Baskin's iconographic repertory, and much comment, both appreciative and adverse, has been devoted to this aspect of his work. Neither admirers nor critics, however, have probed sufficiently into the series' meaning, although Brian O'Doherty, with his usual sensitive insight into the spiritual resonances of art, did indeed, in one brief paragraph, disclose the nature of its inner content. "In his greatest sculpture," O'Doherty wrote, Baskin "has created calm monuments in the image of the human form that have through art transcended the pathos of mortality. But they have first passed through a sort of death in Leonard's imagination. The best of them . . . are resurrections. In his sculpture, death is often a doorway to deeper illumination." And David Porter has seen how the Dead Men "display the strength and beauty that are separate from [man's] carnal ex-

istence, constituting the shared dignity of us all, unkillable."[3] Too often, however, Baskin's figures of dead men and related subjects have been misread as mannered, morbid fantasies. But even some sensitive critics have tended to take as adequate and full explanation the interpretation provided by the artist.

The dead men are about life. In their mordant recumbency they teach the living the upright vibrance of life. Life is calibrated by death. When visiting the cathedrals of Europe, I saw, continuously, the recumbent effigies of princes, knights, kings, and queens, ecclesiasts of all high station, cardinals and bishops, popes and monsignori. But searched in vain for the unpomped and the unceremonious. From the total absence of the plain dead I was moved to celebrate the exhausted factory worker, the forgotten tailor, the inglorious poet, dead from having lived, dead indeed to enjoin the living to note their liveliness; the *gisants moderns*, as I collectively call them, are a memorial in effigy to the unnoticed dead. My *Dead Men* then on one level are small monuments for those who once lived and in the *nature of things* they are marking stones for us who yet live.[4]

Following Baskin's lead, Marvin Sadik in his otherwise excellent and concise appreciation of the artist accepts the materialistic implications of Baskin's statement, and neglects the unavowed but, in my view, implicit spiritual meaning of these works. "They preach no moral about life, abusing or abused; or about death, as reward or retribution. For Baskin, mortality alone is sermon enough," Sadik writes. While I agree that they preach no sermon, it is my conviction that when considered in the light of the artist's cultural and intellectual history, they invite an interpretation that bends the rationalist boundaries in which they are usually seen. They communicate a vibrant yearning for immortality that does indeed have something to do with reward, and retribution, atonement and redemption, although not in the strict sense of any theological doctrine. Baskin's Talmudic studies, however, taught him that "whatever the nature of the world beyond . . . there the dead reap the desserts of the acts they performed while alive . . . and that death served as an atoning process . . . complete forgiveness . . . was dependent . . . on the final atoning value of death." Although the artist disclaims religious belief, his language is enriched by a vocabulary that plucks the resonant chords of the Old Testament, and it is noticeable that when he insists that man is "collectively redemptible," he veers abruptly away from elaborating his meaning, unwilling, one feels, to probe his thoughts on the implications of what he has written.[5] On a conscious level Baskin's conceptions may be conceded to be rationalist; but giving careful attention to his words, following the continui-

Fig. 36: Group of Dead Men. 1952, 1956. Bronze.

ties and *breaks* of his thoughts, and contemplating, all the while, his figures of dead men, we are made to feel that it is on the level of intuition that the artist taps the essential content of his art. I think, then, that we must give his figures of the dead the broader meaning they themselves suggest. Mortality is not "sermon enough," and such a view leads us to see Baskin's dead as Archibald MacLeish saw them—mistakenly, I believe—in terms of their uncompromising materiality.

"They are dead. They are not asleep, they are not on a journey, they are not waiting for a trumpet or for the removal of a stone or a visitation of an angel: they are dead," MacLeish writes, invoking images of immortality from the iconographic tradition of Egyptian and Christian art. Interpreting Baskin's *Dead Men* from the viewpoint of a conventional rationalist liberal-ethical conception of life and death, MacLeish argues that they show us how determined we must be to change the only world we live in and "to know what is necessary for us to know and to live in this place and die in it."[6] He compares Baskin's use of death imagery to that of Baudelaire in his poem "A Carrion" because, he says, both artists use their imagery of death to enhance life. But every artist enhances life to some degree, in some special way. The comparison is more useful for what it tells us of the *difference* between Baskin's imagery of death and Baudelaire's.

It would be hard to think of a more sensually loathsome description of a dead body than Baudelaire's carrion, which,

> quivering
> On a clean bed of pebbly clay,
>
> Her legs flexed in the air like a courtesan,
> Burning and sweating venomously,
> Calmly exposed its belly, ironic and wan,
> Clamorous with foul ecstasy[7]

The nineteenth-century taste for horror, sadism, voluptuous melancholy, and the thrilling fantasies of sexual depravity is perfectly expressed in this masterpiece of morbid verse. Baudelaire stands behind the reader as if holding his head in vise-like hands, pushing him into stenching contact with the putrid vulva swarming with flies. One cannot possibly escape the "dire putrescence," and one is held in thrall, repelled and fascinated by the hypnotic beauty of the fetid and the festered.

Such an image of rotting matter is remote indeed from Baskin's *Dead Men*. We will take up later the question of the meaning of missing arms and legs in Baskin's art, for as we shall see, in some figures dismemberment does produce an extra-aesthetic effect. In the *Dead Men*, however, even those figures with parts missing convey an impression of wholeness

within the modern aesthetic convention of the partial figure.
Unlike Baudelaire's carrion, they express no sense of physical
decay or of struggle or pain or passion, nor is there even a hint
of life extinguished in violence or relinquished with regret.
Considered solely within the context of the partial-figure con-
vention, these figures *could* be merely asleep, and indeed Bas-
kin, speaking to a reporter for *Life* magazine in 1964, said
with a laugh that Esther had suggested he might be able to
sell the *Dead Men* if he called them *Sleeping Men*. "But
they're not asleep, they're dead," he insisted. When Selden
Rodman, one of the first critics to recognize Baskin's extraor-
dinary power as a sculptor, interviewed him in the mid-fifties,
Baskin again laughed when questioned about the *Dead Men*.
"Made me happy, still being around," he told Rodman. "But
seriously . . . in your work—the preoccupation with tor-
ment and death," Rodman persisted, not distinguishing be-
tween Baskin's graphic works and his sculpture: there is
indeed torment in the drawings and prints—exactly that tor-
ment that the artist had found inappropriate to sculpture.
"Maybe because I'm still young," Baskin answered evasively,
redirecting the conversation. "Maybe when I get older per-
haps I'll get around to doing voluptuous women. Wasn't it
Brancusi who said, 'When we are no longer young, we are
dead'?" The talk then turned to Brancusi.[8]

But death is not a laughing matter. Despite Baskin's ban-
tering tone, we cannot be so easily persuaded that his rational-
ist explanation of the source of the *Dead Men* tells us all we
need to know about these strangely compelling works. Why,
indeed, *are* they so lacking in the evocation of material decay?
What *is* the artist telling us about death—or life? Why are
they *not* sleeping men?

Death is the strangest phenomenon known to man, and
consequently for an artist to approach the subject reveals in
itself a willingness, a *will*, to confront the feelings of fear, awe,
and wonder that the idea of death inspires in human beings in
the profoundest recesses of the imagination: death is uniquely
the event that no one ever can experience. This, I think, has
something to do with our inability to imagine our own decay,
and possibly explains why fleshed representations of the dead
as seen, for example, in medieval sculptural reliefs are so much
more effective than skeletons; whether damned in hell or
saved in heaven, the image of the human body communicates
its torment or felicity in terms of living. Perhaps Baskin's
Dead Men are so compelling because they are, in this sense, so
alive; they do deny our rotting in the earth. It is, after all, our
bodies that we love and through which we know ourselves.
The faces of the *Dead Men* are serene. Some of them smile,
as if at some inward, happy knowledge. Not one is tormented.
Seeing them as a group, lying in tall summer grass, as they
are behind Baskin's studio in Maine, one is filled with the com-

forting sense that, like them, one will enjoy forever the warmth of the earth and the radiance of the sky. Hold one in your hand; it is a curiously comforting experience to look so closely at a human figure from which self-conscious conflict has been drained.

Is this absence of pain and decay a clue to the meaning of the *Dead Men?* It seems probable. We cannot forget that traditionally in Judeo-Christian and classical culture death is closely associated with ideas of punishment and reward, and we have the evidence of the artist's words as to his personal identification with these figures. "I consider myself an ordinary person," he told a reporter for *Newsweek.* "I've tried hard in my work to make the ordinary person heroic through the fact of his humanity." Baskin links himself here with the heroic ordinariness of humanity, and thus merges with "the exhausted factory worker, the forgotten tailor, the inglorious poet" on the plane of art's immortality. His unwavering insistence that the figures are not sleeping, but dead, points to his own *willing* of their death, and therefore of his own death —his own punishment and eventual forgiveness. Thus it seems that the fundamental content of these figures is the artist's act of atonement, through art, for his own secret guilts, which personalize the common sense of guilt that seems to be structured into the human psyche since Adam. This is the guilt that from time immemorial the artist has acted out and atoned for on the plane of myth, the guilt that the staunchest materialism and rationalism seem unable to destroy. We have already met this artist in Baskin as Prometheus the Challenger who stole the fire of divine knowledge from his father; in the *Dead Men* we meet him as the atoner. One "dies of shame"— of defilement and sin, as Baskin had indelibly learned from his daily immersion in the Old Testament. "The soul that sinneth, it shall die," Ezekiel promises (18:4).⁹

What a heavy burden of guilt a young mind carries when it takes upon itself the accusations of the Prophets. "Wherefore came I forth out of the womb / To see labour and sorrow, / That my days should be consumed in shame?" (Jeremiah 20:18). Did Leonard Baskin know himself to be guilty of all the sins of which Jeremiah spoke? Who does not so know himself? Who has not thought and wished and done evil? And who has not known in his heart that every ill wish, every selfish hate, every wrong, is a death of the spirit that demands righting as the price of peace? We pay for our transgressions with depressions that render us spiritless, with anxieties that kill us; lying again and again, we may see ourselves lying dead, object-like, dead in atonement to the world, but we do not *feel* ourselves dead—we cannot imagine ourselves deprived of every sense. Eventually we somehow forgive ourselves or find forgiveness elsewhere, in religion or art; the spirit of life returns and we rise again.

The image of "rising again" is ubiquitous in the world's religions and myths. The human need for immortality has found innumerable metaphors in which to be realized, often in ideas linked to the seasonal cycle or to the non-material nature of spirit or soul. For Jews touched by the tradition of the Old Testament, immortality is understood as the destiny of Israel. The individual dies, but the chosen people live under God's everlasting Covenant; they are all but destroyed over and over, but they rise again. The mortal person is thus embodied in the immortal transpersonal Jewish nation. The struggle between death and life can be found projected in myths that deal with the struggle between chaos and form, for death is the absence of the spirit that informs matter, and life is the creative force that gives form to everything it touches. For the Christian in an age of belief, this creative force is Michelangelo's God touching Adam to life as the soul enters his body; but for the worshiper of art it is Michelangelo himself who is "divine" and touches to life with the soul of art the figure that struggles to form in the hard, meaningless stone.

The magic of form-making has given to artists of many cultures a special, often priest-like role. Freely accepting the responsibility for form-making mysteriously thrust upon him by nature, the artist is a kind of savior who divides and proportions and thus holds chaos constantly at bay. Even the ultimate chaos, death, is defeated by the artist—in this sense MacLeish, writing about Baskin's *Dead Men*, is quite right to invoke the name of Baudelaire:

> Speak, then my Beauty, to the dire putrescence,
> To the worms that shall kiss your proud estate,
> That I have kept the divine form and the essence
> Of my festered loves inviolate![10]

The poet, like the sculptor, endows his Beauty with the gift of decay-defying form.

Can we see Leonard Baskin as the child penetrated daily by the thundering threats of Jeremiah; the middle child dying for more love; the born artist who discovers through five pounds of plasticene that he can confess the love he feels for the mother he does not like, and the rivalry and anger he feels against the father he loves? Do we seem to be guessing too deeply? "Difficult to know how the spirit learns / Its scales, or the exact dimensions of fear," as Baskin's friend the poet Anthony Hecht writes. But the spirit of the artist does learn its values, and struggles to encompass its knowledge even beyond the measure of the artist's intentions, and it is the critic's need to understand this spirit. For the artist, as Northrup Frye has maintained, is not the "definitive interpreter of himself,"[11] and it must be the task of the critical biographer to

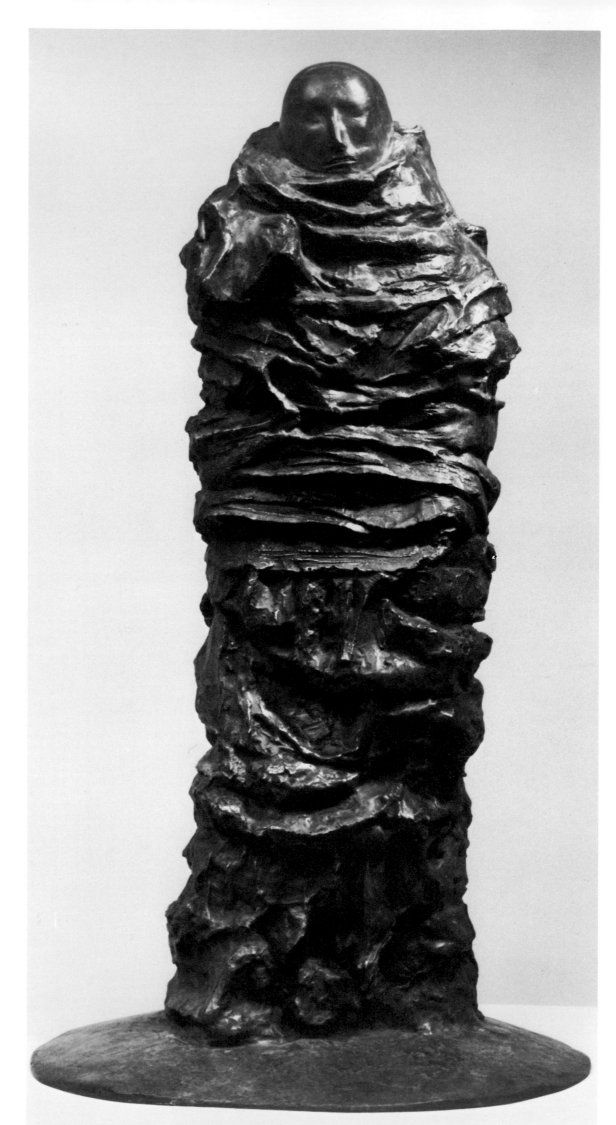

Fig. 37

provide what autobiography cannot—a contextualized account of the artist viewed from outside the borders of his self-knowledge. This does not mean that we can give ourselves the license to invent; it does mean that we must put our evidence in such order that a coherent meaning is elicited from it, and that that meaning must be equal to the emotion that a work of art or an entire *oeuvre* awakens within us. Considering the *Dead Men*, we cannot doubt that their content goes far beyond the artist's claims of merely updating the artistic tradition of the *gisants*. They are not represented clothed, as ancient and medieval tomb effigies invariably are; they are not turned on their sides, like the Pompeian dead, falling into tuffaceous sleep and all the more chilling for their physical naturalness. They are naked, flat on their backs, and fully revealed. They are, in a word, unburdened, in every sense.

Unlike the anonymous figures of *Dead Men*, Baskin's *John Donne in His Winding Cloth* (Fig. 33) and *Lazarus* (Fig. 37) are vertical forms, and they are swathed in drapery, as required by the subject matter. As Professor Julius Held has pointed out,[12] this iconographic demand was in fact one of the attractions of the subject for Baskin, who was intrigued by the sculptural problem of achieving veiled form. But beneath the formal differences with the *Dead Men*, the *Donne* and *Lazarus* further illuminate our understanding of the meaning of death in Baskin's work, for, as we shall see, both figures are represented in a state of life—or death—that is problematical.

Izaak Walton's meticulously detailed account of John Donne's long-heralded death and the macabre story of his death portrait seem destined to have found a place in Leonard Baskin's *oeuvre*. The dying poet and dean of St. Paul's Cathedral, in response to a request of his physician and friend, Dr. Simeon Foxe, agreed to have a monument made of himself. He ordered a wood-carved urn, large enough to stand on, and a life-size wood panel of the kind used for painting. A "choice Painter" (unidentified) was then called in to do the portrait for which Donne stood, first removing his clothes and wrapping himself in a winding cloth "so tyed with knots at his head and feet, and his hands so placed, as dead bodies are usually fitted to be shrouded and put into their coffin or grave. Upon the *Urn* he thus stood with his eyes shut, and with so much of the sheet turned aside as might show his lean, pale, and death-like face. . . . When the Picture was fully finished he caused it to be set by his bedside where it . . . became his hourly object till his death." The death portrait of Donne is, therefore, a picture of the still-living man.[13]

After Donne's death, the painting, which has disappeared, served as a model for an engraved portrait bust (Fig. 38) used as a frontispiece for Donne's last sermon, *Death's Duel*, published in 1632, and for a marble effigy carved by

Fig. 38

Fig. 37: Lazarus. 1959. Bronze, 30½ inches.

Fig. 38: Martin Droeshout. *Portrait of John Donne.* Engraving, 1632.

Nicholas Stone, which was placed in St. Paul's (Fig. 39). Somehow saved from the Great Fire of 1666, the seared statue was reinstalled in Wren's new St. Paul's, where it still stands. Baskin had not seen the carving of Donne when he was moved to make his bronze after reading Walton, but the strong undulating contour of the face framed by its drape shows that he had studied the engraving, in which this contour is very noticeable.

Baskin has depicted the figure tied up, although not exactly as described by Walton, and the poet's profoundly religious spirit is realized in the face and in the tapering candle form of the figure.* The candle is, of course, a widely used metaphor in art and literature; burning, it symbolizes life; extinguished, it is a symbol of death. According to Jewish tradition established in the Talmud, a candle is usually lit in the presence of the *goses*—the dying person—to symbolize the flickering of the human soul.[14]

The enigma of form and the theme of salvation are taken up again in *Lazarus*, the first major bronze that Baskin worked in plaster. The living quickness of clay, its soft malleability, had begun, in the late fifties, to make the sculptor uneasy; he was dissatisfied with a certain facility that he saw in his finished bronzes, and found that by building up his forms with plaster, a technique that he learned from his teacher at the "Y" in 1936, he could realize the rugged surface effect that he began at this time to prefer in his free-standing figures—although, as we shall see, not in his reliefs. Using great handfuls of wet plaster in which were soaked wads of rags and newspapers, he learned to apply this intractable material to his wire armatures, varying the sizes and shapes of the wet, chunky lumps by cutting, rasping, filing, and sanding, and allowing the accident of dripping plaster to suggest the nature of his process. This method, he found, could produce endlessly varied shapes, and gave his surfaces an aggressive and sensual strength.

In the *Lazarus*, using his newly adopted material and method of manipulating it, the artist has contrasted three kinds of surfaces—crumpled, banded, and polished—by means of which he suggests correspondence with three different states of being. The lower half of the figure is rendered with-

Fig 39

Fig. 40

Fig. 39: Nicholas Stone. *John Donne.* Before 1666. Marble. *St. Paul's Cathedral, London.*

Fig. 40: Christo. *Package on Wheelbarrow.* 1963. Cloth, rope, wood, and metal, 59½ inches. *Collection of the artist, New York, N.Y.*

*The image curiously recalls the wrapped mystery of two other twentieth-century works, Man Ray's eerie *Enigma of Isidore Ducasse* and Christo's *Package on Wheelbarrow* (Fig. 40). The rectilinear pattern of the cords superimposed on the curving human figure of Donne creates an effect similar to that of these works, with two independent articulation systems, one on the surface, the other in depth, counterpointing and complementing each other. Although this resemblance between Baskin's sculpture and the other two is coincidental, the metaphysical implications that they share make the formal comparison worth noting, for despite the vast chasm that separates their content, all three artists are dealing with the enigmatic nature of form.

out discernible pattern and thus seems to be in a state of dis-
integration, like formless lumps of earth; the upper half re-
tains more clearly the sense of human form around which
the parallel strips of cloth wind, orderly but with a kind of
irregularity that evokes notions of form in the process of
forming. The smooth sphere of the head is primary form it-
self, not yet fully emerged, but rising from chaos, through
becoming, into being. Baskin's *Lazarus* is still burdened with
his death; his eyes are closed, his mouth is sagging. The three
states of being are in momentary tension. Characteristically,
the artist has chosen the ambiguous moment when Lazarus is
neither dead nor fully alive.

This image, although one of the most memorable of
Baskin's figures and more sophisticated in form and content
than previous bronzes, is not wholly achieved as sculpture.
The ragged irregularities of the profiles are not entirely satis-
factory from a frontal view; the wrappings in some areas are
unexpectedly and disappointingly flattened. But the startling
boldness of the bald head rising up from the heavy-textured
mass does much to redeem these flaws, and despite the con-
fusion in the drapery, *Lazarus* remains a work of extraordi-
nary sculptural force and iconographic interest. It is a worthy
prelude to a long series of bronzes that deal with the con-
cealed, wrapped figure.

Ezra Pound has said that "an image is that which presents
an intellectual and emotional complex in an instant of time."
He was, of course, referring to the literary image, but the
definition is equally apposite to the visual arts. It raises the
interesting question of the nature of aesthetic impact and may
help to clarify at this point a critical difference between
Baskin's sculpture and much of the art of his contemporaries.
What Pound's comment crystallizes so concisely is the dual
experience we may have of a deep-reaching image—its power
to evoke in a moment a dense nexus of memories and associa-
tions that cannot be verbally articulated as *felt* and, at the
same time, to generate thoughts that invite contemplation,
reflection, and speculation. We experience on one hand the
stunning immediacy of recognition, and on the other the
slow unfolding in our consciousness of a controlled structure
of meaning. It is something like what Yeats described: "It
takes so long to know what the feelings we are having are be-
fore we can name them ours."

Modernist art has moved consistently, since Manet's
Olympia, I think, in the direction of seeking increasingly
vivid means of achieving sharper, "purer" aesthetic contact
with the viewer. This effort to achieve impact has been un-
questionably successful; modernist art is characteristically
"closer" to the viewer, in many different ways, than any art
style in the Western tradition; even Baroque art, with its
strong appeal to direct and personal sensation, was remote by

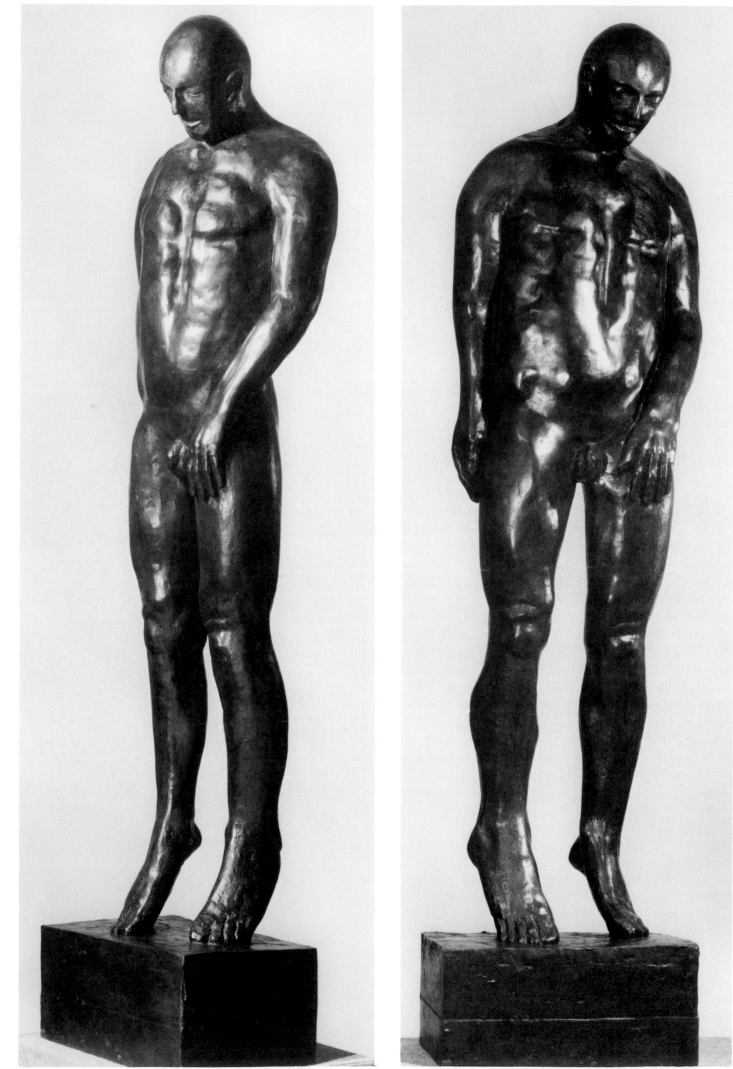

Fig. 41 a Fig. 41 b

Fig. 42

comparison with art that often depends for its effects on the "viewer's" participation by sitting in it, swinging on it, walking into, over, around, or on it, or being otherwise involved with it. But the achievement has tended to produce an emphasis on the sensations of space, color, or form so strong as to overwhelm the participant's power of imagination. What started out, at least partly, as an effort to revitalize the response to art by making the responder more actively engaged with it has too often produced the opposite effect: the responder may be physically activated but is imaginatively passive to the work. The immediate, present, private sensation engendered in the participant even obliterates his consciousness of the work that has stimulated his sensation; his focus shifts from the work to his personal experience, stimulated by but now disengaged from it. He is thus no longer playing the aesthetic game; he is having a psychological experience.

The nature of the aesthetic game is, of course, in some sense psychological; the reverse is not so—the nature of psychology is not aesthetic. And so modernist art in seeking maximum impact chooses to run close to the risky edge of non-art. Its efforts to reinflect traditional aesthetic sensibilities often succeed in redirecting art into what it has tried so hard to avoid—the channel of rational explanation. It has ruptured the link between the immediacy of the signal and the mediation of thought.[15] It is ironic that Leonard Baskin, who has attacked modernist art for what he has called its irrationality, in his best work evokes a complex response that bypasses the rational and yet sets off with that initial response a train of cultural, literary, and mythic associations that deepen the work's impression over a period of time. In various ways a number of critics, notably John Canaday in his *New York Times* reviews, have commented on the power of a Baskin sculpture to deepen its impression over time.[16]

Hanged Man (Fig. 41) is one of a number of superb works by this artist that do indeed present "an intellectual and emotional complex in an instant of time"—but continue to resonate with meaning. Nude like the anonymous *Dead Men*, vertical like *Donne* and *Lazarus*, this figure is a summarizing work that represents Baskin's prolonged consideration of the possibilities inherent in the dead man theme. It is a restatement, now fully developed, of an early, very small *Hanged Man* that was made to be literally suspended, and it is close to the *Hanged Man* woodcut of 1955 (Fig. 42). *Hanged Man*, however, is hanging only illusionistically, since it is actually fixed to the base on which it stands with only the toes touching.

The immediacy of the impact of this "hanging" figure is unsurpassed in Baskin's work. The first impression is wholly naturalistic and we respond with shocked horror at finding ourselves standing in close physical contact with such a death. Suicide? Execution? We cannot know, and we brush the

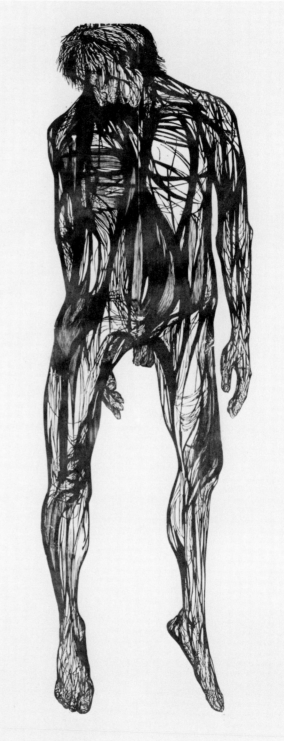

Fig. 41, a & b: Hanged Man. (Two views.) 1976. Bronze, 90 inches.

Fig. 42: Hanged Man. 1955. Woodcut, 67½ x 20 inches. *Collection of University of Nebraska Art Galleries.*

questions impatiently aside, perversely eager to give ourselves totally to an experience that is at once utterly alien and terribly familiar. But simultaneous with horror is our recognition that this graphitic-hued object *is* an object and thus contradicts the illusions to which it pretends. We begin to notice the formal adjustments that contradict naturalistic representation and, in contradicting, draw our attention away from the ostensible subject, a hanging man, toward a consideration of meaning. The head hangs downward, but the tongue does not protrude, nor does the face show the physical distortion that would occur in reality. Only the sternum's irregular, deeply kneaded surface, suggesting the caving in of the rib cage, speaks specifically of the physical destruction of the body. The left arm holds close to the left side and comes forward from the elbow so that the hand rests on the front of the left thigh; the right arm curves down along the back of the right side, creating a slight contrapposto in the whole figure that is chilling to see in a presumed dead body. The legs, too, are thoroughly unnaturalistic as dangling dead limbs, for they retain a sense of living control in the spatial relationship between them. The illusion of literal hanging is strongest in the position of the two feet, which barely touch the base and are turned slightly outward. There is more "real" death at the feet than at the head.

Only slowly, I think, can we move into the many-layered meanings of this figure—or let its meanings penetrate our responses. Having made its initial impact, *Hanged Man* continues to confront us as an alien-familiar sign, but gradually we can begin to sort out, although only partly and imperfectly, some of the memories and associations compacted in this single image. The hanging man is first of all, one sees, unfooted, suspended in uncertainty. Like Kafka's K (Baskin discovered *The Trial* "before it was degraded into a cliché of modern culture," he remembers), he is nameless, and suffering for some unspecified *donné* of an unalterable situation—he is, after all, presented to us effectively without explanation, since we can see for ourselves that he is hanging. On this level of anonymous uncertainty *Hanged Man* seems to be a metaphor for the life of modern man.

But the "uncertainty" of *Hanged Man* is, on another level, an illusion since it is only an illusion that the figure is hanging. But if it is an illusion, there are two questions to be asked: what is the reality, and what is the meaning of the illusion? The first question seems not difficult to answer at first, for the reality is palpably a form that is a work of art; in its particular form, however, with its masses distributed to achieve visually an effect of lightness that belies its real weight, its formal structure leads us deeper into the problem of the work's illusion and its meaning.

Fig. 43: Crucifix. 1966. Wood, 48 inches. *Pierce Chapel at Cranwell, Lenox, Mass.*

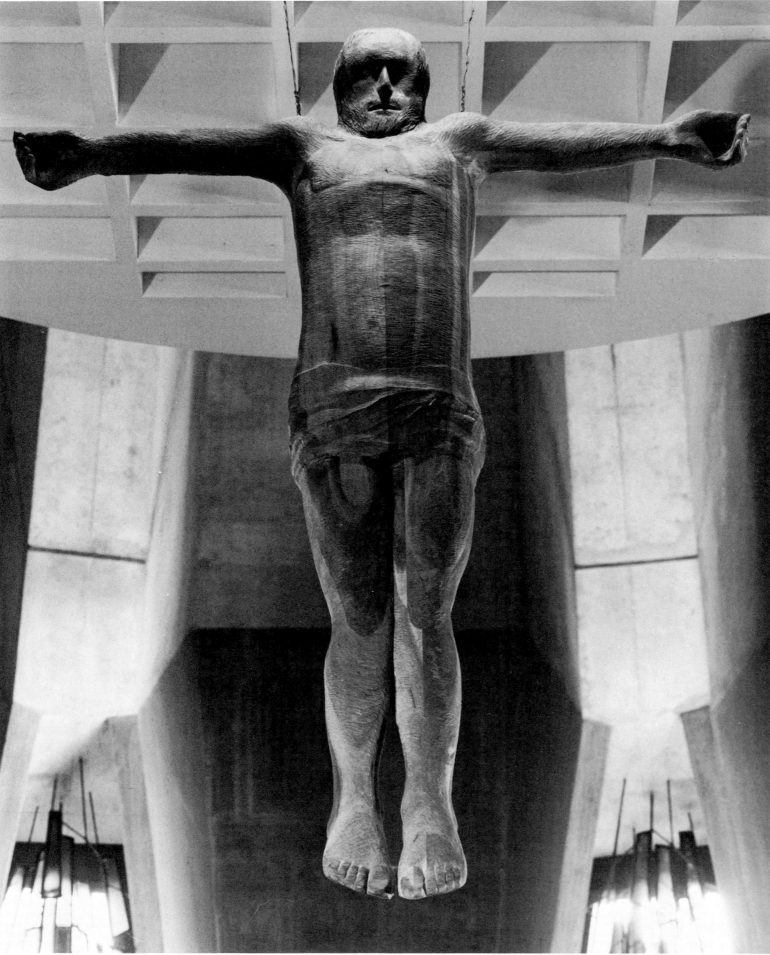

Fig. 43

Following the mind of an artist who is steeped in the imagery of Western art as well as in the symbolism of the Old Testament, we come to recognize in *Hanged Man* the significance of the figure's verticality. Ordinarily, verticality is an attribute of living things; vertical, we mediate earth and sky. Horizontality belongs to the stretched-out earth; horizontal, we merge with the earth and sky. This dead man's vertical orientation, then, becomes highly suggestive, for the archetypal image in Western art of a dead man hanging vertically is Christ on the cross, the meaning of whose death is ultimately eternal life; in the Crucifixion narrative it is death that is the illusion. Furthermore, the real body of Christ as man must have weight, but its meaning has no material substance; the contradictory illusions of hanging weight and weightlessness thus reinforce the metaphysical inferences that we draw through iconographic associations.

The Crucifixion theme occupied Baskin's thoughts for several years in the mid-sixties as a result of a commission he carried out for the Pierce Chapel at the Cranwell School in Lenox, Massachusetts. The school's rector, Reverend Francis C. Mackin, seems to have recognized in Baskin's works those death-denying implications that I have suggested are inherent in his imagery, and asked him to make the crucifix for the main altar of the new and unconventional chapel designed by the architect Peter McLaughlin. Instead of the customary crucifix, Baskin carved a free corpus (Figs. 43 and 44) that is suspended illusionistically, hovering over the altar with arms outstretched and dominating the space. He had at first considered modeling his crucifix on that of the Isenheim altarpiece, with the figure of Christ tormented, tragic, scourged and beaten, as in Grünewald's masterpiece. Thinking of the boys at the school living in a rock-and-roll pop culture, he chose instead to carve a Christ "still and contained . . . expressing a sense of his mission on earth with fervor and without viciousness," inspired, it appears, by Ernst Barlach's Güstrow Memorial (Fig. 45).[17]

That the Crucifixion theme, with variations, had attracted him even before he received the Pierce Chapel commission is clear from a number of earlier drawings and prints. In *Everyman* (Fig. 47), *Pain* (Fig. 48), and *The Agony* (Fig. 49) outstretched arms, embracing the world, are only implied; *Hanged Man* (Fig. 50) with arms hanging downward is a variation of these and leads to the Crucifixion with outstretched arms (Fig. 46). *The Forefather* (Fig. 51), another hanging man, links the Crucifixion and Hanged Man imagery in the notion of the common ancestor, Adam, expelled and suffering for his sin in the anonymous figure of modern man, self-touching, self-enclosed.[18] We see, then, that the formal structure provides an essential clue by which we can grasp a level of meaning beyond the interpretation proposed above. And yet it

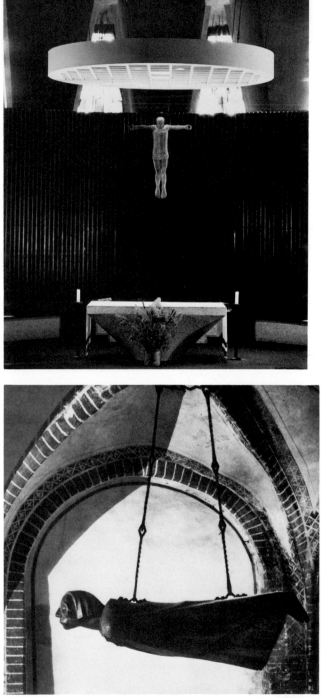

Fig. 44

Fig. 45

Fig. 44: View of the altar. *Pierce Chapel at Cranwell.*

Fig. 45: Ernst Barlach. *The Güstrow Memorial.* 1927. Bronze, 84½ inches (length). *Güstrow Cathedral: Antoniterkirche, Cologne. Crucifixion.*

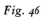

Fig. 46

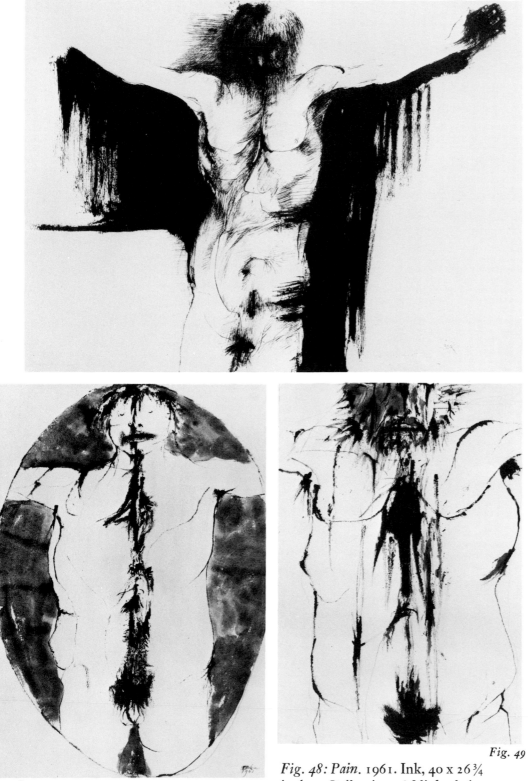

Fig. 48

Fig. 49

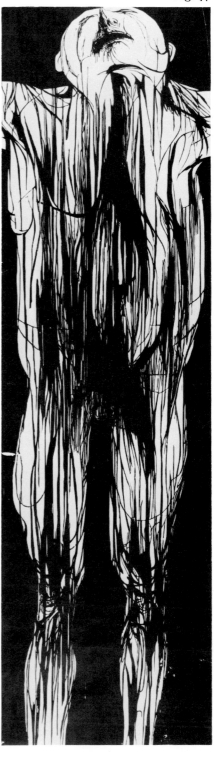

Fig. 47

Fig. 46: Crucifixion. 1966. Ink, 15¼ x 21½ inches. *Collection of Leo and Hilda Lang, Blue Point, N.Y.*

Fig. 47: Everyman. 1960. Woodcut, 117 x 40 inches. *Collection of Amon Carter Museum, Fort Worth, Texas.*

Fig. 48: Pain. 1961. Ink, 40 x 26¾ inches. *Collection of Michael Ayrton.*

Fig. 49: The Agony. 1961. Ink, 40 x 26¾ inches. *Collection of Dr. and Mrs. Seymour Lifschutz, New Brunswick, N.J.*

is possible to see both these interpretations, and others as well, interlocked or oscillating, on multiple planes of interpenetrating meaning.

For the *Hanged Man* is not in a literal sense a figure of Christ. Nevertheless, just as on one level we may concede that Baskin's early *Dead Men* were humble modern analogues of the *gisants* representing great and powerful princes of history, so this *Hanged Man* suggests the modern Christ-Everyman, ponderous with guilt, his own and others'. He is the modern hero-victim, crushed but still calmly and insistently present. Alien and familiar, he is ourselves; and once again, he is the artist. *Hanged Man* is an image, a mystery washed up suddenly on the shore of consciousness out of a chaotic sea of possible meaning, perceived wholly in an instant of time. Its intellectual and emotional impact does not stop with the moment of perception, however, but lives on and, like life, it changes even while it remains itself.

In addition to the sculptures of the dead men, the dying, and the resurrected, the theme of death appears in Baskin's sculpture in allegorical figures entitled *Death*, and also in a number of mourning figures, among which is *Grieving Angel* of 1958 (Fig. 52), a work that reminds us of the impact on Baskin, a few years earlier, of Tino di Camaino's full-bodied carvings. This impact was a continuing one, since Baskin bought and kept at hand a book of large reproductions of Tino's works. Baskin, as Tino did, customarily carves as if working in relief, and Baskin's forms are also characterized by broad planes. With both artists one feels the concern for expressing the character of mass, so that the figures do not interact with space but displace it. In Tino's time, the newer style of Giovanni Pisano was beginning to explore movement in space, just as among Baskin's contemporaries problems of spatial interaction have been prevailing concerns for modernist aesthetics; in both artists there is a clear preference for the iconic mode and for a static strength that runs counter to contemporary tendencies. *Grieving Angel* does not reflect an Old Testament theme, and may have been inspired partly by Tino's winged cardinal virtues on the tomb of Queen Marie of Hungary (Fig. 53). While the virtues are draped and Baskin's angel is nude, they have in common an archaic solemnity and a majestic tenderness of expression that in Baskin's work, as Julius Held has pointed out, are exceptional.[19]

Human grief is first represented in Baskin's mature *oeuvre* in the figure of *Achilles Mourning the Death of Patroklos*, which the artist acknowledges is a self-portrait generated by his grief over the death of Rico Lebrun (Fig. 54). Baskin had illustrated a deluxe edition of the *Iliad* in 1962, and his bronze *Achilles* is based on his drawing of the Achaian hero for the scene where "only Achilles wept still as

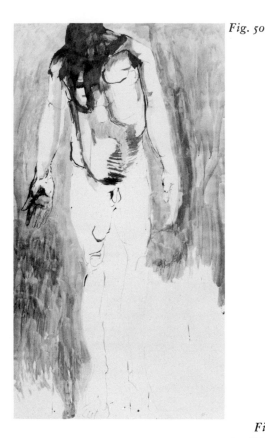

Fig. 50

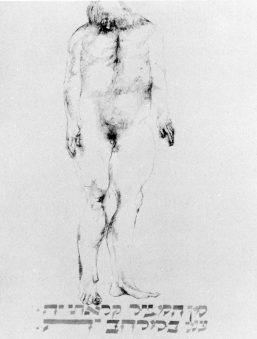

Fig. 51

Fig. 50: Hanged Man. 1964. Ink, 78¼ x 42¼ inches. *Collection of University Art Museum, University of California at Berkeley.*

Fig. 51: The Forefather. 1975. Ink, 30½ x 22 inches. *Collection of Kennedy Galleries, New York, N.Y.*

he remembered his beloved companion . . . and all the actions he had seen to the end with him, and the hardships he had suffered.[20] . . . Remembering all these things he let fall the swelling tears . . ." (Fig. 55).

The principal difference in the conception of the bronze is the position of the head, no longer hidden behind Achilles' right arm, but fully visible, tilted only slightly to suggest the burden of sorrow that Achilles, and Baskin, felt at the loss of the dearly loved companion. The hero's despair saturates the heavy form of *Achilles*, reminiscent of William Rimmer's *Despair* (Fig. 56), which in turn calls up memories of Michelangelo's despairing image of the Damned Man in his *Last Judgment*. Remembering the artist's feeling of being "embattled," one understands Baskin's identification with the Greek hero, but one also remembers the double-edged meaning of *The Guardian* and thus perceives in Achilles, impervious to attack except for his vulnerable heel, Baskin's sense of his great power, and his vulnerability.

Achilles is technically of special significance because in this work Baskin had, in his words, "pushed the plaster technique as far as it could go in the direction of modeling." He had manipulated the material so that the surface was almost as smooth as a clay surface. When cast, the effect was similar to what can be achieved with modeling clay. The rough irregularities ordinarily resulting from working in direct plaster no longer appealed to him, and, in fact, he now began to work once again in clay. "I thought I was finally mature enough," he explained. "I was able to control the forms. You have to guard against getting petty or niggardly when you work with clay—there's that ready-made mellifluousness, the clay is an alive material so you have to put tremendous restraint on it, not allow the fingers to become involved in tiny formulations, keep it big and broad and strong.

"When I was teaching I never allowed the students to use clay. I gave them chunks of stone to carve. In order for them to have sculpture experience I'd let them hack away at that stone, to make a form; however poor it was, it was something they made. Whereas the clay is so alive they could immediately 'make sculpture' without understanding they had to make forms. You have to be a very thoroughly trained artist to work in clay because—you dig in the barrel and there is a sculpture. To put your imprint and your control on clay requires maturity and knowledge. Working in direct plaster is closer to the carving technique. I would build a figure out of plaster and cut it—like carving in wood or stone, where the struggle to make the form became a part of the work. For me, for a long time, that is what sculpture was. That was because I was anti-Bernini."

Baskin is no longer "anti-Bernini," although the great Baroque sculptor's conception of the unification of real and

Overleaf: *Fig. 52, a & b: Grieving Angel.* (Two views.) 1958. Walnut, 81 inches.

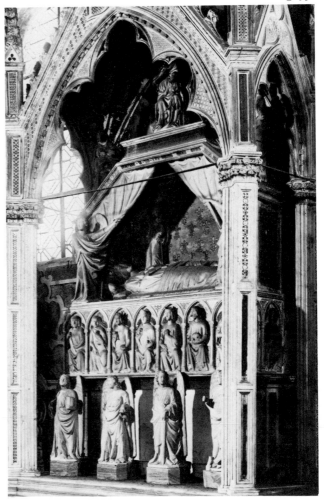

Fig. 53

Fig. 53: Tino di Camaino. *Tomb of Queen Marie of Hungary.* 1325. *Santa Maria Donnaregina, Naples.*

Fig. 52 a

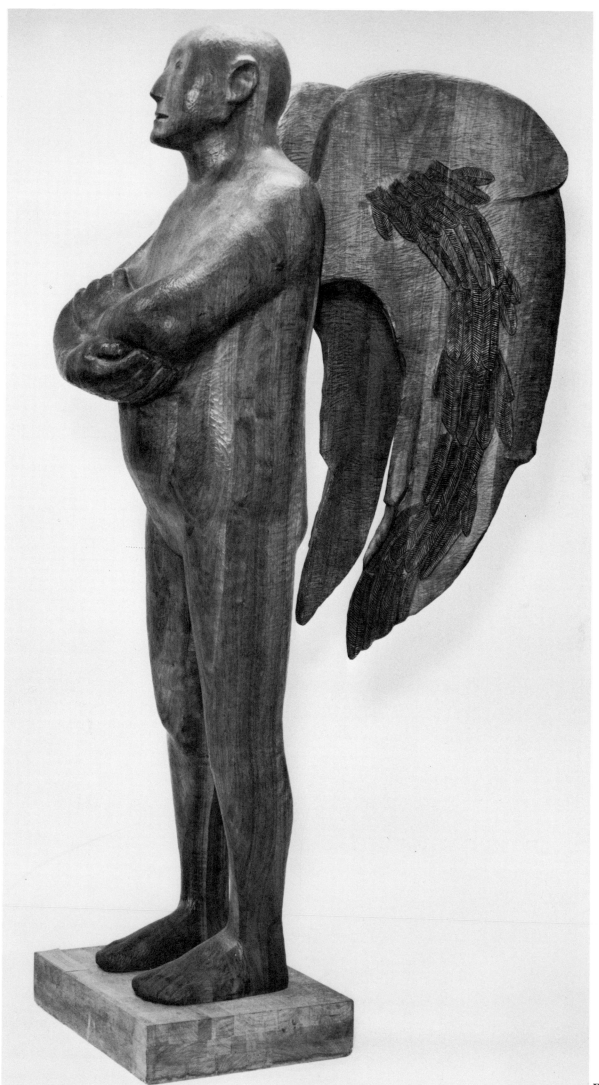

Fig. 52 b

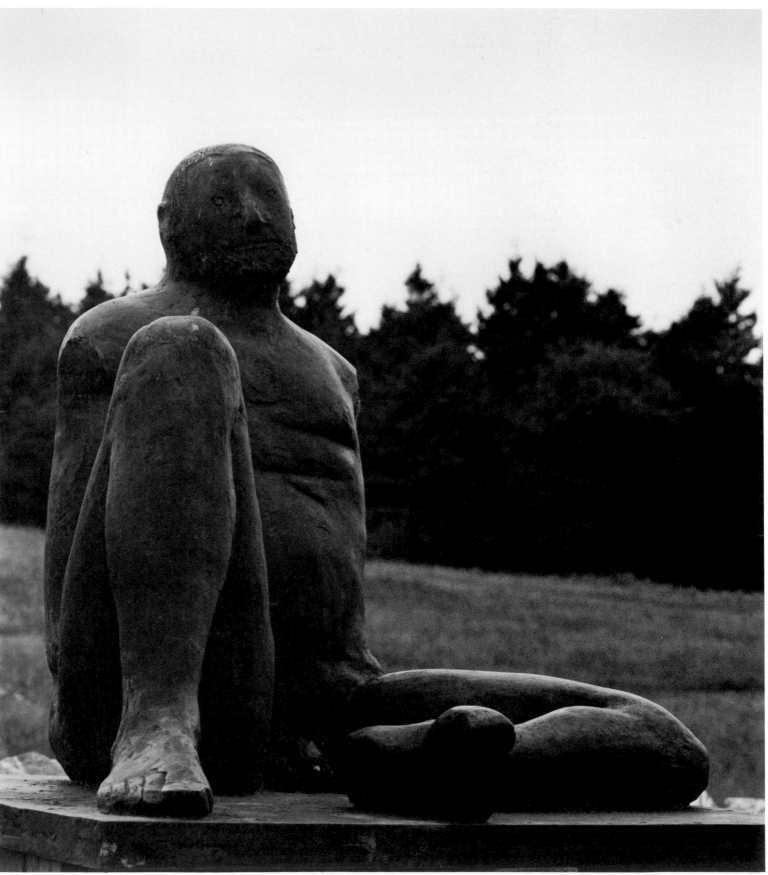

Fig. 54

artistic space and his psychological concerns remain remote from Baskin's own sculptural interests.

"The work of art must have a distinct role to play and it has to be perceived not as participating in the same air with the spectator. Once I thought of just putting the dead people out on the floor of the gallery, and I thought about it and thought how wrong that would be—that what they needed was to be on bases. They're not dead people; they are sculptures of dead people."

Following *Achilles*, Baskin modeled his next figure, *Daedalus* (Fig. 117), in clay, but he did not completely abandon the plaster technique; in 1969 he used it to make his first important female bronze figure, *Phaedra* (Fig. 57). "I had some colossally stupid notion that the male figure was a better vehicle for carrying the kind of concepts I had. Why I had that idea I don't know . . . maybe because all the sculpture of the antique I really loved was male with the exception of the *Hera of Samos*. The Mesopotamian kings and those Egyptian Pharaonic sculptures . . . and then came Barlach, who mostly made men, although he made some female figures. I never had the conscious notion that I was eliminating women. Then Lisa came into my life, and she's a fuse for women, and now I've done a lot of female figures."

In *Phaedra* Baskin not only takes up the female figure as an important image in his sculpture but also begins to develop his "wrapped" figure, with the wrapping used as an expressive device primarily, although not exclusively, for mourning figures. This device has a long and interesting history in painting because of the famous example of Timanthes, the ancient Greek artist whose lost painting, *The Sacrifice of Iphigenia*, is known through the commentaries of Cicero, Quintillian, Valerius Maximus, and Pliny. These writers applauded Timanthes' depiction of Agamemnon hiding his face in his mantle, as described by Euripides: "Agamemnon saw Iphigenia advance towards the fatal altar; he groaned, he turned aside his head, he shed tears, and covered his face with his robe," recognizing that grief of such magnitude is indescribable.[21] In sculpture, too, the heavily mantled figure and head are invoked as a symbol of intolerable grief, as seen, for example, in the ancient *Greek Mourning Woman* sarcophagus from Lydia and in the medieval mourning figures from the tomb of the Duc de Berry in the Cathedral at Bourges. The heavily draped mourner from Barlach's *Magdeburg Memorial* (Fig. 58) is an important instance of the continuing tradition of veiled anguish in the twentieth century.

Wrapping appears in Baskin's work in the fifties, with the *John Donne* and *Lazarus*, and in 1961 in the *Great Bronze Dead Man*. In the major wood carving of that year, *Seated Woman* (Fig. 59), the figure is represented as draped in horizontal wrappings that bring to mind the drapery style of

Fig. 55

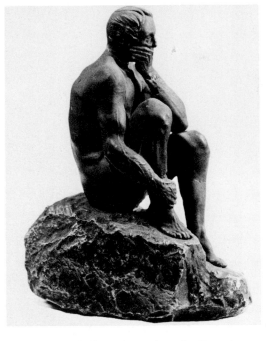

Fig. 56

Fig. 54: *Achilles Mourning the Death of Patroklus*. 1967. Bronze, 29 inches.

Fig. 55: *Achilles*. Illustration from *The Iliad*, Chicago: The University of Chicago Press, 1962, opp. p. 456.

Fig. 56: William Rimmer. *Despair*. 1830. Gypsum, 10 inches. *Museum of Fine Arts, Boston, Mass.*

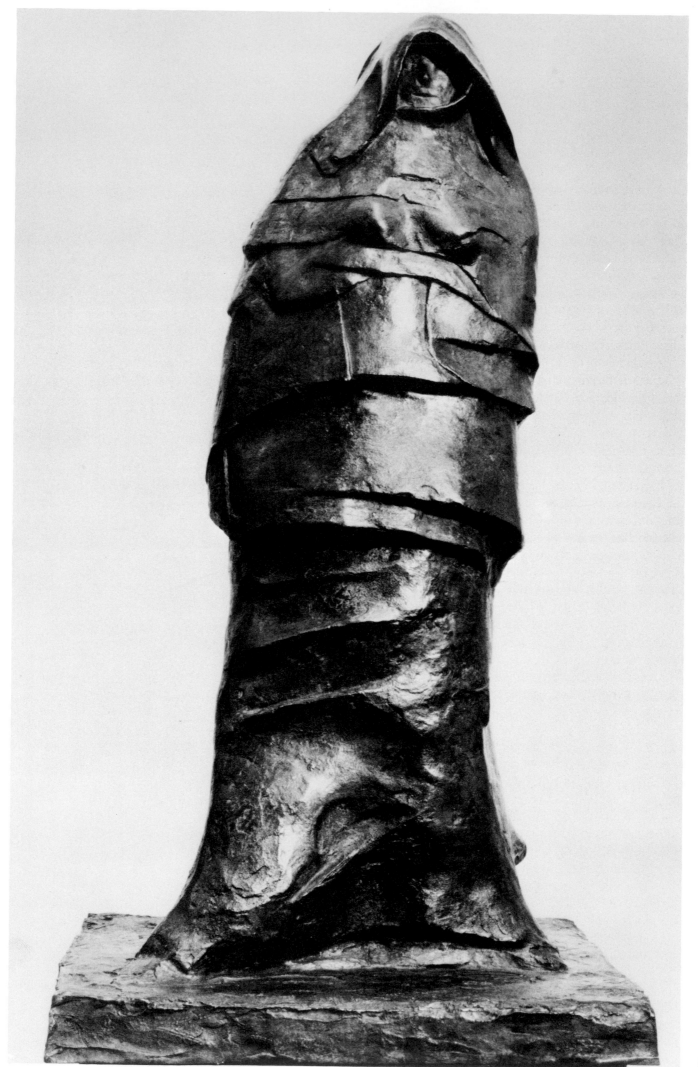

Henry Moore in many of his drawings of the war years, and in his *Madonna and Child* of 1943 (Fig. 60). The large-scale rounded forms and curvilinear rhythms of Moore's stone carving give the work an overall general resemblance to Baskin's wood-carved figure, which, like Moore's stone *Madonna* but unlike other Baskins, is also seated on a bench. While Baskin speaks far less of Moore's influence on him than that of some other artists, particularly Barlach, certain aspects of Moore's style—its monumentality and its adaptation of archaic traditions, particularly in those works where he is most naturalistic—probably confirmed his own tendencies.

Phaedra is Baskin's first fully achieved wrapped figure in bronze. The idea for the subject doubtless arose during the course of his working that year on illustrations for a new translation by Robert Bagg of Euripides' *Hippolytos* for The Gehenna Press, but it took form when Lisa, discussing the concept of the work with her husband, thought of wrapping herself in a sheet as a way of exploring the formal possibilities. Baskin customarily carves direct or works in clay from his imagination, without preparatory drawings and without a model; for *Phaedra*, however, he worked from his wife's pose, as he did again a few years later, for *Judith with the Head of Holofernes* (Figs. 61 a, b, c), which is not only a portrait of Lisa but also a portrait of the artist as the powerful enemy of the Israelites whom the great Jewish heroine slew and beheaded. There is evidently a private joke hidden in Baskin's *Judith*, which brings to mind William Rush's figure of *Comedy*, who holds in her right hand the mirror of truth and in her left her attribute mask.

Baskin has characterized Phaedra by means of the garment that winds around her figure like layered strata of shame and tragic despair. Phaedra had fallen in love with Hippolytos, son of her husband Theseus by a previous marriage. Consumed with illicit love and intolerable guilt, she commits suicide. Baskin appears to represent her in the scene where she expresses her final despair before hanging herself.

> All women, *all* of us
> are violated by destiny.
> The hurt never leaves us.
> Too much has gone wrong
> and now there are no saving words,
> no brilliant maneuvers,
> to shake that noose sliding toward my throat.
> I deserve it.
> In all your expanse, earth and sky,
> there's no hiding from what's happened to me.[22]

As Sadik has imaginatively described this work, *Phaedra's* slightly tilting form suggests "a sobbing figure, and . . . to-

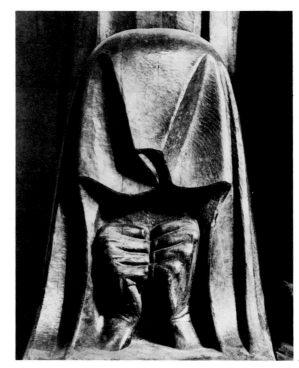

Fig. 58

Fig. 57: Phaedra. 1969. Bronze, 30 inches.

Fig. 58: Ernst Barlach. *Magdeburg Memorial*, detail of a Mourning Figure. 1929. Oak. *Magdeburg Cathedral, Magdeburg, Germany.*

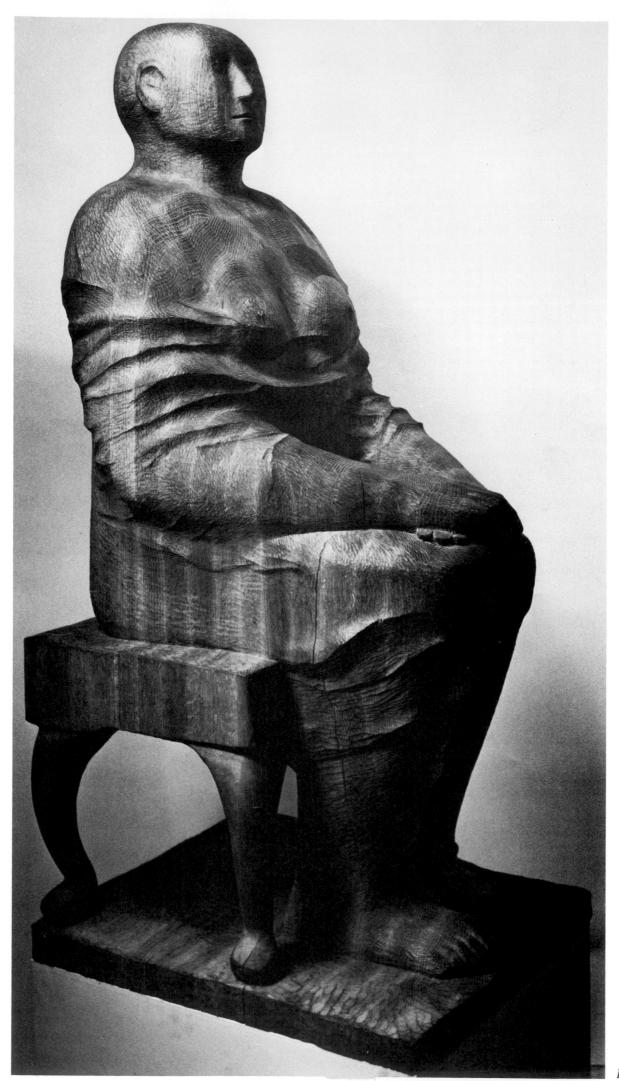

Fig. 59

gether with the architectural handling of the garment makes of her a veritable wailing wall."[23]

Preparing the illustrations for *Hippolytos*, Baskin seems also to have read Euripides' *Andromache*, for in 1971 he modeled his figure of Hector's widow as she appears not in the *Iliad* but in the post-Homeric narrative, a woman bound in slavery to the enemy that had slain her husband and their only son. One of Baskin's finest conceptions, *Andromache* (Figs. 62 a, b) is a departure from the harsh, deliberately anti-haptic style of most of his figures. Baskin has never been concerned with traditional notions of grace and lyrical expression; as do many modern artists, he prefers the beauty of strength to that of harmony. His sculptures invite the eyes and the imagination, rather than the touch, contrary to the more usual experience offered by three-dimensional form; *Andromache* is the most important exception, appealing to all three.

The figure of Andromache is almost completely shrouded, with her garment worked in curvilinear cascades of pleated drapery. Only part of the face and the toes of her right foot are visible. The linear pattern marks out the central axis of the design in undulating verticals, and fans out toward the outer contours of the figure so that one is impelled to move around it, to see the working out of the composition at the back. Wide horizontal bands encircle the knees, as if hobbling them, and they confirm the movement of the drapery down the sloping shoulders and around the softly curving hips. The rhythm of ribbon-like folds changes so that those defining the shoulder and upper arm are thinner, closer together, while those around the hips are wider and change direction slightly, which makes the diagonal movement slower and more looping. These areas complement each other and prepare the eye for the formally and iconographically important horizontal banding around the knees. The broader treatment of the drapery from knees to base, composed of both vertical and horizontal folds, and the slight widening toward the base make of this lower part of the design a kind of low pedestal from which the elaborate drapery can be seen flaming upward. Reading *Andromache* from head to foot we read a figure shrouded in unspeakable grief and bathed in a fall of endless tears; reading upward, we read a figure whose anguish consumes her in its flames. The fullness of the hips and belly, the hands crossed over the breast, the undulation of the drapery between the legs all suggest the sexuality of the woman taken in slavery.

The imagery out of which *Andromache* was formed is undoubtedly complex and derives from many sources. One thinks particularly of Egyptian figures like the New Kingdom *Funerary Figure* in the National Gallery, Washington (Fig. 63), and of Greek works, from the *Hera of Samos* in the

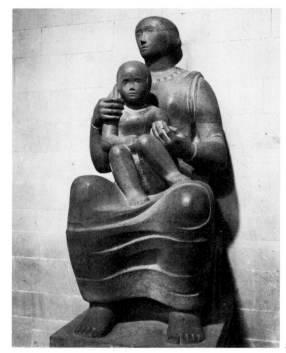

Fig. 60

Fig. 59: Seated Woman. 1961. Oak, 54 inches.

Fig. 60: Henry Moore. *Madonna and Child.* 1943–1944. Hornton stone, 59 inches. *Courtesy of Church of St. Matthew, Northampton, England.*

Overleaf: *Fig. 61, a, b, & c: Judith with the Head of Holofernes.* (Two views.) 1972. Bronze, 38¾ inches. Detail, *61a.*

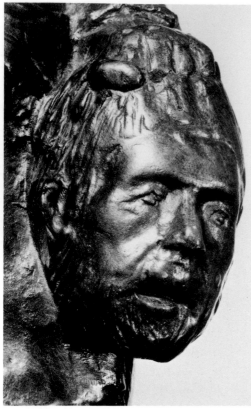

Fig. 61 a

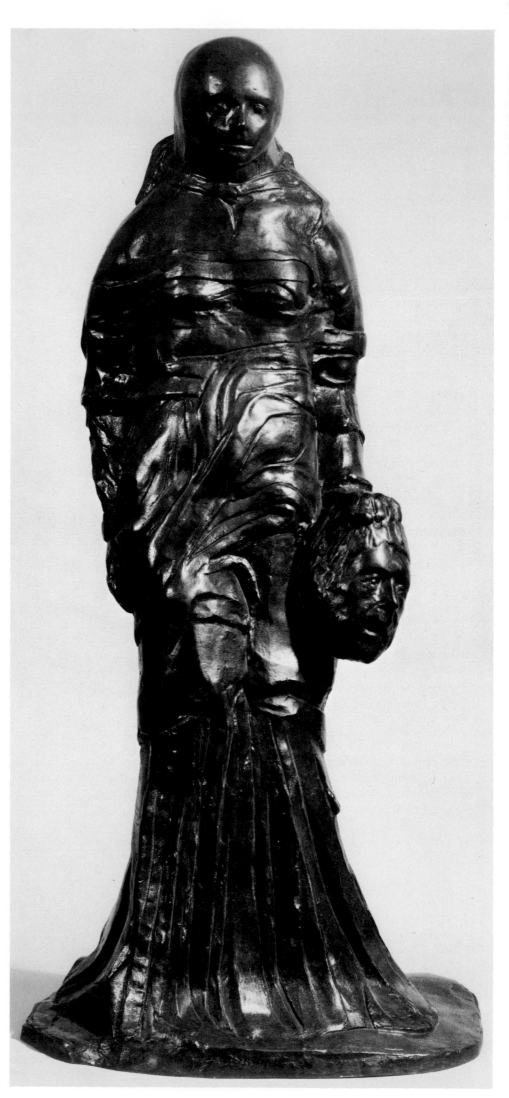

Fig. 61 b

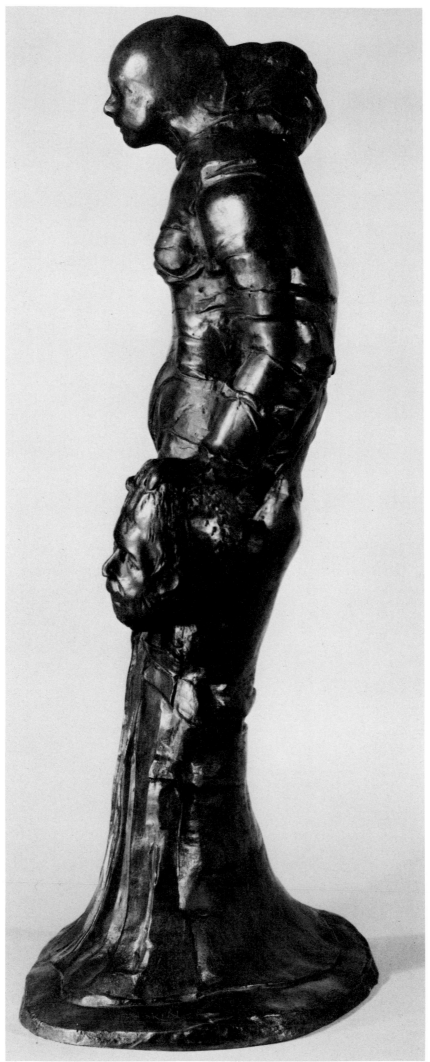

Fig. 61 c

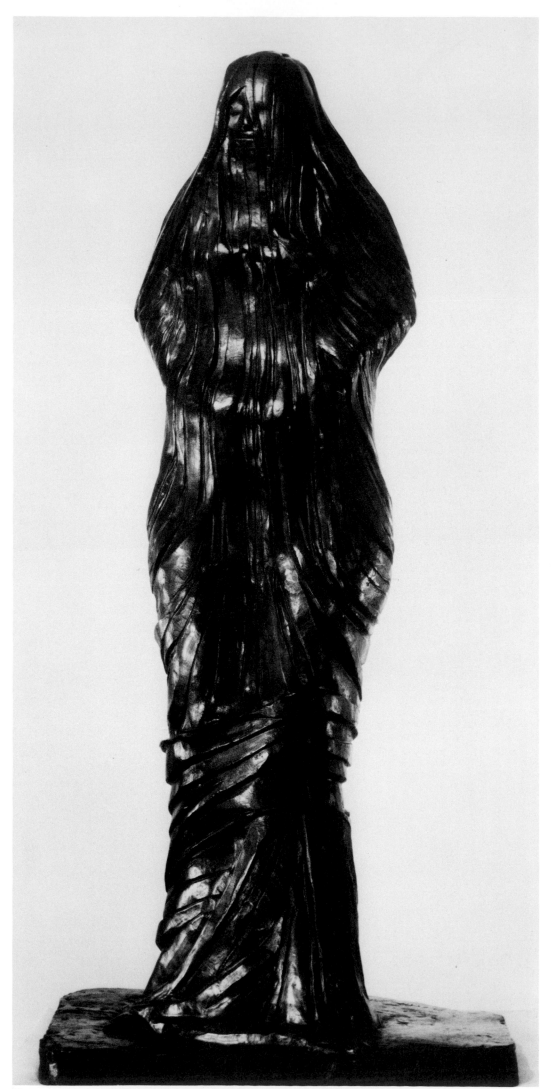

Fig. 62 a

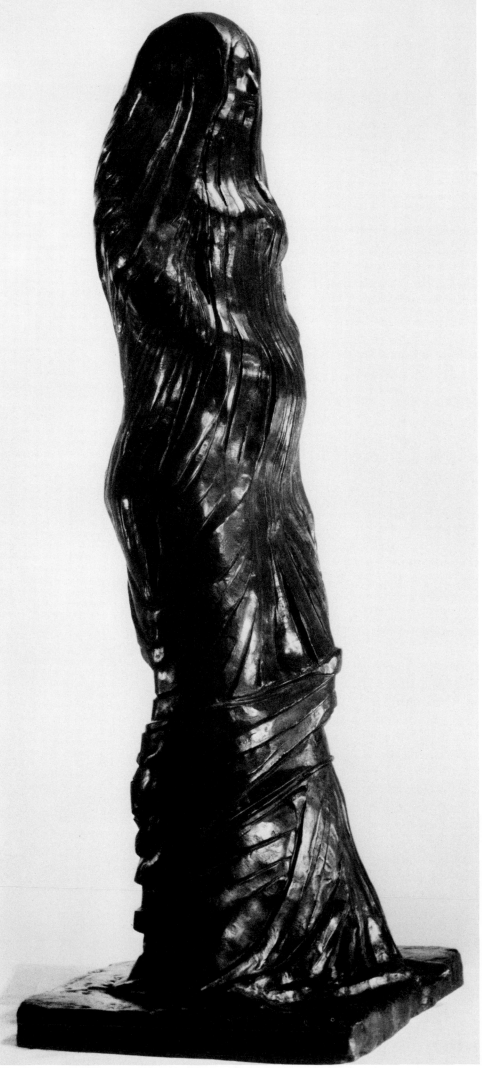

Fig. 62 b

Fig. 62, a & b: Andromache. (Two
views.) 1971. Bronze, 38 inches.

Louvre, to which Baskin returned again and again, through the many draped *korai* of the sixth and fifth centuries. Particularly suggestive, because contemporary with Euripides, whose play was probably the immediate inspiration for *Andromache*, are the late-fifth-century Greek female figures with ribbon-like drapery over fully revealed forms. Considering the impact on Baskin of the Isenheim altarpiece, it seems likely that Grünewald's Magdalen, with her cascading hair streaming into the swirling pleats of her long flowing garment, has also entered into Baskin's conception of the captive Trojan woman, as well as countless Romanesque carvings he had seen, with their heavy, pleated drapery. But additional sources, literary ones, are also suggested for *Andromache's* extraordinary imagery. In 1969 Baskin illustrated a new edition of Dante's *Divine Comedy*, which was surely the source for his figure of *Fortuna* (Fig. 64), and in this translation by Thomas Bergin we find the enigmatic lines, "O you who healthy intellect possess, / Consider well the doctrine here concealed / Under the pregnant veiling of my verse," a vivid image that may well be reflected in *Andromache's* "pregnant veiling."[24] In a poem by Rainer Maria Rilke the poet describes Eurydice walking beside Hermes, "her paces narrowed by long fluttering shrouds / Uncertain, gentle, and without impatience / She was within-herself like women pregnant. . . . / She was already down like streaming hair. . . ." The translation of this poem by Lisa Davis quoted here appeared in *Tri-Quarterly* in 1966, in the same issue that carried drawings by Baskin.

Two mourning figures were finished in 1971, *Prophet* (*Homage to Rico Lebrun*), and *Mourning Woman*, which had originally been designed as a fifteen-foot monument for Mount Greylock in Massachusetts (Fig. 65). In the mid-nineteenth century a five-story steel structure was erected atop the mountain, the highest point in the state, as a scenic lookout point. In the 1930s this structure was replaced by a granite-faced concrete Veterans Memorial Tower, but in 1960 this tower was found to be in poor condition due to weathering. The Boston architectural firm of Perry, Dean, Hepburn, and Stewart was commissioned to redesign the monument, and eventually decided that the marble base could be saved. After years of delay because of funding problems, the firm finally commissioned Baskin in 1969 to make a sculpture for it. He designed a standing *Mourning Woman* as a symbol of the Massachusetts women whose fathers, sons, and husbands had died in American wars, but the local population of North Adams was antagonistic to the idea of demolishing their long-familiar tower landmark and campaigned vigorously for restoration of the original memorial monument. When a photograph of Baskin's tentative model was released in the press, a predictable storm of protest swept Berkshire

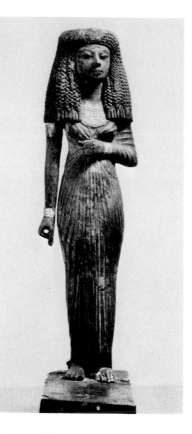

Fig. 63: Funerary Figure. Egyptian, New Kingdom, c. 1580–1090 B.C. Polychrome wood, 9¾ inches. *National Gallery of Art (Gulbenkian Collection), Washington, D.C.*

County and the project was halted. Eventually the restoration group won out. The completed *Mourning Woman*, while differing in some details from the Greylock design, is essentially the same composition as that planned for the mountain memorial. Less lyrical than *Andromache*, it suggests the stalwart nobility of the American pioneer woman and one is inclined to believe that it would have won the hearts of North Adams if given half a chance.

In May 1975 Rabbi Samuel Baskin died and that summer the artist modeled three seated figures representing mourning women. The largest is inscribed in Hebrew *Samuel the son of Benjamin in remembrance of a saint in blessing* (Fig. 66). Seated, leaning forward, with hands pressed to the breast like Barlach's mourning woman at Magdeburg (Fig. 58), and heavily wrapped, this figure of homage to his father suggests the eternal forward and backward rocking motion of a woman wailing in lamentation. "Call for the mourning women, / that they may come," God commands through the voice of Jeremiah. "And teach your daughters wailing, / And every one her neighbour lamentation: / For death is come up into our windows" (Jeremiah 9:17–20).

In view of Baskin's universalizing intentions, his somber awareness of our period's tragic history, and his passionate love for fine prints, perhaps we may also see in *Mourning Woman* Dürer's *Melancholia*, "the tearful and savage elegy of a whole century."[25]

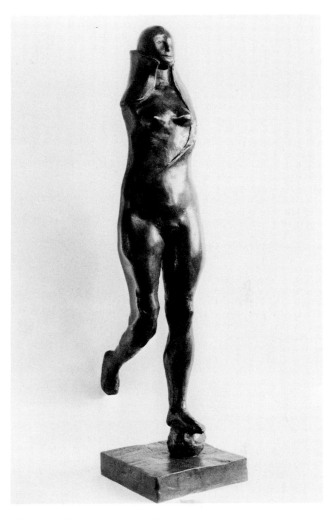

Fig. 64: Fortuna. 1971. Bronze, 29 inches.

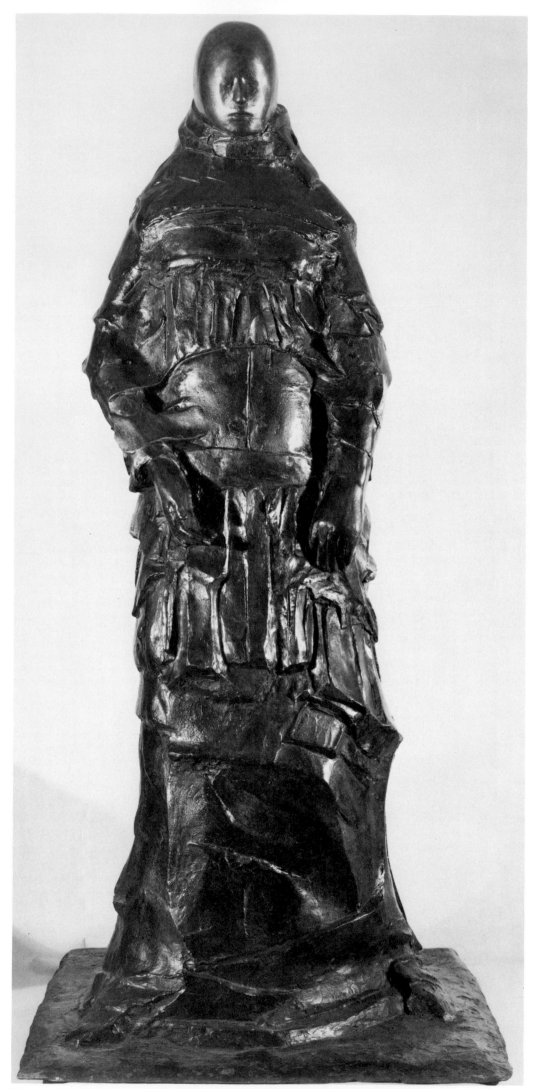

Fig. 65

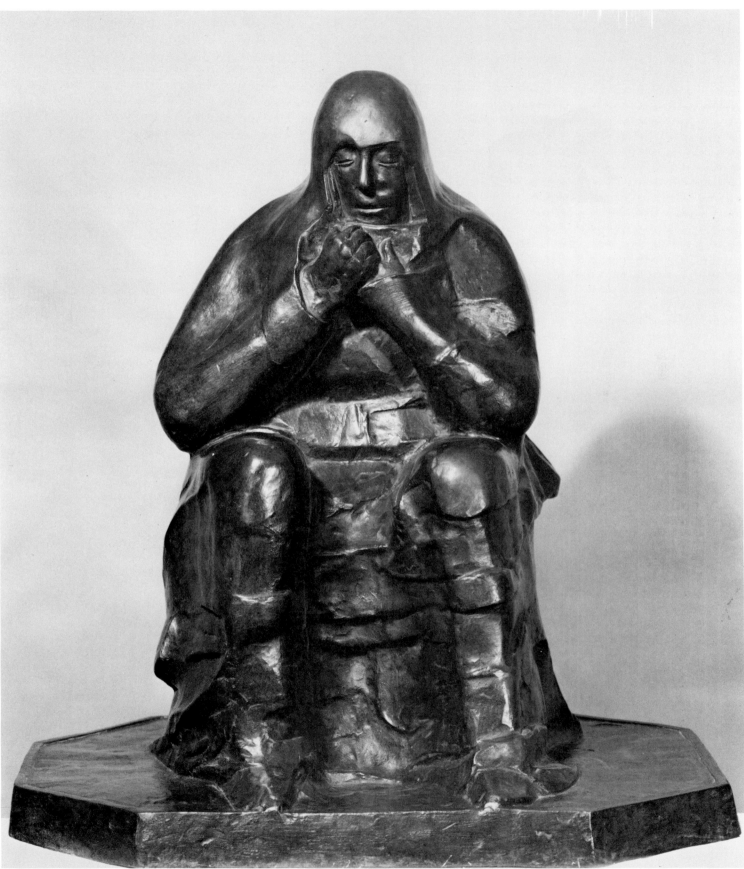

Fig. 66

Fig. 65: Mourning Woman (Standing). 1971. Bronze, 44 inches.

Fig. 66: Mourning Woman: In Memory of the Artist's Father. 1975. Bronze, 25½ inches.

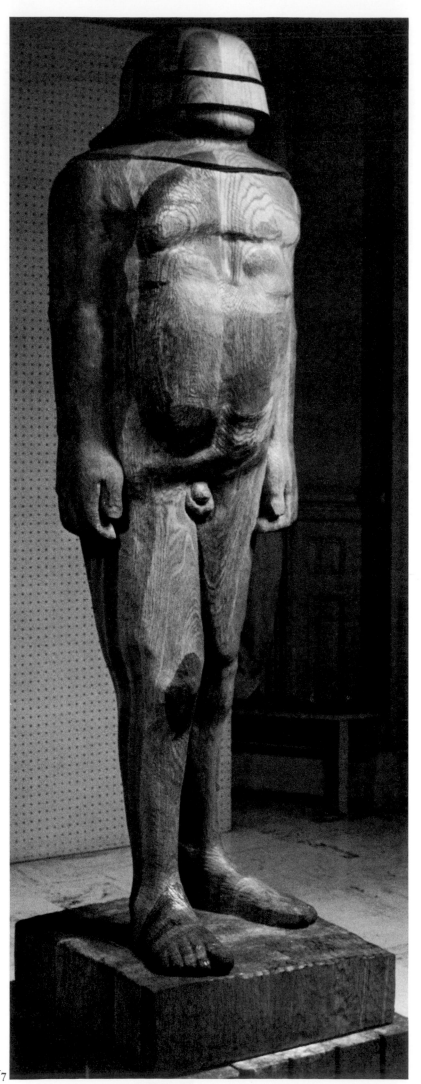

Fig. 67

FIGURES OF EVIL

The creative literature of this century has been thematically obsessed with evil, and poets and novelists alike have described and analyzed the psychology and anatomy of evil in its seemingly infinite forms. Relatively few modern painters and sculptors, on the other hand, have found in evil a major wellspring of inspiration, although it is an important part of the content of one of the most significant paintings of our century thus far—Picasso's *Guernica*—and occupies a central position in the painting of Francis Bacon and a number of German artists, among whom Max Beckmann is pre-eminent. In American painting, Ben Shahn's early *Passion of Sacco and Vanzetti* and his later paintings about the atomic bombing of Hiroshima are among the relatively rare examples of a major artist's thematic interest in evil, as are Rico Lebrun's paintings of Buchenwald; preoccupation with evil is also characteristic of that strange and often fine painter, Ivan Le Lorraine Albright. During the forties, in response to the war and the revelations of the German concentration camps, evil and generalized menace appeared as a more or less important theme in the semi-abstract imagery of a number of American sculptors, including David Smith, Herbert Ferber, Seymour Lipton, and Theodore Roszak, and in the fifties the artists of the so-called Chicago Monster School produced images of horror inspired at least partly by the Nazi terror. Among American sculptors, however, none has confronted the many guises of evil more consistently than Leonard Baskin.

Baskin's figures of evil are linked to his figures of dead men in two important ways. In both, the content is a thick interlacing of personal-transpersonal consciousness of guilt with affirmation: in the dead men, affirmation of life; in the figures of evil, affirmation of good. Baskin is not the kind of optimist who sees shadows in light; rather he is one who sees pinpoints of light in a dark world. Those pinpoints of light are the Olympic torches that are passed from human hand to human hand through the ages. "The human being is paramount. The blazing center is man," he asserts. Not for him is Spinoza's "hope for nothing in order to fear nothing." "Though I despise the corrupt and alien world around me, the tower I have built does have windows, does have a portcullis raised and

Fig. 67: Warrior. 1960. Walnut, 72 inches.

drawbridges permanently lowered. However debased, man, fixed in his splendid natural habiliments of nerves, and held upright by an extraordinary ivory, man is marvelous. Freed from the gesture and manner of his destructive and coercive society, man is glorious. . . ."[1]

Evil, Baskin holds in the tradition of Rousseau, is an aberration in humankind, a distortion of natural human goodness, and his images of evil are characterized by physical distortion that is most often expressed by a monstrous enlargement of natural form. Among his earliest figures of evil, the bronze *Poet Laureate* of 1956 (Fig. 32) and the wood version of the same subject carved in 1957 introduce this symbolic bloat. In the *Warrior* of 1960, however, the idea of evil is depicted by the armor-covered and therefore faceless, inhuman head (Fig. 67). A horizontal chink in the armor at eye level suggests sinister peering out, as if the observer is observed; the mouth is covered, non-communicating. But, as in *The Guardian*, the nakedness of the robot-like figure makes it appear vulnerable, for the armor both protects and imprisons the warrior. Similar in theme is the *Armored Man* that Baskin carved two years later (Fig. 68). Here the armored, mouthless head surmounts a behemoth of a man, a human tank. The misshapen, squat proportions make *Armored Man* almost more beast than man, but still he is man, "however debased . . . held upright by an extraordinary ivory."

Baskin consistently identifies himself with the universal human characteristics that he depicts, as we have already seen, for example, in the swollen pride of *Poet Laureate*. He chose for his Gehenna Press motto, "*Humani nil a me alienum puto* [Nothing human is alien to me]." Although *Armored Man* is surely meant to express modern man's bestiality, and *Warrior* his faceless, anonymous inhumanity, even here we must read the artist's sculptural statement in an autobiographical context as well. While working on these figures, Baskin gave a lecture at the Yale School of Art and Architecture, later published in the *Atlantic Monthly* with the title "The Necessity for the Image." In this lecture, primarily an attack on Abstract Expressionism and formalism in general, Baskin characteristically envisions himself as embattled, and the lecture aims its thrust at avant-gardism, a term that Baskin takes literally—and appropriately—in its military sense. But on the battlefield as he describes it, the two camps, his and that of the enemy, tend to shift relative positions in a way that reveals the dual view that the artist has of himself.

"An art of creating . . . is nothing less than a building of a bastion housed and armed with absolutist beliefs which are the artist's only weapons," he declares. Here "the artist" with whom Baskin identifies is the committed one who takes a stand, that is, builds a bastion. But the image changes. "If one accedes to the notion of an artist as an *armored creature* [my

Fig. 68: Armored Man. 1962. Birch, 29 inches.

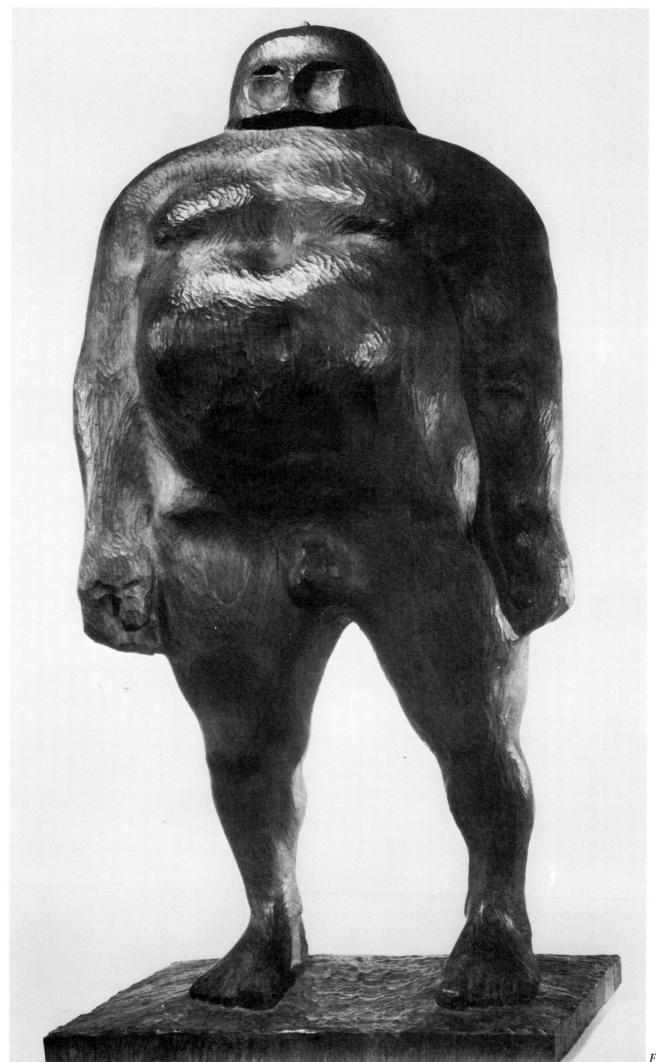

Fig. 68

italics] engaged in stylistic warfare, then one must . . . allow for some artists the role of guerrilla fighters in the struggle." Now Baskin becomes the "self-proclaimed member of a tiny guerrilla band" and it turns out that, like Samson against the Philistines, he must carry out "independent warfare on the larger camps locked in furious battle on 57th Street, Madison Avenue, 53rd Street, and elsewhere. . . . When I with brutal simplicity and aggressive childishness say that avant-garde art is simpleminded, I say it with my cannon and shield in preparation." Soon we find Baskin again behind walls, fighting "from my private charnel house, from my bastion, from my fort, wherein I stand to do battle."[2]

Baskin's imagery places both the enemy and himself by turns in the formidable bastion. Following this thought pattern, we see *Warrior* and *Armored Man* representing both the enemy and Baskin himself. This is not the first time, nor will it be the last, that we find a double meaning in a single image. Indeed, multiple and conflicting meanings in a work are characteristic of Baskin's art, and usually suggest the complex nature of humankind, and of the artist himself, who does not separate himself from the universals with which he deals. *Seated Man with Cloven Hoof* (1965; Fig. 69) is an even more explicit example of humankind's double nature, for here the large forms are not monstrous, and only the disproportionate right leg and its cloven hoof betray the satanic presence in an otherwise sympathetic interpretation of man. What must be emphasized about figures such as *Warrior* and *Armored Man* is that the autobiographical element is transpersonalized. They are not simply symbols of the stylistic warfare in which the artist was engaged. In "The Necessity for the Image" it is clear that Baskin's lofty view of art makes the art world an analogue of society, so that the breakdown of critical criteria, which he deplores as an inevitable consequence of non-objective art, is seen as a symptom of the general breakdown of values in modern life. The freedom and subjectivity of Abstract Expressionism are deprecated as licensed self-indulgence and caprice, and are linked with the widespread violence and irrationality of the twentieth century as expressed in the bombing of Hiroshima, in Buchenwald, and in the ubiquitous symptoms of erosion that threaten Western civilization. His entire attack was sparked by the modernist abandonment of human imagery, which he considers a desertion from the true tradition of art, nothing less than a breach of faith. His tone and his thought recall Jeremiah, whom God made a "fortified city." "My people hath changed its Glory / For that which doth not profit," God reproaches Israel through the voice of the prophet (Jeremiah 2:11). "I had planted thee a noble vine / Wholly a right seed; / How then art thou turned into the degenerate plant / Of a strange vine unto me?" (Jeremiah

Fig. 69: Seated Man with Cloven Hoof. 1965. Walnut, 23 inches.

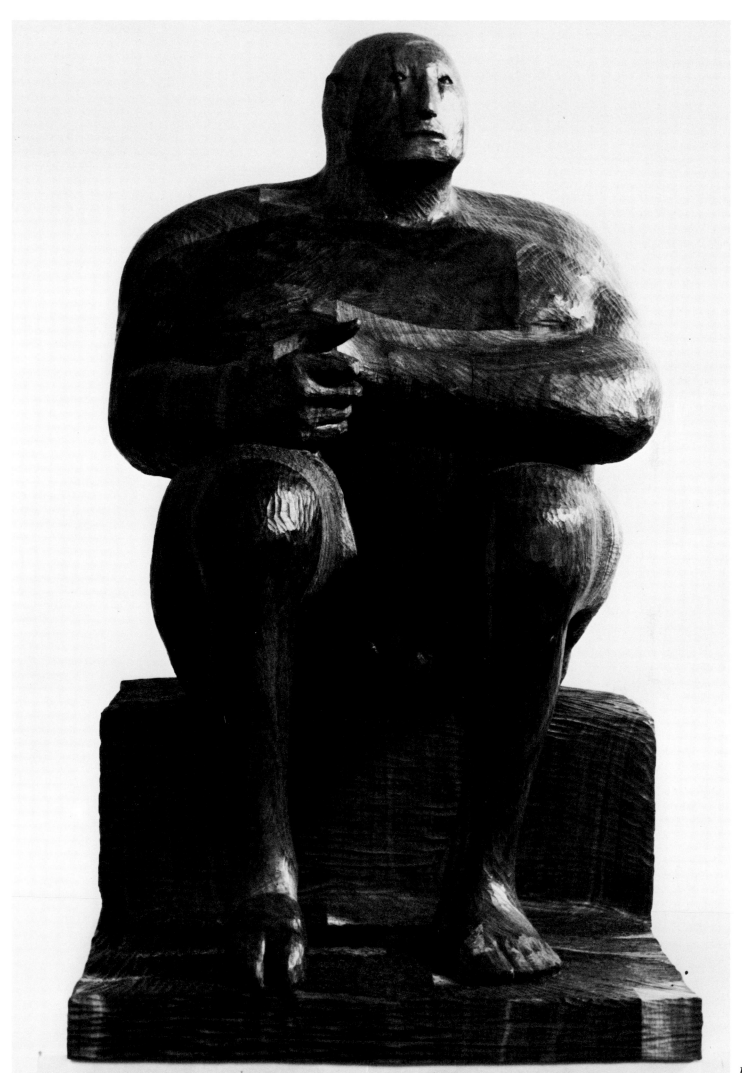

Fig. 69

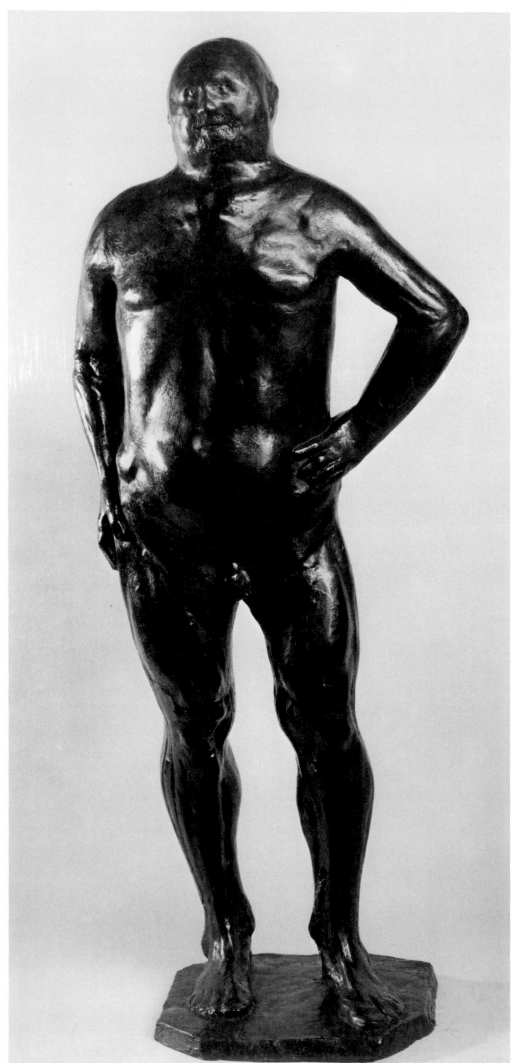

Fig. 70

Fig. 71 Fig. 72

2:21). Abstract art, for Baskin, was like the alien gods whom the prophets called vain and empty. He acknowledges in "The Necessity for the Image" the "absurd simplification, overstated commonplaces and bewildering partisanship" of his charges, but insists that he "must plead the artist's necessity for absolute prejudice, for a vocal and declared partisan attitude and this typically from a beleaguered point of view." His sense of himself as "beleaguered" in 1961 might strike us as odd, since, as we have seen, he was rapidly rising to an eminent position just at this time, when a Museum of Modern Art-sponsored exhibition was being readied for its European tour and when his works were being acquired by important public and private collections. Baskin, one believes, has the psychology of the confirmed dissident.

Although Baskin abandoned topical political content in his sculpture after the early fifties, it reemerges at least once more in his 1971 *Figure* (Fig. 70), a sculptural version of a figure type that appears in a group of drawings and prints of the mid-1960s that refer to the civil rights movement (Figs. 71 and 72). In *Laughing Sheriff* the remarkable rendering of the hand on hip with fingers spread like an eagle's claw, and the dreadful, obscene lumpishness of the flesh, speak eloquently of sheer brutality; the head brings to mind the work of the contemporary sculptor Elizabeth Frink. Frink

Fig. 70: Figure. 1971. Bronze, 39 inches.

Fig. 71: Laughing Sheriff. 1967. Ink, 39½ x 26¾ inches. *Smithsonian Institution.*

Fig. 72: Leader of the White People. 1967. Ink, 40 x 26 inches. Unlocated.

and Baskin share a number of characteristics that surface particularly in their bird and birdman imagery. This seems not to be a matter of any influence either way but, as W. J. Strahan points out, a common response of these artists, and others, to the malaise of the post-war period and the tragedies of the concentration camps, a response frequently expressed in such motifs as claws, spikes, and hooked beaks.[3] The bronze *Figure* is less menacing than its graphic precedents, for its proportions, retaining traces of former youthfulness and grace, give it a pathos far removed from the bullying expression of *Laughing Sheriff, Leader of the White People*, and others of this group of graphic works.

The imagery of evil frequently occurs in Baskin's work not in human form but in figures of animals and birds. Ugly dogs—ugliness symbolizing evil—appeared first in a series of wood engravings that Baskin's Gehenna Press published in book form in 1952, and provide the motif for a number of bronze reliefs beginning about 1958 (Figs. 73, 74, 75). One recalls Francis Bacon's famous *Dog*, painted in 1952, the same year Baskin began his ugly-dog wood engravings. The resemblance, however, is a coincidence arising from similar interests, for Bacon's painting was not exhibited in the United States until 1955. Baskin's work—his graphics more than his sculpture—often reminds one of Bacon's imagery of horror, and he recognizes in Bacon's art an affinity with his own.

Although dogs in art have most often been symbols of fidelity, Baskin's attitude with regard to the canine world, as with much else, was early shaped by the Talmud. "I have a Talmudic aversion to dogs," he told a reporter for *Life*. "The Talmud, you know, says that food is food until a dog refuses it. Curious we say dogs are our best friends and then use expressions like 'die like a dog' and 'you dirty dog' . . . they bite 500,000 persons a year."[4]

Two Dogs (Fig. 73) is an image of evil not because the dogs are coupling but because they are two ugly, hyena-like beasts that will reproduce their own kind. The most grotesque of Baskin's dog monsters is the sardonically entitled, chilling *Love Me Love My Dog* (Fig. 74), a relief in which the animal is seen *schiacciato*, flattened in the manner of the Renaissance bronze reliefs that inspired Baskin to work in this medium. But unlike any Renaissance image, the dog is seen frontally, without perspective, so that the possibilities of *schiacciato*, instead of being exploited for their illusionistic effects as in fifteenth-century Italian reliefs, are quite brilliantly distorted, reinvented, for expressionistic effects. This demonic beast confronts us with his huge maw open, vomiting in our faces. The Talmudic ugliness of the dog is related in Baskin's mind, apparently, to the Talmud's proscription against the eating of pork because of the pig's filthy habits, for Baskin derived the idea for this work from an old English verse:

Fig. 73: Two Dogs. 1958. Bronze relief, 5 ½ x 7 ½ inches.

Fig. 73

Fig. 74: Love Me Love My Dog. 1958. Bronze relief, 6½ x 8 inches.

Porcus, that foule unsociable Hogge
Grunts me out this still: Loue me, loue my dog
And reason is there why we should so doe
Since that his dog's the loulier of the two.

Baskin quotes this verse in "Of Roots and Veins," in a context that makes clear that the dog is a metaphor for the menacing quality of life in modern society. "I do not mean to assume the canker-wormed mien of a half-baked Jeremiah," he writes, well aware of the archaic, jeremiad cadences of thought and phrasing in his speech, "intoning the impending doom of a parched Sodom. But as I walk through my homogenized ambience I cannot but feel isolated and brutally thrust away from what should be my nurture and my increase. Everywhere I see the exploited disbelieving their exploitation, the debauched innocent of their debauchment. The slick talismans are *caveat emptor*, *laissez-faire*, and *status quo;* nowhere do I see carved '*cave canem.*' "[5]

Baskin's images of evil are not always of perpetrators; sometimes they represent victims, and characteristically the perpetrator and victim are often merged in an ambiguous image. Birds—the owl, the crow, and the eagle—have been favored vehicles in his sculpture and graphics for expressing his thoughts about viciousness and its victims. "Birds of prey flutter ominously through my *oeuvre*," Baskin writes. "These predacious creatures symbolize their human counterparts. They exist as allegory, metaphor, and symbol, acting mimetic roles in the broadest sense. [Their] essential meaning in my work is as raptors, carrion devourers, and as swift and startling bolts of death. The owl is perhaps the most complex and mysterious. He kills in hallucinatory silence, and ambiguously symbolizes wisdom and tyranny."[6]

The earliest appearance of the owl, however, a relief of 1960 (Fig. 76), is not particularly evil looking. The bird is rendered with superbly accurate draftsmanship, in profile with its head turned frontally, symmetrically balanced on the central axis of its legs, the claws spread to look like the stable base of a tripod. The two-dimensional ground is stressed by the horizontal baseline so that the relief comes forward out of the plane and yet is caught and held in its surface—a virtuoso piece of designing as well as craftsmanship. But in 1960 Baskin carved a free-standing owl, from which a bronze cast was made the following year, and here indeed is quite a different bird (Fig. 77).

Looking like a great weathered rock shaped by wind and water, the nuanced form of the owl is realized through containing contours. The beady-eyed bird head emerges from a tightly controlled pattern of short, horizontally directed bib feathers rendered like sharp staccato spikes that stab light. The wing and body feathers are worked in a design of gen-

Fig. 75

Fig. 75: Reclining Dog. 1961. Bronze relief, 10½ x 5¾ inches.

Fig. 76: Owl. 1958. Bronze relief, 8 x 10½ inches.

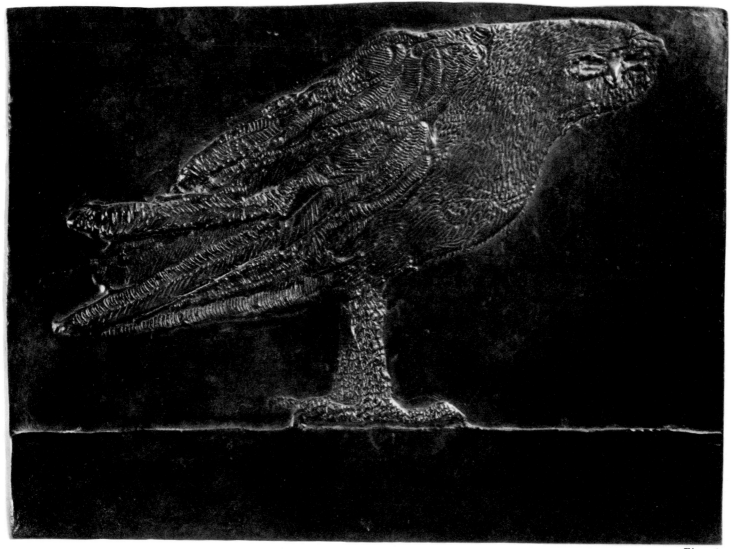

Fig. 76

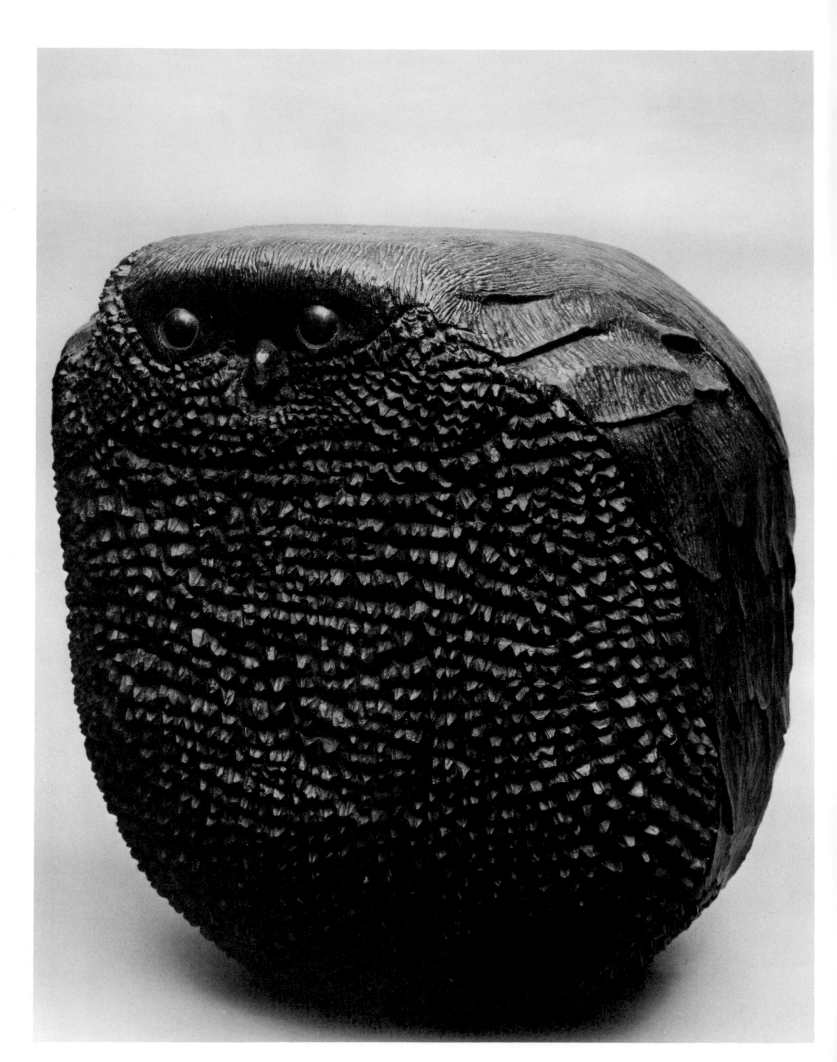

Fig. 77: Owl. 1960. Bronze, 20½ inches.

erally vertical parallel rows that creates a different, more sweeping light pattern. As one slowly absorbs the monolithic form, it appears to metamorphose into a human head, and moving around to the back, one sees the flattened shape of the tail become a human though featureless face, with the long feathers trailing over absent eyes. The idea of seeing and not seeing, of wisdom and blindness, is fused in this strangely shifting image of a bird that seems hauntingly human.

Owl lore is enormous and goes back to the literature of Egypt, the ancient Near East, and the Bible, terrain that has such a special hold on Baskin's artistic imagination. Although this bird is often linked with wisdom—the owl is an attribute of Athena, the goddess of wisdom—in the Middle Ages, as Baskin himself has pointed out, it appears as an evil symbol of the Jew because of its nocturnal character. "It went this way," Baskin explains. "Light equalled truth equalled Christ. Darkness, on the other hand, meant falsehood, or the Jews. The owl was the bird of night, of darkness, therefore the symbol of the Jew . . . symbolic of tyranny and black magic, of necromancy" (Fig. 78).

In Mesopotamian myth a winged goddess with feathered legs and talons, a bringer of death, is said to take the form of an owl seen moving soundlessly at night. She is thought to be linked with Lilith, who is mentioned in an early fragment of the Gilgamesh Epic as having built her house in the middle of a hollow tree, as owls do. On a Mesopotamian relief made between 2025 and 1763 B.C., the goddess is represented with her attributes, including an owl in each lower corner (Fig. 79). What is especially suggestive is the link between the sinister Mesopotamian owl-goddess and the frightful creature referred to in Isaiah (34:14), called in various translations "the screech owl," "the night-monster," or "Lilith." According to *The Jerome Biblical Commentary*, "The owl along with the raven was a symbol of desolation. . . . The 'lilith' is a female demon whose haunt was desert places. The name comes from the Sumerian lil, meaning 'wind' or 'spirit.' She is known as lilieu in Akkadian . . . she turns up later in rabbinical lore as the female who deceived Adam." Owls appear repeatedly in the Old Testament, always in an ugly or menacing context. They were considered unfit to eat, and dreadful to hear, fearful creatures because they lived in caves, tombs, and other dark places.[8]

As we have seen, Baskin is well aware of the sinister character traditionally associated with owls; that his personal obsession with their predatory nature is rooted in his early Old Testament education is probably not so conscious. He has represented them, however, in their Old Testament guise as symbols of torment, destruction, and spiritual desolation in innumerable drawings and in the wood carving *Oppressed*

Fig. 78: The Jewish Owl Pecked at by Christian Birds. French, fifteenth century. Wood. *Les Andelys, Church of Notre-Dame.*

Fig. 79: A Goddess ("Lilith"?). Mesopotamian, 2025–1763 B.C. Terracotta relief, 20 inches. *Collection of Col. Norman Colville.*

Man (Fig. 80). It is impossible to avoid the impression that owls, like some of the human figures we have already considered and many others that will be discussed, not only symbolize human counterparts in a generalized way, as Baskin acknowledges, but also refer to the artist on several levels of meaning. In *Oppressed Man* the owl very probably symbolizes Baskin's own sense of oppression, a feeling that he frequently expresses verbally. But in *Owl* (Fig. 77) Baskin seems to identify with the bird as a powerful predator, possibly seeing himself as destroying his lightweight, moth-like enemies. Such a reading seems justified on the basis of the bronze relief of 1967, *Wisdom Is Lasting, Instinct Fleeting* (Fig. 129), where the owl is surrounded by the night-flying creatures whose wings it will tear off, as did the owl Baskin watched from his window one night for two obsessed, fascinating hours. "Owls obsess me. They're predators, always in control and always mysterious. Late one midsummer night I watched one for two hours. He was after the thousands of moths who were drawn by the light to my window. He grabbed at them with his claws, never missing one, and their wings fell off all over his breast. He was beady-eyed and, in a horrible way, marvelous."[9]

As a bird of evil, the owl spreads itself through the space of the derisively titled *Homage to the Un-American Activities Committee* (Fig. 81). It fills the universe formerly occupied by a man, who now is seen to be about to sink from sight. Some of Baskin's friends probably did "disappear" as a result of persecution by HUAC, infamous child of the post–World War II "cold war."

Baskin casts the owl in one other evil role that we have already seen in a different guise; the swollen-headed image of bloated pride in *Poet Laureate* is given a new formal interpretation in *Caprice* (Fig. 82). Here the bird struts with its chest swelled into a smooth spherical bulge that contrasts with the ruffled and viciously sharp pointed tail feathers. One is reminded of some of Picasso's humanoid owls.[10]

As with the owl, the crow, too, associated as a raven with the owl in the Old Testament in connection with devastation, first appears in a relatively neutral role in a relief of 1958 (Fig. 83). In fact, the *Crow*, facing left, is like a companion piece to the *Owl*, which faces right, and both exhibit a jewel-like surface that results from the meticulous, accurate rendering of the feathers. The *Dead Crow* relief (Fig. 84) of 1961 presents an entirely different conception of relief sculpture, and of the motif as well, for here the crow is rendered impressionistically, with none of the detail of the earlier works, and with the emphasis shifted from description to expression. Like Schwartz the Jewbird in Bernard Malamud's unforgettable short story of the pogromized, humanoid crow-intruder, "The Jewbird," which Baskin had read, the crow lies on the ground, a bedraggled, unkempt

victim, dead of causes known and unknown. That the Jew-bird should come to mind is not surprising.[11] During an interview Baskin told me he thought of crows as "outcasts—not socially tasteful or acceptable. Maybe they are kind of a model for Blacks, Jews, Puerto Ricans, and everyone else who gets trapped in life. As a Jew, I have never had a bad experience, but I identify as a Jew, I feel very Jewish, very Yiddish particularly, and so I think those crows in some sense are an expression of that." When Alan Fern in his interesting introduction to the catalogue of Baskin's exhibition at the Smithsonian Institution in 1970 referred to the crow as an ignoble bird, Baskin noted in the margin, "Crows are hardly ignoble, which is why they interest me. Crows are bright, cunning, noisy, indefatigable, voracious, prodigal. The sort that would be excluded from a modern aviary, with eighteen hole golf course & official length swimming pool!!" The intruder Schwartz could hardly be better characterized. Visually even closer to Malamud's description of the dead Jewbird at the end of the story is the *Standing Crow* relief (Fig. 85), with its body grotesquely splayed and its dislocated head hanging from its broken neck:

> "Who did it to you, Mr. Schwartz?" Maurie wept.
> "Anti-Semeets," Edie said later.

Baskin's *Dead Bird* of 1962 (Fig. 86), also a crow, is a free-standing version of this motif, with the bird's agony specifically stated by its torn legs and wings. The missing parts raise an interpretive problem of considerable interest, which in this instance we will have to approach by a somewhat circuitous route.

It was not until Rodin, as Albert Elsen points out, that partial figures—torsos, figural members, mutilated figures—began to play an important role in Western sculpture. In this century the practice of making figures with missing head or limbs has become a commonplace, closely linked with the development from naturalism to abstraction as interest in subject matter declined in favor of "pure sculpture."[12] Apart from this formal conception, partial figures can serve other ends: the incompleteness of a figure may invite more imaginative spectator participation; it may create a vividness of concentration on the figural part that now has a special focus as a result of the missing parts; it may stimulate historical associations with ancient ruins; it may suggest symbolic meanings such as emergence or decay. One has the impression that in much modern sculpture the partial figure has been used for formal purposes, although even within the work of a single artist one feels that various intentions were responsible for the use of fragmentation or mutilation in one figure as compared with another. In Gaston Lachaise's *Floating Figure*

Fig. 80

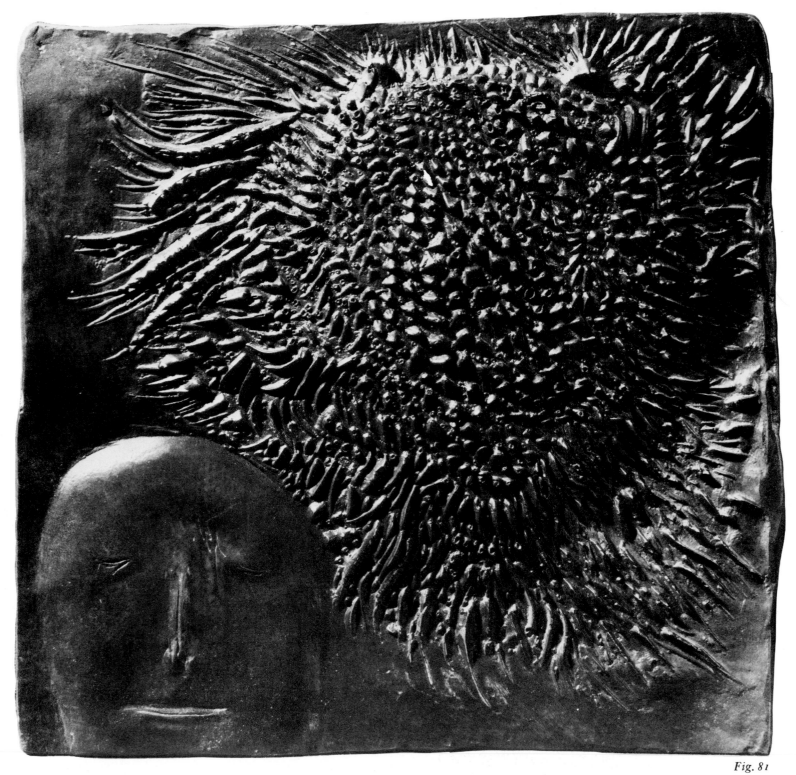

Fig. 81

Fig. 80: Oppressed Man. 1960. Pine, painted white, 31 inches.

Fig. 81: Homage to the Un-American Activities Committee. 1959. Bronze relief, 11½ x 12 inches.

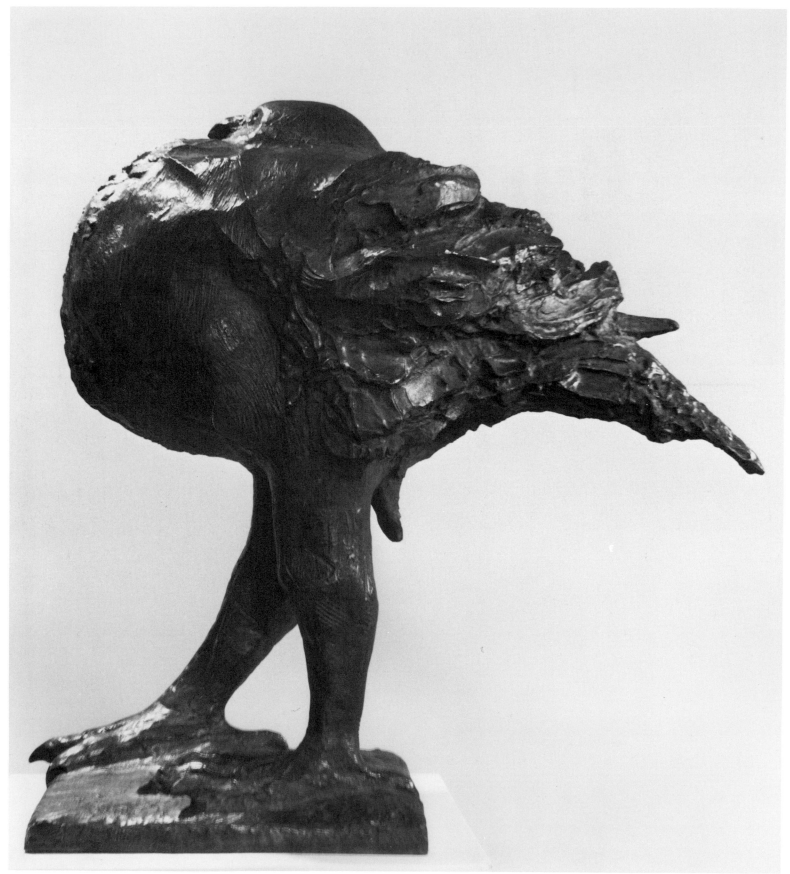

Fig. 82

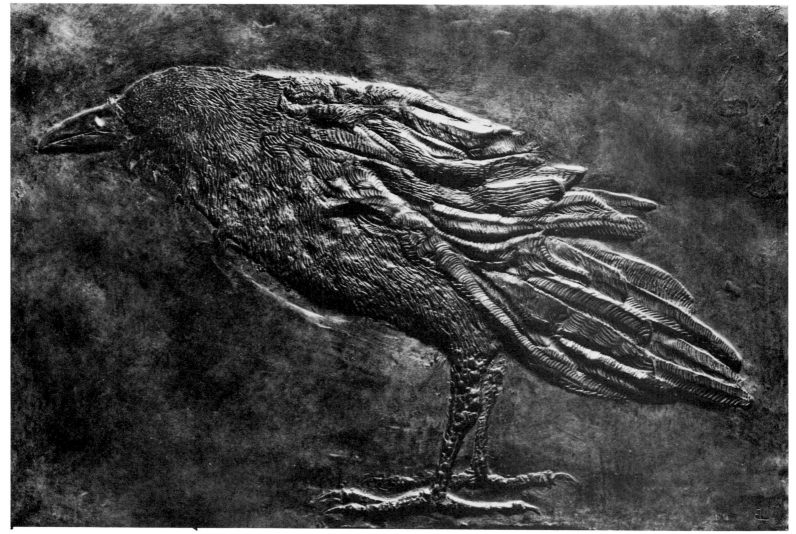

Fig. 83

Fig. 82: Caprice. 1963. Bronze, 25 inches (length).

Fig. 83: Crow. 1958. Bronze relief, 12 x 17¼ inches.

Fig. 84: Dead Crow (Horizontal Bird). 1961. Bronze relief, 19 x 40 inches.

of 1924 (Fig. 87), for example, with arms and legs partly cut off, we hardly notice the missing parts; the figure seems complete, and its mutilation carries no expressive associations with maiming or crippling. In his *Seated Torso* of 1928 (Fig. 88), while there is still no question of maimed dismemberment, the missing head, arms, and legs serve to focus attention on the expressive and explicit sexuality of the torso. Although the missing parts tend to remove the figure from the realm of realistic representation and thus aestheticize its sexuality, we nevertheless apprehend the figure not only as a piece of sculpture but also as a representation of a female body that our imagination is stimulated to complete. Among some artists, however, the mutilated figure does indeed suggest maiming, and often connotes psychological, social, or spiritual crippling, as in César Baldacchini's *Torso* (Fig. 89), a savage image that evokes associations with barbaric cruelty.

In Baskin's sculpture we may read some of the partial figures as formally complete, while others belong in a symbolic context. Those of the *Dead Men* that have missing limbs stimulate no association with extra-aesthetic ideas on account of the missing parts. But in the *Dead Bird* the mutilation does function symbolically. We cannot see this crow's cut-off wings as anything but *torn* off, with all that idea implies of violence and suffering. Such is the kind of reading I give to a major work of 1961, *Seated Birdman* (Fig. 90), the earliest appearance in Baskin's *oeuvre* of a hybrid figure.

The language of visual art, both formal and iconographic, is learned from previous art. The hand of the artist is an extension of his mind, as Matisse has said, and the mind of the modern artist is a vast storehouse of art collected from all over the world and from all periods of art history. Part of the aesthetic pleasure of looking at art derives from this fact, and the viewer who brings to a new work a richly cultivated memory of art has a fuller capacity for enjoyment than one who comes in ignorance. It must be said, however, that sometimes, unfortunately, a viewer's habits of looking at art produce expectations of what art *should* look like and stifle direct, unconceptualized response. The artist may presume—or hope for—a viewer's preparation and make quotations from earlier art, or he may make deliberate departures: in either case, the result for the sophisticated viewer is a heightened awareness of the quality of the language, an intensified response to it, and a deeper understanding of it. Baskin's hybrids make use of these powers of quotation.

Mythological creatures as symbolic images have populated much of art from the ancient Near East and Egypt, through the minotaur of Crete, the centaurs of Greece, to the strange combinations of animals and animal-men that in the Middle Ages so fascinated and exasperated St. Bernard of Clairvaux.

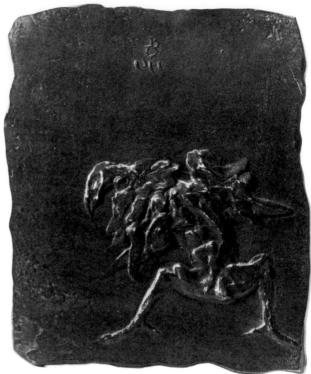

Fig. 85

Fig. 85: Standing Crow. 1961. Bronze relief, 7½ x 6¼ inches.

Fig. 86: Dead Bird (Large). 1962. Bronze, 24 inches (length).

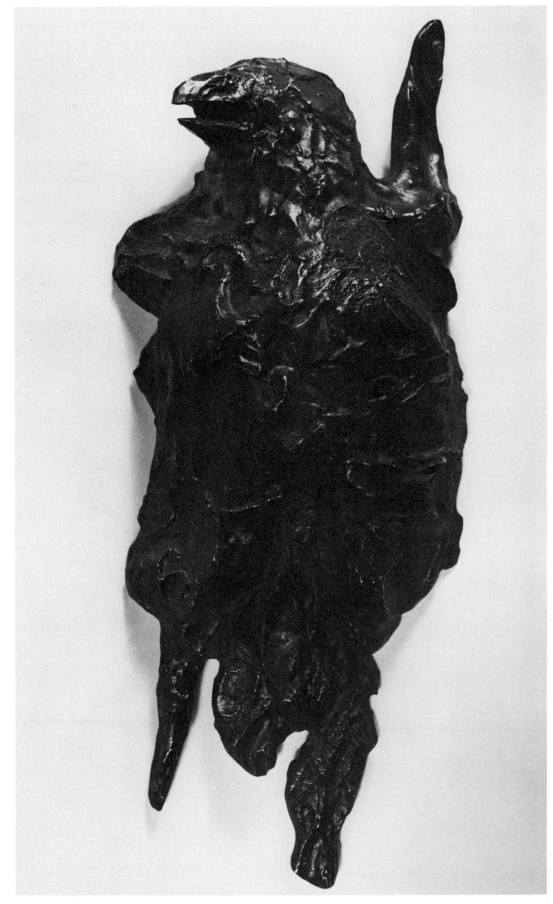

Fig. 86

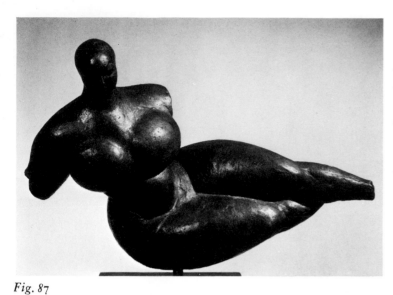

Fig. 87

Fig. 87: Gaston Lachaise. *Floating Figure.* 1924. Bronze, 17½ inches (length). *Collection of Fogg Art Museum, Harvard University; Gift of Lincoln Kirstein.*

Fig. 88: Gaston Lachaise. *Seated Torso.* 1928. Bronze, 9 inches. *Collection of Mrs. Culver Orswell.*

Fig. 89: César Baldacchini. *Torso.* 1954. Welded iron, 30½ inches. *Collection Museum of Modern Art.*

Fig. 88

Fig. 89

Fig. 90: Seated Birdman. 1961. Bronze, 35 inches.

Fig. 91: Henry Moore. *Warrior with Shield.* 1953–1954. Bronze, 62 inches. *Collection of Minneapolis Institute of Arts.*

Fig. 91

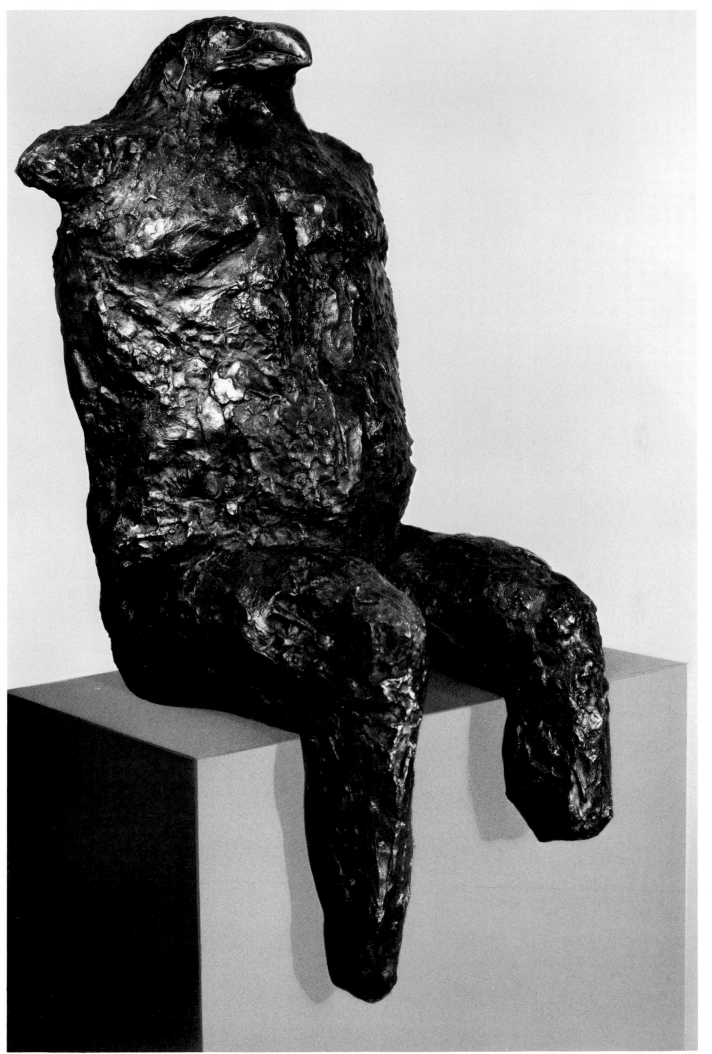

Fig. 90

To what purpose are these unclean apes, those fierce lions, those monstrous centaurs, those half-men . . . many bodies are there seen under one head, or again, many heads to a single body. Here is a four-footed beast with a serpent's tail; there a fish with a beast's head . . . In short, so many and so marvelous are the varieties of divers shapes on every hand that we are more tempted to read in the marble than in our books. . . .[13]

With the gradual triumph of naturalism that bloomed in the Renaissance, these unnatural monsters fell out of favor except for decorative use, and by the time of Goya the monstrous in humans was seen as integral to human nature, not as part of an epic dichotomy. The first important appearance of the hybrid as a symbolic image in modern times occurred in the Dada movement. Marcel Duchamp, Francis Picabia, and other Dada artists created anthropomorphic figures by mating the human with the new cult object, the machine; Ernest Trova's armless mechanomorphic hybrids of the 1960s, the *Falling Man* series, is rooted in this Dada vision. In the thirties Picasso responded to the psychologically oriented Surrealist movement and revived the minotaur as a metaphor for modern man's unconscious and ambiguous drives. Baskin has developed this tradition, taking up the hybrid image as an important and continuing motif for his work, using it to give three-dimensional form to the modern conception of the psyche as comprising the conscious and the unconscious, the rational and the emotional, the literal and the symbolic, the personal and the transpersonal.

Seated Birdman is a human torso with the head of a crow. In this image, according to the artist, he intended to call up those associations of the crow that link this bird with predatory habits. "Man is predacious. The crow is predacious. I meant to express total predaciousness," Baskin said. But we saw earlier that Baskin's art has multiple levels of meaning, and that as he creates his forms, he may be guided by his conscious intentions but often makes choices for reasons of which he is unaware. Thus a work may have an affect that the artist did not anticipate. Such, it appears, is the case with *Seated Birdman*.

Strangely, in view of Baskin's comment about *Seated Birdman*, the impetus for this figure came from Henry Moore's *The Warrior with Shield*, a partial figure that is widely acknowledged to express helplessness and piteousness (Fig. 91). Elsen remarks that Moore's *Warrior* "carries with it a pathetic connotation rare in Moore's work," and J. A. Schmoll connects this work with Rodin's *Voix Interieure* and an eighteenth-century wood statue that presents Peace as a female figure with both arms partly cut off. Schmoll sees in all three an expression of helplessness and passivity. Of the Rodin and Moore works he observes, *"Das Gemeinsame an*

Fig. 92: Birdman (Vertical). 1961.
Bronze relief, 21 x 12½ inches.

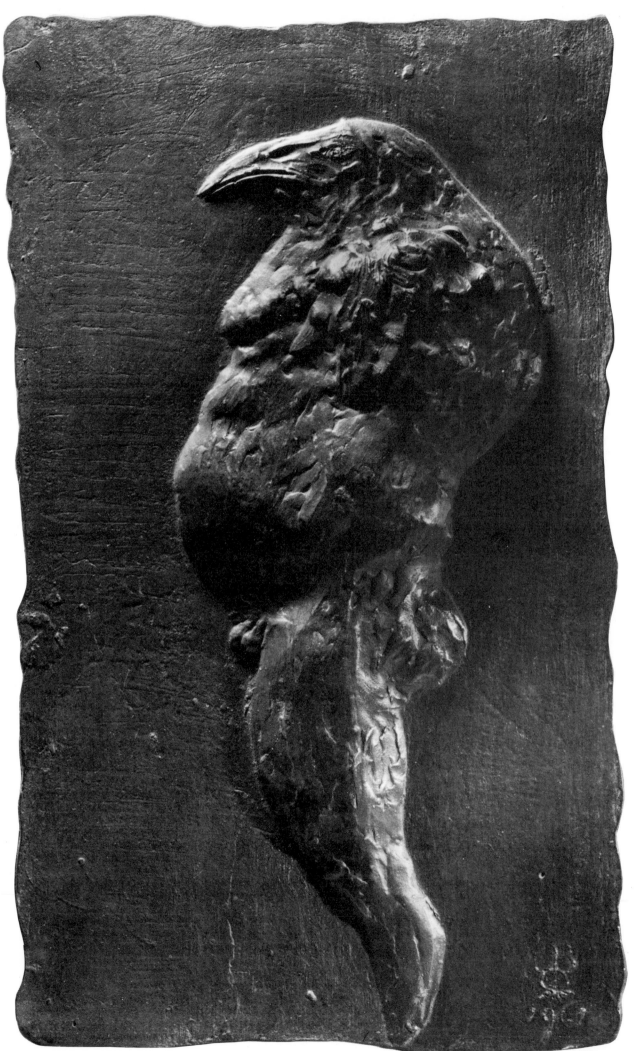

Fig. 92

Fig. 93

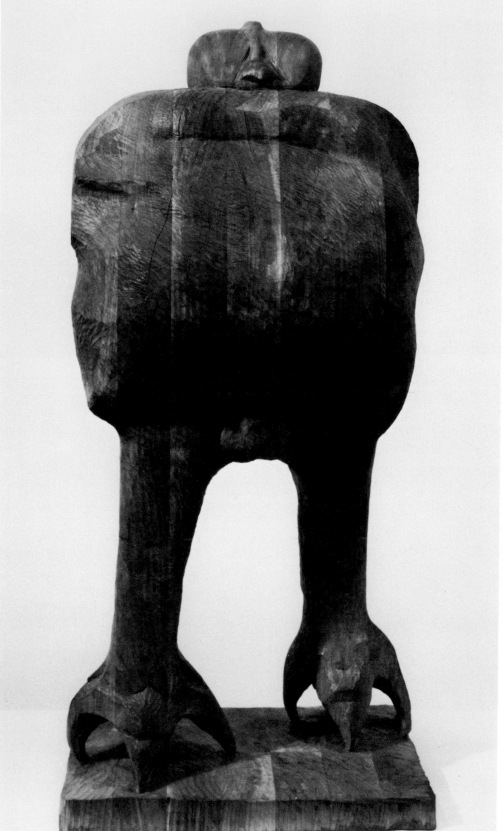

Fig. 93

Fig. 93: Hood (Hooded Figure). 1968. Wood, 27 inches.

Fig. 94 a

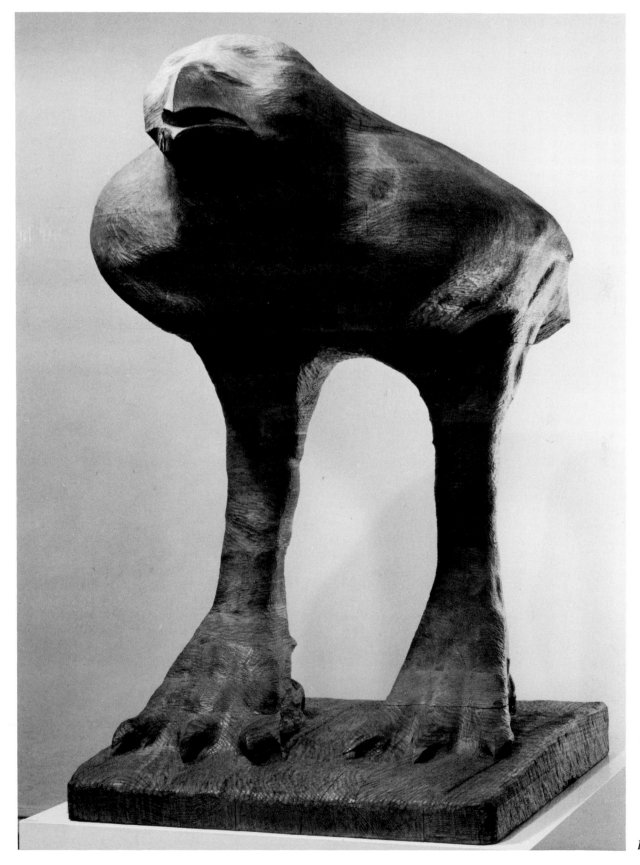

Fig. 94 a

Fig. 94, a & b: Apotheosis. (Two views.) 1963. Wood, 70 inches (length). *Fig. 94b,* overleaf.

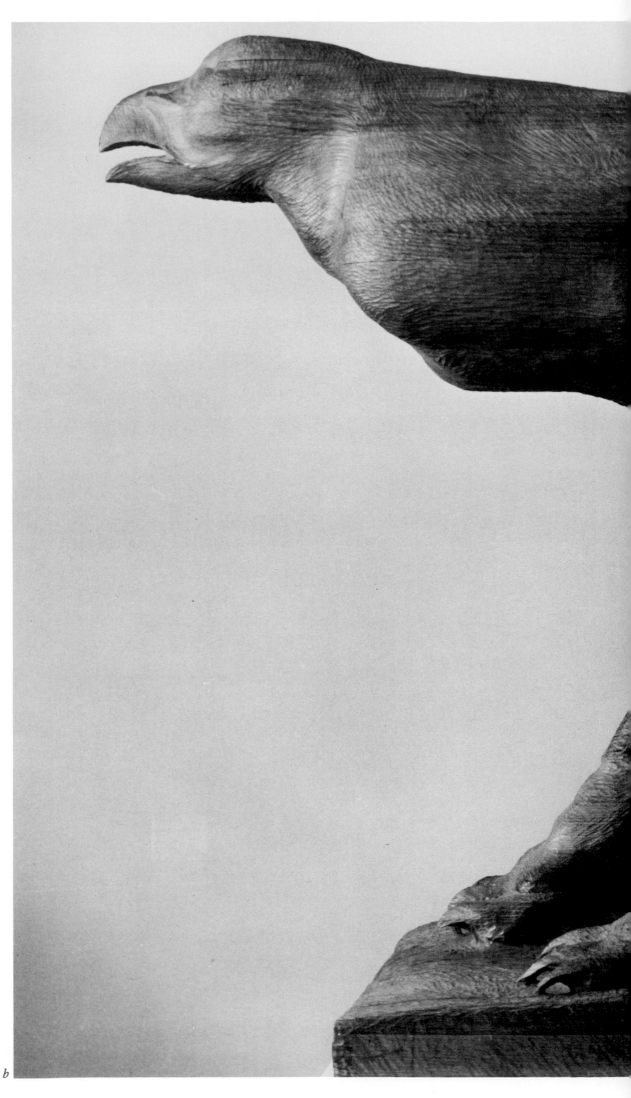

Fig. 94 b

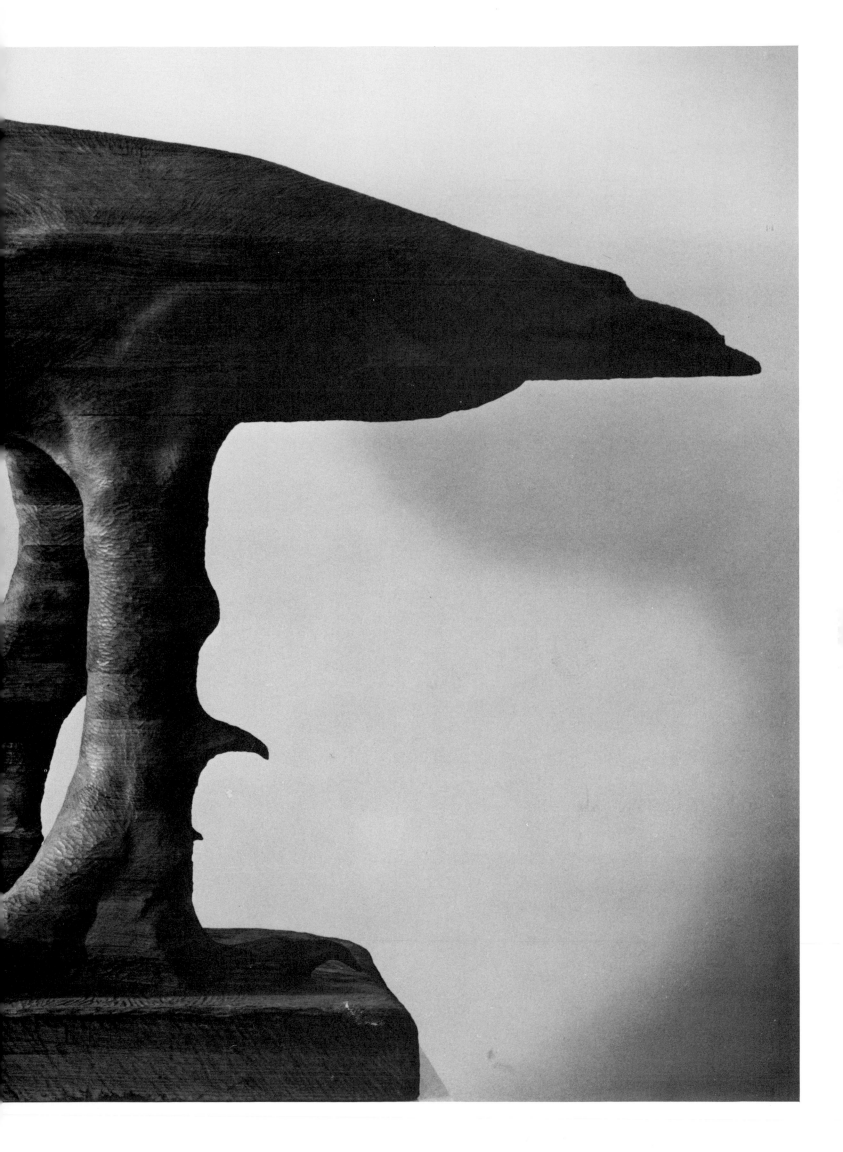

Fig. 95 a

Fig. 95, a & b: Idolatry (Four Way) (Two views.) 1971–1972. Wood, 24 inches.

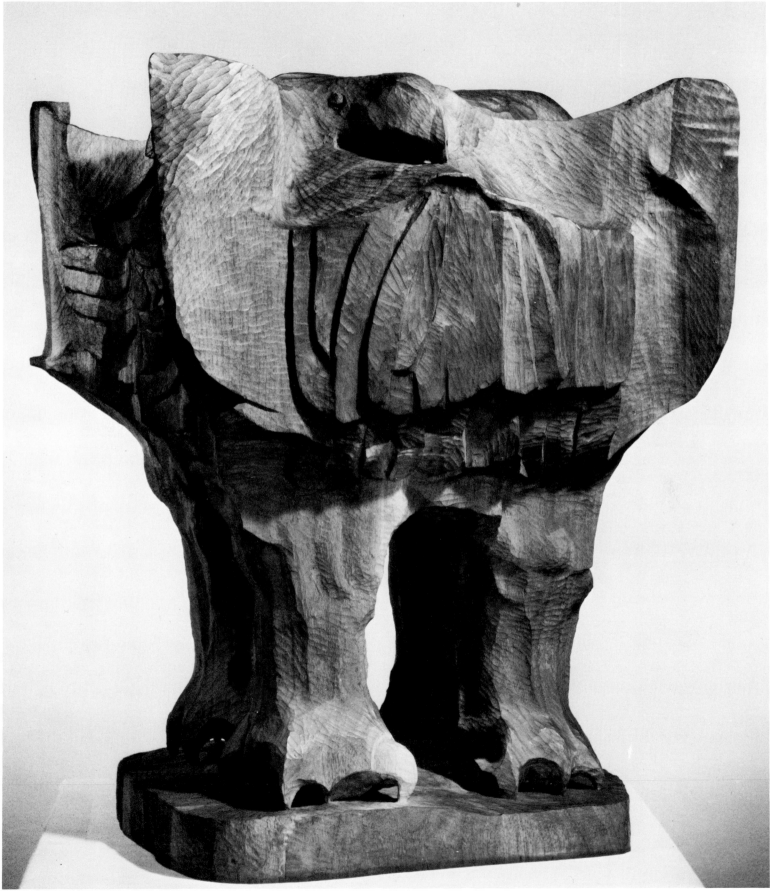

Fig. 95 b

diesen Gestaltungen ist die thematische Begründung der Torsoform [What links these forms is the shared thematics of the torso form]." Dr. Erich Neumann sees Moore's *Warrior* as "perhaps the strangest and most gruesomely tragic warrior that ever an artist created . . . he is the very symbol of mutilation. With his sound right arm he holds . . . in hopeless and despairing defense—a shield. . . . The head, which looks split, the cut mouth, present a picture of fear and defenselessness. . . ."[14]

The partial figure as a modern convention with purely formal meaning is surely irrelevant to the content of Moore's *Warrior*. Baskin, nevertheless, insists that mutilation per se is not to be read as symbolic maiming, and that the mutilation of his own *Seated Birdman*, based on Moore's *Warrior*, is nothing more than a convention. We must disagree. Despite its author's conception of the work, *Seated Birdman*, with legs cut off across the calves, armless (or wingless), is a tragic image of crippled power like the very work that inspired it. The monumental forms—a huge swelling rectangular volume for the torso, cylinders for the thighs and calves—like the earth geometry of Cézanne's formal intuitions, evoke sensations of immovable mass. But this is a Samson shorn of his power; a man without legs or a bird without wings. The mutilations cannot be seen as merely conventional, any more than they can be seen as such in Moore's *Warrior*. In both works, mutilation creates an affect that introduces extra-aesthetic expressive content.

Such an interpretation, running counter to the artist's expressed intention, again raises the problem of meaning in Baskin's art, indeed in the visual arts in general. It is true that the artist's intention must be carefully weighed; still, the critic must confront the artist, and the work of art, on equal ground and claim the right to independent insights. In doing so one must keep in mind the artist's entire *oeuvre* and search in it for those symptoms of coherence of which the artist himself may not be conscious. I have said this earlier, but I think it is worth repeating here, for emphasis. Coherence and consistency are powerful witnesses to authenticity, more powerful than any protestations of the artist or apodictic pretensions of the critic. And it is on the basis of a consistent ambiguity of meaning in Baskin's sculpture, an ambiguity that repeatedly compromises the notion of power, that one arrives at the meaning suggested here for *Seated Birdman*. Like Moore's *Warrior*, it is a figure that expresses tragic mutilation, and it has similar psychological implications.

During the sixties Baskin made a number of hybrid figures of crow-headed and sometimes winged humanoids. Among these is the fine and, for Baskin, relatively high relief *Birdman (Vertical)* (Fig. 92), which is, with its sharp-pointed beak and gross breast and belly more vicious than

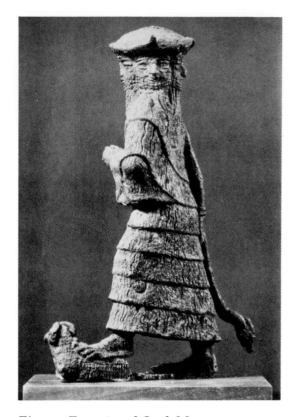

Fig. 96: Four-faced God. Mesopotamian, 2025–1763 B.C. Bronze, 7 inches.

the free-standing *Seated Birdman*. For sheer ugliness, the standing crow called *Hood* (Fig. 93) is the apogee of evil imagery that Baskin achieved with this motif.

As early as *Prometheus* Baskin had represented the eagle as an instrument of torture. In terms of pure power, *Apotheosis* (Fig. 94 a and b), a great carved eagle, is Baskin's greatest metaphor of evil. He associates it in what he calls his "evil ornithology" with the bird of Jupiter and the imperial eagle of Rome, "doubled-headed and barbarous," a symbol of imperial oppression. Baskin also knows that the eagle was the bird of glorification on whose wings the emperor was carried to heaven to become an immortal god, hence the title *Apotheosis*, signifying the ultimate glorification or achievement of power. The Old Testament eagle, too, is a symbol of perennial youthfulness and renewed vigor (Psalm 103:5 and Isaiah 40:31) and a bird of prey, identified with the vulture as a symbol of pitilessness (Habakkuk 1:8)[15] and linked with idolatry in Ezekiel's vision of God. Perhaps *Idolatry* (Fig. 95 a, b), with its four heads, owes its imagery to Ezekiel (1:5–11) as much as to ancient Near East sculptures such as the bronze figure of a four-faced god (Fig. 96).

The massive, generalized forms of *Apotheosis* are enclosed in sleek, streamlined contours that are broken only by the spiky spurs on the legs. These angry-looking, hooked protrusions reinforce the piercing pointedness of the open beak and sharp tail. The spurred legs rise like tree trunks out of huge root-like claws and support the body that is balanced on them symmetrically, its central axis grounded exactly along the front of the left leg. Formal stability and balance are thus combined with a sensually expressive motif to produce a "glorified" image of aggression—not aggression in action, but as a permanent and sinister constant in the human world.

HOMAGE

᪥

"*R*everence for the masters," Odilon Redon remarked in praising Rodolphe Bresdin, "is not a great fault." It is, I think, no fault at all in an artist who feels his own originality strongly enough. Baskin's distinctive style is the creation of a tough-fibered psyche that has nourished itself on the art of the past without being choked by it. If, as Delacroix said, mediocre artists borrow while great artists steal, then Baskin must stand accused of grand larceny. His reverence for the creative achievements of the past is expressed not in any specific copying or eclectic composing, but in the way he has appropriated that past for his own use. It is furthermore expressed with great originality in his splendid collection, and in his graphic and sculptural portraits of painters, sculptors, poets, and musicians, among whom none is closer to him in spirit than William Blake, "one of my great heroes," as Baskin calls him. It was in emulation of this artist and poet, we remember, that he taught himself the art of printing, and then wrote the poetry for his first book, *On a Pyre of Withered Roses*. He does not share Blake's religious fervor, but one meets in him nevertheless Blake's "apocalyptic point of view and prophetic manner of expression."[1] Both artists reveal a profound Biblical influence in their imagery. Blake's fervent celebration of man—Baskin's central theme—provides one of the mottoes in *Flosculi Sententiarum*, The Gehenna Press publication of moralizing mottoes ornamented with flower-shaped decorations that had formerly belonged to the famous printer Bruce Rogers.

> Thou art a man
> God is no more
> Thine own Humanity
> Learn to adore.

In 1959 The Gehenna Press published an edition of Blake's *Auguries of Innocence* with seven engravings illustrating the verses, and one engraved portrait of Blake.

The thinking of both Blake and Baskin is suffused with moral earnestness, and both represent in their respective times

Fig. 98

Fig. 97: Head of Blake. 1955. Bronze, 7 inches.

Fig. 98: James S. Deville. *Life Mask of William Blake.* 1823. *Courtesy of National Portrait Gallery, London.*

Fig. 99

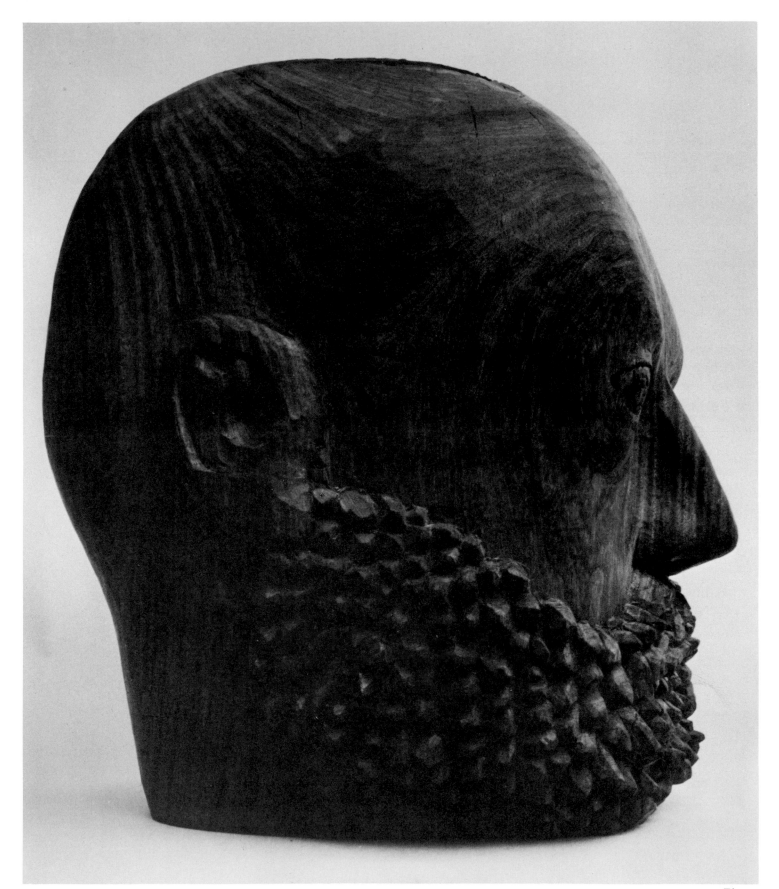

Fig. 99: Rodolphe Bresdin. 1954. Brazilian rosewood, 12¼ inches.

an adversary position based on moral grounds that challenges prevailing aesthetic doctrine. Blake's bitterness and sarcasm, expressed in his Gnomic Verses, in his slashing attacks on the art establishment represented by Sir Joshua Reynolds and his sense of being oppressed by it, find their echo in such writings by Baskin as his essay "On the Nature of Originality," in which Blake is twice quoted.

Much that I say will doubtless [sound] ill-considered, extreme, at times lunatic. . . . It is with the Abstract-Expressionists and Action painters . . . that I am concerned. . . . There is a frightening amount of pure nonsense about these works, the literature about them and the whole ludicrous camp following like so many brainless mackerel. . . . The subject of any given work of art is of no critical consequence. The content . . . is the consequential quotient. I am not fool enough to attempt an exposition of the miraculous workings of form and content . . . [a process whose] generative power and . . . perfect union occur in the human brain. "What immortal hand or eye could frame thy fearful symmetry." . . . Nothing any human being creates is devoid of content and this is true of [Abstract Expressionist and Action painters] as well . . . [but] can the newer painters be said to be original in the context as I have formulated it? . . . I charge that [they] are not original. . . . "Why then [we ask] this insistence on so inane and meaningless an art by the chief artists of our time?" The answers [to that question] would need to deal with . . . the process of man's dehumanization and alienation begun in the chaos of the Industrial Revolution, the "satanic mills" of William Blake, helped along by two titanic, destructive world wars. . . .[2]

Like Blake, Baskin is an intellectual artist whose intellectualizing sometimes brings out mannerist tendencies and who achieves some of his finest effects through the use of archaizing principles.

Several Gehenna Press publications are devoted to Blake and it was in 1955, while working on the wood engravings for *Blake and the Youthful Ancients*, a group of portraits of Blake and the artists in his admiring circle, that Baskin made his first of two sculptural portraits of the English artist. Based on the life mask taken in 1823 by James S. Deville (Fig. 98), a phrenologist, when Blake was in his sixty-sixth year, Baskin's bronze portrait of 1955 (Fig. 97) is extremely faithful to the original, emphasizing, as the mask does, those peculiar bulging forms of the forehead, the unusually deep convexity of the eyelids, and the deep slash of the downward-curving mouth that probably led Blake to joke about his "active physiognomy." It is said to have been Blake's jest that the shape of his forehead made him a republican—which, in his time, meant a revolutionary.[3]

Fig. 100

Fig. 101

Fig. 100: Rodolphe Bresdin. *The Comedy of Death*. Lithograph transferred from etching, 8⁹⁄₁₆ x 5¹³⁄₁₆ inches. *The Art Institute of Chicago, The Walter S. Brewster Collection.*

Fig. 101: Thomas Eakins. 1965. Woodcut, 30½ x 24 inches.

Baskin, as we have seen, grew up in the tradition of direct carving, a tradition in which truth to material was the first principle of aesthetic probity. Although he quite early rejected this doctrine, carving, particularly wood carving, continued to be his favorite means, and it was in wood that he carved the first of his tributes to admired artists, that of *Rodolphe Bresdin* (Fig. 99) taken from a daguerreotype. Baskin's sense of affinity with Bresdin is based in part on his admiration as a printmaker for the French artist's mastery of etching and lithography, but beyond artistry there are shared tendencies of sensibility that doubtless sharpen Bresdin's appeal for him. Bresdin's minute pen-scratched, densely concentrated landscapes often suggest an anguished human physiognomy, as in *The Comedy of Death* (Fig. 100), while many of Baskin's figures and faces, such as the *Thomas Eakins* woodcut (Fig. 101), are landscapes of emotion. Baskin and Bresdin meet in the tangled and often thorny spaces of spiritual pain.

Baskin's confrontation with ancient Near Eastern art in the British Museum and the Louvre had left a lasting impression, and he has handled his *Bresdin* with the characteristic Mesopotamian taste for contrasts of severe and decorated surfaces. In the so-called *Head of Hammurabi* (Fig. 102) the king's tight-fitting cap is like a smooth-skinned dome, while the beard is worked into an ornamental pattern of curls in relief. This persistent trait of ancient Near Eastern art is evident in the late Assyrian statue of Assurnasirpal II (Fig. 103), which Baskin had studied in the British Museum. In his portrait of Bresdin the curly beard not only provides a decorative contrast to the smooth cheeks and bald head, but borders the face with a rhythmic scalloped ornamentation reminiscent of the characteristic hairline and broadly arched eyebrows of Hammurabi and Assurnasirpal.* Like the ancient Near Eastern works, the portrait of Bresdin is carved with a fine sensitivity to the subtle undulations of the surface that testify to the bony structure beneath it, but unlike the ancient portraits, facial details are severely restricted; there are no eyebrows and the eyes are almost lidless. This head is carved in machaerium, a wood whose grain produces a decorative pattern, and which, for this reason, Baskin never again used: he feels that the seductive beauty of the surface competes with the forms. This is one reason why, as a mature artist, he has never been attracted to marble; its color and grain conflict with the wholeness of the image and thus with the basic aesthetic premise on which his art is formed.

Baskin's wood carving of Ernst Barlach (Fig. 104), one of several portraits he made of this artist, is a tribute in the deepest sense to a fellow sculptor. The superficial resem-

* See also the *Winged Genius* from the Citadel Gate, Khorsabad (Fig. 132).

Fig. 102

Fig. 103

Fig. 102: Head of a King (possibly Hammurabi). Babylonian, 1792–1750 B.C. Black granite, 6 inches. Collection of the Louvre.

Fig. 103: Assurnasirpal II. Assyrian, 883–859 B.C. Stone, 36 inches. Collection of the British Museum.

Fig. 104: Barlach Dead. 1959. Poplar, 18½ inches.

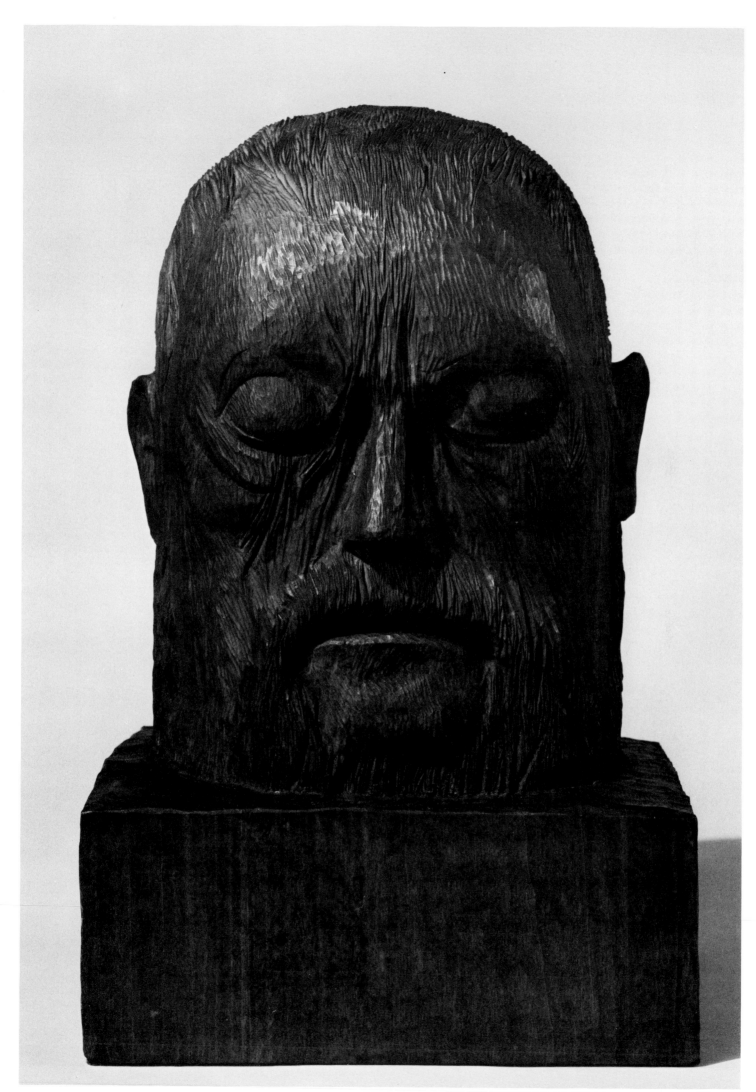

Fig. 104

blance to the German artist, based on photographs, is not strong but the image is infused with the spirit of Barlach's work. Baskin has said of Barlach that he was "one of the great artists of our time because he was concerned with elemental and basic human states, with man's suffering and endurance, with myth, with the future. He was able to integrate such diverse influences as the Gothic and Egyptian. He was able to state great abstract concepts with specificity." Clearly what Baskin saw in Barlach were the concerns and goals central to his own work. He has given to *Barlach Dead* the elemental force of the larger-than-life mythic hero, and the inward-looking power of an inspired seer. Much of the impact of this imposing head is achieved by its oddly squared-off, massive bulk, into the surface of which the artist has gouged wrinkles that "streak the face like tears."[4] Here the sculptor and graphic artist has perfectly fused sculpture and woodcut, one of the rare instances in his *oeuvre* where this is so, and one feels one could lift an impression from his face similar to *Jeremiah*, a woodcut of 1961 (Fig. 105).

Baskin's sculptural homage to Thomas Eakins is expressed in a carved free-standing full figure, a bronze relief, a commemorative medal designed for the Thomas Eakins Home Restoration fund, and in his collection of Eakins' sculpture, which includes three free-standing bronzes, studies for Eakins' painting of *William Rush Carving an Allegorical Figure of the Schuylkill*, and two reliefs, *Arcadia* and *An Arcadian*. Raphael Soyer recalls a visit to Baskin's house in connection with portraying Baskin, at Lloyd Goodrich's suggestion, in his group portrait, *Homage to Thomas Eakins*. "Baskin showed me his treasures: several paintings by Eakins; old photographs of him and photostats of photographs; a letter in Eakins' handwriting, carefully enclosed in transparent plastic; tiny brushes . . . a small wooden penholder whittled by Eakins himself. . . . All these objects he handled with reverence and tenderness."[5]

Unlike Barlach's work, which with its broad planes and bulky, austere forms has close links with his own, Eakins' sculpture has very little to do stylistically with that of Baskin, although both artists prefer power to grace. But the archaizing by means of which Baskin strives for monumentality is foreign to Eakins' primary interest in naturalism even when he is executing allegorical and classical subjects. It is interesting, however, that on a personal level, Baskin and Eakins share a similar position *vis-à-vis* their contemporaries. Baskin belongs with Eakins in the company of "dour and determined artists," as Hilton Kramer writes admiringly of Eakins in a review of the Whitney Museum's Eakins exhibition in 1977, "who, though undoubtedly touched by genius, are narrow and obsessive in their [aesthetic] interests, absolutely dogged in pursuing them, and unwavering in their indifference to alterna-

Fig. 105: Jeremiah. 1961. Woodcut, 29⅜ x 13⅛ inches.

tive modes of feeling or expression." By 1886, the year when Eakins the realist in full career resigned from the Philadelphia Academy because of the scandal raised by his removing the loincloth from a male model in the women's class, Impressionism had conquered French painting. With the symbolist, expressionist, and structuralist tendencies that developed out of Impressionism, French art came into full command of the direction of the modernist aesthetic. American artists, like European artists, went to Paris to absorb what they could from the radical innovations about which they had heard. Eakins' younger contemporaries Robert Henri and his fellow Philadelphia artists who became the nucleus of "The Eight" developed a style that John I. H. Baur has termed "dark impressionism,"[6] and Eakins lived to see the first movement of abstract art in America imported from the School of Paris. He remained untouched by any of this. His commitment to his kind of realism kept him utterly removed from modernist explorations that were leading to conclusions far distant from his strongest convictions. His achievement, like Baskin's, does indeed remind us, as Kramer remarks in the review cited above, that "great art is not always answerable to the laws of historical inevitability."

Thomas Eakins (Fig. 106) is a strangely disturbing figure. There is something abrasive in its aggressive ungainliness, and standing before it one feels intruded upon, more looked at than looking. In this, Baskin captures exactly that quality of Eakins' personality that inspired Walt Whitman's famous comment, "Eakins is not a painter, he is a force." Far from idealized, Eakins is nevertheless represented as a powerful, monumental figure charged with the energy that characterizes his own portraits. The forward-thrusting head and parted legs planted firmly yet apparently relaxed on the low base speak clearly of Eakins' uncompromising nature.

In the 1961 copper relief *Eakins* (Fig. 107) Baskin portrays the great American realist very differently, making him appear almost jovial, as he might have looked when pleased by a student's work. The portrait, with its notable contrast of smooth and irregular surfaces, is executed in the characteristic low relief that Baskin learned from his study of Quattrocento reliefs, a study originally inspired, he has said, by his admiration for Giacomo Manzù, by his collection of medals, and, above all, by his reading in 1958 of H. W. Janson's *Donatello*, to which he responded by modeling that same year several fine reliefs including his *Homage to Gustav Mahler* (Fig. 108). His pleasure in relief was further excited when in 1969 he saw an exhibition at the National Portrait Gallery (Washington) of portrait reliefs by Augustus Saint-Gaudens. Deeply moved by the delicacy and strength of Saint-Gaudens' work, Baskin immediately modeled his homage to this master in the form of a relief portrait (Fig. 109).

Overleaf: *Fig. 106: Thomas Eakins.* 1960. Maple, 27½ inches.

Page 157: *Fig. 107: Eakins.* 1961. Copper relief, 12¼ x 8½ inches.

Page 158: *Fig. 108: Homage to Gustav Mahler.* 1958. Bronze relief, 21 x 11 inches.

Page 159: *Fig. 109: Homage to Augustus Saint-Gaudens.* 1970. Bronze relief, 23½ x 14 inches.

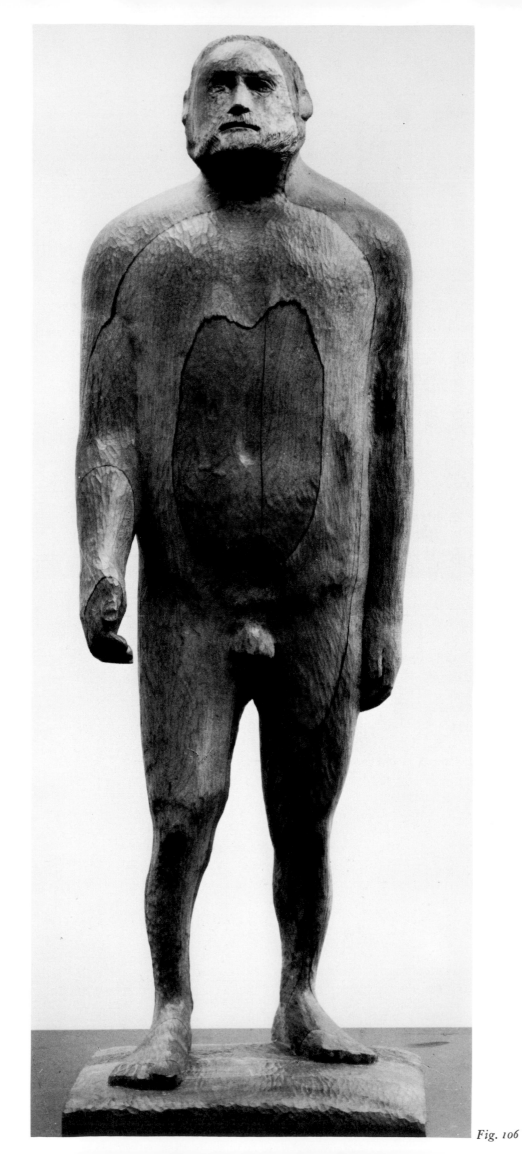

Fig. 106

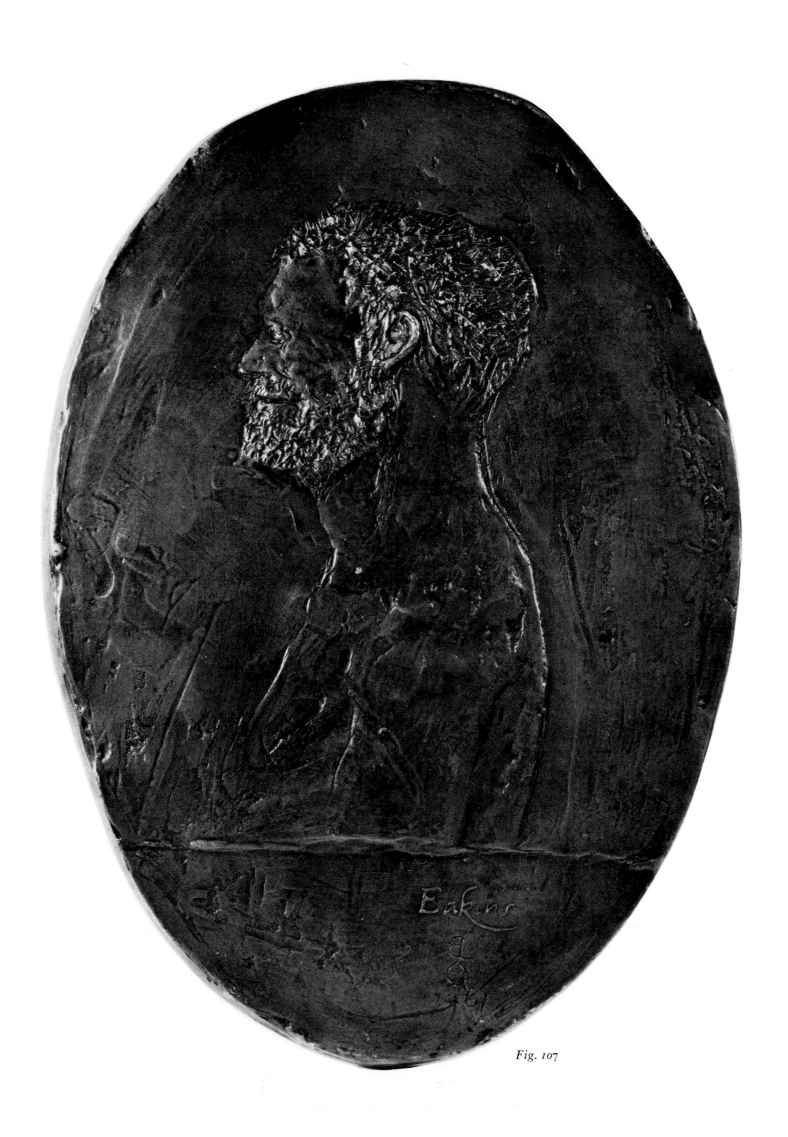

Fig. 107

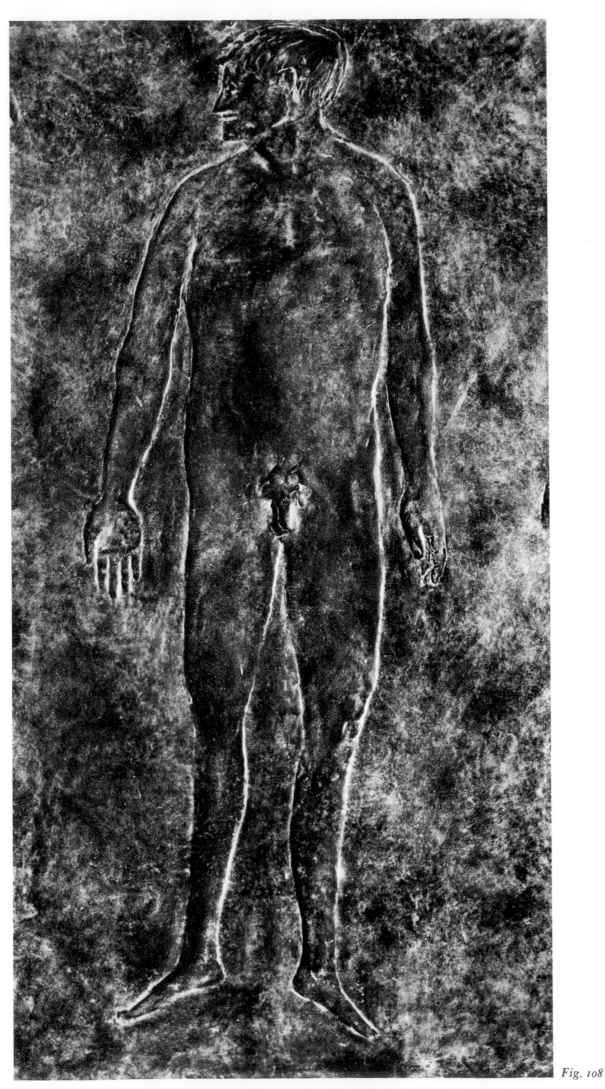

Fig. 108

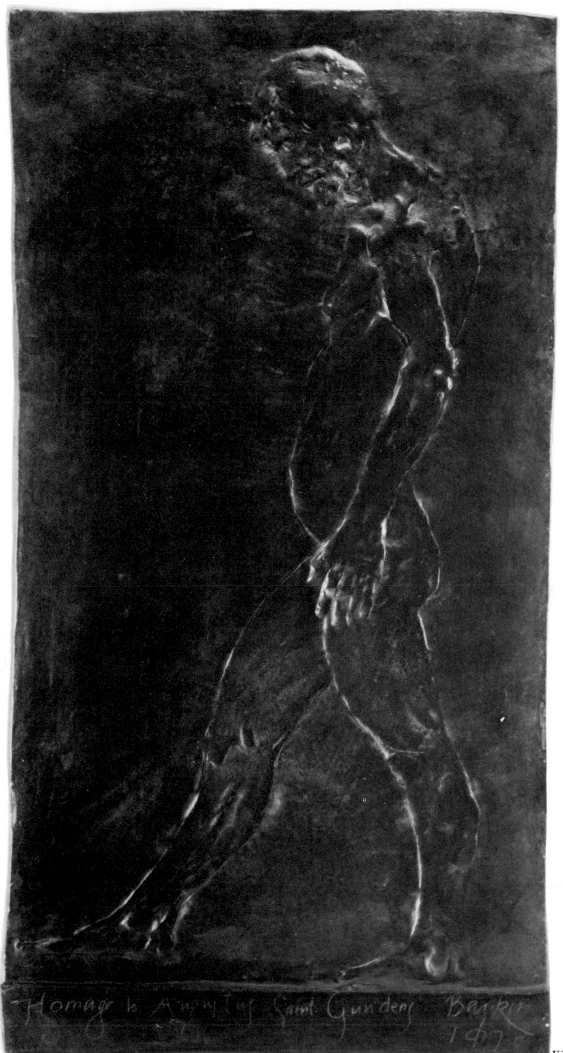

Homage to Augustus Saint Gaudens Bayker
1917

Fig. 109

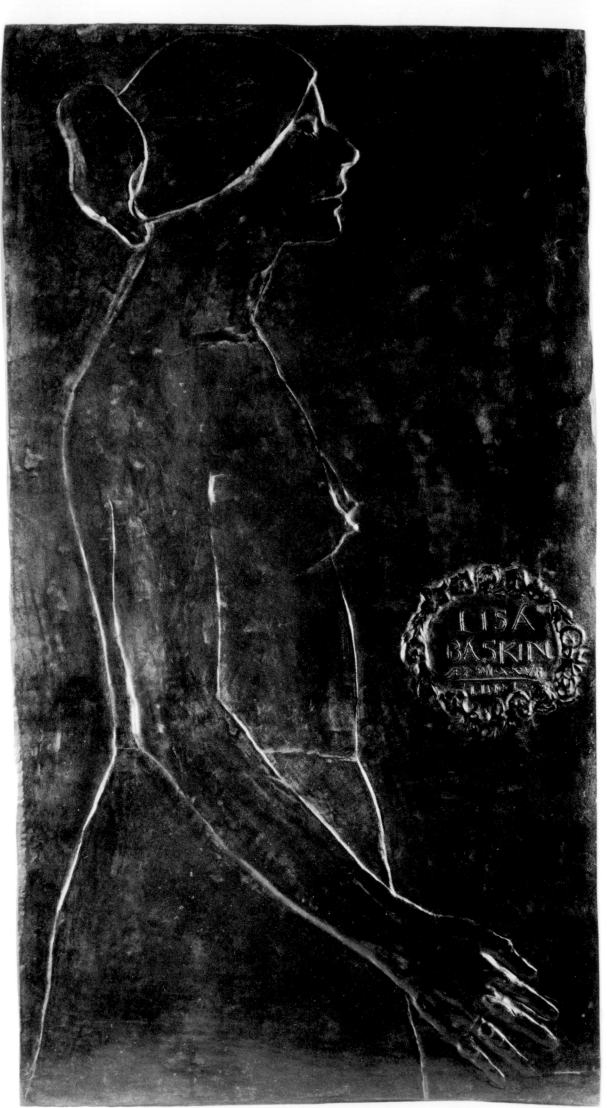

Fig. 110

Fig. 111

Fig. 110: Lisa. 1971. Bronze relief, 32 ½ x 17 inches.

Fig. 111: In Memory of Louis Black. 1959. Bronze relief, 8 ¼ x 17 ¼ inches.

Then he began to make the series of reliefs from life that has now grown into a small gallery of portraits of eminent men and women in the arts and humanities. The most lyrical, and one of the loveliest portraits in relief, is that of his wife, Lisa (Fig. 110), as much a homage, one feels, as the other portraits we have noted.

A homage of a different kind is the extraordinarily beautiful relief *In Memory of Louis Black* (Fig. 111). Baskin made this tribute to a man whose passion for collecting was similar in intensity and in subject matter to his own. Louis Black's collection of Western and Oriental books, prints, and drawings makes evident his preference for the human image and its natural environment, and his lively response to the aesthetics of the print media. Instead of an effigy, Baskin has represented a garden of coarse tall grasses and thorny plants, modeled with a poetic delicacy that brings to mind similar motifs in the engravings of Albrecht Dürer but particularly recalls his famous drawing *The Great Piece of Turf*.

Baskin's tribute to Wilfred Owen is expressed in a portrait head in the round (Fig. 112 a, b) and a relief of 1971. Baskin's feelings about the necessary links between art, humanism, and mortality are paralleled in this poet whose war poems C. Day Lewis has praised as "certainly the finest written by any English poet of the First World War and probably the greatest poems about war in our literature." There are other parallels between them. As a youth Owen had the broad-ranging, serious kinds of interests that Baskin enjoyed at an early age; he studied botany and archaeology, became a competent pianist, and began to read widely and randomly. He collected books, as far as his rather meager means allowed. In 1911, at the age of eighteen, Owen began to undergo a radical transformation of his beliefs, as Baskin had, and in a similar direction. He became socially conscious, even revolutionary, and wrote early in 1912 that the fires of revolt may have died down "in the bosoms of the muses but not in my breast. I am increasingly liberalizing and liberating my thought. . . . From what I hear [around me] I might say there is material ready for another revolution."[7] The awakening of his social conscience brought about a lapse from his Christian faith, just as radical politics had led Baskin away from his Jewish faith. Owen was killed in action on November 4, 1918, a week before the Armistice. His *Poems*, with an introduction by Siegfried Sassoon, appeared in 1920, and new and revised editions were periodically published in England, but the honor of first publishing Wilfred Owen in the United States goes to Leonard Baskin, who brought out at The Gehenna Press in 1956 the volume *Thirteen Poems by Wilfred Owen* with illustrations by Ben Shahn.

The artist did not, however, use Shahn's drawing of Owen for his sculptured portrait head but based it instead on

a photograph of the poet. Far more visionary than the graphic one, the bronze head of Owen is tilted upward, a device Baskin uses often to suggest inner vision. The open eyes and parted lips reinforce the visionary expression and at the same time impart to the face something of the passionate realism of Owen's verses. The sculptor seems to see the poet here as the doomed youth of his self-knowing, prophetic "Anthem for Doomed Youth."

> What passing-bells for these who die as cattle?
> .
> What candles may be held to speed them on?
> Not in the hands of boys, but in their eyes
> Shall shine the holy glimmers of good-byes.
> The pallor of girls' brows shall be their pall;
> Their flowers the tenderness of patient minds,
> And each slow dusk a drawing-down of blinds.[8]

But, as we shall see, it was another war poem, "The Parable of the Old Man and the Young," that in 1956 brought Owen closest to the heart of Baskin's own art.

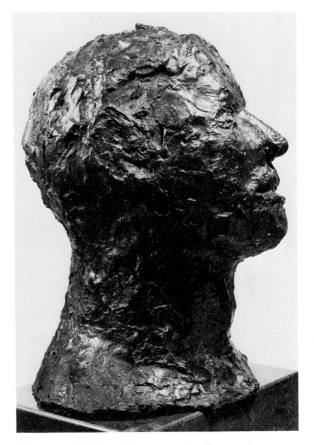

Fig. 112: Wilfred Owen. 1963. Bronze, 13 inches.

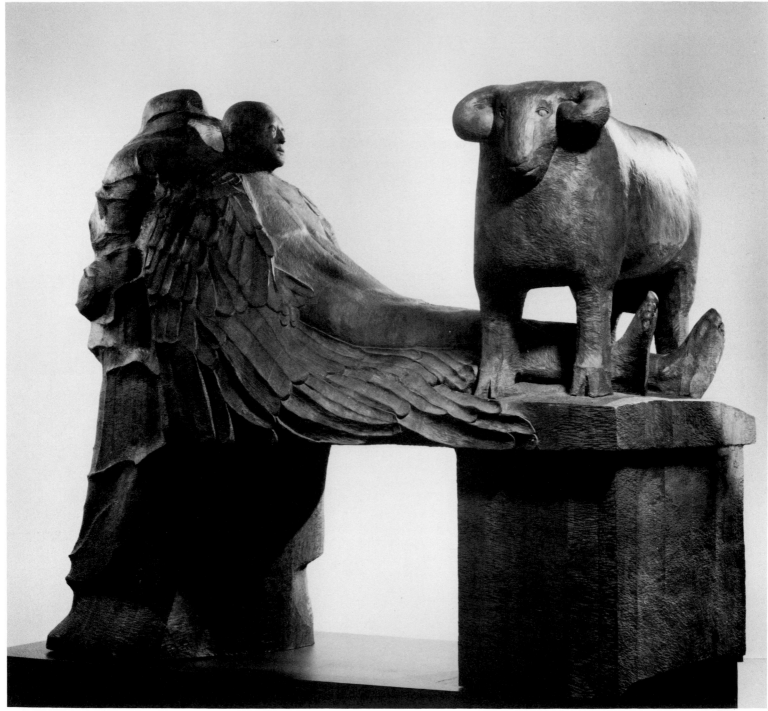

Fig. 113 a

INSIGHT
AND
INSPIRATION

*T*he planes of *The Altar* (Fig. 113 a-f) are plainly shaped by the themes of death, grief, and homage; less apparent is the theme of evil. Nevertheless, Baskin's interpretation of the narrative of Abraham's unwavering obedience to God and Isaac's reverent trust in his father, with its focus on the crucial moment when the patriarch, to save Israel, must honor the Covenant at this terrible cost, does, as he told me, reflect his shocked horror that a father could sacrifice the life of his son. His feelings about Abraham are ambivalent, expressed in Abraham's position, which is turned away from Isaac and yet supports the altar, the symbol of the Covenant on which depends the entire history of the Jews. How ambivalent these feelings are we will be better able to assess after we have considered a number of sculptures that Baskin executed during the past twenty-five years that bear specifically, rather than generally, on this work. And gaining insight into *The Altar* will lead us finally, I believe, to an understanding of the deep structure of Baskin's *oeuvre*.

Two works that Baskin made in 1963, *Hephaestus* and *Teiresias* (Figs. 114, 115), provide a distant yet suggestive point of departure for this investigation into the levels of meaning to be discovered in *The Altar*. The former subject is an artist, the latter a seer, and both are unmistakably self-portraits, stylistically similar to each other, built up in plaster with the rough surfaces and aggressive forms characteristic of Baskin's work at this time. The two works represent two thematic currents that will eventually flow together.

In Greek mythology Hephaestus was the divine artisan of immense skill, the artist who designed the armor of Achilles, famous for its extraordinary beauty. He is also credited with all the masterpieces of metalwork that are described in the stories of the gods and heroes of the ancient Greek world. Hephaestus appears in Homer's *Iliad*, which Baskin illustrated for a deluxe edition in 1962, and it seems likely that Hephaestus occurred to him as a subject at that time. But

Fig. 113 b

Fig. 113 a-f: The Altar. 1977. Linden, 71 inches (length).

Fig. 113 a: The Altar. Full view of finished work.

Fig. 113 b: The Altar. Detail of the work in progress in the artist's studio. *Wings of Isaac.* For Fig. 113 c-f, see pages 200–203.

Overleaf: *Fig. 114: Hephaestus.* 1963. Bronze, 64 inches.

Page 167: *Fig. 115: Teiresias.* 1963. Bronze, 53 inches.

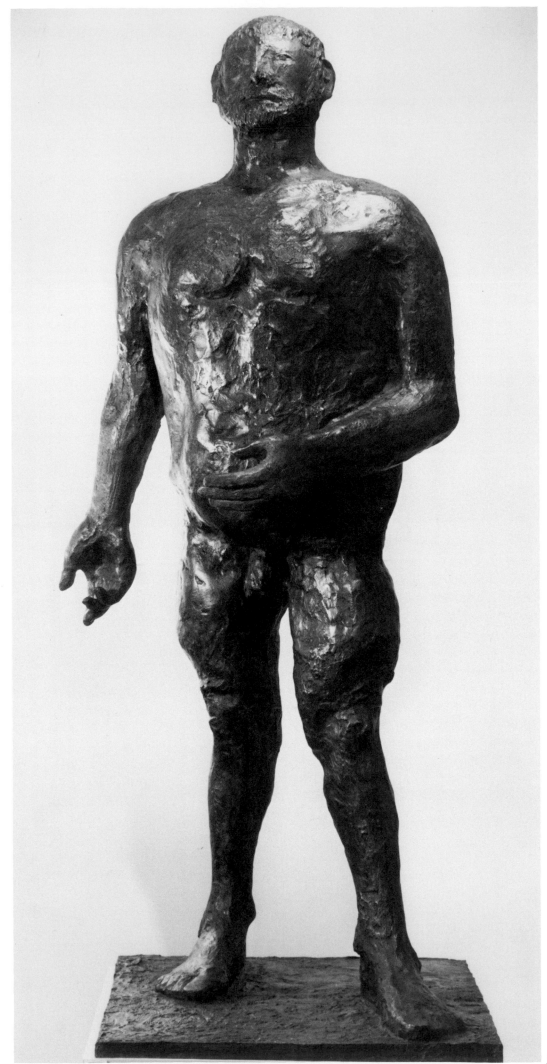

Fig. 114

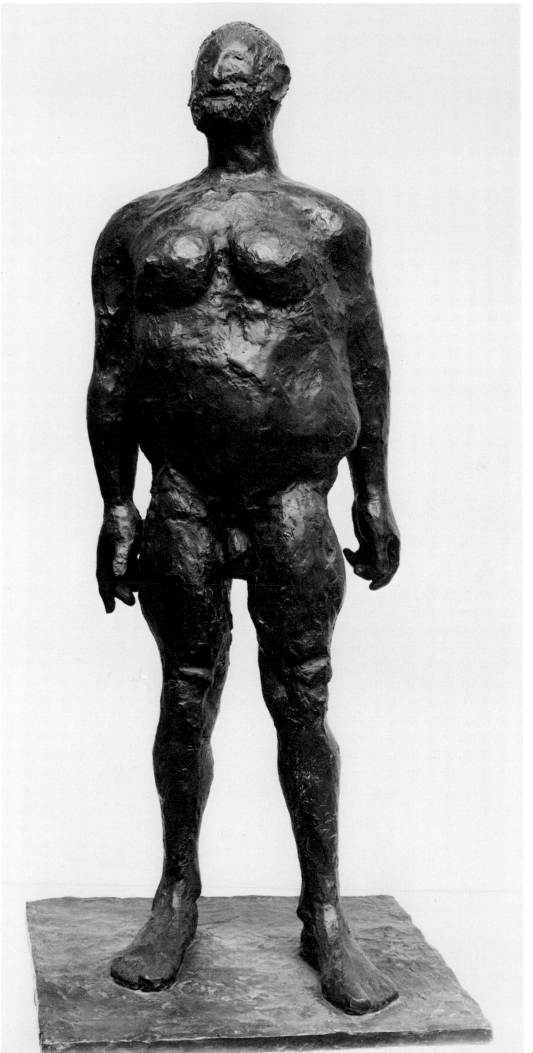

Fig. 115

there are many characters in the *Iliad;* why was it Hephaestus who attracted the artist?

First, surely, because of the professional identification Baskin felt with Hephaestus as a sculptor. But there are elements in the legend of Hephaestus that suggest additional reasons for the character's appeal for him. Hephaestus was the son of Zeus and Hera, king and queen of the gods. Because he was ugly and lame, his mother threw him out of Olympus into the sea, but he was rescued by one of the muses, who hid him for nine years. He began to make marvelous things, including a golden throne with invisible chains. He sent this rich gift to his mother, who when she sat down on it was promptly chained to the seat. No one could release her, except, of course, Hephaestus, who knew the secret since he had made it. He was delighted with his revenge, however, and refused to return. But Dionysus, the god of wine, succeeded in making him drunk, and lured him back in his drunken condition. He released Hera, but then she and Zeus quarreled again and this time the son took his mother's side, whereupon Zeus became angry and threw him out, making him lame, some say, in the other leg. *Mutatis mutandis:* let the reader make what changes he will and come to his own conclusion about what Hephaestus meant to Baskin.

Prometheus, the archetypal form-maker who is said to have molded the human race out of clay, shared an altar with Hephaestus; both were worshiped for the arts they brought to humankind. We have already discussed Baskin's early carving of *Prometheus,* made before 1949; in 1970 Baskin took up the subject again in a relief, *Prometheus Bound* (Fig 116), revealing his continuing interest in the theme of the artist who challenges the ruler of the gods.

As Hephaestus represents Baskin as the artist, Teiresias represents him as the prophet. Teiresias, an important character in several ancient Greek literary works, was blinded for one of a number of reasons—there are several versions of the story. It is said that the gods took away his sight because he revealed to mortals things they were not supposed to know—a pleasant conceit with which many an artist would easily identify. Another story recounts that by accident he saw Athena in her bath and the goddess splashed water in his eyes, blinding him; his mother pleaded with Athena to restore her son's sight, but the goddess was unable to do this so she compensated him by giving him knowledge of the language of the birds, the language of augury. A third story claims that he was blinded by Hera because in a dispute between her and Zeus on the matter of who had more pleasure in sex, the male or the female, he said women did; he knew because for a while he had been turned into a woman. Hera, infuriated, blinded him, but Zeus rewarded him with the gift of insight, of prophecy.

Fig. 116: Prometheus Bound. 1970. Bronze relief, 23½ x 13½ inches.

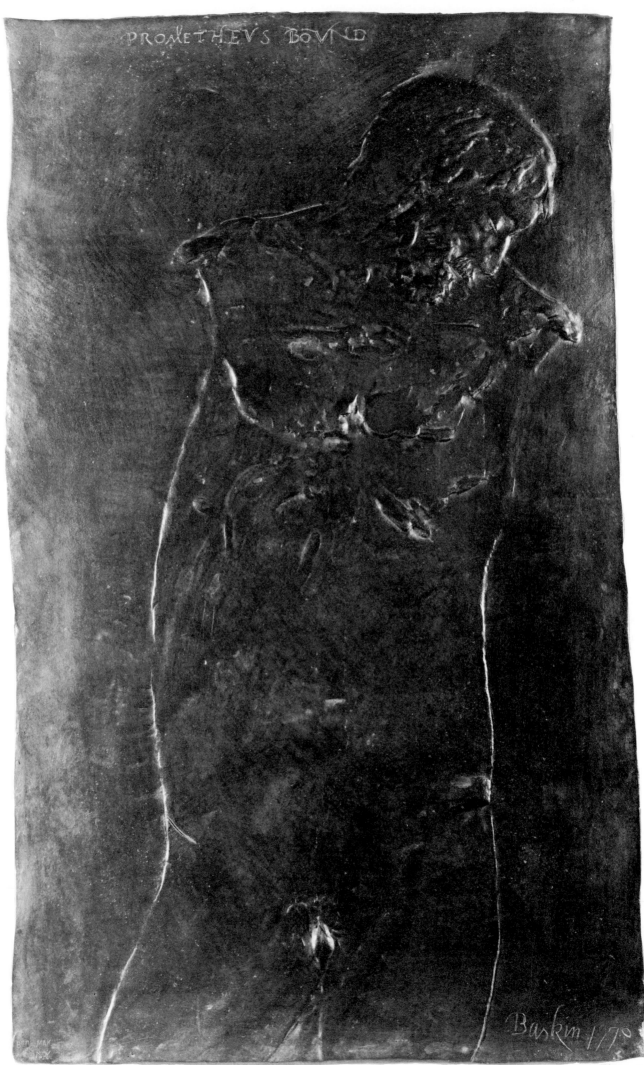

Fig. 116

It has been said that the style of *Hephaestus* and *Teiresias* suggests the influence of Rodin because of the highly irregular surfaces over which light and shadow play.[1] While Baskin's admiration for Rodin is doubtless reflected in his work, as we have already noted in *The Guardian*, in my view it is more enlightening to notice how essentially Baskin differs from the great French sculptor. Rodin was first and foremost concerned with the expression of movement; even his use of irregular surfaces with their play of light was designed to reinforce the idea of fluidity. Baskin, on the contrary, has done everything to emphasize the idea of sculpture as solid mass, and the irregular surfaces do not compromise this aesthetics of mass. In fact, the weight of the jagged hunks of plaster-soaked material with which Baskin built such figures as *Teiresias* (Rodin used softly malleable clay) retains some of its haptic effect in the finished bronze. The contours of these figures are characteristically closed; the arms are close to the body. The legs of *Hephaestus*, misshapen in accordance with his mythical lameness, are close together, and the feet are heavily flat on the base. In *Teiresias* there is more space between the legs; the feet are raised off their heels, a pose that, reinforced by the upward tilt of the head, helps to give the impression of spiritual uplift as if to overcome the physical burden of his aging body. Nevertheless, the only movement of which one can speak is the spiritual dynamism of prophetic inspiration that is expressed in the whole design of the composition.

A few years after *Hephaestus*, Baskin took up the theme of the mythical artist again, this time *Daedalus* (Fig. 117 a, b). Daedalus was famed for his ability to make deceptively lifelike figures, which accounts, at least partly it would seem, for the relatively more naturalistic figure that Baskin has given him. Probably the best-known episode of the Daedalus myth concerns the ancient artist's escape with his son Icarus from Crete by means of wings he had made of wax and feathers. He warned his son not to fly too high because the hot sun would melt the wings, but Icarus ignored, or defied, his father's warning; he soared up and up, and of course flew into the face of disaster. The sun did melt his wings, and down he plummeted into the Aegean Sea, where he drowned. Daedalus, then, is another representation of Baskin as artist—his own features are easily recognizable in the work—and is one of a significant number of works based on themes in which the father-son relationship is crucial. In 1969 Baskin made a relief of the winged boy, *Icarus*.

In *Marsyas* (Fig. 118) the sculptor identifies with a musician. Athena, credited with inventing the flute, threw the instrument away when she found it distorted her face to play it. Marsyas, a satyr, formed like a man but with animalistic features including pointed or horned ears, found the discarded

flute, learned to play it, and foolheartedly challenged Apollo, the god of music, to a musical contest. The outcome was predictable, and Marsyas paid the loser's penalty exacted by Apollo: he was hung from a tree and flayed alive. Baskin's *Marsyas*, with pointed ears, is represented with his arms stretched upward and crossed at the wrist as if he is tied and hanging; the pose thus suggests the entire environment. Again we recognize the face of Baskin, who, identifying with the suffering artist, projects here his own experience of suffering as a result of challenging the gods of the art establishment. In its way, *Marsyas* is a continuation, reversed, of the theme of *The Guardian* carved fifteen years earlier. Over a span of many years, then, we find that Baskin identifies with the role of the artist, or with the archetypal artist. The second thematic current that we are following, represented by Teiresias the seer, takes us more deeply into the relationship between the artist and his art.

The geography of the Old Testament is the terrain of the ancient Near East and Egypt. Modern scholarship has shown many links and parallels between narratives in the Bible and in Egyptian and Mesopotamian literature. Common to all three, and to many other cultures as well, is the central significance of the prophetic tradition in which certain individuals are gifted with special insight that enables them to foretell the future. In rational Western terms we would say that a profound understanding of the present makes possible the discerning of the lineaments of the future, but in older traditions prophets, seers, divinators, and augurs were thought to be inspired, literally possessed by a spirit, and thus were seen as media through whom a god spoke to his believers. The language of the god was never the language of mankind, of course, and it was the prophet's inspired gift to understand and interpret the divine language. Often this language took the form of natural phenomena: lightning, thunder, the formation of clouds, the configurations of the stars, were all instruments of divination. Of particular interest to us, in connection with Baskin's imagery, is the widespread use of birds in divination in the ancient world; usually their flight pattern or direction provided the sign to be interpreted. As counselors to kings and more lowly worshipers in societies where there was no clear distinction between religious and secular life, such seers were powerful figures, enacting the solemn responsibilities of securing the state from enemies and protecting the people from the anger of the gods.

Baskin has made a number of important sculptures entitled variously *Divinator, Prophet, Seer,* and *Augur. Study for The Divinator* (Fig. 119 a, b), with a bird perched on the left shoulder, another with open wings at the base of the skirt, and still another long-necked, beaked bird spread frontally across the back of the shoulders and down the center of the back, is

Overleaf: *Fig. 117, a & b: Daedalus.* (Two views.) 1967. Bronze, 41 inches.

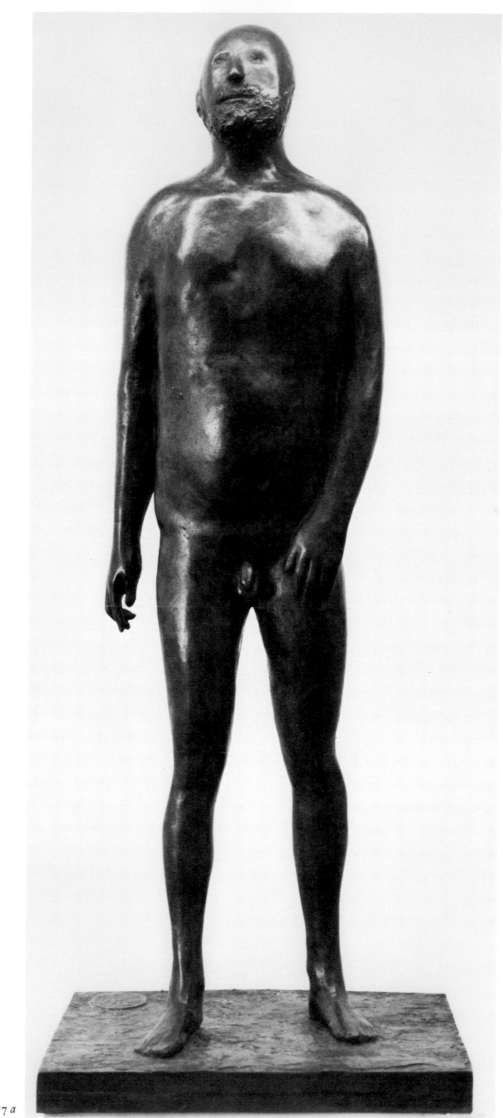

Fig. 117 a

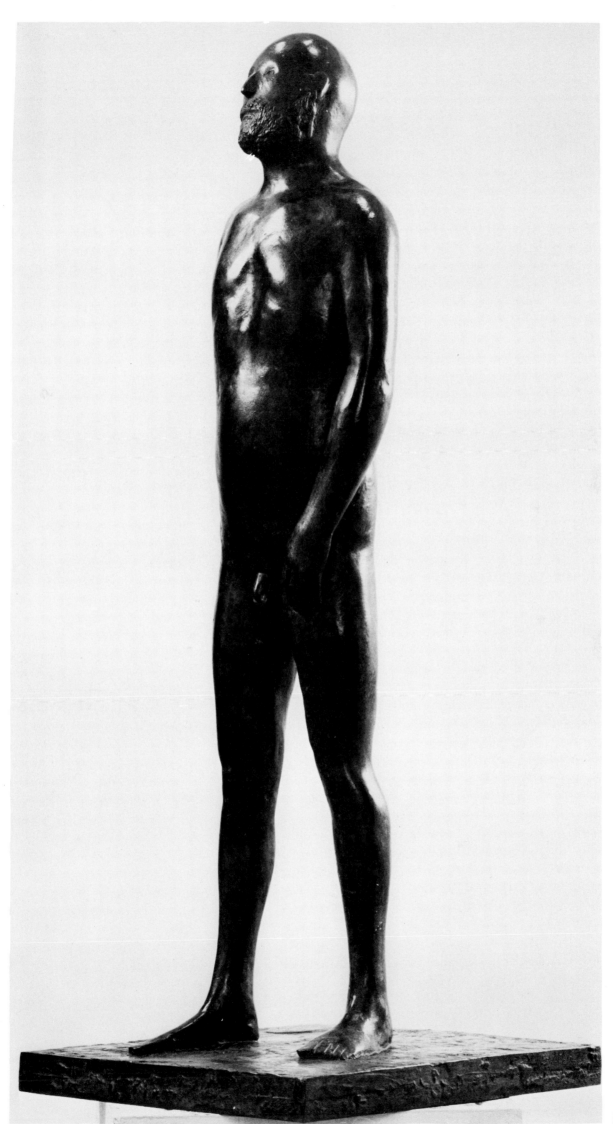

Fig. 117 b

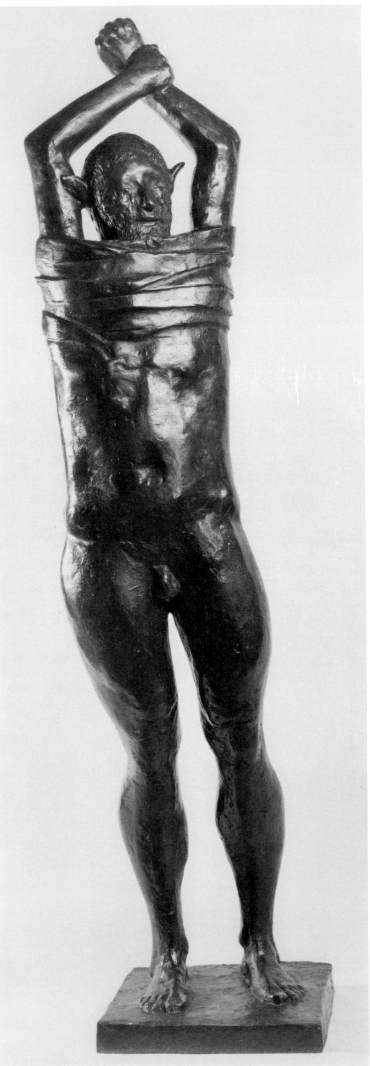

Fig. 118: Marsyas. 1971. Bronze, 46½ inches.

Fig. 119, a & b: Study for The Divinator. (Two views.) 1974. Bronze, 30½ inches.

Fig. 118

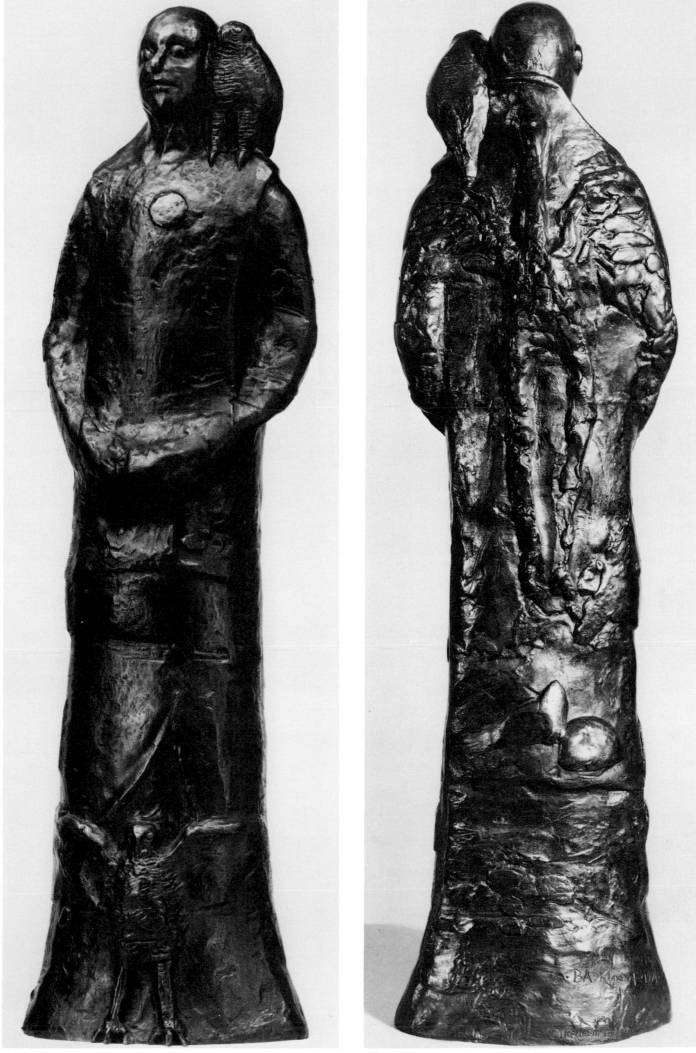

Fig. 119 a *Fig. 119 b*

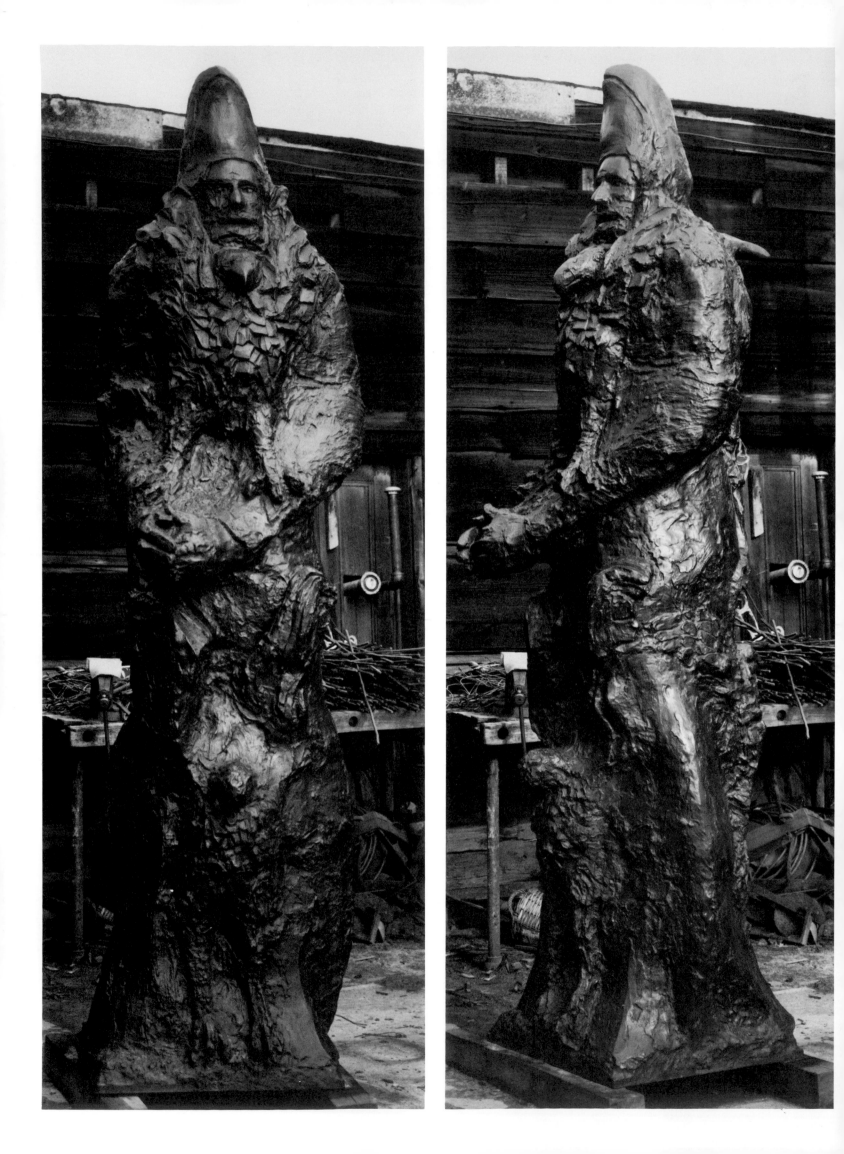

Fig. 120, a, b, & c: Divinator (Three views.) 1974. Bronze, 112 inches. Photo taken at artist's foundry.

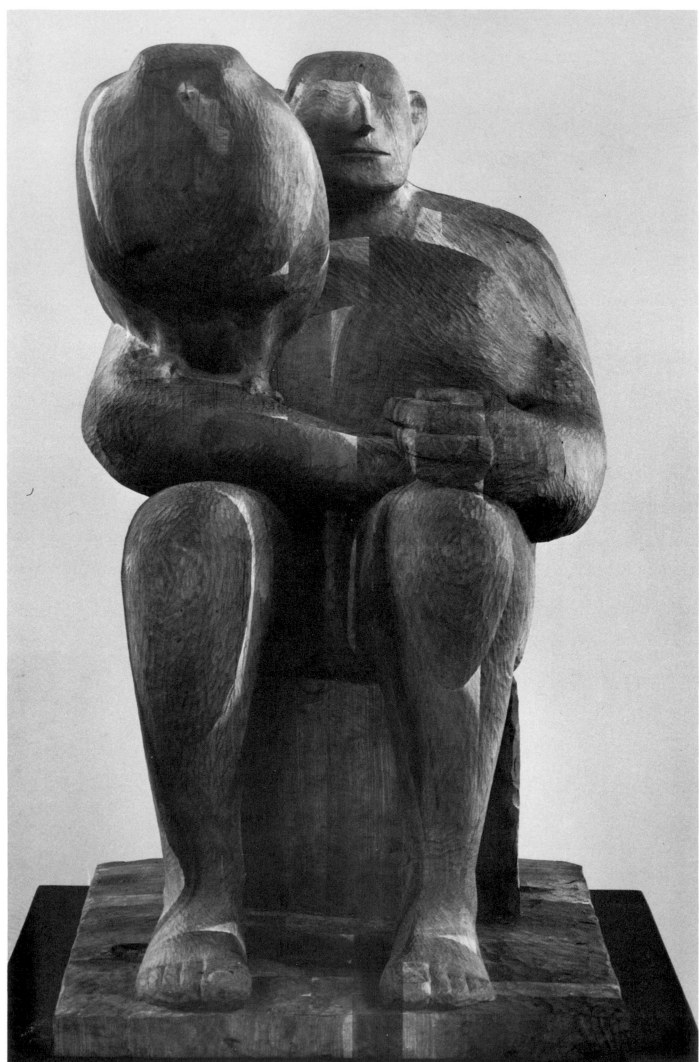

Fig. 121

particularly arresting for its unexpected but highly successful fusing of widely disparate styles. In its strict frontality, solemnity, and subject matter it recalls both Mesopotamian and Egyptian art, but in the extraordinary sloping shoulders and the general contours, especially the flare at the base of the garment, I think we see Baskin incorporating features of Chinese T'ang Dynasty art, of which he has several pieces in his collection. The over-life-size *Divinator* that followed (Fig. 120 a, b, c) is radically different from the *Study*. Built up in plaster instead of clay, its surface is heavily encrusted with the energy of the artist. Birds press forward from the surface of the figure as if growing out of it; sharing his very nature, they become one with the divinator, transforming him into a solemn and powerful totem.

In the context of Baskin's *oeuvre* certain sculptures with unspecific titles representing a man with bird should be included among those that belong iconographically in the group of prophet figures. Even the early *Man with Dead Bird* (Fig. 21) suggests the psychologically burdened man of our time who faces both the freedom and the spiritual imprisonment of modern life, and thus speaks the prophecy of our modern culture, with its ambiguous promise of hope and threat of disaster. Several years after *Man with Dead Bird* Baskin carved, also in wood, the *Seated Man with Owl* (Fig. 121), which, like the former work, reminds us of an Egyptian statue, this time of a pharaoh, *Chefren*, represented with the god Horus in the form of a falcon behind his head as a symbol of his divine nature (Fig. 122). The prophetic content of *Seated Man with Owl* becomes even clearer when the figure is compared with *Augur* (Fig. 123), representing an official divinator of ancient Rome. Seated and holding a large owlish bird before him, now with another bird on top of his head, the *Augur* clearly demonstrates the iconographic relationship; the possession of the birds symbolizes possession of their language, that is, of knowledge hidden from ordinary mortals. We should notice, however, in comparing the two carvings that the use of wrapping in the *Augur* gives it a heightened forcefulness and grandeur, especially as the garment winds around the lower part of the face. With the mouth covered and speech stifled, the eyes are given greater importance, stressing vision and conveying the idea of divination as a secret and mysterious power.

The mystery of prophecy is further developed two years later in the bronze *Prophet* (Fig. 124 a, b). Now heavily wrapped, the figure expresses the total inwardness of prophecy and the essential mystery associated with it. Its secrets are impenetrable and forbidding to all except the gifted ones, the prophets. What is of great interest is that this *Prophet* is subtitled *Homage to Rico Lebrun*, and thus makes explicit Baskin's identification of the artist with the prophet. Further-

Fig. 122

Fig. 121: Seated Man with Owl. 1959. Cherry, 30 inches.

Fig. 122: Chefren. Egyptian, Old Kingdom, c. 2600 B.C. Diorite, 66 inches. *Collection of Cairo Museum, Cairo, Egypt.*

Overleaf: *Fig. 123, a & b: Augur.* (Two views.) 1969. Walnut, 71 inches. *Collection of Boris Mirski Gallery, Boston, Mass.*

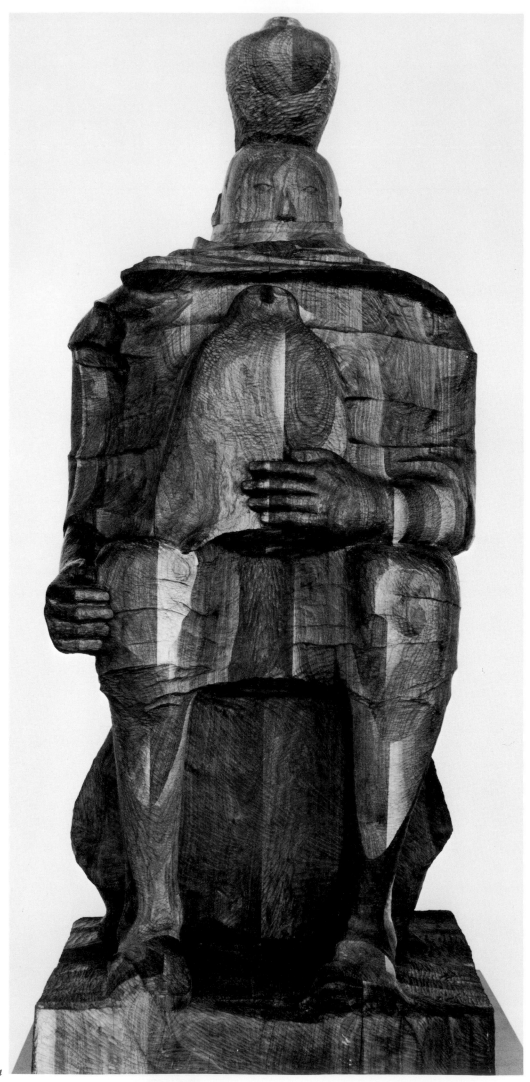

Fig. 123 a

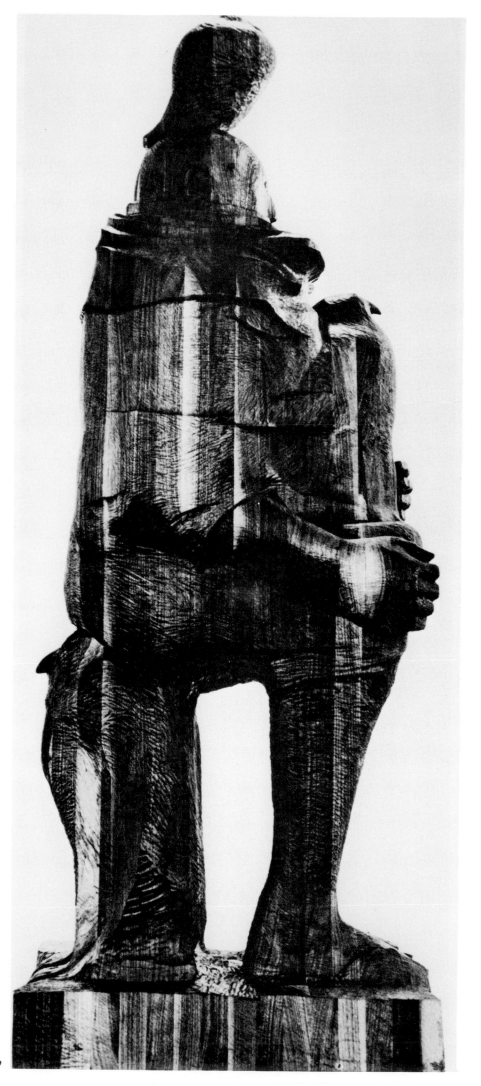

Fig. 123 b

Fig. 124 a

Fig. 124 b

Fig. 124, a & b: Prophet: Homage to
Rico Lebrun. (Two views.) 1971.
Bronze, 36 inches.

more, Rico Lebrun was twenty-two years older than Baskin and I think we may see him as a father figure for the younger artist. This suggests that the *Prophet* is a complex image in which are conflated Baskin's emotions about Lebrun as his friend; about the inspired artist as the insightful prophet and the inspired prophet as the insightful artist; about Lebrun as prophet and spiritual father; about Baskin himself as artist, and thus as prophet; about Baskin's identification with both the prophet image and the father figure. I believe we may define as the seedbed of these emotions Baskin's identification with his own father—a rabbi, scholar, and teacher, and thus a man in the high tradition of Old Testament inspiration and insight. On this level the concealed mystery of the figure of the *Prophet* appears to me to have much to do with the ambivalent nature of the father-son relationship, compounded of love and rivalry.

The prominence of this motif in Baskin's work testifies to the depth of its meaningfulness for him. Prometheus who challenged his father, Oedipus who killed his father accidentally, Theseus who was responsible for his father's suicide, Icarus who defied his father, and Aeneas who escaped from Troy carrying his aged father on his back (Fig. 125) all figure in Baskin's sculpture and graphics over the entire span of his career up to the present. In 1976 he modeled *The Prodigal Son* (Fig. 126), with father and son embracing in accordance with the biblical story. The composition seems to have been influenced by Barlach's *The Reunion* (Fig. 127), but Baskin has intensified the union of the figures beyond the mutually embracing arms, bringing them together in the wrappings of the garments. Here the wrapping motif serves two iconographical meanings; the two figures are literally bound together by bonds of love, but the wrappings are reminiscent of the shroud that we have already seen in *Lazarus*. In the parable of the Prodigal Son, as recounted in Luke 15:24, the father greets his son with tender forgiveness and orders a feast in celebration "because this son of mine was dead and has come back to life; he was lost and is found." The parable is thus a resurrection story. "He was lost and is found" may echo in Baskin's imagination as his own experience of breaking the religious ties of his youth, symbolically leaving his father's house, and then gradually reconciling his mature socialist convictions with his constant sense of himself as a Jew, in his "roots and veins" still belonging to the house of his father. "The *Briss Mileh* has made me kin to the most august and remote Sassoon, the dimmest half-wit masquerading as a 'defender of the gate' and to every other Jew, living and dead. One apprehends this awesome belonging while yet a child, indeed, it spills over one like a secondary trauma."[2]

Among the meanings of the parable of the Prodigal Son are the human love for what is lost and the saving power of

Fig. 125: Aeneas Carrying His Father from Burning Troy. 1971. Bronze, 36 inches.

love, expressed in the metaphor of return and reconciliation. Remembering that Rabbi Samuel Baskin died in 1975, and considering that Leonard Baskin's relationship with his elder brother, Rabbi Bernard Baskin, has flowered into fraternal love in the years since, it seems that *The Prodigal Son* is an autobiographical account of the emotions experienced by the artist in consequence of his father's death.

Ultimately, in my view, the importance to Baskin of the father-son relationship in real life is at the heart of the profound importance he assigns to cultural and artistic continuity, an idea that recurs more or less explicitly in his writings, and metaphorically in three of his most beautiful reliefs, *Fruitfulness from Permanence,** Wisdom is Lasting, Instinct Fleeting,* and *Continuity* (Figs. 128, 129, 130) all made in 1967. Continuity is also the theme of his largest work to date, the group of three over-life-size figures, *Boy, Seated Man, Bird,* that he made for the outdoor plaza of Society Hill Towers in Philadelphia in 1964, commissioned by I. M. Pei. In this light his figures of homage appear to be "father figures" whom he claims as his direct ancestors. Baskin's aesthetic and moral commitment to the human figure may be said to be a covenant with the past that can only be broken, he is convinced, at the cost of destroying the republic of art to which he pays his devoted allegiance.

Against this background, let us now consider *The Altar.* The earliest appearance in Baskin's sculpture of the theme of the sacrifice of Isaac occurs in a bronze relief of 1958, *Isaac* (Fig. 131). Here the figure of the boyishly young Isaac is combined with the wings of the angel and the horns of the ram; Abraham is not present. Again we are reminded of the importance to Baskin of ancient Near Eastern art in which hybrid images of human forms with wings abound (Fig. 132). That same year, Baskin carved his majestic *Grieving Angel* (Fig. 52) and four years later his *Benevolent Angel* (Fig. 133). In 1965 he modeled the beautiful relief *Abraham and Isaac* (Fig. 134) expressly for the Herman Schickman Gallery. It depicts two male heads in profile, back to back, one with a young face, the other old. In 1973 he took up this subject with a freestanding sculpture, a large figure of *Isaac* shown seated on a severe rectangular base with a ram ly-

* A tourist souvenir banner of the Palio that I found in Siena is decorated with a *contrado* emblem that shows a rhinoceros standing in front of a tree so that the tree appears to be growing from the animal's back, so like *Fruitfulness from Permanence* that one would think it was without any doubt Baskin's source. Baskin was intrigued when I showed him a photo of it, but has no memory of ever having seen it. He thinks that Bernini's *Elephant Carrying Obelisk* in Piazza Maria sopra Minerva, Rome, is probably the closest source for his idea. Is it possible that Bernini's enchanting design inspired to the same thought two artists separated by centuries and continents? Or is this a striking example of how an extraordinary visual memory stores everything meaningful to the artist, whether seen consciously or not?

Overleaf: *Fig. 126, a & b: The Prodigal Son.* (Two views.) 1976. Bronze, 55 inches.

Fig. 127: Ernst Barlach. *The Reunion.* 1926. Walnut, 40 inches. *Collection of Ernst Barlach House, Hamburg.*

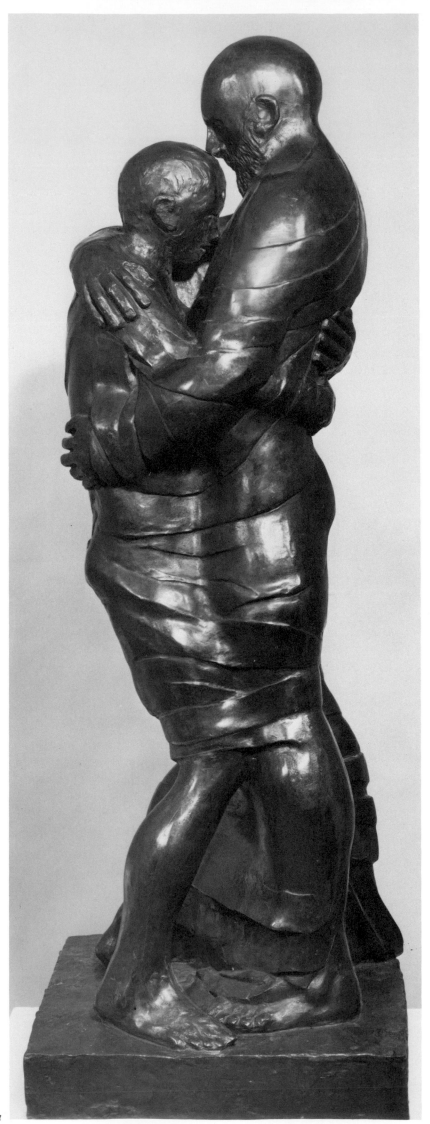

Fig. 126 a

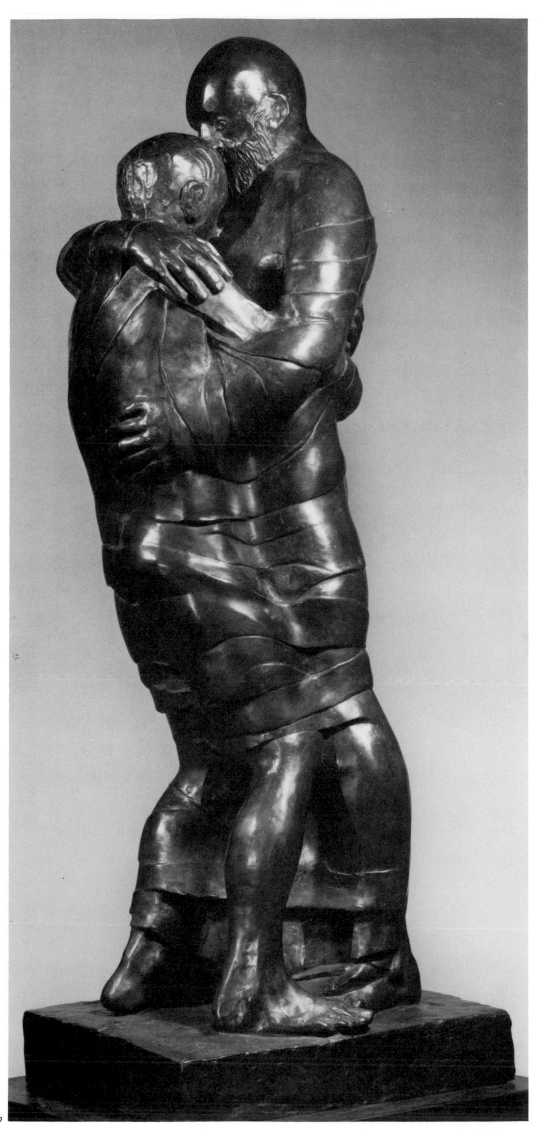

Fig. 126 b

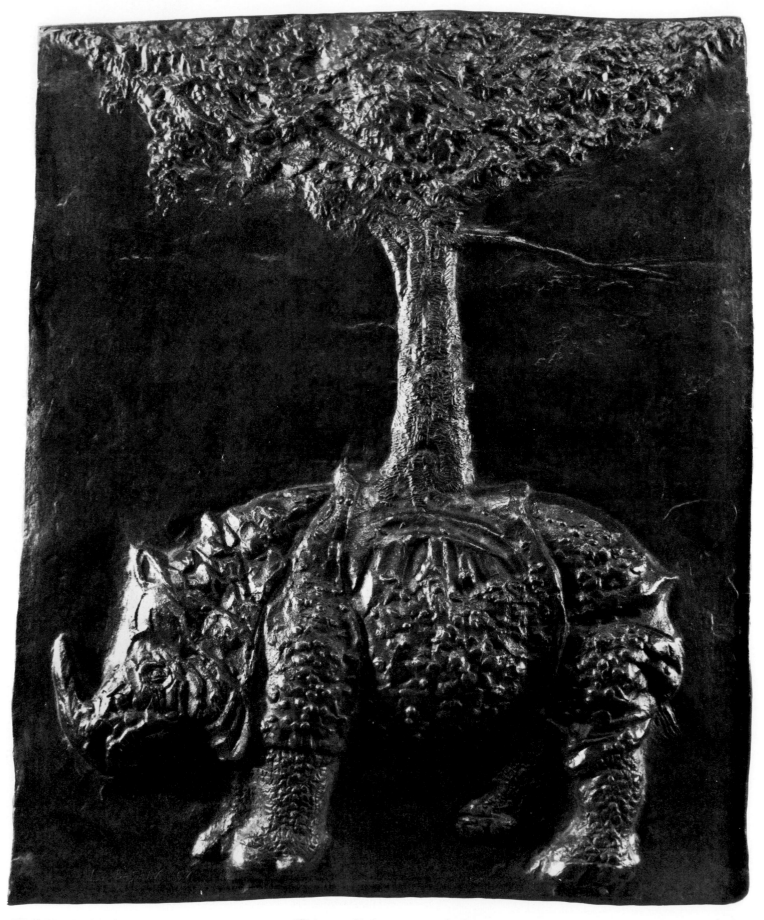

Fig. 128: Fruitfulness from Permanence. 1967. Bronze relief, 19½ x 16 inches.

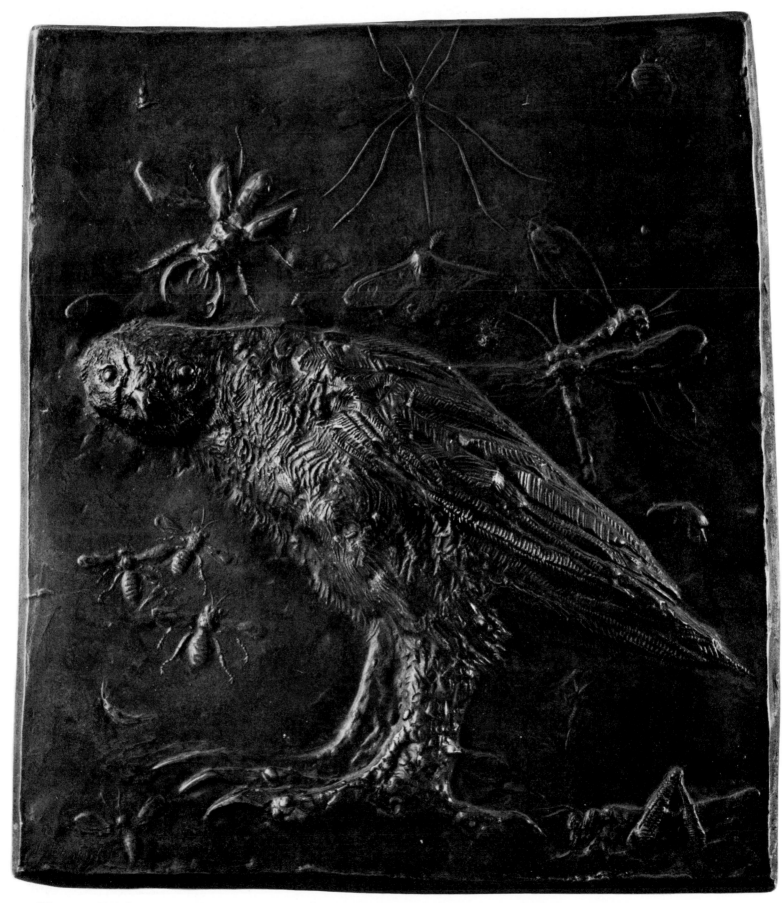

Fig. 129: Wisdom Is Lasting, Instinct Fleeting. 1967. Bronze relief, 19 x 16 inches.

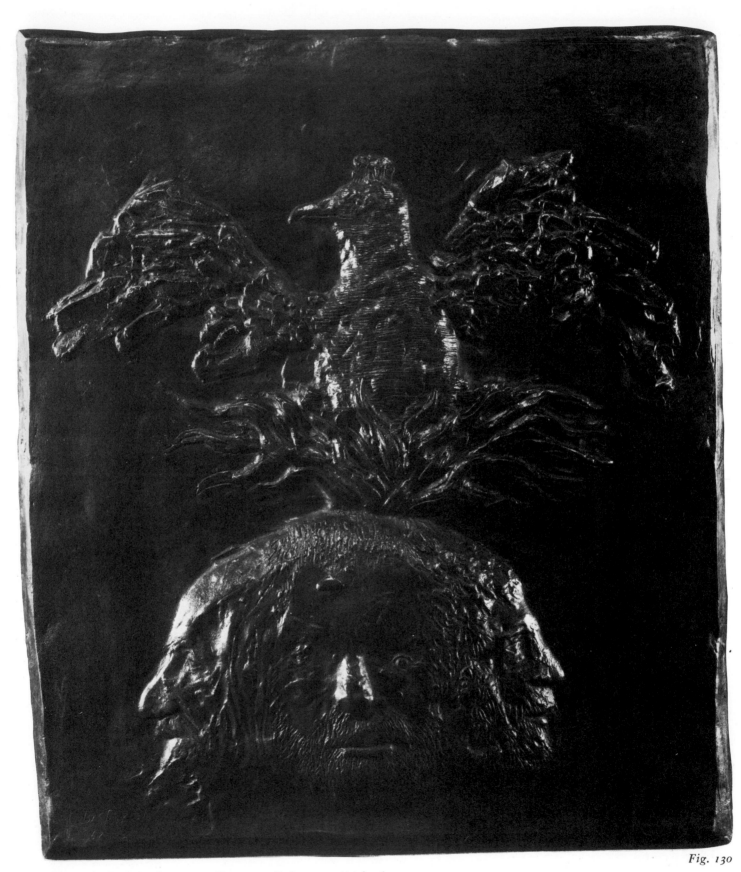

Fig. 130

Fig. 130: Continuity. 1967. Bronze relief, 19 x 16½ inches.

Fig. 131: Isaac. 1958. Bronze relief, 23 x 19 inches.

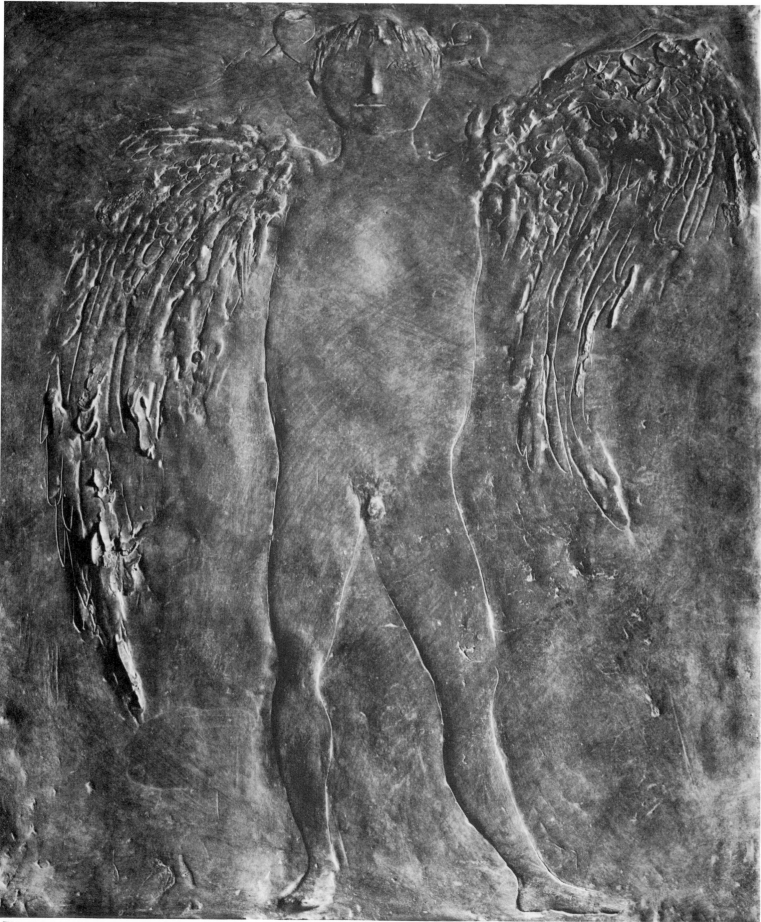

Fig. 131

ing across his knees (Fig. 135). In contrast with the relief of 1958, Isaac is represented bearded, and with the well-developed anatomy of a large mature man. The face resembles Baskin's, and recalls the father face type. Here again the artist has made a composite image, now consisting of Isaac, who is also his father, Abraham, and the ram. This time the angel is omitted.

The sacrifice of Isaac remained on Baskin's mind, as is clear from a number of drawings of this period, and in 1975 he made three sculptures on this theme: *Isaacangel* (Fig. 136), *Abraham* (Fig. 137), and *Ram* (Fig. 138). In the first Isaac is again combined with the angel and is depicted as a youth. In *Abraham* the patriarch is represented enveloped in a billowing cape and voluminous garments that give his figure an expansive, impressive authority. *Ram* reminds us of animal deities from ancient Mesopotamia, such as the *Goat and Tree* (Fig. 139) in which the standing animal plays the role of a masked priest dressed in the fleece of the sacrificed horned beast, enacting sacred ritual. In Baskin's *Ram* we may notice the association of the standing animal form with the spiral garland of leaves, recalling the tree of life in the ancient *Goat and Tree*.

These three figures, *Isaacangel*, *Abraham*, and *Ram*, were made in the same period in which Baskin executed the group of divinator and prophet figures, giving evidence of the association in the sculptor's mind of the iconographic content shared by the two groups: Abraham is the seed of Israel, the patriarch of the nation, the archetypal father. But as the instrument of God's will through whom God made his Covenant with Israel, he is also the archetypal prophet, gifted with inspired insight. Thus in Abraham is united the prophet-father and the inspired teacher of his people. Inspiration, however, as we have said, is also the mark of the artist. Thus, in the idea of inspiration the archetypal prophet sculptures and the archetypal artist sculptures may be seen as coherent variations on a single theme.

In *The Altar* we may now see many of the formal, aesthetic, and moral elements that have absorbed so much of Baskin's artistic imagination. But we must return once more, briefly, to the early years, to a drawing of 1956 called *The Parable of the Old Man and the Young* (Fig. 140). The title of this enormous and magnificent drawing is taken from the poem of the same title by Wilfred Owen, which he wrote during the last year of World War I.

> So Abram rose, and clave the wood, and went,
> And took the fire with him, and a knife,
> And as they sojourned both of them together,
> Isaac the first-born spake and said, My Father,
> Behold the preparations, fire and iron,
> But where the lamb for this burnt-offering?

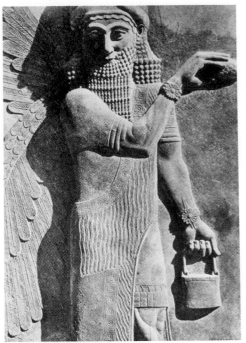

Fig. 132

Fig. 134

Fig. 132: Winged Genius. Assyrian. 742–705 B.C. Stone relief, 144 inches. *Citadel Gate, Khorsabad.*

Fig. 133: Benevolent Angel. 1962. Birch, 29¼ inches.

Fig. 134: Abraham and Isaac. 1965. Bronze relief, 42½ x 23½ inches.

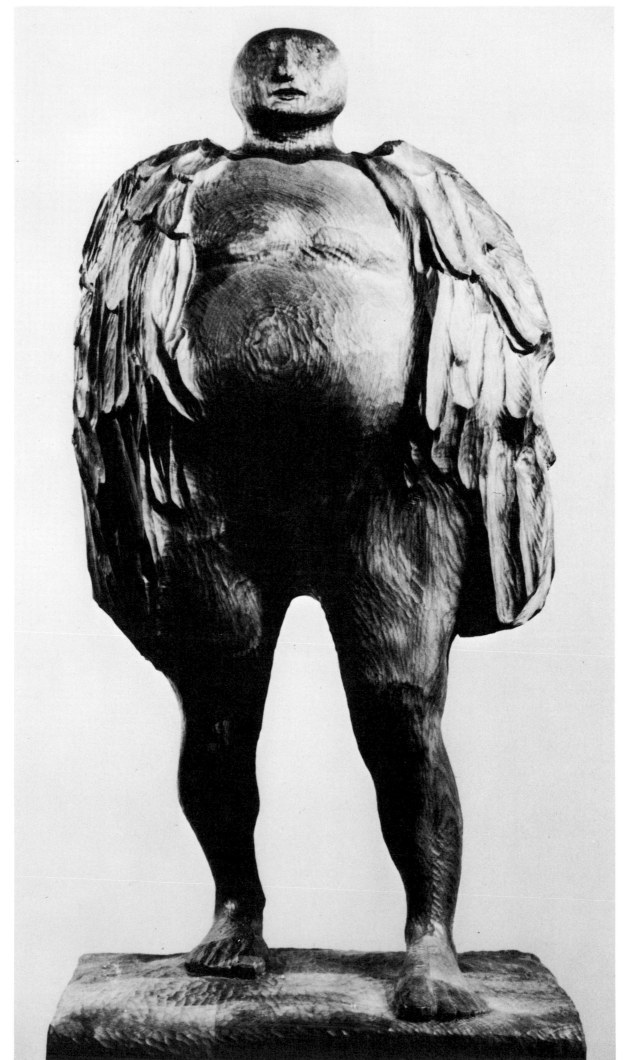

Fig. 133

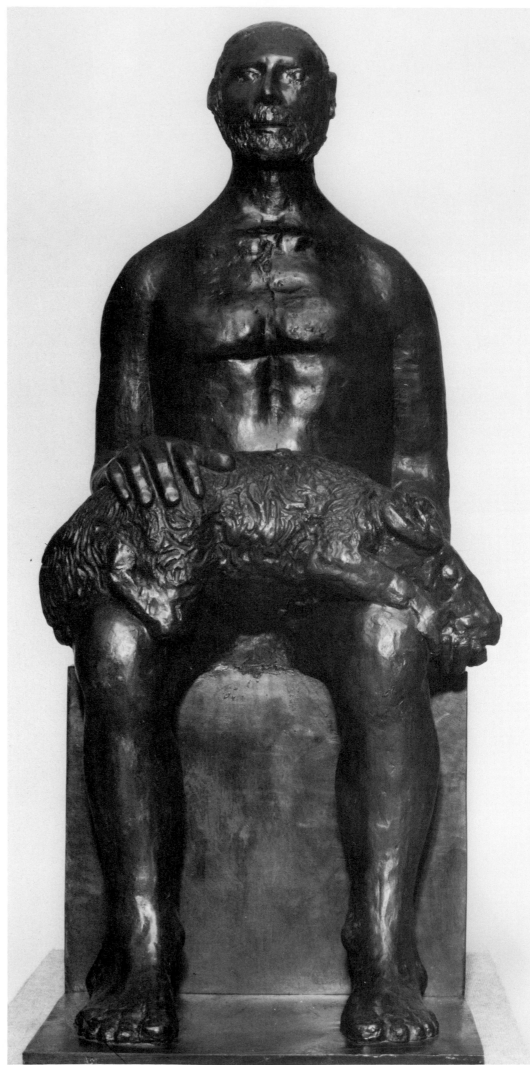

Fig. 135, a & b: Isaac. (Two views.) 1973. Bronze, 59 inches.

Fig. 135 a

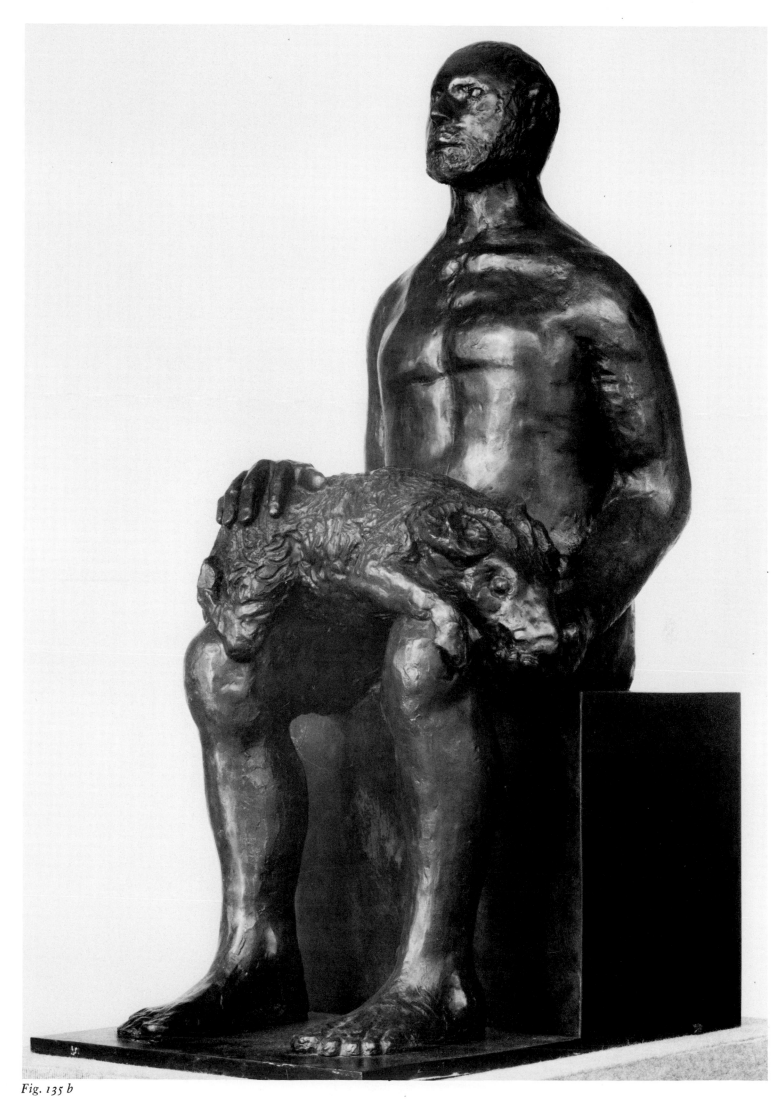

Fig. 135 b

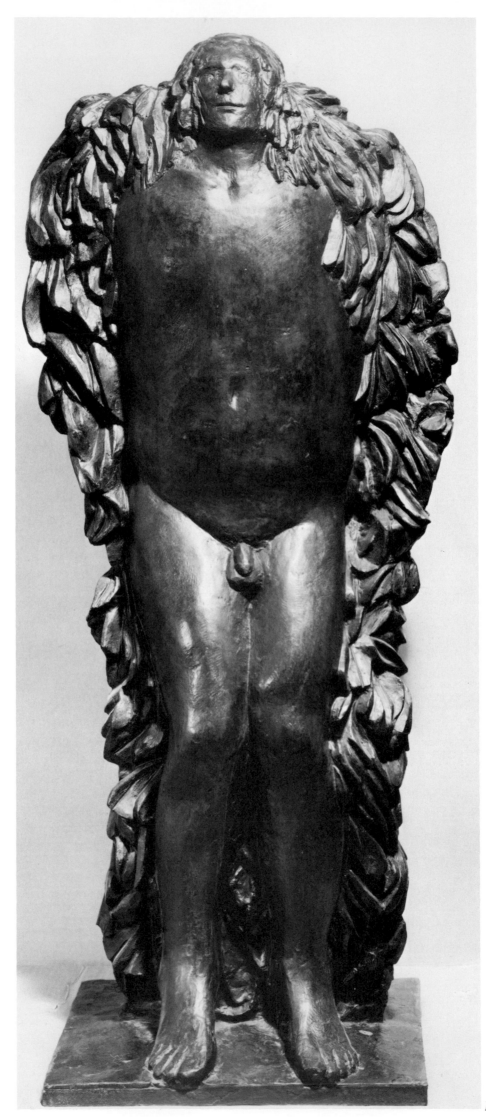

Fig. 136

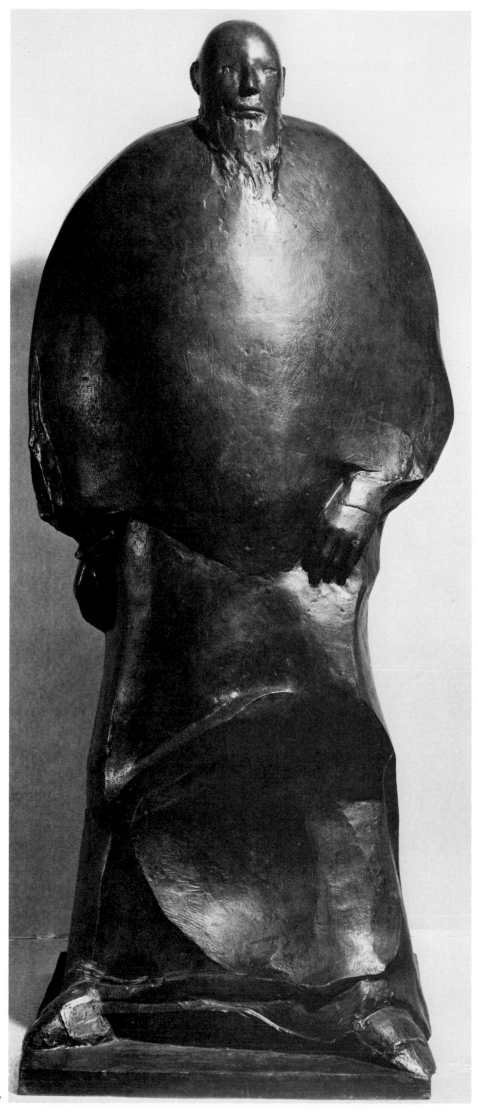

Fig. 137

Fig. 136: Isaacangel. 1975. Bronze, 46 inches.

Fig. 137: Abraham. 1975. Bronze, 42 inches.

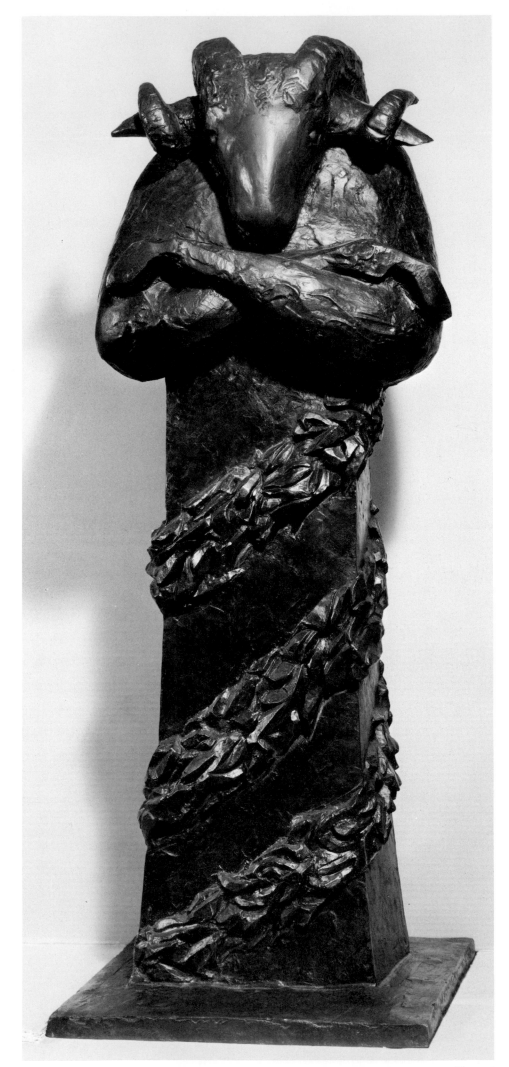

Fig. 138

Then Abram bound the youth with belts and straps,
And builded parapets and trenches there,
And stretchèd forth the knife to slay his son.
When lo! an angel called him out of heaven,
Saying, Lay not thy hand upon the lad,
Neither do anything to him. Behold,
A ram, caught in a thicket by its horns;
Offer the Ram of Pride instead of him.
But the old man would not so, but slew his son,
And half the seed of Europe, one by one.[3]

Like the biblical story, *The Altar* represents a complex drama of conflicting emotions. Baskin has appropriately put his sculptural drama in the strictest, most austere terms. Carved in laminated linden with the chisel marks visible (Fig. 113 a-f), the image is forbiddingly spare. The central figure is Isaac, who lies on the altar, nude, half raised, with his back resting against the back of his father, who stands at the left, turned away from him but fused with him, and with the altar; Abraham thus becomes its support at that end, opposite the stark rectangular block that is reminiscent of the base on which Isaac is seated holding the ram over his knees in the *Isaac* of 1973. This box-like form also reverberates with the memory of the tremendously moving wooden crate serving for a table in Jacques Louis David's *The Death of Marat*, a secularized sacrificial drama. Isaac is embraced by the angel, symbolized by the wings, as in the *Isaac* relief of 1958 and the

Fig. 140

Fig. 139

Fig. 138: Ram. 1975. Bronze, 42½ inches.

Fig. 139: Goat and Tree (also called, *Ram in the Thicket*). Mesopotamian, c. 2600 B.C. Wood, gold, and lapis lazuli, 20 inches.

Fig. 140: The Parable of the Old Man and the Young. 1956. Ink, 120 x 42 inches. *Collection of the Brooklyn Museum, Brooklyn, N.Y.*

Isaacangel, wings that flow from the youth's shoulders, along his sides, and cover the top of the altar like a sacred cloth. The ram stands at the right of *The Altar,* with the legs of Isaac extended beneath the body of the animal and attached to its legs. This physical link identifies Isaac and the ram with each other, as does the placement of the ram over the rectangular block, which becomes a second altar, facing in a different direction—the altar of the ram. *The Altar* is thus a typological image of the Crucifixion: the sacrifice of Isaac is the archetypal sacrifice that prophesies the sacrifice of Christ. It is a visual realization of the Judeo-Christian tradition.

The Altar is a passionate work of art in which physical pain, spiritual suffering, fear, doubt, betrayal, trust, responsibility, high purpose, intense self-awareness, and transcendent selflessness are visually bound together in a single image. Time is compressed into eternal timelessness: Abraham's call and resolution, Isaac's helpless presence, the angel's intervention, and the offering of the ram all appear as if in the airless quiet of the mythic center of the universe, which is both an Inferno of despair and a Sinai of hope. It is the center of consciousness, and of conscience, where many of us, at some crucial moment in our lives, are called upon to face an ultimate test of our moral strength. *The Altar* is a majestic image, an aesthetic, emotional, intellectual, and spiritual unity. In its formal grandeur and simplicity as well as in its content, it is the achievement toward the attainment of which the sculptor has risked his struggle for personal and artistic maturity. It is a climactic statement of Leonard Baskin's perception of artistic purpose.

Pursuing his own vision of art, and life, Baskin has been at odds with the major interests of the contemporary modernist art community. Since the nineteenth century the basic critical assumption about art has been that it must in some explicit way be of its own time: in the long dialogue that Western culture has carried on between the philosophical poles of Eternal Being and Eternal Flux, the presumption has prevailed for the past century and a half—not only about art, of course—that truth travels on the currents of change. Baskin, we have seen, has quite deliberately taken a different route. He has been on "that ancient thoroughfare" that turns and twists but never loses its way, the thoroughfare of humankind on which we all can walk forward looking back and see where we were, in the remote past, "that summer, on that day and hour." He has given a particular shape to his experience of the road, a shape that we have come to recognize as the artist, Leonard Baskin. Our eyes sweep over the now familiar forms —of dead men, of dogs and birds, of artists he has absorbed within himself, of Abraham and Isaac—forms with which he lined the thoroughfare as he walked. But even as we look, the artist has taken his next step.

Fig. 113 c

The Altar. Details of the work in progress in the artist's studio.

Fig. 113 c: Legs of Isaac and the Ram.

Fig. 113 d: Isaac. Fig. 113 e: Abraham.

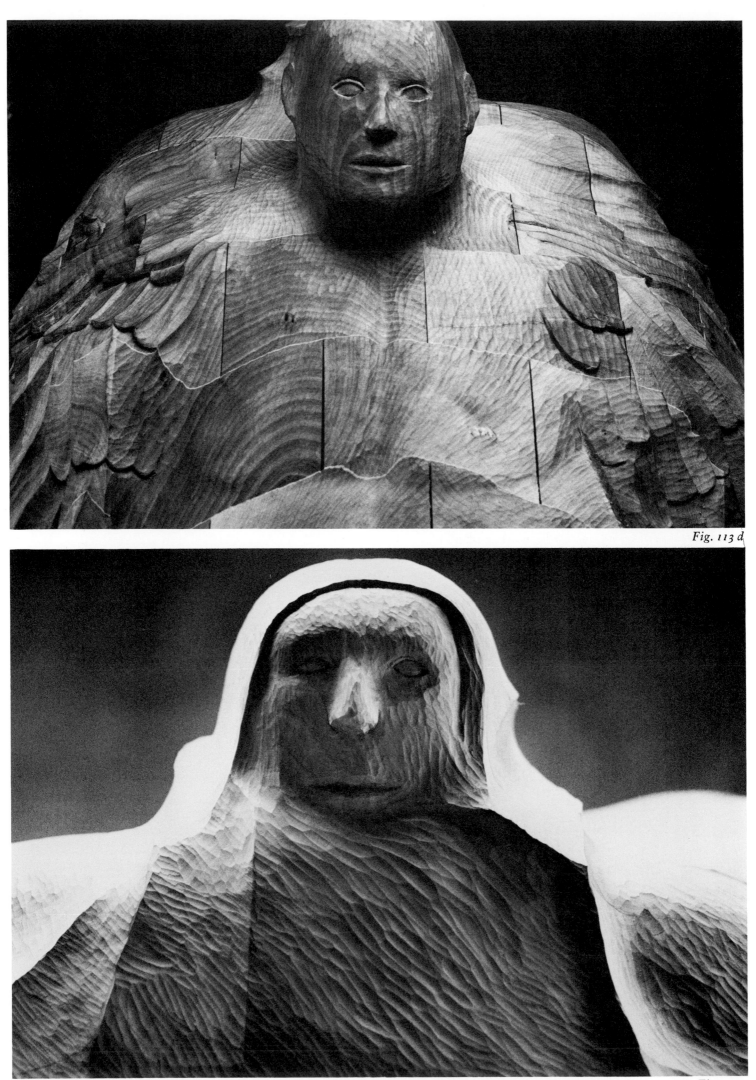

Fig. 113 d

Fig. 113 e

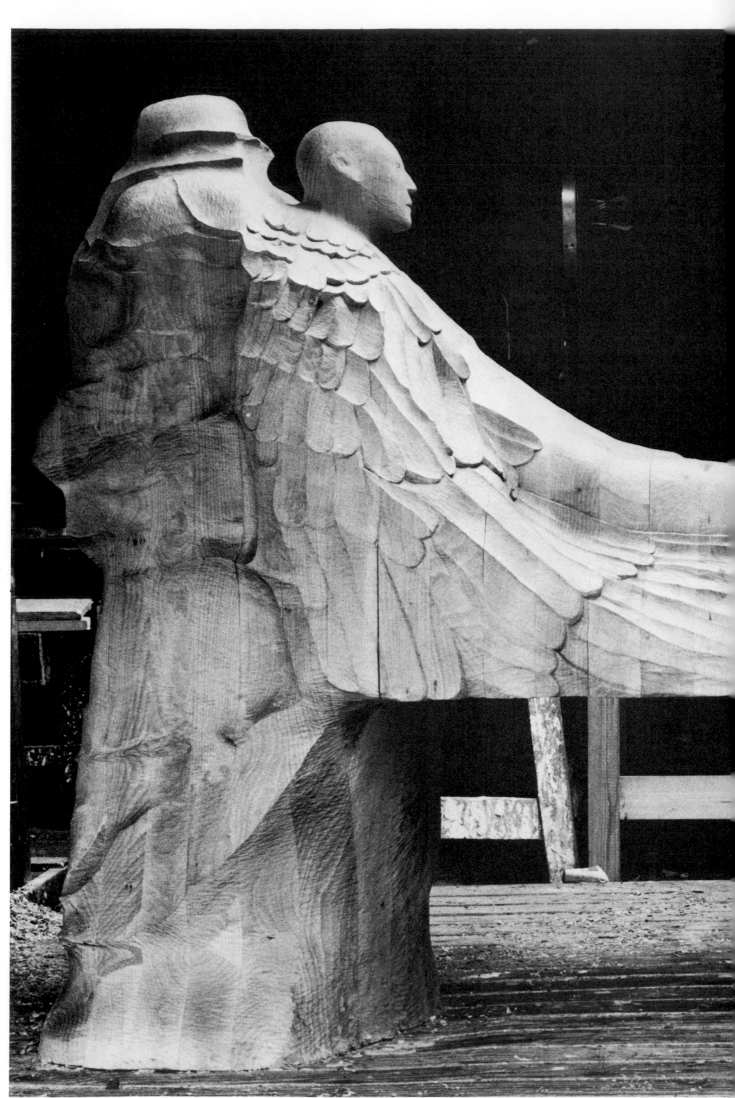

Fig. 113 f

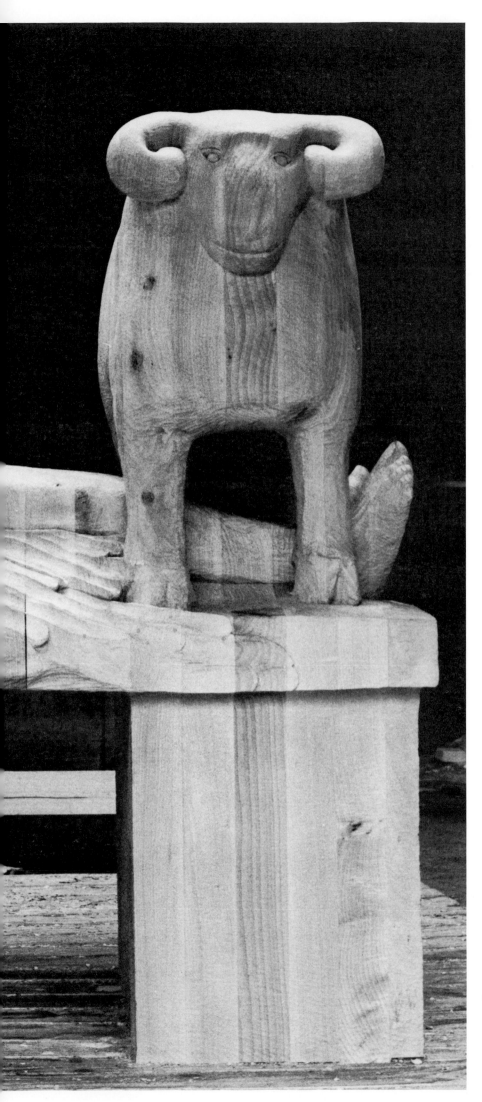

Fig. 113 f: The Altar (detail). Profile view of work in progress in artist's studio.

Overleaf: *Fig. 141, a & b: Ruth and Naomi*. (Two views.) 1978. Bronze, 52 inches.

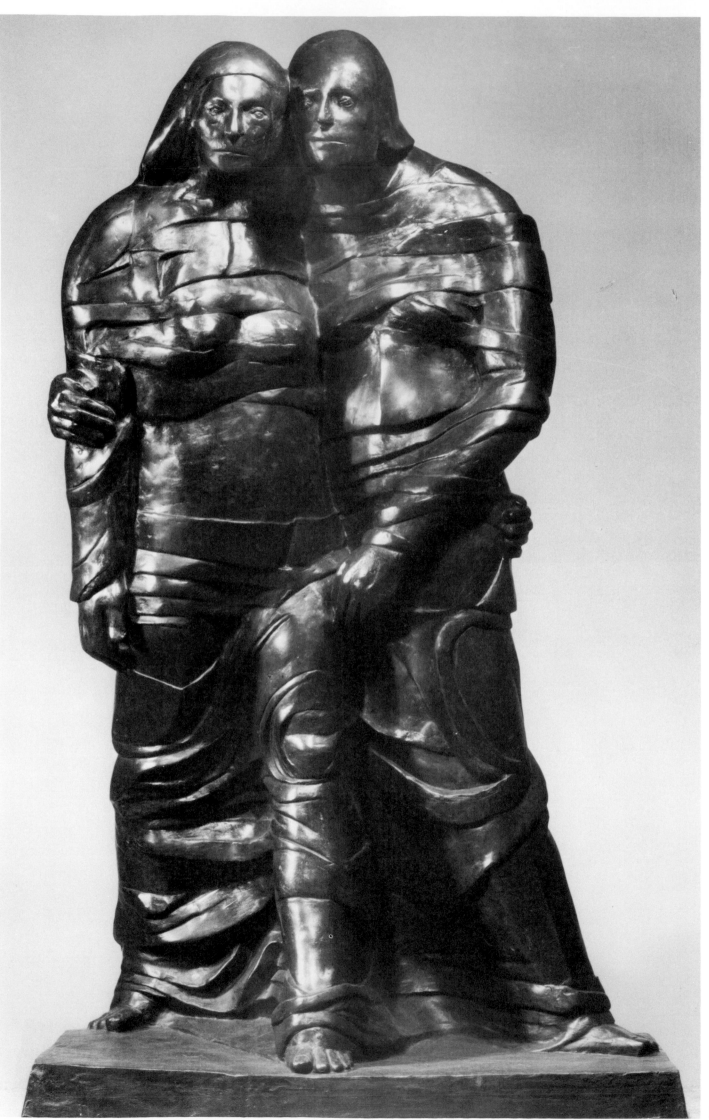

Fig. 141 a

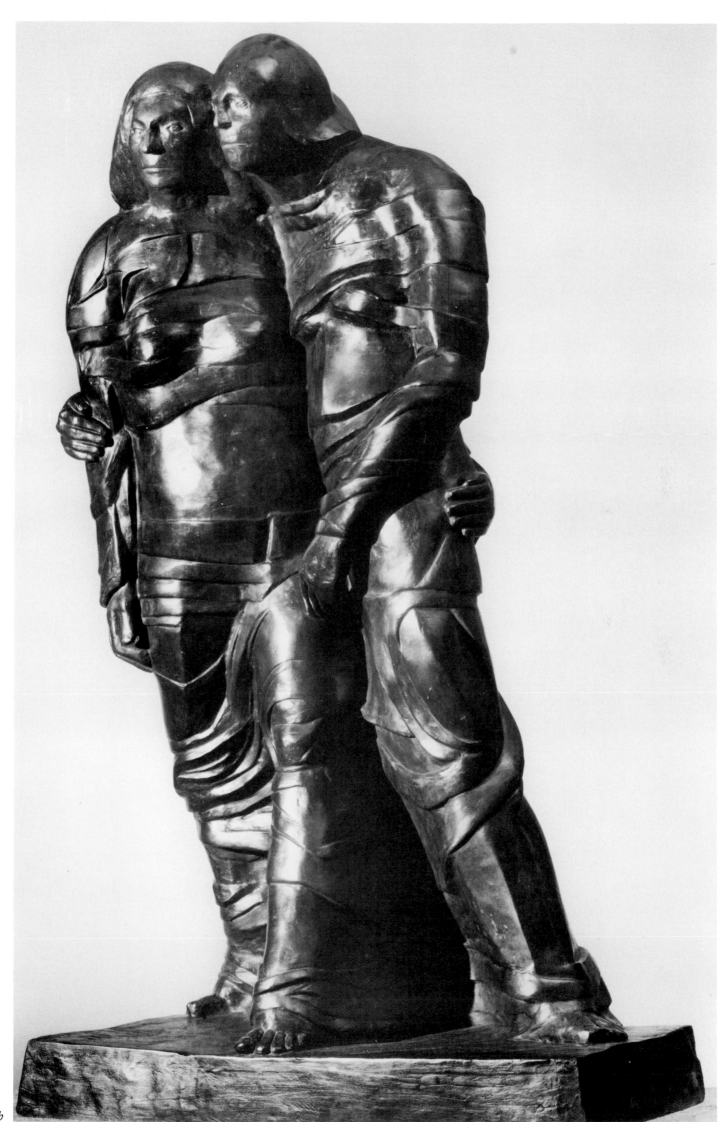

Fig. 141 b

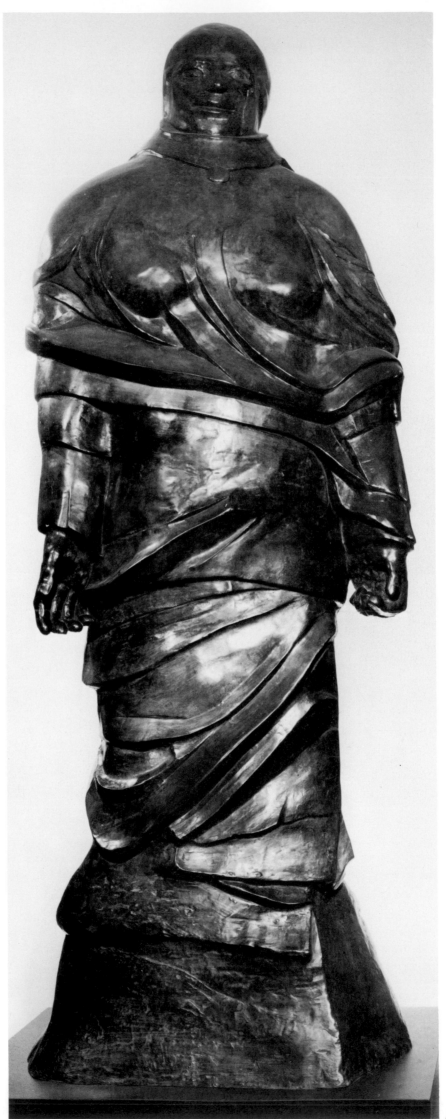

Fig. 142

A F T E R W O R D

Writing a book about a living artist is an exhilarating experience. For my studies of Joseph Stella (1877–1946) and John Trumbull (1756–1843) I had a large quantity of written material on which to base my understanding of those artists' works, and I spent long hours in libraries reading letters and documents of all kinds, trying to reconstruct what had happened and why, hoping to catch hold at last of the elusive mystery of what makes art. I was almost always fascinated, but there were times when I felt frustrated or questions arose for which no answers could be found in the documents. I sometimes thought how pleasant and easy it would be to write about an artist to whom one could go whenever one wanted to know some fact that promised to shed light on his or her art, or gain some interpretive insight about one work or another.

As it turned out, it was not always pleasant and not at all easy. Unlike Stella and Trumbull, Baskin could talk back. We sometimes disagreed sharply about what was significant in his biography, and, as I have indicated in the text, we had long, hard discussions about the expressive affect of some of his works. Does this contradict what I have written in the acknowledgments of this book—that my interviews with Baskin were "a delight"? Not at all: our differences were challenging, and the challenge was part of the delight, far more bracing than merely pleasant or easy. And what I have learned, working with a contemporary artist, is that the power of art is as mysterious to the artist as it is to everyone else—as mysterious as the power of myth or religion with which art is so closely allied.

As myth or religion—one person's myth is another's religion—ancient insights into cosmological and human behavior have persisted through the centuries and have been given ever new physical realizations in the visual arts. In Baskin's *oeuvre*, myth and religion have been strangely and repeatedly conflated, as we have seen in such figures as his *Augur, Isaacangel*, and many others, and, given his convictions about the communal meaning and obligations of art it seems likely that myth and religion will continue to inspire him. In the years ahead we will surely see more female figures and we suspect, looking at his recent *Ruth and Naomi* and the *Large Sibyl* (Figs. 141, 142), that there will someday be a great summarizing work based on the theme of the female form.

But who knows? As I have said above, writing a book about a living artist is exhilarating; partly that excitement comes, I think, from one's knowledge that what has happened is only part of the story, and from one's sense of anticipation that there is still more to come.

Fig. 142: The Large Sibyl. 1977. Bronze, 86 inches.

INTRODUCTION

1. Leonard Baskin, "To Wear Blood Stain with Honor," *Judaism* (1961), p. 294.
2. Roy Pascal, *Design and Truth in Autobiography* (1960), p. 3. Georg Misch, *A History of Autobiography in Antiquity* (1951), pp. 5–7.
3. Leonard Baskin, "On the Nature of Originality," *Show* (August 1963). Also see Dore Ashton's reply to Baskin in *Studio* (1963), pp. 194–197.
4. Quoted in E. R. Dodds, *The Greeks and the Irrational* (1971), p. 238.
5. T. S. Eliot, *The Sacred Wood* (1930), pp. 48–49.
6. Donald B. Kuspit, "Two Critics: Thomas B. Hess and Harold Rosenberg," *Artforum* (September 1978), p. 32.
7. See Paul Ricoeur, *The Symbolism of Evil* (1967), especially pp. 347–357.

P A R T · O N E

CHAPTER ONE · BEGINNINGS

1. Quoted in William J. Richardson, *Heidegger, Through Phenomenology to Thought* (1963), p. 401.
2. Leonard Baskin, "Of Roots and Veins: A Testament," *Atlantic Monthly* (September 1964), p. 65.
3. Educational Alliance Art School, *The History of the Art School*, Retrospective Exhibition, 1963.
4. Baskin, "Of Roots and Veins," p. 67.
5. Paul Cummings, "Interview with Leonard Baskin, April 17, 1969," transcript, Archives of American Art.
6. *Baskin: Sculpture, Drawings, Prints* (1970), p. 2.
7. Baskin, "To Wear Blood Stain with Honor," p. 295.
8. Jane Howard, "Leonard Baskin: Printer, Teacher, Affluent Artist. The Pleasant Pariah," *Life* (January 1964), p. 42.
9. Harry Slochower, *Three Ways of Modern Man* (1969), pp. 140–144.
10. Whitney Museum of American Art exhibition label, "William Carlos Williams and the American Scene, 1920–1940," Whitney Museum, December 12, 1978–February 4, 1979.
11. Wayne Andersen, *American Sculpture in Process: 1930–1970* (1975), p. 35; p. 36 *n.* 36.
12. Lassaw, quoted in Andersen, ibid., p. 35.

CHAPTER TWO · MISSTEPS IN THE RIGHT DIRECTION

1. Dale Roylance, "Leonard Baskin's Gehenna Press," *Art in America* (November–December 1966), p. 56.
2. Garnett McCoy, ed., *David Smith* (1973), p. 22.
3. Andersen, *American Sculpture*, p. 38.
4. *Tribune of Art* (May–June 1948).
5. Baskin's first notice, as a student artist, appeared in Howard Devree's column in *The New York Times*, October 17, 1939.
6. Leonard Baskin, "Notes on Style and Reality," *New Foundations* (Summer 1948), p. 217.

7. Paul Cummings, "Interview with Leonard Baskin, April 17, 1969."
8. Linda Nochlin, *Realism* (1971), p. 13. Baskin, "Notes on Style and Reality," p. 218.
9. Baskin, "Notes on Style and Reality," p. 218.
10. Irving Sandler, *The Triumph of American Painting* (1970), pp. 62, 69.
11. Ibid., p .62.
12. Ibid., p. 63. *Baskin*, p. 21.
13. Peter Selz, *New Images of Man* (1959), p. 35.
14. Leonard Baskin, "The Art of Frasconi," *New Foundations* (Spring 1948), p. 134.
15. *The Brooklyn Museum Bulletin*, Vol. 17, No. 2 (Winter 1956).

CHAPTER THREE · ACHIEVEMENT

1. Ernst Kris, *Psychoanalytic Explorations in Art* (1952), p. 296.
2. *Baskin*, p. 16.
3. *Baskin*, p. 5.
4. A catalogue of Gehenna Press publications was compiled by Stephen Brook, *A Bibliography of the Gehenna Press, 1942–1975* (1976).
5. Katherine Kuh, "New Talent in the U.S.A.," *Art in America* (February 1956), pp. 48–49.
6. Irving Sandler, *Triumph of American Painting*, p. 215.
7. Peter Selz, *New Images of Man*, p. 99.
8. Peter Selz, "The Genesis of 'Genesis,'" *Archives of American Art Journal* (1976), p. 6; quoted from the Archives of American Art Lebrun papers, Baskin to Lebrun, March 10, 1961.
9. *Baskin*, p. 19.
10. Barbara Rose, ed., *Readings in American Art* (1975), p. 135.
11. *Arts*, Vol. 31 (March 1957), p. 53.
12. University of Illinois, *Contemporary American Painting and Sculpture* (1957), introduction by Allen Weller, p. 8. Dore Ashton, "From the 1960s to the Present Day," *The Genius of American Painting*, John Wilmerding, ed. (1973), p. 318.
13. William C. Seitz, *The Art of Assemblage* (1961), p. 92.
14. Alan Fern, *Leonard Baskin* (1970), p. 7. Baskin, "Of Roots and Veins," p. 68.

P A R T · T W O

CHAPTER FOUR · DEATH AND GRIEF

1. Bert Van Bork, *Jacques Lipchitz: The Artist at Work* (1966), pp. 189, 201.
2. Published in *New Foundations* (Spring 1948).
3. Brian O'Doherty, "Leonard Baskin," *Art in America* (Summer 1962), p. 68. David Porter, "Beasts/Shamans, Baskin: The Contemporary Aesthetics of Ted Hughes," *Boston University Journal* (1974), p. 15.
4. *Baskin*, p. 16.
5. Marvin Sadik, "Leonard Baskin" (1972), n.p. *Encyclopedia Judaica*, Vol. 5, p. 1423. *Baskin*, p. 15.

6. Archibald MacLeish, *Figures of Dead Men by Leonard Baskin* (1968), n.p.
7. Charles Baudelaire, *Flowers of Evil* (1955), p. 38.
8. Jane Howard, "Leonard Baskin," p. 38. Selden Rodman, *Conversations with Artists* (1961), p. 173.
9. Yvonne Korshak discusses the theme of death as punishment or reward in her "Suffering in Western Art," *Journal of Dharma* (July 1977). *Newsweek* (October 22, 1962), p. 66. Baskin quotes from *Baskin*, p. 16. See Paul Ricoeur, *The Symbolism of Evil*, especially Chapters I, II, and III, for a suggestive discussion of defilement, guilt, and sin in the Old Testament.
10. Baudelaire, *Flowers of Evil*, p. 39.
11. Anthony Hecht's lines are from his poem "Dichtung und Wahrheit." Frye, *Anatomy of Criticism* (1957), p. 6.
12. Bowdoin College Museum of Art, *Leonard Baskin* (1962), n.p.
13. Izaak Walton, *Lives of John Donne, Sir Henry Wotton, Richard Hooker, George Herbert and Robert Sanderson* (1640). Also see Sir Edmund Gosse, *The Life and Letters of John Donne* (1899).
14. *Encyclopedia Judaica*, Vol. 5, p. 1425.
15. Rocoeur, *Symbolism of Evil*, formulates this issue that confronts modern criticism.
16. Canaday's admiration for Baskin's work is expressed in numerous reviews in *The New York Times* during the 1960s.
17. Ralph Etchepare, "Cranwell Chapel: A History and Critique," *The Well* (May 12, 1967), p. 3.
18. Iconographic sources for Baskin's hanging figures also include drawings by Pisanello and Rembrandt.
19. Bowdoin College Museum of Art, *Leonard Baskin*.
20. Richmond Lattimore, *The Iliad of Homer*, opp. p. 457.
21. Sir Joshua Reynolds, *Discourses on Art* (1965), pp. 137–138.
22. Lines 1014–1023, translation by Robert Bagg.
23. Sadik, *Leonard Baskin*.
24. For *Fortuna* see *Inferno*, VII: 88–96; "pregnant veiling," IX: 63–65, in Dante Alighieri, *The Divine Comedy*, translated by Thomas G. Bergin.
25. Theodore de Banville, "Le Salon de 1861," *Revue Fantaisiste* (Paris) 2: 164–175 (June 15, 1861), quoted by Harold Joachim in Museum of Modern Art, *Odilon Redon, Gustave Moreau, Rodolphe Bresdin* (1962), p. 149.

CHAPTER FIVE · FIGURES OF EVIL

1. University of Illinois, *Contemporary American Painting and Sculpture*, Artist's statement, p. 162. "Though I despise . . ." Baskin, "Of Roots and Veins," p. 68.
2. Baskin, "The Necessity for the Image," *Talks on Art 2* (1961), n.p. Reprinted in *Atlantic Monthly* (April 1961), pp. 73–76.
3. W. J. Strahan, *Towards Sculpture* (1976), pp. 227–28.
4. Jane Howard, "Leonard Baskin," p. 42.
5. Baskin, "Of Roots and Veins," p. 66.
6. *Baskin*, p. 16.
7. Ibid., p. 19.

8. I wish to thank Yvonne Korshak for drawing my attention to the Lilith relief. *The Jerome Biblical Commentary* (1968), Vol. 1, p. 280, ¶59. On the various cultural attitudes to owls, and their representation in art, see Faith Medlin, *Centuries of Owls* (1967).
9. Jane Howard, "Leonard Baskin," p. 38.
10. See illustrations in Roland Penrose, *The Sculpture of Picasso* (1967), pp. 120, 127, 135, 140, 141.
11. In Isaiah (34:11) the Lord promises to lay waste the lands of Israel's enemies: "But the pelican and the bittern shall possess it, / and the owl and raven shall dwell therein." I am grateful to Yvonne Korshak for her insightful response to *Dead Crow*, which led her to draw the Malamud story to my attention.
12. Albert E. Elsen, *The Partial Figure in Modern Sculpture from Rodin to 1969* (1969), p. 15.
13. Elizabeth Holt, *A Documentary History of Art* (1957), Vol. I, p. 21.
14. Elsen, *Partial Figure in Modern Sculpture*, p. 57. J. A. Schmoll (gen. Eisenwerth), *Das Unvollendete als Künstlerische Form* (1959), p. 121. Erich Neumann, *The Archetypal World of Henry Moore* (1959), p. 119.
15. *Jerome Biblical Commentary*, Vol. I, p. 297, ¶37.

CHAPTER SIX · HOMAGE

1. The Museum of Modern Art, *Odilon Redon, Gustave Moreau, Rodolphe Bresdin*, p. 161. Baskin quoted by Roylance, "Leonard Baskin's Gehenna Press," p. 56. Jean Hagstrum, *William Blake* (1964), p. 104.
2. For Blake on Reynolds, see Robert Goldwater and Marco Treves, eds., *Artists on Art* (1947), pp. 261–62. Baskin, "On the Nature of Originality."
3. David V. Erdman, *Blake: Prophet Against Empire* (1969), pp. 407–8.
4. Baskin quoted on Barlach in Museum Boymans-van Beuningen, *Leonard Baskin: Sculptuur, Tekeningen, Grafick* (1961). "Streak the face like tears," Peter Selz on *Barlach Dead* in *Leonard Baskin: Sculptuur, Tekeningen, Grafick*, p. 28.
5. Raphael Soyer, *Diary of an Artist* (1977), pp. 76–77.
6. Kramer on Eakins, *The New York Times*, June 5, 1977, Section D, p. 27. Baur, *Revolution and Tradition in Modern American Art* (1958), p. 81.
7. C. Day Lewis on Wilfred Owen in Wilfred Owen, *The Collected Poems of Wilfred Owen* (1964), p. 11. Owen quoted in ibid., p. 17.
8. Lewis, *The Collected Poems of Wilfred Owen*, p. 44.

CHAPTER SEVEN · INSIGHT AND INSPIRATION

1. The University Art Museum, University of California, Berkeley, *Selection 1967: Recent Acquisitions in Modern Art* (1967), pp. 110–11.
2. Baskin, "To Wear Blood Stain with Honor," p. 295.
3. C. Day Lewis, *The Collected Poems of Wilfred Owen*, p. 42.

This list comprises all sculptures made by Leonard Baskin between 1952 and the spring of 1978 and includes a few recorded works executed earlier. The date in parenthesis after the collector's name gives the most recently recorded date of ownership. Height (or length, for horizontal works) is given for sculpture in the round, height before width for reliefs.

1938–1951

Male Figure, Arms Upraised. c. 1938. Wood, 46 inches. Coll.: Estelle and Jay Sam Unger, Brooklyn, N.Y. (1978).

Woman Playing Cello. c. 1938. Wood, 10¼ inches. Coll.: Estelle and Jay Sam Unger, Brooklyn, N.Y. (1978).

Bust of Pearl Baskin (married Norman Rabinowitz). c. 1940. Alabaster, 14 inches. Coll.: Anonymous.

Blind Woman. Before 1949. Wood. Coll.: Mr. and Mrs. L. Friedman (1948). Reference: *New Foundations*, Vol. 2, No. 1, Fall 1948.

Death Head of Lorca. Before 1949. Stone, 10 inches. Coll.: Gloria and Bernard Beckerman, New York, N.Y. (1978).

Mourning Mother. Before 1949. Wood. Coll.: Mr. Julius Stien (1949). Reference: *New Foundations*, Vol. 2, No. 1, Fall 1948.

No More War. Before 1949. Coll.: Unknown. Reference: *Tribune of Art*, No. 12, Feb.–Mar., 1948.

Oedipus Blind. c. 1946. Clay, 9½ inches. Coll.: Gloria and Bernard Beckerman, New York, N.Y. (1978).

Pelle the Conqueror. Before 1949. Wood, 18 inches. Coll.: Dr. and Mrs. Alan B. Tulipan, Ardsley, N.Y. (1978).

Prometheus. Before 1949. Wood. Coll.: Unknown. Reference: *New Foundations*, Vol. 2, No. 1, Fall 1948.

Thief—Crucified with Christ. Before 1949. Wood. Coll.: Mr. Arthur Schiff, New York, N.Y. (1978).

Torso. C. 1943. Wood, 13¼ inches. Coll.: Gloria and Bernard Beckerman, New York, N.Y. (1978).

Wounded Soldier. Before 1949. Wood. Coll.: Unknown. Reference: *New Foundations*, Vol. 2, No. 1, Fall 1948.

Seated Sick Woman. 1950. Terra cotta. Coll.: Unknown. Reference: the artist.

Dead Man. 1951. Bronze, 22 inches (approx. length). Coll.: Mr. and Mrs. Herman Schickman, New York, N.Y. (1978).

Dead Woman. 1951. Bronze. Coll.: Unknown. Reference: the artist.

Sleeping Man (formerly *Dead Man*). 1951. Bronze, 22½ inches (length). Coll.: Harry I. Rand, New York, N.Y. (1978).

1952–c. 1955

Rodolphe Bresdin. 1954. Brazilian rosewood, 12¼ inches. Coll.: Mr. Leon Pomerance, New York, N.Y. (1978).

Classic Head. 1952–1955. Limestone, 3½ inches. Coll.: Unknown. Reference: Worcester Art Museum, catalogue, *Leonard Baskin: Sculpture, Drawings, Woodcuts*, Nov. 30, 1956–Jan. 1, 1957, No. 12.

Dead Man. 1952. Bronze, 18 inches (length). Coll.: Lisa Baskin, Little Deer Isle, Me. (1978).

Dead Man. 1952. Bronze, 21 inches (length). Coll.: Lisa Baskin, Little Deer Isle, Me. (1978).

Dead Man. 1952. Bronze, 7½ inches (length). Coll.: Dr. and Mrs. Seymour Lifschutz, New Brunswick, N.J. (1978); Anne Ratner, New York, N.Y. (1978); Rita and Edwin P. Rome, Philadelphia, Pa. (1978).

Dead Man. 1952–1955. Bronze, 22½ inches (length). Coll.: Mr. and Mrs. Howard L. Kaye, Philadelphia, Pa. (1978).

Effigy of a Fascist. 1952–1955. Oak, 27 inches. Coll.: Dr. and Mrs. Robert G. Gardner, Boston, Mass. (1957).

Esther, 1952. Carved wood, 30½ inches. Coll.: Dr. John Esterley, Baltimore, Md. (1961).

Hanging Man. 1952–1955. Bronze, 8 inches. Coll.: Lisa Baskin, Little Deer Isle, Me. (1978); Anne Ratner, New York, N.Y. (1978).

Man with Dead Bird. 1954. Walnut, 63 inches. Coll.: Museum of Modern Art, New York, N.Y. (1978).

1955

Head of Blake. 1955. Bronze, 7 inches. Coll.: The Baltimore Museum of Art, Baltimore, Md.: museum purchase, Mrs. D'Arcy Paul Bequest Fund and Frederic W. Cone Fund (1978); Dr. and Mrs. Malcolm W. Bick, Longmeadow, Mass. (1978); Mrs. Sidney Kingsley (1958); Mr. Jay C. Leff, Uniontown, Pa. (1956); Mrs. Saul Sandinsky, Philadelphia, Pa. (1957); Mrs. Herbert Singer (1957); Miss Faith Stern, New York, N.Y. (1978).

Boy. 1955. Oak, 11½ inches. Coll.: Mr. Sampson Fields (1957).

Dead Man. 1955. Bronze, 15 inches (length). Coll.: Lisa Baskin, Little Deer Isle, Me. (1978).

Dead Man. 1955. Bronze, 17 inches (length). Coll.: Lisa Baskin, Little Deer Isle, Me. (1978).

Dead Man. 1955. Bronze, 18 inches (length). Coll.: Lisa Baskin, Little Deer Isle, Me. (1978).

John Donne in His Winding Cloth. 1955. Bronze, 22 inches. Coll.: Rabbi and Mrs. Bernard Baskin, Hamilton, Ontario, Canada (1978); Hirshhorn Museum and Sculpture Garden, Washington, D.C. (1978); Emma and Sidney Kaplan, Northampton, Mass., "cast iron" (1978); Mr. Earle Ludgin, Hubbard Woods, Ill. (1978); Mr. Stanley J. Winkelman (1967); Mr. and Mrs. Arthur Vershbow, Newton Center, Mass. (1962).

Fat Man with Folded Arms. 1955. Oak, 16 inches. Coll.: Mrs. Susan Esty, New York, N.Y. (1978).

Glutted Death. 1955. Stone, 15½ inches. Coll.: The Weintraub Gallery, New York, N.Y. (1978).

Little Fat Man. 1955. Bronze, 9 inches. Coll.: Mr. and Mrs. B. J. Cutler, Washington, D.C. (1978); Judy Pitt, Leonia, N.J. (1978).

The Quiet Man. 1955. Walnut, 8 inches. Coll.: Lisa Baskin, Little Deer Isle, Me. (1978).

Sebastian. 1955. Bronze, 13 inches. Coll.: Mr. Alan Brandt, New York, N.Y. (1978).

Thistle. 1955. Plaster relief, 8 inches. Coll.: Mr. Harold Hugo, Meriden, Conn. (1978).

Walking Man. 1955. Oak, 18¼ inches. Coll.: Dr. and Mrs. Malcolm W. Bick, Longmeadow, Mass. (1978).

1956

Study for Rodolphe Bresdin. 1956. Bronze, 5 inches. Coll.: Anonymous; Mrs. Susan Esty, New York, N.Y. (1978); Mr. and Mrs. Robert G. Gardner, Boston, Mass.; Judy Pitt, Leonia, N.J. (1978).

Bust of a Dead Man. 1956. Bronze, 14½ inches. Coll.: Boris Mirski Gallery, Boston, Mass. (1961).

Dead Man. 1956. Bronze, 26½ inches (length). Coll.: Lisa Baskin, Little Deer Isle, Me. (1978); Emma and Sidney Kaplan, Northampton, Mass. (1978).

Dead Man. 1956. Bronze, 31 inches (length). Coll.: Lisa Baskin, Little Deer Isle, Me. (1978); Worcester Art Museum, Worcester, Mass., gift of Dr. Allan Roos and Mrs. B. M. Roos (1978).

Dead Man. 1956. Bronze, 18 inches (length). Coll.: Lisa Baskin, Little Deer Isle, Me. (1978).

Dead Man with Folded Arms. 1956. Bronze, 14 inches (length). Coll.: Lisa Baskin, Little Deer Isle, Me. (1978).

Dead Man. 1956. Bronze, 40 inches (length). Coll.: Lisa Baskin, Little Deer Isle, Me. (1978).

Dying Man. 1956. Bronze, 16 inches (length). Coll.: Mrs. Morton Baum, New York, N.Y. (1978); Mr. Jules Bricken (1959).

Esther. 1956. Bronze, 8½ inches. Coll.: Brooklyn Museum, Brooklyn, N.Y. (1978); Rabbi and Mrs. Bernard Baskin, Hamilton, Ontario, Canada (1978); Hirshhorn Museum and Sculpture Garden, Washington, D.C. (1978); Mrs. Martin Jacobs, New York, N.Y. (1963); Alfred and Betty Landau, Rockville Centre, N.Y. (1978); Dr. and Mrs. Seymour Lifschutz, New Brunswick, N.J. (1978); Mr. I. London (1957); Anne Ratner, New York, N.Y. (1978); Selden Rodman, Oakland, N.J. (1978); Mr. Joseph Rudick (1963); Mr. and Mrs. Herman Schickman, New York, N.Y. (1978).

The Great Stone Dead Man. 1956. Limestone, 70 inches. Coll.: Lisa Baskin, Little Deer Isle, Me. (1978).

The Guardian. 1956. Limestone, 27 inches. Coll.: Hirshhorn Museum and Sculpture Garden, Washington, D.C. (1978).

Hanged Man. 1956. Bronze, 7½ inches. Coll.: Anonymous; Dr. and Mrs. Seymour Lifschutz, New Brunswick, N.J. (1978); Rita and Edwin Rome, Philadelphia, Pa. (1978); Mr. Jacob Schulman, Gloversville, N.Y. (1978); Mr. and Mrs. Louis Smith, Northampton, Mass. (1978).

Poet Laureate. 1956. Bronze, 9 inches. Coll.: Anonymous; Mrs. Henry Attias, Beverly Hills, Cal. (1957); Murray and Cyd Braun, Brooklyn, N.Y. (1978); Mr. and Mrs. Jerry Goldberg (1959); Hirshhorn Museum and Sculpture Garden, Washington, D.C. (1978); Neuberger Museum, State University of New York at Purchase, Purchase, N.Y. (1978); Mr. and Mrs. Louis Smith, Northampton, Mass. (1978).

Queen Vashti. 1956. Bronze, 4¼ inches. Coll.: Lisa Baskin, Little Deer Isle, Me. (1978); Alfred and Betty Landau, Rockville Centre, N.Y. (1978); Museum of Fine Arts, Boston, Mass. (1978); Selden Rodman, Oakland, N.J. (1978).

Seated Fat Man. 1956. Bronze, 12½ inches. Coll.: Professor and Mrs. Julius Held, Old Bennington, Vt. (1978); Dr. and Mrs. Malcolm W. Bick, Longmeadow, Mass. (1978).

Seated Man. 1956. Bronze, 13½ inches. Coll.: Murray and Cyd Braun, Brooklyn, N.Y. (1978); Mr. Sampson Fields (1957); Joseph Grippi, New York, N.Y. (1959); Mrs. Herbert C. Morris (1959).

Youth. 1956. Oak, 49 inches. Coll.: F. M. Hall Collection, University of Nebraska, Lincoln, Neb. (1978).

1957

Dead Man. 1957. Bronze, 36 inches (length). Coll.: Anonymous; Lisa Baskin, Little Deer Isle, Me. (1978); Grey Art Gallery and Study Center, New York University, New York, N.Y. (1978).

Poet Laureate. 1957. Cherry, 36 inches. Coll.: Elvehjem Art Center, Madison, Wis. (1978).

Standing Man. c. 1957. Wood, 15¾ inches. Coll.: Mrs. Susan Esty, New York, N.Y. (1978).

1958

Crow. 1958. Bronze relief, 12 x 17¼ inches. Coll.: Max Blatt and Sophie Maslow, New York, N.Y. (1978); The Detroit Institute of Arts, gift of Mr. and Mrs. Walter B. Ford (1978); Hirshhorn Museum and Sculpture Garden, Washington, D.C. (1978); Mr. Philip Strauss, Larchmont, N.Y. (1978); Alan H. Temple, Scarsdale, N.Y. (1978).

Dog. c. 1958. Bronze relief, 7 x 3½ inches. Coll.: Lisa Baskin, Tiverton, Devon, England (1978).

Dog and Thistle. 1958. Bronze relief, 8½ x 8½ inches. Coll.: Mrs. S. Bochner (1960).

Grieving Angel. 1958. Walnut, 81 inches. Coll.: Munson-Williams-Proctor Institute, Utica, N.Y. (1978).

Isaac. 1958. Bronze relief, 23 x 19 inches. Coll.: Rabbi and Mrs. Bernard Baskin, Hamilton, Ontario, Canada (1978); Lawrence Fleischman, New York, N.Y. (1978); J. L. Hudson Company, Detroit, Mich. (1965); Krannert Art Museum, Champaign, Ill. (1978); University of Wisconsin, Elvehjem Art Center, Madison, Wis. (1978).

Love Me Love My Dog. 1958. Bronze relief, 6½ x 8 inches. Coll.: Lisa Baskin, Little Deer Isle, Me. (1978); Mrs. Grace Brandt, New York, N.Y. (1978); Mrs. Terry Dintenfass, New York, N.Y. (1959); Mr. Lawrence Fleischman, New York, N.Y. (1978); Dr. and Mrs. Seymour Lifschutz, New Brunswick, N.J. (1978); Mrs. Margarete Schultz, New York, N.Y. (1978).

Homage to Gustav Mahler. 1958. Bronze relief, 21 x 11 inches. Coll.: Professor Alfred Appel, Jr., Wilmette, Ill.; Dr. and Mrs. Malcolm W. Bick, Longmeadow, Mass. (1978); Lisa Baskin, Tiverton, Devon, England (1978); Mr. Nathan Chaikin (1962); Mr. and Mrs. Kurt H. Grunebaum, Harrison, N.Y.

(1978); Mr. Robert Livingston (1960); Steven R. Rand, New York, N.Y. (1978); Anne Ratner, New York, N.Y. (1978).

Owl. 1958. Bronze relief, 8 x 10½ inches. Coll.: Mr. Lawrence Fleischman, New York, N.Y. (1978); Neva Krohn (Benjamin Galleries), Chicago, Ill. (1978).

Ricordo di Napoli. 1958. Limestone, 31 inches. Coll.: Lisa Baskin, Little Deer Isle, Me. (1978).

Two Dogs. 1958. Bronze relief, 5½ x 7½ inches. Coll.: Lisa Baskin, Little Deer Isle, Me. (1978); Mr. and Mrs. George Staempfli, New York, N.Y. (1978).

Walking Angel. 1958. Bronze relief, 12 x 8 inches. Coll.: Mr. Robert L. Livingston (1959).

1959

Barlach, Study for Portrait. 1959. Bronze, 6 inches. Coll.: Mr. and Mrs. Louis Smith, Northampton, Mass. (1978); Hirshhorn Museum and Sculpture Garden, Washington, D.C. (1978).

Barlach Dead. 1959. Poplar, 18½ inches. Coll.: Dr. and Mrs. Seymour Lifschutz, New Brunswick, N.J. (1978).

Festina Lente. 1959. Bronze relief, 6 x 3½ inches. Coll.: Anonymous; Miss Moni Adams (1960); Dr. and Mrs. Malcolm W. Bick, Longmeadow, Mass. (1978); Max Blatt and Sophie Maslow, New York, N.Y. (1978); Grace Borgenicht Gallery, New York, N.Y. (1978): Mr. Edward T. Cone, Princeton, N.J. (1978); Mr. and Mrs. Harry Copen, New York, N.Y. (1978); Mr. Ambrose Doskow, New York, N.Y. (1978); Mrs. Susan Esty, New York, N.Y. (1978); Mr. Lawrence Fleischman, New York, N.Y. (1978); Mr. Robert Gallo, New York, N.Y. (1978); Mrs. William Goodman, New York, N.Y. "unlocated" (1978); Mr. Richard Hofstadter (1960); Miss Dorothy Knowles, New York, N.Y. (1978); Mr. Herbert Kohl, London, England (1960); Mrs. Josiah Marvel (1960); Mr. H. C. Milholland, Sarasota, Fla. (1960); Dr. William H. Miller (1960); Mrs. George Rentschler, New York, N.Y. (1960); Mrs. Allan H. Rosenthal, New York, N.Y. (1978); Mrs. Margarete Schultz, New York, N.Y. (1978); Mr. and Mrs. George Staempfli, New York, N.Y. (1978); Mr. and Mrs. Lester Brown Werneck, Longmeadow, Mass. (1978).

Glutted Death. 1959. Bronze relief, 16½ x 8 inches. Coll.: Anonymous; Barbara Babcock, New York, N.Y. (1960); Mr. Arnold H. Maremont, Chicago, Ill. (1978); Barbara B. Millhouse, New York, N.Y. (1978); Mr. Arnold Perl (1963).

Homage to the Un-American Activities Committee. 1959. Bronze relief, 11½ x 12 inches. Coll.: Mr. Albert Arenberger, Highland Park, Ill. (1960); Dr. and Mrs. Malcolm W. Bick, Longmeadow, Mass. (1978); Max Blatt and Sophie Maslow, New York, N.Y. (1978); Ed Dickson of Houston, Chicago, Ill. (1978); Mr. Abraham Friedman (1964); Dr. and Mrs. Milton and Madeleine Gardner, Watermill, N.Y. (1978); Dr. Wilfred Hulse (1960); Jeremie Rockwell Gardiner Knott, Vancouver, B.C., Canada (1978); Ms. Dorothy Knowles,

New York, N.Y. (1960); Mr. and Mrs. A. S. Lane, Riverdale, N.Y. (1978); Smith College Museum of Art, Northampton, Mass. (1978); Mr. Walter Werner, New York, N.Y. (1978).

In Memory of Louis Black. 1959. Bronze relief, 8¼ x 17¼ inches. Coll.: Lisa Baskin, Tiverton, Devon, England (1978); Professor and Mrs. Julius Held, Old Bennington, Vt. (1978); Mr. William Bright Jones, New York, N.Y. (1978); Mr. Jay C. Leff, Uniontown, Pa. (1960); Dr. and Mrs. Seymour Lifschutz, New Brunswick, N.J. (1978); Anne Ratner, New York, N.Y. (1978); Smith College Museum of Art, Northampton, Mass. (1978).

Lazarus. 1959. Bronze, 22 inches. Coll.: Mr. and Mrs. Lawrence A. Fleischman, New York, N.Y. (1961).

Lazarus. 1959. Bronze, 30½ inches. Coll.: Professor Alfred Appel, Jr., Wilmette, Ill.; Lisa Baskin, Little Deer Isle, Me. (1978); Mr. Leo Lang, Blue Point, N.Y. (1978); Dr. and Mrs. Seymour Lifschutz, New Brunswick, N.J. (1978); Mr. Selden Rodman, Oakland, N.J. (1978); Williams College, Williamstown, Mass. (1978).

Lazarus. 1959. Plaster, painted bronze, 30½ inches. Coll.: Emma and Sidney Kaplan, Northampton, Mass. (1978).

The Moon of the Fools of Chelm. 1959. Bronze relief, 6 x 5½ inches. Coll.: Mrs. Nathan Borgenicht (1960); Mrs. Carroll Cartwright (1960); Mr. and Mrs. Harry Copen, New York, N.Y. (1978); Mrs. Terry Dintenfass, New York, N.Y. (1978); Mr. Armand Erpf, New York, N.Y. (1960); Mrs. Susan Esty, New York, N.Y. (1978); Mr. David Finn (1960); Mr. R. Gleitman (1960); Mrs. Milton Handler (1960); Mr. Peter Hanson (1960); Mr. Harvey Kaplan, Chicago, Ill. (1978); Mrs. Katharine Kuh, New York, N.Y. (1978); The Albert A. List Family Collection, Greenwich, Conn. (1978); Mrs. Eliot Noyes, New Canaan, Conn. (1978); Mr. Allan Rosenthal, New York, N.Y. (1960); Mr. Jacob Schulman, Gloversville, N.Y. (1978); Grete Schultz (1960); Monroe Wheeler, Rosemont, N.J. (1960); Estelle and Jay Sam Unger, Brooklyn, N.Y. (1978).

One-Legged Man. Bronze, 9¼ inches. Coll.: Mr. and Mrs. Louis Smith, Northampton, Mass. (1978).

Owl. 1959. Wood, 20¾ inches. Coll.: Mr. and Mrs. Jacob M. Kaplan, Easthampton, N.Y. (1978).

Seated Man with Owl. 1959. Cherry, 30 inches. Coll.: Smith College Art Museum, Northampton, Mass. (1978).

Standing Figure. 1959. Wood, 33 inches. Coll.: Mr. Jacob Schulman, Gloversville, N.Y. (1978).

Thistle. 1959. Bronze relief, 9½ x 9 inches. Coll.: De Cordova and Dana Museum and Park, Lincoln, Mass. (1978); Lawrence Fleischman, New York, N.Y. (1978).

Thistle. 1959. Bronze relief, 22 x 16 inches. Coll.: Mr. Robert Solotaire, Irving-on-Hudson, N.Y. (c. 1963); Dr. and Mrs. Malcolm W. Bick, Longmeadow, Mass. (1978).

1960

Thomas Eakins. 1960. Maple, 27½ inches. Coll.: Hirsh-

horn Museum and Sculpture Garden, Washington, D.C. (1978).

Head. c. 1960. Walnut, 8½ inches. Coll.: Unknown. Reference: Exhibited, The Museum, George Peabody College for Teachers, Nashville, Tenn. (1960).

Man with Crossed Legs. c. 1960? Wood. Coll.: Boris Mirski Gallery, Boston, Mass. (1965).

Man with Owl. 1960. Walnut, 19 inches. Coll.: Mr. and Mrs. Herman D. Schickman, New York, N.Y. (1978).

Oppressed Man. 1960. Painted pine, 31 inches. Coll.: Whitney Museum of American Art, N.Y. (1978).

Owl. 1960. Bronze, 20½ inches. Coll.: Mr. and Mrs. Anthony Dias Blue, New York, N.Y. (1978); Chase Manhattan Bank, New York, N.Y. (1961); Hirshhorn Museum and Sculpture Garden, Washington, D.C. (1978); The Albert A. List Family Collection, Greenwich, Conn. (1978); Mr. and Mrs. Meyer Potamkin (1979); Mr. and Mrs. Max Wasserman, Newton, Mass. (1966); Whitney Museum of American Art, New York, N.Y. (1978).

Owl and Pomegranate. Bronze, 6½ inches. Coll.: Mr. Harold Hugo, Meriden, Conn. (1978); Mrs. Mervin Jules; Alfred and Betty Landau, Rockville Centre, N.Y. (1978).

Warrior. 1960. Walnut, 72 inches. Coll.: The Albert A. List Family Collection, Greenwich, Conn. (1978).

Young Man. 1960. Cherry, 61 inches. Coll.: Dr. and Mrs. Malcolm W. Bick, Longmeadow, Mass. (1978).

1961

Birdman. 1961. Bronze, 15 inches. Coll.: Dr. Herbert J. Kayden, New York, N.Y. (1978).

Birdman (Oval). 1961. Bronze relief, 13 x 8½ inches. Coll.: Samuel Josefowitz; Mr. Herbert Goldstone, New York, N.Y. (1978); Alfred and Betty Landau, Rockville Centre, N.Y. (1978); Mrs. G. MacCulloch Miller, New York, N.Y. (1978); Smith College Museum of Art, Northampton, Mass. (1978); Mr. Vernon Wagner (1962).

Birdman (Vertical). 1961. Bronze relief, 21 x 12½ inches. Coll.: Anonymous; Mrs. Martin D. Jacobs, New York, N.Y. (1978).

Dead Crow (Horizontal Bird). 1961. Bronze relief, 19 x 40 inches. Coll.: Lisa Baskin, Little Deer Isle, Me. (1978); Mr. and Mrs. Arthur Magill, Greenville, S.C. (1978); Whitney Museum of American Art, New York, N.Y. (1978).

Death. 1961. Bronze, 20 inches (length). Coll.: Mr. Edward Albee, New York, N.Y. to Grey Art Gallery and Study Center, New York University, New York, N.Y. (1978); University of Wisconsin, Elvehjem Art Center, Madison, Wis. (1978).

Death Bird. 1961. Bronze, 31½ inches. Coll.: Carnegie Institute, Pittsburgh, Pa. (1978).

Dentate Art Nouveau Flower. 1961. Bronze, 9 inches (diameter). Coll.: Lisa Baskin, Little Deer Isle, Me., (1978); Dr. and Mrs. Seymour Lifschutz, New Brunswick, N.J. (1978); Mr. William Bright Jones, New York, N.Y. (1978); Mr. and Mrs. Edward J. Ross, New York, N.Y. (1978).

Eakins. 1961. Copper relief, 12¼ x 8½ inches. Coll.: Professor Alfred Appel, Jr., Wilmette, Ill.; Mr. Lawrence Fleischman, New York, N.Y. (1978); Emma and Sidney Kaplan, Northampton, Mass. (1978); Dr. Joseph Klein (1975); Mr. Theodor Siegl; Mrs. Rheta Sosland, Shawnee Mission, Kan. (1978); Mr. Murray Tinkelman, Peekskill, N.Y.

Great Bronze Dead Man. 1961. Bronze, 72 inches. Coll.: Smith College Museum of Art, Northampton, Mass. (1978).

Reclining Dog. 1961. Bronze relief, 10½ x 5¾ inches. Coll.: Lisa Baskin, Tiverton, Devon, England (1978).

Seated Birdman. 1961. Bronze, 35 inches. Coll.: Anonymous; Museum of Modern Art, New York, N.Y. (1978); Mr. and Mrs. Herman Schickman, New York, N.Y. (1978).

Seated Woman. 1961. Oak, 54 inches. Coll.: Pennsylvania Academy, Philadelphia, Pa. (1978).

Standing Crow. 1961. Bronze relief, 7½ x 6¼ inches. Coll.: Unknown.

1962

Armored Man. 1962. Birch, 29 inches. Coll.: The New School for Social Research, New York, N.Y. (1978).

Benevolent Angel. 1962. Birch, 29¼ inches. Coll.: Mr. Jacob Schulman, Gloversville, N.Y. (1978).

Homage to Blake. 1962. Bronze, 16 inches. Coll.: Mr. Lawrence Karter, New York, N.Y. (1963); Dr. and Mrs. Jost J. Michelsen, Boston, Mass. (1978); Mr. and Mrs. Max Wasserman, Newton, Mass. (1966).

Bouquet. 1962. Bronze, 14¼ x 4½ inches. Coll.: Walker Art Museum, Bowdoin College, Brunswick, Me. (1978).

Crow Man. 1962. Walnut, 30¼ inches. Coll.: Mr. Edward Bragaline, New York, N.Y. (1978).

Dead Bird (Small). 1962. Bronze, 18 inches (length). Coll.: Mr. and Mrs. Joseph Greenberg, Great Neck, N.Y. (1978).

Dead Bird (Large). 1962. Bronze, 24 inches (length). Coll.: University Art Collections, University of Massachusetts, Amherst, Mass. (1978).

Horned Beetle. 1962. Plaster relief, 4¾ x 14½ inches. Coll.: The artist, Little Deer Isle, Me. (1978).

Imaginary Botany A. 1962. Bronze relief, 9¼ inches (diameter). Coll.: Dr. and Mrs. Seymour Lifschutz, New Brunswick, N.J. (1978).

Imaginary Botany B. 1962. Bronze relief, 8¼ inches (diameter). Coll.: Unknown. Reference: Grace Borgenicht Gallery files.

Imaginary Botany C. 1962. Bronze relief, 14½ x 4½ inches. Coll.: Unknown. Reference: Grace Borgenicht Gallery files.

Imaginary Botany D. 1962. Bronze relief, 8¼ inches (diameter). Coll.: Unknown. Reference: Grace Borgenicht Gallery files.

Imaginary Botany E. 1962. Bronze relief, 8¼ inches (diameter). Coll.: Unknown. Reference: Grace Borgenicht Gallery files.

The Owl. 1962. Bronze. Coll.: Smith College, Northampton, Mass. (1978).

St. Thomas Aquinas. 1962. Walnut, 39 inches. Coll.: St. John's Abbey, Collegeville, Minn. (1978).

Stalk. 1962. Bronze relief, 4 x 10 inches. Coll.: Unknown. Reference: Grace Borgenicht Gallery files.

Teasel. 1962. Bronze relief, 13¾ x 4¾ inches. Coll.: Walker Art Museum, Bowdoin College, Brunswick, Me. (1978).

1963

Apotheosis. 1963. Wood, 70 inches (length). Coll.: Brooklyn Museum, Brooklyn, N.Y. (1978).

Caprice. 1963. Wood, 25 inches (length). Coll.: Mr. and Mrs. Howard L. Kaye, Bryn Mawr, Pa. (1978).

Caprice. 1963. Bronze, 25 inches (length). Coll.: Albright-Knox Art Gallery, Buffalo, N.Y. (1978); Rabbi and Mrs. Bernard Baskin, Hamilton, Ontario, Canada (1978); Mr. and Mrs. Harold N. Gast, Westfield, N.J. (1978); Alfred and Betty Landau, Rockville Centre, N.Y. (1978); Mr. Philip Macht, Baltimore, Md. (1965); Whitney Museum of American Art, New York, N.Y. (1978).

For Nicholas Cheronis. 1963. Bronze relief, 22 x 13¼ inches. Coll.: Unknown.

Dutch Artist. 1963. Bronze, 8¼ inches. Coll.: Mr. and Mrs. Anthony Dias Blue, New York, N.Y. (1978); Mr. Michael Boel (1964); Dr. Gerhard K. Cotts, Reston, Va. (1978); Mr. and Mrs. Herbert S. Landau, Lodi, N.J. (1978); Dr. and Mrs. Seymour Lifschutz, New Brunswick, N.J. (1978); Mr. Arnold Perl (1964); Mr. and Mrs. Marshall Potamkin, New York, N.Y. (1979); Mr. Sol Sardinsky, Philadelphia, Pa. (1964); Mr. Sam Sarick, Toronto, Canada (1978); Mr. and Mrs. Herman Schickman, New York, N.Y. (1966); Mr. and Mrs. Carl Selden, New Milford, Conn. (1978); Daisy Shapiro, New York, N.Y. (1978); Dorothy and Marvin Small, New York, N.Y. (1978); Rheta Sosland, Shawnee Mission, Kansas (1978); Emily and Jerry Spiegel, Kings Point, N.Y. (1978); Mr. Frank Titelman (1966).

Hephaestus. 1963. Wood, 47 inches. Coll.: Portland Art Museum, Portland, Ore. (1978).

Hephaestus. 1963. Bronze, 64 inches. Coll.: Mr. Armand Erpf, New York, N.Y. (1964); Hirshhorn Museum and Sculpture Garden, Washington, D.C. (1978); John and Mabel Ringling Museum of Art, Sarasota, Fla. (1978); Whitney Museum of American Art, New York, N.Y. (1979).

Wilfred Owen. 1963. Bronze, 13 inches. Coll.: Anonymous; Ms. Barbara S. Peskin, Princeton, N.J. (1978); Daryl and Lee Rubenstein, Washington, D.C. (1978).

Poet Laureate. 1963. Bronze, 6 inches. Coll.: Anonymous; Murray and Cyd Braun, Brooklyn, N.Y. (1978); Mrs. Marie S. Frankel (1968); Luba Glade Gallery (1969); Mrs. Martin D. Jacobs, New York, N.Y. (1978); Mr. Luis Lastra, Washington, D.C.; Marianna and David Mandel, Perth Amboy, N.J. (1978); Drs. Paul and Laura Mesaros, Steubenville, Ohio (1978); Mr. Norman Rochlin (1964); Daryl and Lee Rubenstein, Washington, D.C. (1978); Mr. Sol Sardinsky, Philadelphia, Pa.

(1966); Dain Schiff, Inc., New York, N.Y. (1964); Mr. and Mrs. Harvey Schulman, New York, N.Y. (1978).

Small Birdman Seated. 1963, Bronze. 25½ inches. Coll.: Mr. Lester Avnet, New York, N.Y. (1964); Banfer Gallery, New York, N.Y. (1964); Mr. Eli Black, New York, N.Y. (1964); Dr. and Mrs. Herbert Kayden, New York, N.Y. (1978).

Teiresias. 1963. Bronze, 53 inches. Coll.: University Art Museum, University of California, Berkeley (1978).

1964

Bird (Maquette). 1964. Bronze, 12 inches. Coll.: Mr. Jacob Schulman, Gloversville, N.Y. (1978).

Bird. 1964. Bronze, 12½ inches. Coll.: Mr. Meyer M. Alperin, Scranton, Pa. (1966); Mr. and Mrs. Anthony Dias Blue, New York, N.Y. (1978); Dr. Herbert J. Kayden, New York, N.Y. (1978); The Albert A. List Family Collection, Greenwich, Conn. (1978): Dr. Thomas Mathews, Washington, D.C. (1978).

Boy (Maquette). 1964. Bronze, 15 inches. Coll.: Mr. Jacob Schulman, Gloversville, N.Y. (1978).

Birdman, Standing. 1964. Aluminum relief, 20 x 20 inches. Coll.: Reynolds Metals Company, Richmond, Va. (1978).

Eagle. 1964. Oak, 19 inches. Coll.: University Art Collection, University of Massachusetts, Amherst, Mass. (1978).

Seated Man. 1964. Bronze, 17 inches. Coll.: Mr. and Mrs. Joseph Bernstein, New Orleans, La. (1978): Murray and Cyd Braun, Brooklyn, N.Y. (1978).

Standing Boy. 1964. Bronze, 15 inches. Coll.: *Seventeen* magazine, New York, N.Y. (1964); St. Armand's Gallery (1968).

1965

Abraham and Isaac. 1965. Bronze relief, 42½ x 23½. Coll.: Mr. and Mrs. Herman Schickman, New York, N.Y. (1978).

Black Bird. c. 1965. Wood, 30 inches. Coll.: Lisa Baskin, Little Deer Isle, Me. (1978).

Boy, Seated Man, Bird. 1964–1965. Bronze, Boy, 72 inches; Seated Man, 78 inches; Bird, 54 inches. Coll.: Society Hills Towers, Inc., Philadelphia, Pa. (1978).

Dead Man. 1965. Bronze relief, 16½ x 23½ inches. Coll.: Dr. Louis L. Heyn, Compston, Cal. (1966).

Imaginary Renaissance Artist (also called *Italian Artist*). 1965. Bronze, 13 inches. Coll.: John Baird Hudson Foundation and Trust, San Francisco, Cal. (1978); Kennedy Gallery, New York, N.Y. (1978).

Man with Folded Arms. 1965. Walnut, 24 inches. Coll.: Mr. Jacob Schulman, Gloversville, N.Y. (1978).

Seated Man with Cloven Hoof. 1965. Walnut. 23 inches. Coll.: Mr. Bertram Lindner, Dalton, Pa. (1965).

Seated Man with Crossed Arms. 1965. Wood, 23½ inches. Coll.: Mr. Burton Machinist, Auburn, Me. (1965).

1966

Classical Head. 1966. Wood. Coll.: Mr. and Mrs. Andrew T. McEvoy, Jr., Croton-on-Hudson, N.Y. (1966).

Crucifix. 1966. Wood, 48 inches. Coll.: Pierce Chapel at Cranwell, Lenox, Mass. (1978).

Dead Man. 1966. Bronze, 30 inches. Coll.: Lisa Baskin, Deer Isle, Me. (1978).

Dead Man. 1966. Bronze, 43 inches (length). Coll.: University of Wisconsin, Elvehjem Art Center, Madison, Wis. (1978).

Man with Terminus. 1966. Wood, 17 inches. Coll.: Mr. and Mrs. Alfred Appel, New York, N.Y. (1978).

Theodore Roosevelt. 1966? Wood. Coll.: Container Corporation of America, New York, N.Y.

Three-Headed Birdman. 1966. Wood relief, 11 x 6½ inches. Coll.: Mr. and Mrs. Kurt H. Grunebaum, Harrison, N.Y. (1978).

Torso. 1966. Wood relief, 10¾ x 7½ inches. Coll.: Kennedy Galleries, New York, N.Y. (1978).

1967

Achilles Mourning the Death of Patroklus. 1967. Bronze, 29 inches. Coll.: The artist, Little Deer Isle, Me. (1978); Longchamps Restaurants, New York, N.Y. (1969).

Continuity. 1967. Bronze relief, 19 x 16½ inches. Coll.: Anonymous; Mr. Channing Blake, Pawling, N.Y. (1979); Mr. Jacob Schulman, Gloversville, N.Y. (1978).

Daedalus. 1967. Bronze, 41 inches. Coll.: Mr. Seymour Alpert (1969); Mr. and Mrs. Alfred Appel, New York, N.Y. (1978); Mr. José Luis Cuevas, Mexico City (1978); Mr. and Mrs. Elliot Picket, New York, N.Y. (1978); Anne Ratner, New York, N.Y. (1978).

Dead Man. c. 1967. Walnut, life-size. Coll.: Sawed in half: the upper part is in the collection of the Kennedy Galleries, New York City; the lower part is in the artist's collection, Little Deer Isle, Me.

Dead Man, Head. 1967. Bronze, 4 inches. Coll.: Lisa Baskin, Little Deer Isle, Me. (1979).

Dead Man, Head. 1967. Bronze, life-size. Coll.: Lisa Baskin, Little Deer Isle, Me. (1979).

Fruitfulness from Permanence. 1967. Bronze, 19½ x 16 inches. Coll.: Lisa Baskin, Little Deer Isle, Me. (1978); Gerald and Ruth Carrel Birnberg, Toronto, Canada (1978); Mr. Channing Blake, Pawling, N.Y. (1979); Mrs. Susan Esty, New York, N.Y. (1978); Michael E. Hall, Jr., New York, N.Y. (1978).

The Mendicant. 1967. Bronze relief, 24½ x 13 inches. Coll.: Anonymous; Alfred and Betty Landau, Rockville Centre, N.Y. (1978).

Small Head. 1967. Bronze, 6 inches. Coll.: Anonymous; Mr. Fred Ferretti (1967); Mrs. Henry Gardstein (1967); Mr. Milton S. Harrison, New York, N.Y. (1967); Mr. Joseph D. Isaacson (1967); Mr. Francis Murphy (1975); Rita and Edwin Rome, Philadelphia, Pa. (1978); Mr. B. H. Shulman (1967);

Mr. and Mrs. Bernhard Smulovitz, Tenafly, N.J. (1978); Philip and Lynn Straus, Larchmont, N.Y. (1978).

Wisdom Is Lasting, Instinct Fleeting. 1967. Bronze relief, 19 x 16 inches. Coll.: Mr. and Mrs. Alfred Appel, New York, N.Y. (1978); Richard Fisher, Pittsburgh, Pa. (1971); Museum of Fine Arts, Boston, Mass. (1978); Mrs. Edith Naidich, Freeport, N.Y. (1978); C. D. Robinson (1967); Mrs. Howard A. Seitz, New York, N.Y. (1978); Smith College Museum of Art, Northampton, Mass. (1979).

1968

Crow Herm. 1968. Bronze, 36 inches. Coll.: Lisa Baskin, Little Deer Isle, Me. (1978); Juanita K. Bromberg, Dallas, Tex. (1978).

Hood (Hooded Figure). 1968. Wood, 27 inches. Coll.: Mrs. Pearl Slusky (1969).

Man with Pomegranate. 1968. Walnut, 31 inches. Coll.: Anonymous.

Man with Pomegranate. 1968. Bronze, 37½ inches. Coll.: Kennedy Galleries, New York, N.Y. (1975).

Oedipus at Colonnus. 1968. Bronze, 74 inches. Coll.: Anonymous.

1969

Andromache. 1969. Bronze relief, 6½ inches (diameter). Coll.: Mr. and Mrs. Robert M. Hughes, South Hadley, Mass. (1978); Anne Ratner, New York, N.Y. (1978); Virginia Museum of Fine Arts, Richmond, Va. (1978).

Apollo. 1969. Bronze relief, 6½ inches (diameter). Coll.: Rabbi and Mrs. Bernard Baskin, Hamilton, Ontario, Canada (1978); Mr. and Mrs. Robert M. Hughes, South Hadley, Mass. (1978); Mrs. Edith Naidich, Freeport, N.Y. (1978); Anne Ratner, New York, N.Y. (1978); Virginia Museum of Fine Arts, Richmond, Va. (1978).

Athena's Shield. 1969. Bronze relief, 6½ inches (diameter). Coll.: Rabbi and Mrs. Bernard Baskin, Hamilton, Ontario, Canada (1978); Mr. and Mrs. Robert M. Hughes, South Hadley, Mass. (1978); Anne Ratner, New York, N.Y. (1978); Virginia Museum of Fine Arts, Richmond, Va. (1978).

Augur. 1969. Walnut, 71 inches. Coll.: Amon Carter Museum, Fort Worth, Tex. (1978).

Bird. 1969. Bronze, 17½ inches. Coll.: Dr. Hans Keitel, New York, N.Y. (1978); Anne Ratner, New York, N.Y. (1978).

Cerberus. 1969. Bronze relief, 6½ inches (diameter). Coll.: Mr. and Mrs. Robert M. Hughes, South Hadley, Mass. (1978); Anne Ratner, New York, N.Y. (1978); Virginia Museum of Fine Arts, Richmond, Va. (1978).

Crow, Standing. 1969. Pine, 47 inches. Coll.: Rose Art Museum, Brandeis University, Waltham, Mass. (1978).

Hanged Man. 1969. Bronze, 32 inches. Coll.: Unknown.

Reference: Grace Borgenicht Gallery files.

Head with Bird. 1969. Bronze, 9½ inches. Coll.: Mr. and Mrs. D. Dennis Allegretti, Lake Forest, Ill. (1978); Huntington Galleries, Huntington, W. Va. (1970); Mr. and Mrs. Herbert S. Landau, Lodi, N.J. (1978); Edith Naidich, Freeport, N.Y. (1978); Mr. Jacob Schulman, Gloversville, N.Y. (1978).

Herm Figure. 1969. Bronze, 23 inches. Coll.: Kennedy Gallery, New York, N.Y.

Icarus. 1969. Bronze relief, 6½ inches (diameter). Coll.: Rabbi and Mrs. Bernard Baskin, Hamilton, Ontario, Canada (1978); Mr. and Mrs. Robert M. Hughes, South Hadley, Mass. (1978); Anne Ratner, New York, N.Y. (1978); Virginia Museum of Fine Arts, Richmond, Va. (1978).

Medusa-Gorgon. 1969. Bronze relief, 6½ inches (diameter). Coll.: Virginia Museum of Fine Arts, Richmond, Va. (1978).

Minotaur. 1969. Bronze relief, 6½ inches (diameter). Coll.: Mr. and Mrs. Robert M. Hughes, South Hadley, Mass. (1978); Anne Ratner, New York, N.Y. (1978); Virginia Museum of Fine Arts, Richmond, Va. (1978).

Phaedra. 1969. Bronze, 30 inches. Coll.: Dr. A. Gabriel (1971); Joslyn Art Museum, Omaha, Neb. (1978); Alfred and Betty Landau, Rockville Centre, N.Y. (1978); H. Spero (1972).

The Sun. 1969. Bronze relief, 6 x 5½ inches (diameter). Coll.: Mr. and Mrs. Louis Smith, Northampton, Mass. (1978).

Swathed Youth. 1969. Bronze, 24½ inches. Coll.: Anonymous; Dr. J. L. Chason, Bloomfield Hills, Mich. (1978); Lawrence Fleischman, New York, N.Y. (1978); Mrs. Morris W. Primhoff, New York, N.Y. (1978).

Swathed Youth, 1969. Bronze, 56½ inches. Coll.: Anonymous.

Theseus. 1969. Bronze, 38 inches. Coll.: Anonymous.

1970

Anatomist. 1970. Bronze relief, 26½ x 16 inches. Coll.: Dr. Hans Keitel, New York, N.Y. (1978); Kennedy Galleries, New York, N.Y. (1978).

Bookseller (Timothy Trace). 1970. Bronze relief, 13 x 9 inches. Coll.: Mr. and Mrs. Timothy Trace, Peekskill, N.Y. (1978).

Clusius. 1970. Bronze relief, 27 x 16½ inches. Coll.: Anonymous.

Man with Sheep's Head. 1970. Bronze relief, 28 x 16½ inches. Coll.: Avis and Rockwell Gardiner, Stamford, Conn. (1978).

Prometheus Bound. 1970. Bronze relief, 23½ x 13½ inches. Private coll.

Marvin Sadik. 1970. Bronze relief, 27¾ x 13 inches. Coll.: Marvin Sadik, Washington, D.C. (1978).

Homage to Augustus Saint-Gaudens. 1970. Bronze relief, 23½ x 14 inches. Coll.: Lisa Baskin, Little Deer Isle, Me. (1978).

Karl Schrag. 1970. Bronze relief, 26 x 15 inches. Coll.: Karl Schrag, Little Deer Isle, Me. (1978).

Why Do the Gentiles Ask Where Is Your God. 1970.

Bronze relief, 24½ x 14 inches. Coll.: Lisa Baskin, Little Deer Isle, Me. (1978).

St. Anthony of Padua. 1970. Cherry, 21 inches. Coll.: Mr. and Mrs. Nicholas D. Bonadies (1975).

1971

Aeneas Carrying His Father from Burning Troy. 1971. Bronze, 36 inches. Coll.: Arlene and Arnold Richards, New York, N.Y. (1978).

Andromache. 1971. Bronze, 38 inches. Coll.: Anonymous: Kennedy Galleries, New York, N.Y. (1978).

Portrait of Hosea Thomas Baskin. 1971. Bronze relief, 6 x 8 inches (oval). Coll.: Anonymous.

Tobias Isaac Baskin. 1971. Bronze relief, 11 x 9 inches. Coll.: Anonymous; Lisa Baskin, Little Deer Isle, Me. (1978).

Portrait of Helen Bassine and José Yglesias. 1971. Bronze relief, 11½ x 24½ inches. Coll.: Helen Bassine and José Yglesias, New York, N.Y. (1978).

Portrait of Marilyn and Michael Boyle. 1971. Bronze relief, 13 x 17 inches. Coll.: Marilyn and Michael Boyle.

Peter Boynton. c. 1971. Bronze relief, 20½ x 12½ inches. Coll.: Kennedy Galleries, New York, N.Y. (1978).

Figure. 1971. Bronze. 39 inches. Coll.: Kennedy Galleries, New York, N.Y. (1978).

Eliot Feld, Choreographer. 1971. Bronze relief, 17 x 11 inches (oval). Coll.: Alice and Ben Feld, New York, N.Y. (1978).

Portrait of Lawrence Fleischman. 1971. Bronze, 17 x 11 inches. Coll.: Mr. and Mrs. Lawrence E. Fleischman, New York, N.Y. (1978).

Fortuna. 1971. Bronze, 29 inches. Coll.: Kennedy Galleries, New York, N.Y. (1978).

Harold Hugo, Printer. 1971. Bronze relief, 23½ x 14 inches. Coll.: Mr. Harold Hugo, Meriden, Conn. (1978).

Lisa. 1971. Bronze relief, 32½ x 17 inches. Coll.: Lisa Baskin, Little Deer Isle, Me. (1978); Estelle and Jay Sam Unger, Brooklyn, N.Y. (1978).

Head. 1971. Bronze, 7½ inches. Coll.: Mr. Johan Throne-Holst, Stockholm, Sweden (1978).

Idolatry (Four Way). 1971–1972. Wood, 24 inches. Coll.: Kennedy Galleries, New York, N.Y. (1978).

Sidney Kaplan. 1971. Bronze relief, 18 x 12 inches. Coll.: Emma and Sidney Kaplan, Northampton, Mass. (1978).

Prophet: Homage to Rico Lebrun. 1971. Bronze, 36 inches. Coll.: Mr. Channing Blake, New York, N.Y. (1978); Franklin D. Murphy Sculpture Garden, University of California at Los Angeles, Los Angeles, Calif. (1978).

Mandan Indian Chief (Four Bears). 1971. Bronze, 36 x 16 inches. Coll.: Kennedy Galleries, New York, N.Y. (1978).

Marsyas. 1971. Bronze, 46½ inches. Coll.: Kennedy Galleries, New York, N.Y. (1978).

Monument to Labor. 1971. Bronze, 12½ inches. Coll.: Anonymous; Gerald and Ruth Carrel Birnberg, Toronto, Canada (1978); Mr. Bengt E. R. Julin, Stockholm, Sweden (1978); Anne Ratner, New

York, N.Y. (1978); Mr. Johan Throne-Holst, Stockholm, Sweden (1978).

Mourning Woman (Standing). 1971. Bronze, 44 inches. Coll.: Anonymous; Rabbi and Mrs. Bernard Baskin, Hamilton, Ontario, Canada (1978); Mr. Johan Throne-Holst, Stockholm, Sweden (1978); Dr. and Mrs. David Kruger, Alexandria, Va. (1978); Dr. and Mrs. Harry Naidich, Freeport, N.Y. (1978); Mrs. Jerome B. Smith, Swarthmore, Pa. (1978); Estelle and Jay Sam Unger, Brooklyn, N.Y. (1978); Vatican Museums, Vatican City, Italy (1978).

Oedipus in Exile. 1971. Bronze, 39 inches. Coll.: Anonymous.

Osage Chief. 1971. Bronze relief, 12¾ x 12½ inches. Coll.: Anonymous.

Wilfred Owen. 1971. Bronze relief, 12¾ x 12½ inches. Coll.: Anonymous: Kennedy Galleries, New York, N.Y. (1978).

Silence. 1971. Bronze, 9½ inches. Coll.: Anonymous; Mr. and Mrs. Hugh W. Greenberg (1978); Anne Ratner, New York, N.Y. (1978); Dr. and Mrs. Milton Shiffman, Huntington Woods, Mich. (1978); Dr. and Mrs. Nathaniel Spier, Great Neck, N.Y. (1978).

Small Crow Term. 1971. Bronze, 18 inches. Coll.: Anonymous.

Three-Headed Crow Man. 1971. Bronze, 40½ inches. Coll.: Kennedy Galleries, New York, N.Y. (1978).

Ugolino. 1971. Bronze relief, 26½ x 16 inches. Coll.: Anonymous; Kennedy Galleries, New York, N.Y. (1978).

Portrait of Shirley Verrett. 1971. Bronze relief, 15 x 11¼ inches. Coll.: Shirley Verrett, New York, N.Y. (1978).

Wolf Robe. 1971. Bronze relief, 12 x 11½ inches. Coll.: Anonymous; Mr. and Mrs. Alfred Appel, New York, N.Y. (1978); Lisa Baskin, Little Deer Isle, Me. (1978); Kennedy Galleries, New York, N.Y. (1978).

1972

American Artist. 1972. Bronze, 30½ inches. Coll.: Kennedy Galleries, New York, N.Y. (1978).

Armando Balboni, Sculptor. 1972. Plaster relief, 21 x 16 inches. Coll.: Armando Balboni, Northampton, Mass. (1975).

Chief with Peace Medal. 1972. Bronze, 36 inches. Coll.: The Warner Collection of Gulf States Paper Corp., Tuscaloosa, Ala. (1978).

Egyptian Ballet: Bat Dancer. 1972. Bronze, 28¼ inches. Coll.: Kennedy Galleries, New York, N.Y. (1978).

Egyptian Ballet: Bird Dancer. 1972. Bronze, 36 inches. Coll.: Kennedy Galleries, New York, N.Y. (1978).

Egyptian Ballet: Cat Dancer. 1972. Bronze, 29½ inches. Coll.: Kennedy Galleries, New York, N.Y. (1978).

Egyptian Ballet: Ram Dancer. 1972. Bronze, 29½ inches. Coll.: Kennedy Galleries, New York, N.Y. (1978).

Indian Bird Woman. 1972. Bronze, 29 inches. Coll.: Kennedy Galleries, New York, N.Y. (1978).

Indian Chief with Peace Medal. 1972. Bronze, 30 inches. Coll.: Kennedy Galleries, New York, N.Y. (1978).

Indian Woman. 1972. Bronze, 29½ inches. Coll.: Drs. Leonard and Roberta Griff, Harrisburg, Pa. (1978); The Warner Collection of Gulf States Paper Corp., Tuscaloosa, Ala. (1978); Whitney Gallery of Western Art, Cody, Wyo. (1978).

Job. 1972. Bronze, 9¼ inches. Coll.: Dr. Hans Keitel, New York, N.Y. (1978); Mr. Jacob Schulman, Gloversville, N.Y. (1978).

Judith with the Head of Holofernes. 1972. Bronze, 38¾ inches. Coll.: Mr. and Mrs. Leonard Greenberg, West Hartford, Conn. (1978); Vatican Museums, Vatican City, Italy (1978).

The Paradigm. 1972. Bronze relief, 9¾ x 9¼ inches. Coll.: Kennedy Galleries, New York, N.Y. (1978).

Prayer. 1972. Bronze, 34 inches. Coll.: Anonymous.

Princess. 1972. Bronze and silver, 12 inches. Coll.: Mr. and Mrs. Lawrence E. Fleischman, New York, N.Y. (1978).

Sphinx. 1972. Bronze, 36 inches. Coll.: Kennedy Galleries, New York, N.Y. (1978).

Thought (Man with Raised Arms). 1972. Bronze, 34 inches. Coll.: Mr. Jacob Schulman, Gloversville, N.Y. (1978).

Wrapped Man. 1972. Wood, 24 inches. Coll.: Dr. and Mrs. Joseph Klein, Kingston, Pa. (1978).

1973

Capriccio. 1973. Bronze, 30 inches. Coll.: Anonymous.

Chimera. 1973. Bronze, 14 x 17 inches. Coll.: Kennedy Galleries, New York, N.Y. (1978).

Doppleman. 1973. Bronze relief, 25 x 15½ inches. Coll.: Anonymous.

Hermes. 1973. Bronze, 15 inches. Coll.: Virginia Museum of Fine Arts, Richmond, Va. (1978).

Isaac. 1973. Bronze, 59 inches. Coll.: Johan Throne-Holst, Stockholm, Sweden (1978); Vatican Museums, Vatican City, Italy (1978).

1974

The Divinator, Study for. 1974. Bronze, 30½ inches. Coll.: Anonymous; Mr. Bengt E. R. Julin, Stockholm, Sweden (1978).

Divinator. 1974. Bronze, 112 inches. Coll.: Brooks Memorial Art Gallery, Eugenia Buxton Whitnel Fund, Memphis, Tenn. (1978).

The Old Prophet. 1974. Bronze, 36 inches. Coll.: The Institute for the Arts, Washington, D.C. (1978).

The Prophet. 1974. Bronze, 15½ inches. Coll.: Dr. Hans Keitel, New York, N.Y. (1978); Anne Ratner, New York, N.Y. (1978).

The Seer. 1974. Bronze, 47½ inches. Coll.: Anonymous.

Standing Figure. 1974. Bronze, 35¼ inches. Coll.: Kennedy Galleries, New York, N.Y. (1978).

Portrait of Estelle Unger. 1974. Bronze relief, 10½ x 13½ inches. Coll.: Estelle and Jay Sam Unger, Brooklyn, N.Y. (1978).

Portrait of Jay Sam Unger. 1974. Bronze relief, 10½ x 13½ inches. Coll.: Estelle and Jay Sam Unger, Brooklyn, N.Y. (1978).

1975

Abraham. 1975. Bronze, 42 inches. Coll.: Indianapolis Museum of Art, Indianapolis, Ind. (1978); Mr. Jacob Schulman, Gloversville, N.Y. (1978); Henry Kaufman, New York, N.Y. (1979).

Classical Figure. 1975. Bronze, 57 inches. Coll.: Anonymous.

Crowman. 1975. Bronze, 54 inches. Coll.: Kennedy Galleries, New York, N.Y. (1978).

Isaacangel. 1975. Bronze, 46 inches. Coll.: Anonymous.

Leaning Man. 1975. Bronze, 33½ inches. Coll.: Anonymous.

Mask. 1975. Bronze, 14 inches. Coll.: Kennedy Galleries, New York, N.Y. (1978).

Mourning Woman, Early Summer. 1975. Bronze, 18 inches. Coll.: Anonymous.

Mourning Woman: In Memory of the Artist's Father. 1975. Bronze, 25½ inches. Coll.: Pearl and Norman Rabinowitz, Massapequa, N.Y. (1978).

Mourning Woman, Late Summer. 1975. Bronze, 18 inches. Coll.: Anonymous.

Prophet. 1975. Bronze, 15 inches. Made for The League School, Brooklyn, N.Y. Coll.: Anne Ratner, New York, N.Y. (1978).

The Prophet. 1975. Bronze, 35 inches. Coll.: Kennedy Galleries, New York, N.Y. (1978).

Ram. 1975. Bronze, 42½ inches. Coll.: Kennedy Galleries, New York, N.Y. (1978).

Seated Figure. 1975. Bronze, 28 inches. Coll.: Anonymous.

Skeleton. 1975. Bronze relief, 25 x 15½ inches. Coll.: Anonymous.

1976

Spencer Fullerton Baird. 1976. Bronze, 85 inches. Coll.: Smithsonian Institution, Victorian Garden, Washington, D.C. (1978).

Spencer Fullerton Baird. 1976. Plaster, 30⅞ inches. Coll.: Hirshhorn Museum and Sculpture Garden, Washington, D.C. (1978).

Spencer Fullerton Baird. 1976. Plaster, 23⅛ inches. Coll.: Hirshhorn Museum and Sculpture Garden, Washington, D.C. (1978).

Spencer Fullerton Baird. 1976. Plaster relief, 28⅛ inches. Coll.: Hirshhorn Museum and Sculpture Garden, Washington, D.C. (1978).

Centurion. 1976. Bronze, 30 inches. Coll.: Harberg Collection, Houston, Tex. (1978); Kresge Art Center Gallery, Michigan State University, East Lansing, Mich. (1978).

Dead Woman. 1976. Bronze relief, 34 x 8 inches. Coll.: Kennedy Galleries, New York, N.Y. (1978).

Half-Sibyl. 1976. Bronze, 29 inches. Coll.: Kennedy Galleries, New York, N.Y. (1978).

Hanged Man. 1976. Bronze, 90 inches. Coll.: Anonymous.

Heron. 1976. Bronze relief, 16 x 8½ inches. Coll.: Kennedy Galleries, New York, N.Y. (1978).

Isaac Angel. 1976. Bronze, 30 inches. Coll.: Harberg Collection, Houston, Tex. (1978).

President Andrew Jackson. 1976. Bronze relief, 24 x 16 inches. Coll.: General Services Administration, Federal Court Building, Nashville, Tenn. (1978).

President Andrew Johnson. 1976. Bronze relief, 24 x 16 inches. Coll.: General Services Administration, Federal Court Building, Nashville, Tenn. (1978).

Naturalist with Fish and Birds. 1976. Bronze relief, 29½ inches. Coll.: Anonymous.

President James Knox Polk. 1976. Bronze relief, 24 x 16 inches. Coll.: General Services Administration, Federal Court Building, Nashville, Tenn. (1978).

Prodigal Son. 1976. Bronze, 55 inches. Coll.: Mr. Johan Throne-Holst, Stockholm, Sweden (1978).

Seated Naturalist. 1976. Bronze, 23½ inches. Coll.: Anonymous.

Sibyl. 1976. Bronze, 43 inches. Coll.: Kennedy Galleries, New York, N.Y. (1978).

Study for Standing Sibyl (Wearing Cap). 1976. Bronze, 29 inches. Coll.: Kennedy Galleries, New York, N.Y. (1978).

Standing Naturalist. 1976. Bronze, 31 inches. Coll.: Kennedy Galleries, New York, N.Y. (1978).

Standing Woman. 1976. Bronze, 43 inches. Coll.: Anonymous.

Study for Sibyl. 1976. Bronze, 29 inches. Coll.: Anonymous.

1977

The Altar. 1977. Linden, 71 inches (length). Coll.: Kennedy Galleries, New York, N.Y. (1978).

Portrait of Max Blatt and Sophie Maslow. 1977. Bronze relief, 14 x 27 inches. Coll.: Max Blatt and Sophie Maslow, New York, N.Y. (1978).

The Conversion of St. Paul. 1977. Bronze relief, 28½ x 20 inches. Coll.: Vatican Museums, Vatican City, Italy (1978).

Dr. Carl Fenichel. 1977. Bronze relief, 25 x 19 inches. Coll.: The League School, Brooklyn, N.Y. (1978).

The Large Sibyl. 1977. Bronze. 86 inches. Coll.: Kennedy Galleries, New York, N.Y. (1978).

The Poet. 1977. Bronze, 34 inches. Coll.: Mr. Jacob Schulman, Gloversville, N.Y. (1978).

Seated Sculptor. 1977. Bronze. 45 inches. Coll.: Kennedy Galleries, New York, N.Y. (1978).

Western Woman. 1977. Bronze. 43 inches. Coll.: Kennedy Galleries, New York, N.Y. (1978).

1978

Jacob Wrestling with the Angel. 1978. Bronze, 55 inches. Coll.: Kennedy Galleries, New York, N.Y. (1978).

Lazarus. 1978. Bronze, 40 inches. Coll.: Kennedy Galleries, New York, N.Y. (1978).

Muse. 1978. Bronze, 30 inches. Coll.: Kennedy Galleries, New York, N.Y. (1978).

Ruth and Naomi. 1978. Bronze, 52 inches. Coll.: Kennedy Galleries, New York, N.Y. (1978).

BIBLIOGRAPHY

This bibliography lists alphabetically all sources to which references have been made in the notes to the text. A bibliography that includes articles about Baskin, exhibition reviews, books containing references to him, and selected exhibition catalogues through 1970 is available in *Baskin: Sculpture, Drawings, Prints*, listed below.

Old Testament quotations are drawn from *The Holy Scriptures According to the Masoretic Texts*. Philadelphia: The Jewish Publication Society of America, 1955.

Andersen, Wayne. *American Sculpture in Progress: 1930–1970*. Boston: New York Graphic Society, 1975.

Arts. Vol. 31 (March 1957).

Ashton, Dore. "A to B: Dore Ashton Answers Leonard Baskin on the Question of Originality in Art." *Studio*, Vol. 16 (November 1963), pp. 194–197.

Baskin, Leonard. "The Art of Frasconi." *New Foundations*, Vol. 1, No. 3 (Spring 1948), p. 134.

———. "Three Poems." *New Foundations*, Vol. 1, No. 3 (Spring 1948), p. 148.

———. "Notes on Style and Reality." *New Foundations*, Vol. 1, No. 4 (Summer 1948), pp. 217–218.

———. "To Wear Blood Stain with Honor." *Judaism: A Quarterly Journal*, Vol. 10, No. 4 (1961), pp. 294–295.

———. "The Necessity for the Image," *Talks on Art 2*. New Haven, Conn.: Yale University School of Art and Architecture, 1961, n.p. Reprinted in *Atlantic Monthly*, Vol. 207 (April 1961), pp. 73–76.

———. "On the Nature of Originality." *Show*, Vol. III, No. 8 (August 1963), n.p.

———. "Of Roots and Veins: A Testament." *Atlantic Monthly*, Vol. 214 (September 1964), pp. 65–68.

Baskin: Sculpture, Drawings, Prints. New York: George Braziller, 1970.

Baudelaire, Charles. *Flowers of Evil*. Selected and edited by Marthiel and Jackson Mathews. Norfolk, Conn.: New Directions Books, 1955.

Baur, John I. H. *Revolution and Tradition in Modern American Art*. Cambridge (Mass.): Harvard University Press, 1958.

Bowdoin College Museum of Art. *Leonard Baskin*. 1962. Texts by Winslow Ames, Julius S. Held, Harold Joachim, Rico Lebrun, Ray Nash.

Brook, Stephen. *A Bibliography of The Gehenna Press, 1942–1975*. Northampton, Mass.: J. P. Dwyer, 1976.

The Brooklyn Museum Bulletin. See Johnson, Una E.

Cummings, Paul. "Interview with Leonard Baskin, April 17, 1969." Archives of American Art, transcript.

Dante Alighieri, *The Divine Comedy*, translated by Thomas G. Bergin. 3 vols. New York: Grossman Publishers, 1969.

Dodds, E. R. *The Greeks and the Irrational*. Berkeley, Los Angeles, London: University of California Press, 1971.

Educational Alliance Art School. *The History of the Art School*. New York, 1963.

Eliot, T. S. *The Sacred Wood*. New York: Alfred A. Knopf, 1930.

Elsen, Albert E. *The Partial Figure in Modern Sculpture from Rodin to 1969*. Baltimore, Md.: The Baltimore Museum of Art, 1969.

Encyclopedia Judaica. Vol. 5.

Erdman, David V. *Blake: Prophet Against Empire*. Princeton, N.J.: Princeton University Press, 1969.

Etchepare, Ralph. "Cranwell Chapel: A History and Critique." *The Well* (The Cranwell School, Lenox, Mass.), Vol. 29, No. 8 (May 12, 1967), pp. 1–4.

Fern, Alan. See National Collection of Fine Arts.

Frye, Northrup. *Anatomy of Criticism*. Princeton, N.J.: Princeton University Press, 1957.

Goldwater, Robert, and Treves, Marco. *Artists on Art*. New York: Pantheon Books, 1947.

Gosse, Sir Edmund. *The Life and Letters of John Donne*, Vol. II. New York: Dodd Mead & Co., London: William Heinemann, 1899. 2 vols.

Hagstrum, Jean. *William Blake*. Chicago: The Chicago University Press, 1964.

Holt, Elizabeth. *A Documentary History of Art*, Vol. I. New York: Doubleday & Co., 1957. 4 vols.

Howard, Jane. "Leonard Baskin: Printer, Teacher, Affluent Artist. The Pleasant Pariah." *Life*, Vol. 56 (January 1964), pp. 38–42.

Howe, Irving. *World of Our Fathers*. New York and London: Harcourt Brace Jovanovich, 1976.

The Jerome Biblical Commentary, ed. Raymond E. Brown, Joseph A. Fitzmyer, Roland E. Murphy. Englewood Cliffs, N.J.: Prentice-Hall, Inc., 1968. 2 vols. in 1.

Johnson, Una E. "Head of a Poet, 1954." *Brooklyn Museum Bulletin*, Vol. 17, No. 2 (1956), p. 14.

Korshak, Yvonne. "Suffering in Western Art." *Journal of Dharma*, Vol. 2, No. 3, pp. 318–338.

Kramer, Hilton. "Eakins Was a Merciless Truth Teller." *The New York Times*, June 5, 1977, Section D, p. 27.

Kris, Ernst. *Psychoanalytic Explorations in Art*. New York: International Universities Press, 1952.

Kuh, Katherine. "New Talent in the U.S.A." *Art in America*. Vol. 44 (February 1956), pp. 48–49.

Kuspit, Donald B. "Two Critics: Thomas B. Hess and Harold Rosenberg." *Artforum*, Vol. 17, No. 1 (September 1978), pp. 32–33.

Lattimore, Richmond (trans.). *The Iliad of Homer*. Chicago and London: The University of Chicago Press; Toronto 5, Canada: The University of Toronto Press, 1962. Introduction by Richmond Lattimore.

Lewis, C. Day. See Owen, Wilfred.

MacLeish, Archibald (preface). *Figures of Dead Men by Leonard Baskin*. Amherst: The University of Massachusetts Press, 1968.

McCoy, Garnett, ed. *David Smith*. New York, Washington, D.C.: Praeger, 1973.

Medlin, Faith. *Centuries of Owls*. Norwalk, Conn.: Silvermine Publishers, 1967.

Misch, Georg. *A History of Autobiography in Antiquity*. Cambridge, Mass.: Harvard University Press, 1951.

Museum Boymans–van Beuningen, Rotterdam, Nether-

lands. *Leonard Baskin: Sculptuur, Tekeningen, Grafick.* 1961. Introduction by Peter and Thalia Selz.

The Museum of Modern Art. *Odilon Redon, Gustave Moreau, Rodolphe Bresdin.* 1961. With essays by John Rewald, Dore Ashton, and Harold Joachim.

National Collection of Fine Arts. *Leonard Baskin.* Introduction by Alan Fern. Washington, D.C.: Smithsonian Institution, 1970.

Neumann, Erich. *The Archetypal World of Henry Moore,* trans. R. F. C. Hull. New York: Pantheon Books for the Bollingen Foundations, Inc., 1959.

Newsweek. "They Frighten People." Vol. 60 (October 1962), p. 66.

Nochlin, Linda. *Realism.* New York, Baltimore: Penguin Books, 1971.

O'Doherty, Brian. "Leonard Baskin." *Art in America,* Vol. 50 (Summer 1962), pp. 66–72. Reprinted as "The Homeric Art of Leonard Baskin" in *Perspective on Ideas and the Arts,* Vol. 11, No. 10 (October 1962), pp. 25–30. Reprinted in *Art in America,* Vol. 51 (August 1963), pp. 118–123.

Owen, Wilfred. *The Collected Poems of Wilfred Owen.* Edited with an introduction and notes by C. Day Lewis. New York: New Directions Books, 1964.

Pascal, Roy. *Design and Truth in Autobiography.* Cambridge, Mass.: Harvard University Press, 1960.

Penrose, Roland. *The Sculpture of Picasso.* New York: The Museum of Modern Art, 1967.

Porter, David. "Beasts/Shamans'/Baskin: The Contemporary Aesthetics of Ted Hughes." *Boston University Journal,* No. 3 (1974), pp. 13–25.

Reynolds, Sir Joshua. *Discourses on Art,* ed. Stephen O. Mitchell. New York: The Bobbs-Merrill Company, 1965. First published in 1797.

Richardson, William J. *Heidegger, Through Phenomenology to Thought.* The Hague: Martinus Nijhoff, 1963.

Ricoeur, Paul. *The Symbolism of Evil,* trans. Emerson Buchanan. New York, Evanston, and London: Harper & Row, 1967.

Rodman, Selden. Conversations with Artists. New York: Capricorn Press, 1961.

Rose, Barbara, ed. *Readings in American Art.* New York: Praeger, 1975.

Roylance, Dale. "Leonard Baskin's Gehenna Press." *Art in America,* Vol. 54, No. 6 (November–December 1966), pp. 56–59.

Sadik, Marvin. *Leonard Baskin.* Exhibition catalogue, Kennedy Galleries, 1972.

Sandler, Irving. *The Triumph of American Painting: A History of Abstract Expressionism.* New York, Washington, D.C.: Praeger, 1970.

Schmoll, J. A. (gen. Eisenwerth). *Das Unvollendete als Künstlerische Form.* Bern, Munich: A. Francke AG Verlag, 1959.

Seitz, William C. *The Art of Assemblage.* New York: The Museum of Modern Art, 1961.

Selz, Peter. *New Images of Man.* New York: The Museum of Modern Art, 1959.

———. "The Genesis of 'Genesis.'" *Archives of American Art Journal,* No. 3, 1976, pp. 2–7.

Slochower, Harry. *Three Ways of Modern Man.* New York: International Publishers (Kraus Reprint Co., 1969), 140–144.

Soyer, Raphael. *Diary of an Artist.* Washington, D.C.: New Republic Books, 1977.

Strahan, W. J. *Towards Sculpture: Drawings and Maquettes from Rodin to Oldenburg.* Boulder, Colo.: Westview Press, 1976.

Tribune of Art, No. 13, May–June 1948.

The University Art Museum. University of California, Berkeley. *Selection 1967: Recent Acquisitions in Modern Art.* Berkeley: University of California Press, 1967.

University of Illinois. *Contemporary American Painting and Sculpture.* Introduction by Allen Weller. 1957, 1961.

Van Bork, Bert. *Jacques Lipchitz: The Artist at Work.* With a critical evaluation by Dr. Alfred Werner. New York: Crown Publishers, Inc., 1966.

Walton, Sir Izaak. *Lives of John Donne, Sir Henry Wotton, Richard Hooker, George Herbert and Robert Sanderson.* New York, Toronto: Oxford University Press, 1962. First published in 1640.

Wilmerding, John, ed. *The Genius of American Painting.* New York: William Morrow & Co., 1973.

Figure 1—photo courtesy Deborah Brown. *Figures 2, 32, 59, 67, 86, 107, 112, 117b, 129*—photos by Barney Burstein. *Figures 3, 5*—photos by B. A. King. *Figure 4*—photo courtesy Pearl Rabinowitz. *Figures 6, 8, 9, 11, 15a, 15b, 16a, 16b, 24, 25, 35, 36, 43, 54, 74, 83, 104*—photos by David Allison. *Figure 7*—from *New York Journal and American*, 1937. *Figure 10*—from *New Foundations* (New York: New Foundations Cooperative Press, vol. 2, no. 1, 1948). *Figure 12*—courtesy of the Brooklyn Museum; gift of the artist. *Figures 13, 102*—Musée du Louvre; photo from Chuzeville. *Figure 14*—courtesy Edizione Vincenza Carcavallo, Naples. *Figures 17, 34, 37, 49, 69, 72, 73, 81, 82, 85, 94a, 94b, 111, 117a, 128, 130*—courtesy Grace Borgenicht Gallery, Inc.; photos by Walter Rosenblum. *Figure 18*—from *Tino di Camaino* (Milan: Fratelli Fabbri Editori, 1966). *Figure 19*—The Museum of Modern Art, New York; gift of Mr. and Mrs. Peter A. Rübel. *Figures 20, 101, 105, 123b*—from *Leonard Baskin: the Graphic Work 1950–1970* (New York: FAR Gallery, 1970). *Figure 21*—The Museum of Modern Art, New York. *Figures 22, 122*—courtesy Cairo Museum. *Figure 23*—from *The Sculpture of Picasso* by Roland Penrose (New York: The Museum of Modern Art, 1967). *Figure 26*—Weintraub Gallery, New York. *Figures 27a, 27b*—Hirshhorn Museum and Sculpture Garden, Washington, D.C.; photos by Walter Rosenblum. *Figure 28*—The Museum of Modern Art, New York; presented in memory of Curt Valentin by his friends. *Figure 29*—from *Rodin* by Albert Elsen (New York: The Museum of Modern Art, 1963). *Figure 30*—Museum of Fine Arts, Boston; Fund Harvard–MFA Expedition. *Figure 31*—Professor and Mrs. Julius Held; photo by Jonathan Barber. *Figure 33*—from *St. Paul's Cathedral Guidebook* (London: Pitkin Pictorials Pride of Britain Books, 1975). *Figure 38*—from *The Life and Letters of John Donne* by Sir Edmund Gosse (New York: Dodd Mead & Co., 1899). *Figure 39*—Courtauld Institute of Art, London. *Figures 40, 89*—The Museum of Modern Art, New York; Blanchette Rockefeller Fund. *Figures 41a, 41b, 62a, 62b, 76, 92, 95a, 95b, 109, 110, 113a, 119a, 126b, 131, 135a, 135b, 141a, 141b, 142*—Kennedy Galleries, Inc.; photos by Otto E. Nelson. *Figure 42*—J. M. Hall Collection, 1960. *Figure 44*—J. A. Cacciola. *Figures 45, 58*—from *Barlach* by Carl D. Carls (New York: Praeger, 1969). *Figures 46, 48, 71, 93*—Yale University Library. *Figures 47, 123a*—Amon Carter Museum, Fort Worth, Texas. *Figure 50*—University Art Museum, University of California, Berkeley; gift of the artist. *Figures 51, 57, 61a, 61b, 61c, 64, 65, 66, 70, 75, 116, 118, 119b, 124a, 124b, 125, 126a, 136, 137, 138*—copyright Kennedy Galleries, Inc. *Figures 52a, 52b*—Munson-Williams-Proctor Institute. *Figure 53*—Alinari/Editorial Photocolor Archive, Inc. *Figure 55*—The University of Chicago Press. *Figure 56*—Museum of Fine Arts, Boston; gift of Mrs. Henry Simonds. *Figure 60*—courtesy Henry Moore. *Figure 63*—from *The Art of Sculpture* by Herbert Read (Princeton, New Jersey: Princeton University Press, 1956). *Figure 68*—The New School; photo by Otto E. Nelson. *Figure 77*—Whitney Museum of American Art, New York; gift of Howard and Jean Lipman. *Figure 78*—from *The Hidden World of Misericords* by Dorothy and Henry Kraus (New York: Braziller, 1975). *Figures 79, 96, 103, 132*—from *The Art and Architecture of the Orient* by Henri Frankfort (New York, Penguin Books, 1963). *Figure 80*—Whitney Museum of American Art, New York. *Figure 84*—Whitney Museum of American Art, New York, photo by Otto E. Nelson. *Figure 87*—Fogg Art Museum, Harvard University; anonymous gift. *Figure 88*—Fogg Art Museum, Harvard University; anonymous permanent loan. *Figure 90*—The Museum of Modern Art, New York; gift of Mr. and Mrs. Herman D. Shickman. *Figure 91*—Minneapolis Institute of Arts; John Cowles Foundation Fund. *Figure 97*—Baltimore Museum of Art. *Figure 98*—copyright National Portrait Gallery, London. *Figure 99*—photo by Herbert B. Walden. *Figure 100*—The Art Institute of Chicago; gift of Walter S. Brewster. *Figure 106*—Hirshhorn Museum and Sculpture Garden, Washington, D.C.; photo by Otto E. Nelson. *Figure 108*—photo by Otto E. Nelson. *Figures 113b, 113c, 113d, 113e, 113f*—copyright Noel Chanan. *Figure 114*—Whitney Museum of American Art, New York; photo by Walter Rosenblum / Grace Borgenicht Gallery Inc. *Figure 115*—University Art Museum, University of California, Berkeley. *Figures 120a, 120b, 120c*—copyright Kennedy Galleries, Inc.; photos by Bruce C. Jones. *Figure 121*—Smith College Museum of Art; photo by Herbert P. Vose. *Figure 127*—H. P. Cordes Fotograf. *Figure 133*—Jacob Schulman; photo courtesy Yale University Library. *Figure 134*—H. Shickman Gallery. *Figure 139*—University Museum, University of Pennsylvania, Philadelphia. *Figure 140*—The Brooklyn Museum.

INDEX